GRAPHIC DESIGN USA: 16

THE ANNUAL

OF THE

AMERICAN INSTITUTE OF

GRAPHIC ARTS

THE ANNUAL OF THE
AMERICAN INSTITUTE
OF GRAPHIC ARTS

Written by David R. Brown, Moira Cullen,
Steven Heller, Ellen Lupton, and Rick Poynor

Designed by Beth Crowell,
Cheung/Crowell Design

Computer composition by Mark F. Cheung,
Cheung/Crowell Design

Marie Finamore, Managing Editor

Distributed to the trade by Watson-Guptill
Publications, 1515 Broadway, New York, NY 10036.

ISBN 0-8230-6391-7

Printed in Hong Kong by Everbest Printing Co. Ltd.
Typeset by Cheung/Crowell Design, Rowayton, CT.
First printing, 1995.

Distributed outside the United States and Canada
by Hearst Books International, 1350 Avenue of the
Americas, New York, NY 10019.

Contents

The American Institute of Graphic Arts is the national non-profit organization that promotes excellence in graphic design. Founded in 1914, the AIGA advances graphic design through competitions, exhibitions, publications, professional seminars, educational activities, and projects in the public interest.

Members of the Institute are involved in the design and production of books, magazines, and periodicals as well as corporate, environmental, and promotional graphics. Their contributions of specialized skills and expertise provide the foundation for the Institute's programs. Through the Institute, members form an effective, informal network of professional assistance that is a resource to the profession and the public.

Separately incorporated, the thirty-seven AIGA chapters enable designers to represent their profession collectively on a local level. Drawing upon the resources of the national organization, chapters sponsor a wide variety of programs dealing with all areas of graphic design.

By being a part of a national network, bringing in speakers and exhibitions from other parts of the country and abroad, focusing on new ideas and technical advances, and discussing business practice issues, the chapters place the profession of graphic design in an integrated and national context.

The competitive exhibition schedule at the Institute's national gallery in New York includes the annual *Book Show* and *Communication Graphics*. Other exhibitions include *Illustration, Photography, Covers* (book jackets, compact disks, magazines, and periodicals), *Posters, Signage,* and *Packaging*. The exhibitions travel nationally and are reproduced in *Graphic Design USA*. Acquisitions have been made from AIGA exhibitions by the Popular and Applied Arts Division of the Library of Congress. Each year, the *Book Show* is donated to the Rare Book and Manuscript Library of Columbia University, which houses the AIGA collection of award-winning books dating back to the 1920s. For the past twelve years, the *Book Show* has also been exhibited at the Frankfurt Book Fair.

The AIGA sponsors a biennial national design conference, covering such topics as professional practice, education, technology, the creative process, and design history. The 1995 design conference was held in Seattle. In 1994, the AIGA also instituted a business conference, to be held biennially. The 1996 business conference will be held in New York.

The AIGA also sponsors an active and comprehensive publications program. Publications include *Graphic Design USA*, the annual of the Institute; the *AIGA Journal of Graphic Design*, published quarterly; *Graphic Design: A Career Guide and Education Directory*; the 1994 *Salary and Benefits Survey*; *Symbol Signs*, second edition (the accompanying portfolio of fifty passenger/pedestrial symbols originally designed for the U.S. Department of Transportation is also available on disk); the *AIGA Membership and Resource Directory*; the *AIGA Standard Form of Agreement* (contract); and the *Graphic Design Education Statement*.

We would like to thank the following individuals
and corporations who have contributed, as of
May 1995, to the three-year Capital Campaign
to support the renovation and transformation of
the AIGA's new building at 164 Fifth Avenue
into a national center of design.

FRIENDS $1,000+

Acme Printing Company, Inc.
Adams/Morioka
Eric Baker Design Associates
Bernhardt Fudyma Design Inc.
R. O. Blechman
David Boorstin
The Cooper Union
Tad Crawford
Hugh Dubberly
John M. DuFresne
Kris Edwards
Marc English
Dan Friedman
Stephen Frykholm
Roz Goldfarb
Richard Grefé
Carla Hall
Jessica Helfand
D K Holland
Heidi Humphrey
Michael Josefowicz
Willi Kunz
Stuart Leventhal
Ellen Lupton
Judith A. Majher & Company
Anthony McDowell
Mohawk Paper Mills
Janou Pakter
Chee Pearlman
Karen Salsgiver
Paul Shaw
Lucille Tenazas
George Tscherny
Clare Ultimo Inc.
Veronique Vienne

Wiggin Design Inc.
Fo Wilson
Alan Woodard
Sylvia Harris Woodard

CONTRIBUTORS $3,000+

Primo Angeli
Bass/Yager & Associates
Roger Black
Sheila Levrant de Bretteville
Doug Byers
Bob Callahan Design
Mark Coleman
Concrete Design Communications Inc.,
 Toronto
Concrete/The Office of Jilly Simons
Michael Cronan
James Cross
David Cundy
Donovan and Green
Joe Duffy
Joseph and Susan Feigenbaum
Mark Fox
Keith Godard
Hopper Papers
Hornall Anderson Design Works, Inc.
Kent Hunter
Meyer Design Associates, Inc.
J. Abbott Miller
Richard Poulin
Wendy Richmond
Shapiro Design Associates
Dugald Stermer
Michael Vanderbyl

DONORS $5,000+

Carbone Smolan Associates
Richard Danne & Associates
Graffito/Active 8
Diana Graham
Hansen Design Company
Hawthorne/Wolfe
Steven Heller
The Hennegan Company
Mirko Ilic
Alexander Isley
Karen Skunta
Wechsler & Partners, Inc.
Weyerhaeuser

SPONSORS $10,000+

Addison Corporate Annual Reports
Harvey Bernstein Design Associates
Chermayeff & Geismar Inc.
Designframe, Inc.
Fine Arts Engraving Company
Frankfurt Balkind Partners
Milton Glaser
Steve Liska
Maddocks & Company
Clement Mok
Stan Richards
Arnold Saks Associates
Siegel and Gale Inc.
Sussman/Prejza & Co., Inc.
Vignelli Associates
Alina Wheeler

PATRONS $25,000+

Crosby Associates Inc.
Drenttel Doyle Partners
Pentagram Design, Inc.
Team Design/Anthony Russell

BENEFACTORS $50,000+

Adobe Systems Inc.
Champion International Corporation
Strathmore Paper

An annual, by its nature, is normally a look backward on a year and its achievements. This volume of *Graphic Design USA* serves to celebrate once again the vitality of our profession and its practice, in many of its forms.

This annual also marks a change for the AIGA. Every institution that intends to survive generations experiences transitions.

This is the first annual in which the director's letter has not been written by Caroline Hightower, the director of the AIGA for seventeen years. The annual itself was one of the many innovations she introduced over a distinguished career. This annual is dedicated to her contribution to our profession.

Change in leadership offers an opportunity to look at the values of the Institute and the expectations of the profession.

Designers often work alone. While they may work on a team within the studio, when they work with clients, they are often the only design voice at the team's table. So when designers associate with the Institute and their colleagues, there must be a very specific need they are seeking to satisfy. What is that need? What do designers want from an association of colleagues that is greater than they can obtain alone?

This is the most compelling question we want to answer over the next year, as we redesign the AIGA for a new century.

What do designers need to ensure sustained vitality, relevance, and success as we near the millennium?

Stunning waves of change are coursing around us — in terms of the public, our clients, information, and tools.

We at the AIGA will be listening, carefully, to what designers want and need. This year — 1995 to 1996 — will be one of transition.

We will celebrate and protect the legacy of design excellence and we will celebrate today's innovations. Yet we will also be designing a place and a relationship that will be as hospitable and rewarding to tomorrow's giants as it was to yesterday's.

The new AIGA building in the heart of the design district of New York City signals the two challenges we face. One is to increase the visibility of design as a profession and a discipline in the public eye. The second is to develop services that help our members succeed, achieve their own dreams, and prosper.

The Capital Campaign is critical to achieving both, for it allows us to develop the building as a permanent and visible statement. And it allows us to develop the services that will emerge from that building to empower designers and their local chapters around the country. I hope that each of you will invest in the future of our profession.

The energy of the profession comes from the individual designer, not the association. What role can we play to capture but a small portion of that energy and channel it to increase the psychic and real rewards for all designers as we enter a new century?

We will be looking at many new roles and services, including increasing success sharing, electronic forms of communication, and beginning to advocate designers' interests at the federal level, in terms of use of the profession and protection of their rights. I hope you will be there with us.

Join us in this conversation so that we can look back next year together and celebrate how critical the AIGA can be to the future of the profession.

Richard Grefé
April 15, 1995

THE AIGA MEDAL

For seventy-four years, the medal of the AIGA has been awarded to individuals in recognition of their distinguished achievements, services, or other contributions within the field of the graphic arts. Medalists are chosen by the awards committee, subject to approval by the Board of Directors.

PAST RECIPIENTS

Norman T. A. Munder, 1920

Daniel Berkeley Updike, 1922

John C. Agar, 1924

Stephen H. Horgan, 1924

Bruce Rogers, 1925

Burton Emmett, 1926

Timothy Cole, 1927

Frederic W. Goudy, 1927

William A. Dwiggins, 1929

Henry Watson Kent, 1930

Dard Hunter, 1931

Porter Garnett, 1932

Henry Lewis Bullen, 1934

Rudolph Ruzicka, 1935

J. Thompson Willing, 1935

William A. Kittredge, 1939

Thomas M. Cleland, 1940

Carl Purington Rollins, 1941

Edwin and Robert Grabhorn, 1942

Edward Epstean, 1944

Frederic G. Melcher, 1945

Stanley Morison, 1946

Elmer Adler, 1947

Lawrence C. Wroth, 1948

Earnest Elmo Calkins, 1950

Alfred A. Knopf, 1950

Harry L. Gage, 1951

Joseph Blumenthal, 1952

George Macy, 1953

Will Bradley, 1954

Jan Tschichold, 1954

P. J. Conkwright, 1955

Ray Nash, 1956

Dr. M. F. Agha, 1957

Ben Shahn, 1958

May Massee, 1959

Walter Paepcke, 1960

Paul A. Bennett, 1961

William Sandberg, 1962

Saul Steinberg, 1963

Josef Albers, 1964

Leonard Baskin, 1965

Paul Rand, 1966

Romana Javitz, 1967

Dr. Giovanni Mardersteig, 1968

Dr. Robert R. Leslie, 1969

Herbert Bayer, 1970

Will Burtin, 1971

Milton Glaser, 1972

Richard Avedon, 1973

Allen Hurlburt, 1973

Philip Johnson, 1973

Robert Rauschenberg, 1974

Bradbury Thompson, 1975

Henry Wolf, 1976

Jerome Snyder, 1976

Charles and Ray Eames, 1977

Lou Dorfsman, 1978

Ivan Chermayeff and
 Thomas Geismar, 1979

Herb Lubalin, 1980

Saul Bass, 1981

Massimo and Lella Vignelli, 1982

Herbert Matter, 1983

Leo Lionni, 1984

Seymour Chwast, 1985

Walter Herdeg, 1986

Alexey Brodovitch, 1987

Gene Federico, 1987

William Golden, 1988

George Tscherny, 1988

Paul Davis, 1989

Bea Feitler, 1989

Alvin Eisenman, 1990

Frank Zachary, 1990

Colin Forbes, 1991

Rudolph de Harak, 1992

Tomoko Miho, 1993

THE DESIGN LEADERSHIP AWARD

The Design Leadership Award has been established to recognize the role of perceptive and forward-thinking organizations that have been instrumental in the advancement of design by applying the highest standards, as a matter of policy. Recipients are chosen by the awards committee, subject to approval by the Board of Directors.

PAST RECIPIENTS

IBM Corporation, 1980

Massachusetts Institute of Technology, 1981

Container Corporation of America, 1982

Cummins Engine Company, Inc., 1983

Herman Miller, Inc., 1984

WGBH Educational Foundation, 1985

Esprit, 1986

Walker Art Center, 1987

The New York Times, 1988

Apple and Adobe Systems, 1989

The National Park Service, 1990

MTV, 1991

Olivetti, 1991

Sesame Street, Children's
 Television Workshop, 1992

Nike, Inc., 1993

THE LIFETIME ACHIEVEMENT AWARD

The Lifetime Achievement Award, presented in 1991 for the first time, is posthumously awarded to individuals in recognition of their distinguished achievements, services, or other contributions within the field of graphic arts. This award is conclusive and is for special and historical recognition. This award has been created to ensure that history, past and present, is integral to the awards process, is part of the awards presentation, and is documented in the Annual. Recipients are chosen by the awards committee, subject to approval by the Board of Directors.

PAST RECIPIENTS

E. McKnight Kauffer, 1991 – 1992

George Nelson, 1991 – 1992

Lester Beall, 1992 – 1993

Alvin Lustig, 1993 – 1994

Caroline Hightower

DESIGN ADVOCATE

By David R. Brown

When Caroline Warner Hightower was introduced to the small committee of AIGA board members who had been charged with finding a new director for the then-struggling organization, she was on paper as near-perfect as a candidate could be. She had been both a writer and an editor (*Saturday Review* and McGraw-Hill). She had worked extensively in the visual arts, particularly in how they are funded and would be funded in the future. She had had major league non-profit experience as a grant officer for the Carnegie Corporation, and as vice-chair of the board of CAPS, the arm of the New York State Council on the Arts that made grants to individual artists. She had produced work such as *How Much Are Students Learning?* for the Carnegie Commission on Education and *Private Philanthropy and Public Need* for the Filer Commission. Not only did she know what graphic design was, she had actually been a designer for the University of California Press. She was tied into the top stratum of New York's contemporary art scene by virtue of her husband's having been director of the Museum of Modern Art. Even her "geography" was right: Born in Cambridge, Massachusetts, she was one of three children raised in the community of the University of Chicago, where their father, Lloyd

Warner, was a prominent anthropologist (Moholy-Nagy, Margaret Mead, and David Reisman were family friends). Her father and grandparents were Californians, and she had graduated from Pomona College after a year at Cambridge University in England. Now, with both her career and family well established (a daughter, Amanda, and a son, Matthew), she was completely at home in New York. She was bright, articulate, accomplished, quietly self-assured, sophisticated, very attractive in a very tony way, and no doubt an altogether intimidating prospect to many members of the then all-male board, which was about evenly divided between graphic designers and people from the printing, production, and book publishing industries that represented the AIGA's roots.

Richard Danne, who chaired the committee as the newly elected president of the AIGA, recalls the urgency of the times: "We were in the red, big time, and for an organization that represented the pinnacle of design to us, things seemed in danger of unraveling. The candidates we'd interviewed so far were totally uninspiring. It was Bob Scudellari who asked that I take just a half hour to talk with a person named Caroline Hightower. I agreed, and when we did get together we talked for four hours,

Photograph by Bard Martin.

which seemed to pass in minutes. We clicked, and that marked the beginning of the most rewarding relationship of my professional life."

Other members of the committee were not quite so sure about her. Some felt that Caroline might be too "social"; not quite serious enough about design, perhaps a bit above it all. At the suggestion of a design friend, she revealed something at her final interview not on the résumé — that she'd also been a singer at the Drinking Gourde, a San Francisco bar. Any tension about her authenticity as a person was immediately released, and the job was hers by acclamation.

The venerable AIGA, founded in 1914, was not in great shape in 1977. Membership was around twelve hundred, and was neatly and parochially divided between "members" and "out-of-town members," of which there weren't many. There was very little programming beyond juried competitions, exhibitions in rented space on the third floor of 1059 Third Avenue, and the quarterly exhibition catalogs. The *AIGA Journal*, the annual, chapters, conferences, a permanent home, a large and vital national membership — none of these existed. And there was no money — less than that, actually — and virtually no tangible assets. But there was enthusiasm among the members of the board, a deep respect for what the AIGA represented, a sense of idealism, a willingness to put in the time, and a common purpose to share with the wider world their own wonder at the power of brilliantly conceived and executed visual/verbal print communication and the joy they knew in creating it.

I was invited to join the board in 1978. In those days we talked earnestly about "community"; argued passionately about what constituted excellence in graphic design; committed ourselves to "outreach"; and cheerfully volunteered a lot of time, energy, and occasionally extremely undignified labor to keep the AIGA afloat. As our new director, Caroline didn't arrive with a grand strategic plan, replete with goals, objectives, and so on, but her experience at

Carnegie had imbued her with a sense of what made an institution viable, and she had a kind of strategic empathy, underpinned by a set of solid values of her own. Ideas like the importance of content and meaning, the inherent value of aesthetic beauty, social justice, and the twin concepts of community and inclusiveness formed the lattice of her way of leading us, as an organization called the AIGA, and following our lead as its members, beneficiaries, volunteers, and protectors. Though somewhat threadbare in resources, the AIGA was rich in possibilities.

The things we dreamed about collectively were, one by one, put into motion. Each major programming initiative was approached, loomed large, and was ultimately accomplished by dint of volunteer effort, caring, the upbeat leadership of Caroline, and the small staff of extraordinary individuals she invariably referred to fondly as "the crew." Building from the juried competitions, an annual volume was nursed into being, providing a permanent record of the AIGA's work and examples of the year's best graphic design. A periodic journal gave the organization a voice. Important projects in the public interest gave the AIGA an outlet for its members' commitment to employing graphic design for public benefit and installing it more prominently on the public agenda. A national conference enabled a biennial gathering of the graphic design community. Caroline hired a consultant to guide the board as a group through formal strategic planning and help it achieve its dreams and priorities. Plans were put in place and the mission statement was strengthened. Finally, a permanent home for the organization was found, purchased, and occupied. The AIGA was, at last, a place as well as an organization.

Through changing boards, successive presidents, and the varied trajectories of volunteer zeal, Caroline was the constant. She worked personally and hard for what is known as a "membership organization," a category of institution that can be by turns maddening in its amorphousness and overwhelming in both its ambitions and

demands, its professional staff ping-ponged across a spectrum of member commitment and expectation that ranges from disengaged consumerism to zealous identification. The importance of a sense of humor in this environment is a given, and has always been included in AIGA job descriptions.

From the first moment of my own involvement, I, as many before me, wanted the AIGA to be a truly national force — an ambition impossible to achieve with only twelve hundred members, most of them located between Fourteenth and Eighty-sixth streets in Manhattan. Embracing the agenda of a few pioneers, Caroline and successive presidents and boards "went national." In retrospect, the pace of expansion was frenetic. For a period of ten years, another new AIGA chapter was formed every three months (on the average) until total membership vaulted to five times what it had been at the beginning of the decade.

With such growth inevitably comes all kinds of opportunity but also tension, stresses, strains, and fundamental change — some anticipated and some not. Through it all, Caroline managed well the many inherently contradictory forces (both from within and without) pulling and pushing at the rapidly enlarging organization, which operated in a wider society that itself was changing rapidly and not always for the better.

The central mystery of leadership lies not with the leader alone, but also in the collective willingness of the led to be led. There's a reciprocity of trust: I'll follow you if you lead me more or less where I want to go (even if I'm not sure exactly where that is...) For the better part of two decades, Caroline Hightower was the leader the AIGA wanted her to be, and along the way she made leaders of a lot of us. Her role is not over; she continues to maintain a relationship with the organization.

At an event held in the gallery of the AIGA's new headquarters on Fifth Avenue, purchased as Caroline's last major undertaking as director, several of those who paid tribute to her seventeen years as AIGA's director used the word "grace" to describe her central attribute through many years

and change, much of it positive for the organization. But "grace" isn't alone a personality trait. Rather, it is the hard-won mix, through time and event, of character, values, education, role models, self-knowledge, some good luck and some bad. Having grace is having earned a sense of proportion, and of having allowed others to earn theirs, too. Grace is being able to disavow a "passion for graphic design" in favor of a deep belief in what, at its best, graphic design can do.

In her seventeen years, Caroline did a lot of very good work for the AIGA, as an organization of sometimes all-too-real people and as the ongoing embodiment of a set of closely held but ultimately abstract professional ideals. Both for the organization and its people, she had to play several roles. Many of them fit her well; others were more difficult but were performed equally well nonetheless. Yes, she was an advocate of graphic design and, yes, she had a great deal of affection and respect for graphic designers. But there was another piece of it, and that was simply that there was work to be done and Caroline did it extremely well because, for her, there was no other way. I count myself lucky to have been given, on behalf of the AIGA, this very public, very permanent forum in which to say to Caroline, Thank you.

Artifacts and Influence

A VIRTUAL MUSEUM OF GRAPHIC DESIGN

Curated by Steven Heller

*I*f a museum were built to house the icons of our profession, the inclusions and exclusions would be subject to heated debate. Every generation has its own icons. Some are more widely accepted than others; others are more obscure but no less significant. That is why we asked thirty-five designers representing a range of disciplines and points of view to contribute one significant artifact to our virtual museum. We asked them to describe why this particular piece had an impact on them personally, and by extension affected the practice — indeed, the history — of graphic design. We stipulated that these need not be works of art or design in the broadest sense but narrowly focused on commercial art, graphic design, and visual communications (no Greek coffee cups, please!). The responses varied, but don't mistake this for a consensus — only two of the artifacts were chosen by more than one "curator." For now, this is merely a sampler of what a real museum might contain. And although history is more than a collection of artifacts, with these images and icons, we begin to piece our legacy together.

New Haven Railroad Logo

Herbert Matter and Norman Ives, 1954

 Brodovich, Rand, Beale, Lustig, and Matter were visiting critics and Albers was our teacher. That was Yale in the midfifties and these were the hotshots of graphic design who serenaded us visually. The gap between their work and ours was unbridgeable. The projects they encountered were real, their solutions original and stunning; the problems we confronted as students were phony, the solutions derivative at best.

We were awestruck. We were never privy to the design processes of our mentors. We help-lessly concluded there was a magic eluding us.

One exception in this elite band was Herbert Matter, who was designing a new logo for the New Haven Railroad. He was working with one of the era's best (albeit unheralded) typographic designers, one of our teachers, Norman Ives. Their collaboration could be witnessed on an ongoing, daily basis. I watched and eavesdropped as Matter and Ives stalked a worktable littered with N's and H's, whole and in pieces. They visibly struggled with the width of verticals, the degree of letter expansion, the spacing between N and H, and I heard them argue, during the course of two weeks, whether the right foot of the N should have a serif. They labored, physically, with letterforms having a variety of details and in an array of colors. Not on a screen but cut with single-edge razor blades from Color Aid papers. Then they took their cutouts into the railyards and designed the paint scheme on locomotives.

After continually observing Ives and Matter

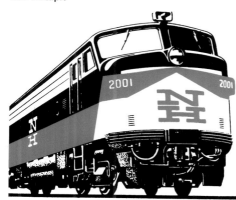

manipulate those paper forms and listening to their constant muttering (through their cigarette-gripping lips), we realized a truth rarely taught: successful design is a continuum of work and thought, not instanaeous magic and not to be found in the utterances of heroes.

Sam Antupit

Graphis *1948–1986*

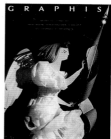

Walter Herdeg and his magazine, *Graphis*, captured my imagination and were the spark that ignited my ambition as an aspiring designer in Canada, where the concept of "graphic design" was relatively unknown as such. When I could find the cash to buy an issue, I'd devour each article and image.

Through *Graphis* I was introduced to such significant artists as Herbert Bayer and Max Bill, and influenced by the work of Hans Neuburg, Josef Müller-Brockmann, Armin Hofmann, Saul Bass, and Emil Ruder, to name a few. The work of these forefathers of the Constructivist graphic design movement informed and communicated objectively, free of manipulation. A hotbed of international design ideas, *Graphis* was for me the equivalent of the Information Superhighway. It provided the impetus around which I could develop my own approach to graphic design.

Stuart Ash

The cerebral, abstract covers; the elegantly reticent typography, editorializing without hype in three languages; the precisely composed pages of modest gray halftones; the teeny portraits of the designers, invariably wearing their glasses: Walter Herdeg's *Graphis* regularly delivered a vision of the world of graphic design as stable, smart, cosmopolitan, optimistic, and open. Though many writers contributed to it, the contents were shaped by Herdeg's particular vision and taste, consistent and wide ranging. During his years as editor, global communications were less immediate, allowing for regional or national variations in graphic design, and he embraced and disseminated those variations — Iron Curtain posters, German advertising, French illustration, American Modernism — with his own Swiss objectivity. And, most remarkably in retrospect, an open mailbox: anyone could send their work into Herdeg's *Graphis Annual* for free. The international community that *Graphis* helped define was democratic without strict borders, delineated only by Herdeg's fine eye and open heart.

Lorraine Wild

Anatolian Figures *2000 B.C.*

Early on, I found myself deeply affected by the archaeological remnants of the past. As a kid, I spent delicious Saturdays at the Met or the Natural History Museum, absorbing these compelling, puzzling artifacts.

It was not just the past that seemed to interest me, but the very, very distant past. What fascinated me was the mystery and unreality of it all. The most intriguing culture was the one about which we knew something, but not everything — the less, the better. That left holes which I filled with my fantasies and imagination. Aside from their intrinsic beauty, they brought with them a special kind of mystery — the unknown that

reaches a very deep and hidden place.

No surprise, then, that my film work has often dealt with a mysterious and strange fantasy past; that my graphic work focused so much on metaphor and ambiguity. As in these artifacts, in graphic work the ambiguous seems more challenging, more involving, more potent. It forces examination, adds tension, gives it life.

Pictured are a group of figures (Anatolian, 2000 B.C.) that had a profound effect on me when I encountered them early on, and spent my then entire fortune on them. I had to have them. The tallest is six inches high, but they are unexpectedly monumental Easter Island–like figures. Very little is known about this culture, even now. Wonderful! Why are they so monumental and yet so small? Who are they? What do they represent? Why are they staring at me? What are they up to?

Saul Bass

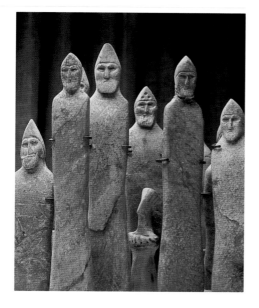

The Man with the Golden Arm
Saul Bass, 1955

In 1955 I was a pudgy teen who hid out at the movies, where I remember being startled by the sassy beginning of *The Man with the Golden Arm*. I eventually learned that I had encountered a unique example of "graphic design." I cannot say that this experience persuaded me to pursue the field, but the fact that its mood registered on my naive psyche and that I retained this particular memory attest to the lasting impact of excellent design.

This vintage production launched Saul Bass's numerous contributions to and through films; gave birth to the concept of unified media/print campaigns; pioneered a kinetic design path that married sight and sound; force-fed mass, captive audiences healthy doses of symbolic, evocative, and satisfying visual appetizers; and nudged many of us toward the arena.

Gordon Salchow

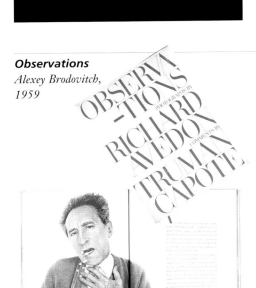

Observations
Alexey Brodovitch, 1959

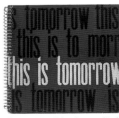

Some designed objects are so perfect that I consider their mere existence miraculous. The book *Observations* is such an object.

Published by Simon & Schuster in 1959, *Observations* was the product of a collaboration between three men at the height of their creative powers: the photographer Richard Avedon, the writer Truman Capote, and the legendary art director Alexey Brodovitch.

Everything about this book is mysterious to me. The content seems almost haphazard, with beautiful but sometimes jarringly unrelated images by Avedon alternating with musings tossed off with obvious insouciance by the young Capote. Yet the result, in Brodovitch's hands, has the reflective self-evidence and sublime beauty of a mathematical equation. The layouts are deceptively simple, but I have never deciphered the rules that governed their creation. The type, widely leaded Bodoni Book italic punctuated with exquisite Didot capitals, is set in measures and placed on the page in ways that seem consistent yet infinitely variable; similarly, the cropping and placement of the pictures seem both surprising and somehow inevitable. As someone who came of age in the Modernist tradition, I find this combination of dead-accurate rigor and carefree intuition as foreign as something arrived from another planet. Brodovitch's talent was indeed otherworldly.

Two other small pleasures make *Observations* a classic. First, its final image, Avedon's photograph of Brodovitch striding over the book's preliminary layouts like God moving over the face of the waters: no designer ever had a better tribute. And finally, the rumor that Brodovitch often told Capote how to begin the text's sentences in order to provide suitable initial capitals: every designer's fantasy fulfilled.

Michael Bierut

This Is Tomorrow
Edward Wright, 1956

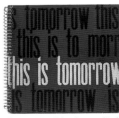

I was an undergraduate in art school when I first came across the catalogue for the exhibition *This Is Tomorrow* by the Independent Group, progenitors of Pop Art in Britain in the 1950s. I had very little idea of the exhibition's historical significance. For me, the drama of its typographic introduction — the extremely large scale of the letterforms — and the structured anarchy of its spreads held a certain vitality. I understood the design as largely improvisational; the roughness of its production expressed the immediacy of its ideas and the typewriter text characterized the urgency of the message. Later, now, I see it differently, in historical context. The abruptness of its juxtapositions, the ad hoc nature of image and text, are the perfect graphic translation of the "tackboard" method of the Independent Group members, who collected fragments of modern life — American automobile advertisements, scientific photographs, science fiction magazines. As a designer of a number of exhibition catalogues, I consider this particular catalog design important because it exceeds the exhibition itself: the catalogue begins to take on a life of its own and adds to, rather than simply records, the event. The ideas in the text are important to my interest in popular culture. The Independent Group's commitment to a timely understanding of cultural events through their activities as artists and designers, embracing ideas intrinsic to most art and design at that time, reflects my personal approach to understanding the making of graphic design in the largest possible cultural terms, including the gathering of ideas from other disciplines in order to chart a course to tomorrow.

Andrew Blauvelt

Observations on the Mystery of Print
Hendrik Willem van Loon
and Frederic W. Goudy, 1937

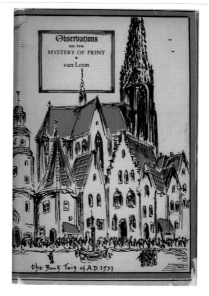

As a child of the thirties, my life centered around Little Blue Books, nickel pamphlets issued by the hundreds, dealing with subjects as diverse as *Grammar Self Taught* and *How Bees Live*, learning games like Knapp's Electric Questionnaire, and on the radio every Wednesday evening, "The Quiz Kids." The decade was on an autodidactic binge.

In this period of mind-building (now, alas, it's only our bodies we seem to build), Hendrik Willem van Loon was the great popularizer. The author/artist of more than twenty books ranging from *The Story of Mankind* to *The Arts* (major and minor), nothing escaped his cosmic

eye or nervous hand.

Influence often works subliminally, and I can't help wondering if his spare drawing influenced my own minimalist approach to art.

His book jacket for *Observations on the Mystery of Print* shows van Loon at his best. In the field of book jackets, the coolness of typography and the warmth of illustration often make for ill-matched bedmates. But here the idiosyncratic typography — each line is set in a different font or size — perfectly complements the scratchy drawing. Typography and illustration are neatly tied together by the hand-drawn box containing title and author. And notice the star within the box. It's a dingbat, yet as natural in that sky as the drawn birds.

The typography is by Frederic W. Goudy, who assisted van Loon with the jacket. What a little wonder they produced!
R.O. Blechman

The Dylan Poster
Milton Glaser, 1967

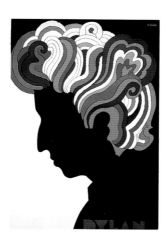

For me, this piece represents a holy trinity of creative influence: Duchamp, Dylan, and Milton, with a sacrament of psychedelia thrown in. The fact that three of my major artistic influences, representing creative innovation and cultural change, are wed together in a single image is not surprising. It underscores the thoughtfulness and conceptual multi-layering of Milton's work. Without text or illustrative artifice, the poster clearly conveys its message in totally graphic terms. Looking at it today, after countless viewing in design history books over the years, it looks as fresh to me as when I first viewed it as a teenager, over twenty-five years ago.
Steven Brower

Few pieces of graphic design transcend their original commercial purpose and become an emblematic symbol for a generation. The Dylan

poster created by Milton Glaser nearly thirty years ago is that and more. The poster is a work of art that continues to provide insights and educate us about the zeitgeist of the sixties counter-culture movement.

In looking back, this interpretive depiction of a young Dylan with wild colored hair entranced in deep thought is even more meaningful now than it was then. It demands our participation in a mental dialogue with our past, forcing us to reconcile the idealism of our youth with the reality that we face today. The poster's capacity to evoke these self-reflective mental discourses is its power. The beauty of the piece is what is not there.

The Dylan poster is logged in my memory bank to serve as a reminder to me to design and create work that feeds the mind.
Clement Mok

"The Mummers Parade" in *Portfolio* no. 2
Alexey Brodovitch, 1950

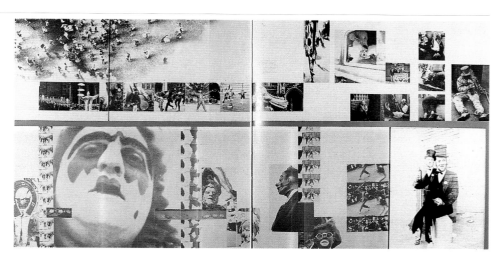

"A layout man should be simple with good photographs. He should perform acrobatics when the pictures are bad." — **Alexey Brodovitch**

"The Mummers Parade" design is both personally meaningful and generally important. To me as a graphic design professor, the project is important because it involved students in Brodovitch's teaching — the photographs were taken by various students of the Philadelphia Museum School of Art. Assigning students a project and then incorporating their work into a final publication design brings new freshness and challenge while advancing the capabilities of the students. As an inspiration for my own multi-page graphic design projects and artists' books, "The Mummers Parade" embodies the essence of pacing, scale,

contrast, sequencing, transition, and visual narrative. As designed time, this fold-out presentation engages the viewer both visually and physically. The general importance of this design artifact is evident in the timeless layout of the phtographs. Brodovitch's design acrobatics bring the action to

life on the printed page. As a printed publication, its format is astoundingly influential on the editing, fast-forwarding, channel-surfing, remote control, and instant replay of today's MTV and video capabilities.
Martha Carothers

Punk Posters
Circa 1977

I was a college student making my way through school doing posters and graphic design (even though I didn't know what that was back then). I had become interested in the visual ideas that cultures and subcultures create and how they interact to form general popular culture when I was suddenly confronted with my first punk poster. I had been fascinated with the ideas and work of the Dadaists and early Surrealists, almost as long as I had been fascinated with rock and roll, but nothing prepared me for what I saw. The poster actually *shocked* me. Here was a visual assault of Dada imagery combined with nihilism so violently plowed into rock culture that it was frightening to think about. What did it mean? What did they want? What if it was infectious?

As an example, I've chosen the work of my favorite Seattle punk poster maker. His name was Franko (now Frank Edie) and his style was the classic scrappy no-budget, do-it-yourself look that launched a thousand imitations. Punk visuals jammed a collective finger into our eyesockets, courtesy of Jamie Reid, Genesis P. Orridge, Gary

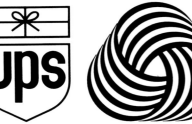

Panter, Tomata DuPlenty, Malcolm Garrett, Mark Michaelson, Helene Silverman, Winston Smith, Lynda Barry, Charles Burns, Peter Saville, Neville Brody, Frank Kizik, Raymond Pettibone, Peter Belsito, Penelope Houston, and thousands of other nameless kids. Ninety-nine percent of punk poster artists are untraceable: a true punk remained personally anonymous. The poster communication was the focal point — shock the

straights and scare them away. "We don't want you around — but we want you to *know* we don't want you around."

Viewing a punk poster for the first time shook me down to my bootheels. I took that poster home (tearing it off the telephone pole) and stared at it for months. It was a revelation that there was now a place where new rules applied, and rule number one was, There are no rules. Pretty and ugly, good and bad meant nothing. It was the most liberating experience of my life. It pointed a new direction that would allow me to live the way I wanted to live, think what I wanted to think, and practice my kind of design language and still find acceptance. It wasn't an easy road to travel, but we survived. And now, here we all are — absolutely nowhere.

Art Chantry

CBS Logo *William Golden, 1951*
United Parcel Service Logo
Paul Rand, 1961
Wool Mark *Francesco Saroglia, 1968*

All communication is personal.

Books printed in the tens of thousands, commercials aired for millions of viewers, and gazillions of little white "m's" on every M&M candy are all read by, seen by, or consumed by one person at a time. The success of the communication depends on the familiarity of the audience with the messenger and the appropriateness of the message to the messenger. Like friends, the longer we've known them, the more we understand and appreciate them. Relationships with companies

are built the same way.

Trademarks that represent companies are more than reflections of their faces; they are the sum of our shared experiences. If a company's appearance is appropriate to their message, we are predisposed to accept it, even when the relationship is new.

Creating a trademark that can communicate familiarity at its inception and continuously throughout its life is like meeting an old friend for the first time. While there are other trademarks created by talented designers, these three — William Golden's CBS eye, Paul Rand's United Parcel Service package, and Francesco Saroglia's Wool mark — were like my friends from the beginning.

Joseph Michael Essex

The Daily News and The Evening Graphic
1920s

We were living in Bensonhurst then and my father would take the Canal Street stop of the BMT from his men's clothing contracting shop every night, armed with two newspapers — the *Daily News*, which he had purchased in the morning, and the *Evening Graphic*, which he picked up on his way home. This he did six days a week. He was a self-taught reader of English, giving due credit to these two tabloids. I recall spotting him as he turned the corner in the

evening, when I would rush out to him and grab the papers even before saying hello. These two papers — in particular, their front pages — made a lasting impression on my subconscious. I'm certain that I wasn't initially aware of the magnificent bold, black Gothic letters used by the *Daily News* for its shrieking heads. Nor did the artificial photomontages of the *Evening Graphic* do any more than tell me a story. My point is that bold, black Gothic types and photomontaged imagery were important devices in many solutions I developed in communicating ideas throughout my graphic design career. There is an interesting correlation to be made between my father's and my education — his being verbal and mine visual.

Gene Federico

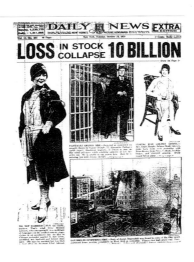

The Pushpin Almanack 1954
and The Pushpin Monthly Graphic

Oh, the sway of the *Push Pin Almanack* and the *Push Pin Monthly Graphic!* It might seem obvious now, in retrospect, but during the late fifties these little mailings from New York were certainly a copious (not to mention "copyous") influence on me, a young designer just out of high school and starting in the "art" business in Detroit, as it was on so many of my contemporaries. Not only did the illustration attract us, but the unique typography also had an immense impact — equivalent, I would imagine, to the effect of *Ray Gun* or *Emigre* on today's generation of design students.
Edward Fella

Canyon Lake Logo
Michael Vanderbyl, 1980

My first encounter with Michael Vanderbyl's Canyon Lakes logo was on the resort developer's embroidered golf shirt. It was an incident that left me embarrassed as I tried to corner the garment's owner to record every visual detail. In subsequent months, every major design annual reprinted this mark. It was 1980 and corporate identity designers had already visited the circle, the square, the triangle, and the Gordian knot. Corporations were looking pretty big and pretty stoic. Yet there in the midst of a sensible square, Vanderbyl spread the reeds with his fingers to push a tranquil drake onto the surface of the page. It was the seminal marriage of the geometric rhythm we had grown to love with the grace of the hand-crafted image.
Bill Gardner

Tales from the Tube 1973

It should have been a dopey pulp destined to end up in the dustbin of graphic design history. Instead, when introduced in 1973 as an insert in *Surfer* magazine, *Tales from the Tube* became a transition piece, deftly bridging the tail end of the psychedelic era with the emergence of a new generation of graphic improvisers weaned on comic books, pop art, and Baby Boom detritus. Easily missed by the highbrow design crowd, *Tales* spoke to an audience that could decode this comic art genre without a hitch. It easily blended image, narrative, and type in an updated exercise of discipline crossing. With its primal, overly produced colors, *Tales* heralded the rise of the graphic novel and the "new" illustration.

Although *Tales* was a combined effort, Rick Griffin stood out in the crowd. Truly an original, he was part of a group of West Coast surf-art bohemians that plied the backwaters of twentieth-century imagery, plowing them back into hip, humorous, and original graphics.

Tales brought the genius of Griffin full circle. I had followed his career since junior high days — aping his comic surf character Murphy on my canvas notebook. When Griffin took off to San Francisco, his dance posters prompted me to major in art and seek out the graphic design department, where I naively figured they would teach me the art of psychedelic poster making.

I was fresh out of college when *Tales* appeared and filled with a whole new set of design directives. It brought me back to my original "stoke" for commercial art, reinspiring me to pursue a multi-track career.

With Griffin's untimely death a few years back, I began to realize how many fellow designers had caught a glimpse of *Tales from the Tube*, marvelling at it in all its underground glory. A graphic masterpiece? Maybe not in the traditional sense. But it touched a nerve that still resonates today.
Jim Heimann

"And Babies?" "And Babies."
Ronald Haeberle and Peter Brandt, 1969

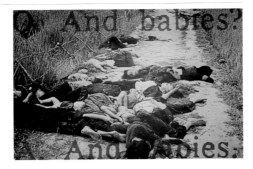

In November 1969 the United States Army brought charges against a platoon commander, Lieutenant William L. Calley, for the incident at My Lai that took place on March 16, 1968, during which 347 Vietnamese civilians were murdered. Shortly after the world learned of the My Lai massacre, the first such American atrocity completely documented, this poster began appearing on billboards around New York City. The photograph was taken by Ronald Haeberle, a photographer sent by the Army's 31st Public

Information Department to record a routine mission. Instead, this eyewitness account became the essential evidence in the case against Calley. In its original form, published in *Life* magazine, it was a powerful, distressing image, the product of a war that offered many grotesque icons, including those of the Saigon police chief about to blow the brains out of a suspected spy and the naked, napalmed girl running helplessly down an embattled roadway, to name but two. The My Lai image alone would have triggered a passionate response, but to transform it into a poster required something more. By adding the question and answer (which were taken directly from the testimony of one of the soldiers at My Lai), Peter Brandt, an artist associated with the Art Workers Coalition, which was responsible for distributing

the poster, created a memorable coda. Over the heap of corpses eerily framed by green grass, the words in red, "And Babies," introduced me to the shame of this war.
Steven Heller

The Powers of Ten
Charles and Ray Eames, 1968

In choosing *The Powers of Ten*, I will surely join the thousands of other designers who recognize the immense influence of the work of Charles and Ray Eames on their careers.

It was the sixties. I had just started a fledgling business with Tony Russell when I saw a black-and-white film titled *Rough Sketch for a Proposed Film, Dealing with the Powers of Ten*. It was the first time that I truly understood the unique role of the designer within our culture. Here in a single eight-minute film, the Eameses had visualized with absolute clarity the abstract mathematical meaning of the power of ten.

The viewer, called the "traveler" in the film,

is magically transported from a square meter of a south Florida picnic to the outer reaches of the universe and back again, to the nucleus of a single cell within the picnicker's hand. While this is happening, a set of clocks at the side of the film ticks away earth time and the traveler's elapsed time, while a narrator explains the graphic experience. I was being educated in a subject that I had little interest in, at best, yet I loved every moment.

Ten years later, IBM translated this early version into a full-color rendition without losing any of the film's initial impact.

Through the next quarter century, I have continued to draw upon the clarity of thinking, the use of metaphor, relative scale, levels of information, and the dozens of other graphic guides exhibited in this unique artifact. Our profession owes a great debt to Charles and Ray Eames.
Kit Hinrichs

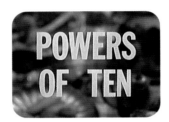
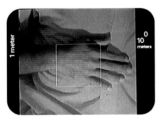

MTV Logos
1981 to present

How many instances of graphic design can be called the icons of a generation?

MTV's logo is powerful because it has attitude. Rebellious, rule-breaking, constantly changing, it represents an intersection of graphic design and video that opened up a new medium for designers. It marked a turning point, leading us farther along the road toward multimedia and interactivity. The "MTV look" goes beyond the work of design, into society at large, and rightfully takes its place in the history of pop culture.
Kent Hunter

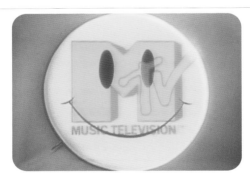
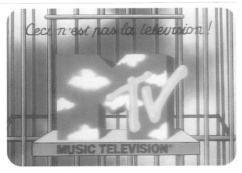
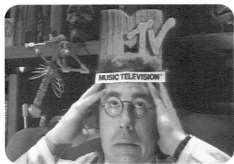
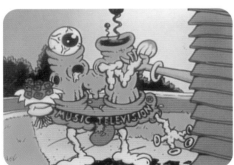

Swissair Brochure
Kurt Wirth, assisted by Paul Beer, 1956

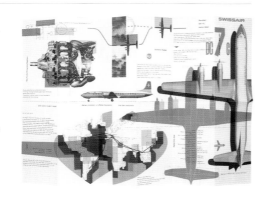

This is one of my favorite examples from the "More Is More" school of design. This brochure tells you everything you needed to know about Swissair's DC-7 transatlantic service, including (but definitely not limited to) how the engine and radar worked, which routes the plane flew, how the seats reclined, and what was on the menu.

It's beautiful, mostly because nothing is thrown into the design just for decoration's sake. The reader is led down a carefully constructed path of information, where the more you look, the more you learn.

It has inspired me to try to create in my own work an environment where the curious, the thoughtful, and the patient are rewarded. To see just how far the world has progressed since 1956, compare this to any current piece of informative literature you can find in a travel agency or an an airliner.

Alexander Isley

Wet Magazine *1976–1980*

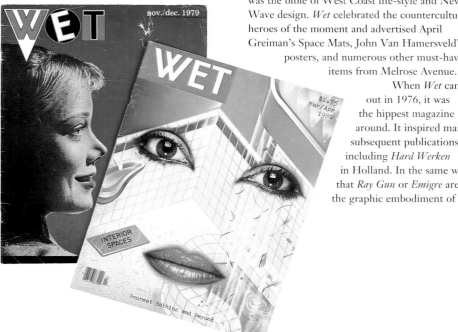

"The magazine of gourmet bathing and beyond" was the bible of West Coast life-style and New Wave design. *Wet* celebrated the counterculture heroes of the moment and advertised April Greiman's Space Mats, John Van Hamersveld's posters, and numerous other must-have items from Melrose Avenue.

When *Wet* came out in 1976, it was the hippest magazine around. It inspired many subsequent publications, including *Hard Werken* in Holland. In the same way that *Ray Gun* or *Emigre* are the graphic embodiment of today's zeitgeist, *Wet* was the style manual of the early eighties. Not a music, design, or art magazine, it was truly a counterculture publication that featured the work of many designers, photographers, illustrators, artists, architects, and writers.

Wet reinvented itself constantly. You were never sure what the next issue would bring except that it would be eclectic, ephemeral, and fun. The masthead logo changed seven times in the magazine's first three years, and no two issues were ever laid out the same way. It was this lack of definition that gave *Wet* its broad appeal. It's hard to imagine a magazine like this existing today.

Mr. Keedy

Merz Matinée Flyer
El Lissitsky, 1923

Kurt Schwitters was a one-man movement. Under the rubric Merz, he made collages, wrote poetry and stories, published a magazine, organized performances, and worked continuously on a wood sculpture that filled an entire room of his house. Schwitters's collages imposed a firm order on the most disparate flotsam and jetsam of daily life. This flyer by El Lissitsky, which promoted two Merz performances in Hanover by Schwitters and Raul Hausmann, likewise creates a composition out of information that threatens to degenerate into noise but doesn't. The flyer is a visual counterpart to James Joyce's prose, filled as it is with puns, nonsense sounds, and a narrative structure that defies conventional reading syntax. El Lissitsky reveals his architectural training through

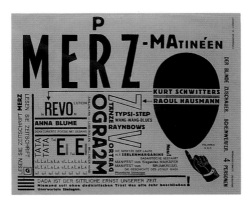

the complicated balance of elements. The huge letters MERZ catch our attention first and lead us in one of several directions. We can either move to the black ovoid shape where we find Schwitters's and Hausmann's names, with arrows that direct us to blocks of text describing their performances, or we can find our way to the same place by reading the word "program," which func-

tions as a pole that we slide down into a confusing morass of text, which only slowly sorts itself into communicative phrases. El Lissitsky mixes different types of signals, substituting the number 2 for the plural of program, for example, and builds multiple words out of single roots, as in "Revon" (Schwitters's name for Hanover) and "Revolution." He combines sounds from Schwitters's *Lautgedichte*, or sound poems, and makes us twist and turn through the letters of Hausmann's program, which consists of seven dances and a lecture. We need never lose our way in this maze, where we find other statements besides the announcement of the performances, and we can invent our own means of navigation to take it all in. El Lissitsky lets us find our way through the text as we might wander through the rooms of a building. To carry the architecture metaphor forward, the flyer is a funhouse where we encounter the spirit of the performance it announces.

Victor Margolin

Champion's *Imagination* Series *1973*

Remembering 1973 — I was a college freshman, first exposed to Champion Paper's *Imagination* series, which awakened me to the possibilities of design. The series, designed by James Miho, was one of the first paper promotions to integrate a comprehensive design vocabulary through the innovative use of paper, printing techniques, photography, illustration, typography, and rich text, while presenting a fascinating array of cultures. *Imagination* epitomized the power of great design by seducing, enchanting, informing, and stimulating the viewer.

Jennifer Morla

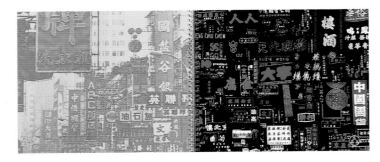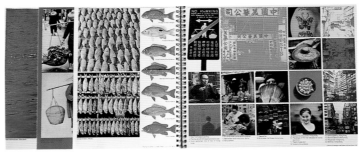

The Family of Man
Leo Lionni, 1955

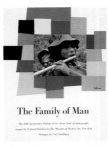

What better expression of design that so eloquently captures the dreams of people and their quest for a better world, where people were not just created equal, but where their universal experiences would unify humanity, ideals that were duly impressed upon me at the age of twelve, when I was ready to become a photographer, by my father, a true Modernist who, after summer vacations of architectural tours and science museums, instilling the positive vision of progress and determination to create, gave me *The Family of Man*, where this vision is so elegantly exhibited in the five hundred photographs (curated by Edward Steichen) that portray the bonds of love, birth, pain, death, and hope, and dramatized by Leo Lionni's classic book design, which reveals the narrative through

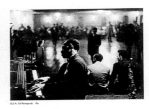

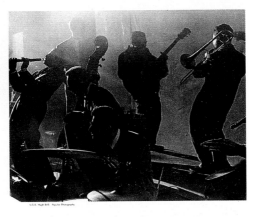

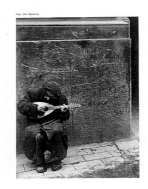

the compositions and contrast of unadulterated black-and-white photographs, before images were to be as readily manipulated as emotions; what better expression could there be?

Rhonda Rubinstein

West Magazine
Mike Salisbury, 1970s

In the 1970s, I liked looking at the work of Mike Salisbury. I especially liked *West* magazine, the Sunday magazine supplement to the *Los Angeles Times*. Salisbury's work was terrific because there were great ideas that were beautifully executed. The style of the typography, or illustration, or photography, always existed to reinforce a good idea. Style was merely a tool. I learned a lot from *West* magazine because Salisbury employed the broadest of visual vocabularies. These six covers prove my point.

Paula Scher

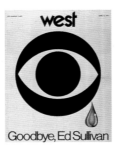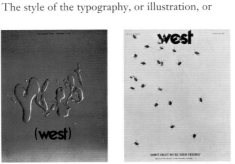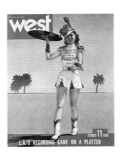

Lubalin Burns & Co.
Capabilities Brochures
1971

One day in about 1971 I received in the mail at the UCLA Alumni and Development Center what appeared to be yet another pitch from a type shop. But this one stopped me in my tracks.

The First Typo-Graphics Agency — Lubalin Burns & Co. was a series of incredible little capabilities booklets showcasing hand-lettering, original "LSC" typefaces such as Avant Garde Gothic, alphatype and typositor typography, and design. Logotype, editorial, and packaging design. The work of Herb Lubalin, Tom Carnase, Tony DeSpigna, and others who had formed a partnership with Aaron Burns to offer a whole new level of advertising typography and typographic design.

Exquisitely produced, with Spencerian script engraved on covers of Fabriano *Ingres* paper,

these booklets were surely as inspirational to hundreds of designers as they were to me. My lifelong commitment to hand-kerned typography, as well as my entire career, emanated from them.

The copy offered: "Visit our house at 223 East 31st Street in Manhattan." One day on vacation, during my first trip to New York, I did. Sandra Willis, Herb's secretary, welcomed me as "a designer from the coast" (where?) and showed me around. Herb was in. We chatted about topics such as the horribly distorted way Avant Garde was used in Suntory Royal Whisky ads — letters going every which way. He agreed he never intended it to be used like that. I showed him my work, and he especially liked a birth announcement I did for Richard Schaffer, a Los Angeles typographer, in which an R and K meet, do some acrobatics, and the K gives birth to an M. Within six months, I had given up my $145-a-month apartment near Santa Monica beach and my orange Karmann Ghia convertible, and was a designer at Lubalin, Smith, Carnase, Inc.

Michael Schaffer must be twenty-four years old now. But Herb's work — especially those booklets — looks just as fresh to me today as it did when these booklets first came across my desk.

I'm still in New York. And I still love to design logos that need to be hand-lettered by Tom Carnase and/or Tony DeSpigna. I can hand-kern most stuff myself on the computer — but nothing compares to hand-lettering.
Ellen Shapiro

Blue Note Records
Francis Wolff and Reid Miles, 1950s

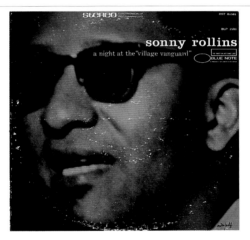

When I discovered jazz in high school, I also discovered modern design. I owe both discoveries to Blue Note Records. Legendary for its roster of artists and the sound of its recordings, Blue Note was also noted for its album covers. They were different from those of other jazz labels. They were the essence of cool. There were no corny Technicolor photos of musicians with adoring women. Instead, there were atmospheric black-and-white photographs, sometimes tinted

and always drastically and dramatically cropped. The typography was simple, though occasionally playful. And there was always plenty of open space. The photographs were by Francis Wolff, co-owner of Blue Note; the designs were by Reid Miles.

The cover of Sonny Rollins's landmark live recording "Night at the Village Vanguard" (1957) is quintessential miles/wolff (their cover signature). The design perfectly captures the nightclub ambience while avoiding clichés. There is no saxophone, no jazz group, no nightclub scene. Instead, there is only a full-bleed, rose-colored closeup of Rollins's face, eyes hidden behind sunglasses. The title, in small type, runs across the right lens of Rollins's shades.
Paul Shaw

Westvaco *Inspirations* Series
Bradbury Thompson 1938–1962

Bradbury Thompson's designs for the aptly named Westvaco *Inspirations* series were published by the West Virginia Pulp and Paper Company to show its printing papers. Under Thompson's direction, *Inspirations* demonstrated excellent examples of meaningful word-image compositions and startling juxtapositions of type, color, and form. These publications show the importance of common sense and clarity; of how to use contrast, scale, rhythm, and sequence. Thompson balanced the traditional constraints inherent in producing readable typography with the creative freedom of modern form-making. His work is based on exploration, experimentation, and innovation while honoring the traditions of the graphic arts developed over hundreds of years. From these publications we learn that design is intricately linked to all forms of human endeavor. The series is as fresh and enlightening today as it was fifty years ago. Thompson's merging of content and form in witty, coherent, appropriate, and exciting ways is truly inspirational. Westvaco's *Inspirations* are the examples that I most often show to students.
Douglass G. A. Scott

Magazines from a Bygone Era

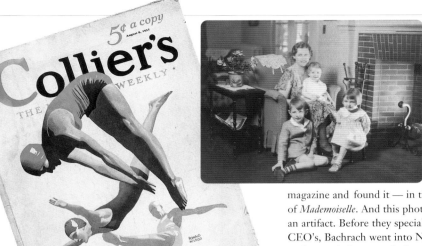

Magazines that are gone, like the *Collier's* in my family picture, shaped opinion, culture, and political attitudes in a way uniquely American. Ever since *The Century Illustrated Monthly Magazine* pioneered the use of wood engravings to illustrate memoirs of the Civil War, a current of fiction and articles, interpreted by commercial artists and photographers, flowed into three and thirty million homes each week — from *Harper's, Scribner's, McClure's,* and *The Saturday Evening Post* to dozens more. In the 1940s and 1950s, William Saroyan, John O'Hara, Martha Gellhorn, and William Faulkner

published their short stories there, and John Kennedy ("the Senate's gay young bachelor") was introduced to the nation. Naturally, when I came to New York I looked for a job at a magazine and found it — in the art department of *Mademoiselle*. And this photograph itself is an artifact. Before they specialized in portraits of CEO's, Bachrach went into New England homes to do posed photos at the hearthside. The proofs from this photo session probably appeared in our mailbox with the following week's *Collier's*.
Virginia Smith

Herman Zapf: Calligrapher, Type-Designer, and Typographer
1960–1961

I first encountered this little keepsake, co-published by the AIGA, in 1961, when I was fresh out of school and working at my first real job in design. Between paper covers, it embodied for me, at the time, nearly everything I aimed toward

in graphic design. The typography, calligraphy, the plates, the feel and look of the paper, and the subject of the booklet — Herman Zapf — all worked together beautifully to provide this neophyte with an inspiring object lesson.

Today, nearly thirty-five years later, we can easily pick away at the designer of Palatino, Optima, and especially Melior, but the grace, elegance, and charm of this slender volume endure undiminished.
Dugald Stermer

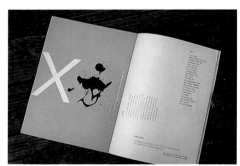

About U.S. 1960

These four brochures on experimental typography by American designers top my list of mind-expanding graphic design artifacts from the 1960s. The booklets were designed by Gene Federico, Herb Lubalin, Lester Beall, and Brownjohn/Chermayeff

& Geismar studio. All were written by Percy Seitlin and produced, conceived, edited, and set in type by the Composing Room. What these designers did with type in the 1960s was beyond words.
Pat Taylor

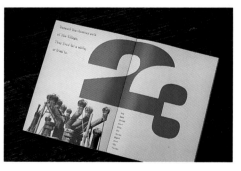

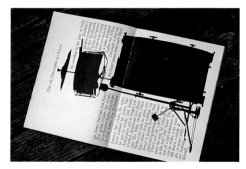

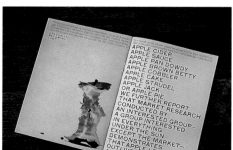

The Push Pin Style
The Push Pin Studio, 1970

While a fine arts/painting major in the early seventies, I was given this book, published by *Communication Arts* magazine and featuring Push Pin Studio design and illustration being exhibited at the Louvre in 1970. It was full of inspiring work by Milton Glaser, Cosmos Sarchiapone, Seymour Chwast, and a whole bunch of other guys whose names I couldn't, and still can't, pronounce. But their editorial illustration, graphic design, and activist posters had a profound effect on me.

I realized I could fulfill my creative passion without prostituting my craft. This book saved me from becoming just another mediocre painter.

Twenty-five years later, I found that it affected a number of other designers as well. Michael Mabry told me, "It represented what graphic design really could be — fun, intelligent, versatile, and captivating. Most of all... this book spoke to the human spirit. It was, and still is, an inspiration. If I only could be that good." For Michael Vanderbyl, the book presented a dichotomy: "I was educated in the Swiss and International school, but seduced by the emotional side of design that this book represented. I try to resolve this conflict between rational and

irrational every day in my work."

In 1986 someone "borrowed" my copy and never returned it. The publisher had no more copies. Even Milton Glaser told me he wished

he knew where he could find one. I ran a classified ad in a national design publication and found another. This one doesn't leave our studio.
Rick Tharp

Circus Poster
Henryk Tomaszewski, 1965

One of the earliest pieces of graphic design that influenced me was this 1965 poster made for the Polish circus by Henryk Tomaszewski. My initial reaction was that this couldn't possibly be graphic design. Graphic design has rules. Graphic design has grids and typography and "isms." *This* was fun. Tomaszewski, like Alexander Calder, had invented his own one-ring circus. I can spend hours looking at these clowns on their unicycles. Or is that a dancing bear...
James Victore

Design and Cultural Identity

A STUDY IN MIXING VISUAL MESSAGES

By Ellen Lupton

his essay is research toward the exhibition Mixing Messages: Graphic Design in Contemporary Culture, *which will be on view at the Cooper-Hewitt, National Design Museum and the AIGA's national headquarters in New York in Fall 1996. Mixing Messages will be a critical survey of graphic design in the United States from 1980 through 1995. Images reproduced in this essay include objects from the National Design Museum's permanent collections.*

The expression of cultural identity is a central function of graphic design. In the 1950s the corporate identity designer shed the bohemian image of the artist in favor of the businesslike guise of the communications expert. The corporate consultant became the most professional of all design professionals, elevating the status of the field with sophisticated terminology and high-profile, high-paying clients. Yet design's role in shaping identity extends beyond corporate logos and annual reports. Graphic design articulates visual cultures for the clients who commission it, the audiences who use it, and the designers who create it.

A culture can be as narrow as a neighborhood or as generic as the national news. There is no single culture in the United States but rather a vast number of overlapping, interlocking mass cultures and subcultures organized around class, race, geography, age, profession, and other affiliations.

The design profession encompasses a range of subcultures within the larger system of media production. "Design culture" consists of a network of schools, studios, magazines, professional societies, paper companies, and so on. Although all public communication takes some physical form, graphic designers, in the "professional" sense, are not always included in the process. Designers must prove their relevance and find their place among editors, advertisers, marketing people, software engineers, corporate communicators, public relations experts, and other figures involved in determining the look of things.

The subculture of graphic design experienced its own identity crisis in the 1980s and early 90s. Angered that the polished Modernism of by corporate communications had come to dominate the values of the profession, designers drew on what they called "the vernacular" — a range of styles and structures seemingly free of arty, psuedo-scientific pretensions. From Charles Anderson's nostalgic clippings of quaint illustrations to M&Co's cool quotations of ready-made business ephemera, designers rebelled against the ethos of corporate Modernism.

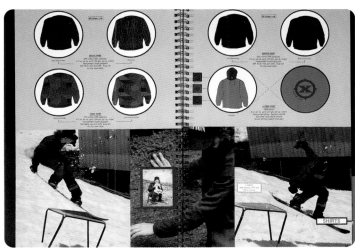

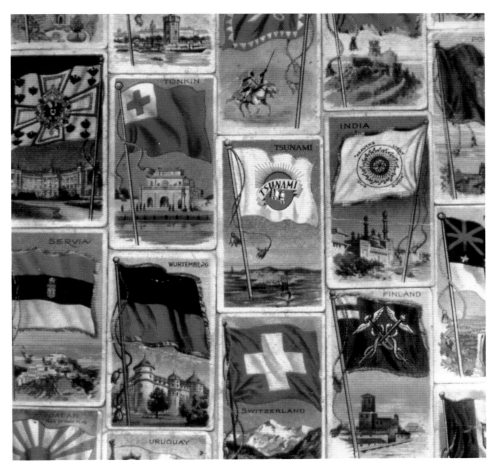

TOP Prudential Life Insurance logos. Redesigned by Siegel & Gale, 1989. CENTER LEFT AND RIGHT Burton Snowboards catalogue. Designed by David Covall and Adam Levit, Jager de Paola Kemp, 1992.

CLOCKWISE FROM CENTER RIGHT "Why?" Time Warner annual report cover, designed by Frankfurt Gips Balkind, 1990. "Silence = Death" logo on T-shirt, designed by members of ACT UP, 1987. Betty Crocker logo, designed by Lippincott & Margulies, 1956. "Be Like That Newspaper" (Tsumani) album cover. Designed by Kristin Thomson and published by Simple Machines, 1993.

The design profession has always defined itself in opposition to commercial styles generated outside its peculiar canon of myths and heroes. Sometimes the vernacular has been despised and sometimes it has been celebrated, but in either case it has been seen as the naive, unknowing Other of the professional discourse. The dichotomy between vernacular and professional design is a false one, however. The word "vernacular" is useful for thinking about graphic design insofar as it suggests the existence of visual "languages" evolving out of diverse cultures. But "the vernacular" should be seen not as a realm beneath and outside "the profession" so much as a broad territory whose inhabitants speak a range of local dialects, from the specialized argot of late Modernist experimentation to the corporate hieroglyphics of national brand names.[1] Design annuals like this one are visual dictionaries of our "professional" vernacular.

A vernacular phrase entered the realm of global corporate identity with Landor Associates' visual makeover of Federal Express in 1994. In place of the flamboyantly futuristic logo the company had used since the 1970s, Landor cut the name down to the more manageable phrase "FedEx" and set it in businesslike roman letters whose only "design" flourish is a subtle arrow lurking between the *E* and the *x*. The new identity capitalizes on a piece of international slang that had, through everyday use, replaced the company's proper name.

While the new FedEx identity converted a vernacular phrase into an official logotype, the visual styles and practices that graphic designers commonly call "vernacular" are exemplified by the work of job printers. Companies such as Globe Poster Printing Corporation in Baltimore sell design *and* manufacturing to clients, making the professional graphic designer an unnecessary middleman. Globe Poster has created music promotions for black communities in the Baltimore/Washington region since 1929. Under the direction of in-house compositor Harry Knorr, Globe produced a distinctive poster style in the 1950s that

printed wood and metal typography on top of brightly silkscreened color fields. After the company switched to digital composition and offset printing in 1988, many of Knorr's signature headlines lived on in electronic scans. The distinctive identity of Globe's posters, currently designed and typeset by Fred Dvorak, evolved at a slow, deliberate pace across decades of cultural and technological change.

Although Globe's work might be called a crude "vernacular" by some graphic designers, the posters are viewed as an authoritative language by the community that uses them. According to Ken Moore of IcyIce Productions, a company that promotes music events, "Globe pretty much sets the standard in making the show 'official.' People in the metro area are conditioned to recognize that, when they see a Globe poster, they know the show is really going on. You see flyers and handbills all the time, but if someone goes to the expense of ordering from Globe and putting up the posters, people feel pretty good that an artist

ABOVE FedEx logo, redesigned by Landor Associates, 1994. RIGHT Envelope and postcard for Savage Republic, 1985–1989. Designed and printed by Bruce Licher, Independent Project Press.

IBM

IBM

IBM

IBM

ABOVE IBM logo, designed
by Paul Rand, 1956. TOP RIGHT
Statesboro Arena poster, 1970.
BOTTOM RIGHT North American
Tour '94 poster. Both designed
and printed by Globe Poster
Printing Corporation. BOTTOM
LEFT AT&T logo, designed by
Bass & Yager, 1984.

or a group actually is going to be there."[2] Globe posters give credibility to the events they announce.

The job printer re-entered a world of more refined and self-conscious design values with the recent revival of letterpress printing. Bruce Licher's Independent Project Press in Los Angeles was established in 1984 to produce packaging and graphics for Licher's own band, Savage Republic, and for other groups attracted to the Press's seductively tactile use of hand-set wood and metal type on industrial materials. Licher's visual identity for Savage Republic included not only a logo but stamps, banknotes, and flags — the visual trappings of a mythic nation in which raw primitivism converged with civilized democracy.

The use of design to visualize cultural identity extends from such imaginary constructions as Savage Republic to the language, artifacts, and customs of massive business establishments. "Corporate culture" is a set of shared attitudes in an institution, ranging from dress codes and taste in furniture to meeting styles, mission statements, and lines of power. In *Culture and Corporations*, a 1991 promotional booklet for Simpson Paper, Frankfurt Gips Balkind predicted the convergence of corporate image-making with mainstream media, and argued that a company should include a mix of "counter-cultures" in its overall framework rather than aspire to a single, monolithic personality.

This shift in corporate communications is a reaction against the Modernist ideal of a universal visual language that emerged in the 1950s, when the implementation of large-scale identity programs signaled the maturing of the design profession. Paul Rand's work for IBM employed geometric forms, clean typography, and modular grid systems to generate a coherent visual language, while Lippincott & Margulies brought Modernism to the supermarket, infusing streamlined designs for logos and packaging with techniques of consumer research.

One of the most prominent symbols of the 1980s was designed by Bass & Yager

after the divestiture of AT&T. Yet although AT&T's digitized globe successfully symbolized universal strength for the former monopoly, other marks of similar design hit rough waters. Debuting the same year as AT&T's striped globe was Prudential's striped rock, a severe abstraction of an icon the company had employed since 1896. Retreating from its streamlined rock in 1989, Prudential hired Siegel & Gale to design a "new" version, which returned to a more conventional illustration.[3]

Prudential's retreat from abstraction to illustration revealed the fragile authority of Modernist theory within the corporate

climate of the eighties. A similar reaction against Modernism erupted around Danne & Blackburn's logo for NASA. The Modernist mark, known as the "worm" by people at the space agency, had been designed in 1974. It was rejected in 1992 in favor of reviving the illustrative, sci-fi trademark designed in 1959 by James Modarelli.[4] The older logo (known at NASA as the "meatball") represented optimistic days of glory for the embattled space program. The NASA logo in both its incarnations has been borrowed by the promoters of rave dance parties, who saw possibilities for camp exploitation in the Modernist Worm as well as the Disneyesque Meatball.

One of the most spectacular corporate

consolidations of the late eighties was the merger of Warner Communications and Time, Inc. The flashy West Coast stylishness of Warner — embodied in the flamboyant personality of chief executive Steven J. Ross — confronted the Ivy League, East Coast traditionalism of Time, Inc. In 1990 Time Warner commissioned Chermayeff & Geismar Associates to symbolize the massive new conglomerate with a mark that would reconcile the company's clash of cultures. Ross championed the remarkable hieroglyph created by the designers, but in 1993, about a year after his death, Time Warner replaced the icon with a drab typographic mark.[5] Chermayeff & Geismar Associates' unusual eye/ear symbol, widely praised by graphic designers for its wit and originality, proved too strong a statement for the corporation's management.

The eye/ear logo premiered a few weeks after the publication of Time Warner's 1989 annual report, provocatively titled *Why?* Designed by Frankfurt Gips Balkind, *Why?* was greeted in the general press as a shocking new approach to business communications, mixing the visual languages of mass culture with the sober messages of corporate identity.[6] Reflecting the influence of *Spy* and other "culture" magazines, the designers used icons, photographs, and factoids instead of running text wherever possible. According to Kent Hunter, "We took things from surf culture, fashion, and media, and we brought them into corporate communications. We don't claim to have invented anything new, but we brought these forms into a new place."[7] Time Warner's 1989 annual report exemplified the ability of a major corporation to build an image of its own "culture" by absorbing the languages of smaller ones. (The conventional design of Time Warner's 1993 annual report is in keeping with the company's bland new logotype.)

The entertainment industry, dominated by giants like Time Warner, includes numerous smaller producers and distributors as well, whose visual languages emerge out of the artists and consumers who make and use their product. Design for the alternative music industry is often produced in an entre-

KEEP REFRIGERATED

BUZZMUSCLE

ASSEMBLER b/w 33°

SHELL

SHELLAC

smells like smoked sausages

Prairie Belt

SMOKED SAUSAGE

MADE WITH PORK, CHICKEN AND BEEF
SOY PROTEIN CONCENTRATE ADDED • PACKED IN MEAT STOCK NET WT

CLOCKWISE FROM TOP LEFT
Buzzmuscle album cover.
Designed by Greg Dunlap and
Rob Warmoski and printed by
Barefoot Press, 1991. Shellac
album cover, designed by Steve
Albini and Bob Weston, 1993.
"Smells Like Smoked Sausages"
album cover, designed by
Art Chantry, 1992. Liquor
Giants CD cover, designed by
Art Chantry, 1992.

preneurial spirit. The independent label Simple Machines is owned and operated by Kristin Thomson and Jenny Toomey, who are also the company's chief graphic designers. Members of the band Shellac produce their own packaging, which revels in the materiality of printing and design — some pieces are printed with root beer syrup, while others are parodies of the design process. Art Chantry's posters and packages for the Seattle-based music industry merge quotations of "vernacular" sources with life on the street.

The designers of rave flyers — portable, palm-sized posters announcing dance parties

— typically lift material from ads, stock photos, television, comic books, packaging, and other sources.[8] Working in Los Angeles, Raymond Leon Roker not only stages rave parties but designs the flyers that advertise them. He is also the editor, publisher, and art director of the music tabloid *Urb*, forerunner of the more mainstream black music magazine *Vibe*.

The youth movements associated with hip-hop and raves have also found their identity in skateboarding, snowboarding, and surfing. The skateboard industry since the late eighties has consisted mostly of small, skater-owned companies who use members

of their own skating teams to design product graphics. The hijacking of mainstream corporate logos became a hallmark of streetwear in the early nineties. Mike Mills, a skater and graphic designer, has described this mode of appropriation as a "new critical materialism" that reacted against the anti-consumer ethos of punk by embracing a cycle of rapidly changing styles and symbols. While anti-consumerism may be a privilege of the shopping-centered lifestyle of the suburbs, conspicuous consumption challenges common stereotypes about the buying power of urban young people.[9]

The products and graphics of snowboarding lean heavily on the language of the skateboard scene. Snowboarding began as an extension of skiing and its sleek, taut sports culture. But after the introduction of freestyle snowboarding in the late eighties, snowboard manufacturers began to take design cues from the skate world. The Vermont studio Jager di Paola Kemp has applied extremely high production values to its trade catalogues for Burton snowboards, in contrast with the crudely made literature of the skate industry. Although snowboarding has a streetwise style, it remains an expensive sport with elaborately constructed graphics and paraphernalia to match.

In addition to giving visual identities to the consumption of music and sports, graphic design has expressed the agendas of groups organized around political issues. ACT UP, the AIDS Coalition To Unleash Power, was founded in New York in March 1987.[10] The group adopted as its logo the phrase "Silence = Death" written under a pink triangle, in reference to the tags of pink fabric sewn on the sleeves of homosexuals in German prison camps. By turning the Nazi triangle upside down, the design-

ers of the Silence = Death symbol aimed to suggest resistance and strength.

WAC, the Women's Action Coalition, was founded in New York in 1992 in response to the Clarence Thomas/Anita Hill Congressional hearings on sexual harrassment.[11] WAC staged a series of public interventions that combined techniques of performance art with media-conscious, photogenic graphics. WAC's logo, designed by Bethany Johns and Marlene McCarty, was emblazoned on T-shirts, buttons, posters, and other ephemera to publicize the group and galvanize its members around a shared image.

As a tool of culture, design expresses the identities of people and products. The marks of everyday life, whether crafted by professional consultants or stolen from the supermarket shelf, materialize the character of communities and institutions, from corporate cultures and mass cultures to subcultures and countercultures. Creating an image around which groups of individuals form a common view of themselves — or around which a company understands its products and markets — is design's chief social function. Designers also use their work to articulate their own identities as visual producers, whether they view themselves primarily as artists, activists, fans, or members of the "profession" of graphic design.

ABOVE Women's Action Coalition logo, designed by Bethany Johns and Marlene McCarty, 1992. BELOW World Industries catalogue, c. 1994.

1 See my article "Been Down So Long It Looks Like Up to Me," *AIGA Journal of Graphic Design* 10, 3 (1992): 1–2.

2 The history of Globe Poster is lovingly documented by Michael Dolan in "How Globe Poster Turned Its World Dayglo," *Washington City Paper* (September 9, 1994): 18–30.

3 "Object: Maud Lavin on the New Traditionalism and Corporate Identity," *Artforum* 28 (October 1989): 17–19. See also Rose DeNeve, "What Ever Happened to Corporate Identity?" *Print* 43 (May/June 1989): 92–98.

4 On the design of the 1974 NASA logo and the controversy around its rejection, see Philip B. Meggs, "Government Style: Design Consciousness and the Feds," *AIGA Journal of Graphic Design* 6, 1 (1988): 11; Meggs, "The Crash of the NASA Logo: It Could Have been Worse!" *AIGA Journal of Graphic Design* 10, 4 (1992): 12–13; and Michael Rock, "Logo Wars: Should NASA Go Back to the Future with Its Visual Identity?" *I.D.* (September/October 1993): 24–26. On NASA's own view of the logo situation, see Glen E. Swanson, "The 'Meatball' Is Back! A Look at the Origins of NASA Insignias and Crew Patches," *Quest*, NASA in-house publication (Summer 1992): 26–30.

5 Steff Geissbuhler, "Making a Mark," *AIGA Journal of Graphic*

Design 8, 2 (1990): 12; and Geissbuhler, "(Eye)/Ear Today–Gone Tomorrow," *AIGA Journal of Graphic Design* 12, 1 (1994): 8.

6 Kim Foltz, "Bored by Annual Reports? Try Time Warner's," *The New York Times* (Wednesday, April 4, 1990).

7 Interview, Kent Hunter and Aubrey Balkind with Ellen Lupton, July 1994.

8 On rave graphics see Michael Dooley, "Frequent Flyers," *Print* (March/April 1993): 42–53; and Peter Tulupman, "Rave Exhibit," *Project X* 28 (Spring 1994): 34–35.

9 Mike Mills, "Which One Doesn't Belong with the Others? The Style and Graphics of Skateboarding," *Lift and Separate: Design and the Quote Unquote Vernacular*, ed. Barbara Glauber (New York: The Cooper Union, 1993), 48–55.

10 An illustrated history of ACT UP New York is provided by Douglas Crimp and Adam Rolston, *AIDS Demo Graphics* (Seattle: Bay Press, 1990). See also Dan Friedman, "Guerilla Design I: Gran Fury," and Julie Lasky, "Guerrilla Design II: ACT UP," *AIGA Journal of Graphic Design* 8, 2 (1990): 6–7.

11 On WAC and other feminist collectives founded between 1985 and 1992, see Pamela A. Ivinski, "Women Who Turn the Gaze Around," *Print* (December 1993): 36–43.

TOP LEFT *Urb* magazine cover.
TOP RIGHT California Dreaming rave card. Both designed by Raymond Leon Roker, 1994.

Graphic Design as Performance Art

By Steven Heller

The great poster makers of the early twentieth century might never have imagined a time when their grand posters would and could be posted in the mail. In their day, the true poster was wall art. In more recent times, the thousands of posters sent out annually by the American Institute of Graphic Arts alone are ample evidence that posters are no longer restricted to hoardings, kiosks, or placards. For three decades, designers have been creating unique poster-like missives, usually calls for entry to the AIGA's national design competitions or announcements of chapter events. Every conceivable graphic method — classical, Modern, post-Modern, parody, pastiche, and all manner of quirky experiments — has been used to convey the AIGA's message and mission. During the past ten years, some of these images have become icons of contemporary design. So those who perennially lament the death of the American poster must not be on any of the AIGA's mailing lists. They have missed a wellspring of original work.

The AIGA did not always champion the poster cause. Founded in 1914 by the new guard of an old profession, the American Institute of Graphic Arts upheld the standards of fine commercial printing and typography in the classical tradition, before the advent of the poster. The earliest announcements of the fledgling institute were superbly crafted specimens of small letterpress ephemera printed on sheets of handmade paper. The poster, which for the most part was regarded as crassly conceived and shoddily produced advertising, was rarely if ever considered suitable for the institute's own communications. Following World War I, the AIGA's focus slowly shifted to include a much broader definition of graphic arts, but its members still undervalued posters unless, of course, they were the masterpieces imported from the distant centers of fine poster design in Paris, Berlin, or Milan. The billboard was the indigenous American poster, and garish twenty-four-sheet billboards were not taken seriously by the AIGA's "keepers of the crystal goblet," the canon of classical typography.

It was not until the 1950s that the poster was ultimately accepted as a viable means of communication by the AIGA. This was when the institute's essentially book-oriented membership was finally superseded by a group of young Modern generalists working in corporate, advertising, packaging, and other growing contemporary commercial design media. Some of the earliest poster announcements and calls for entry — created by Gene Federico, Herb Lubalin, Paul Rand, Alexey Brodovitch, and Lou Dorfsman —

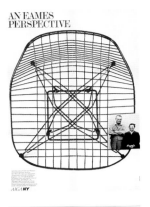

AN EAMES
PERSPECTIVE

ABOVE "An Eames Perspective," AIGA/NY, 1988. Designed by Ellen Shapiro. TOP RIGHT "Communication Graphics," AIGA/National, 1967. Designed by Paul Rand. RIGHT "See Between the Lines," AIGA/ Chicago and ACD, 1955. Designed by Tim Hartford and Kerry Grady. BELOW TOP "Graphics in Packaging Design," AIGA/National, 1959. BELOW BOTTOM MIT Visual Language Workshop exhibition, AIGA/ National, 1970.

OPENING

The Officers and Directors of
THE AMERICAN INSTITUTE OF GRAPHIC ARTS
cordially invite you to attend
the opening reception
of the second annual

GRAPHICS IN PACKAGING EXHIBITION

presented in the gallery of
THE AMERICAN INSTITUTE OF GRAPHIC ARTS
5 east 40 street New York.
On Tuesday March 24 1959 5-7:30 PM
Donald Deskey, Chairman
of the show, will be
introduced at 6:15 PM

RSVP

VLW
AIGA

indicated the expressive direction typography was taking. These works were not the most exquisite displays of a classical typeface, but were more often than not conceptually based ideograms wedding type and image unconventionally. Though each poster was imbued with the personality of its maker, collectively, they were also reflective of the period, in which the confluence of Swiss rationalism and American commercialism dominated much sophisticated design.

Early AIGA posters from the 1950s conformed to two distinct models: Modernism and eclecticism. The latter connotes an approach initiated in the late 1950s by New York's Push Pin Studio and was practiced by acolytes whose inspiration was not the European Modern movement but a more timeworn Victorian, Art Nouveau, and Art Moderne aesthetic, which became the foundation of Push Pin's and Lubalin's contemporary iconography and typography. An examination of AIGA ephemera from the mid-1960s suggests that diverse practitioners with distinctive, often contradictory, methods were compatible under the AIGA banner because the institute was not rooted in a single ideological or methodological principle, but celebrated a loosening of strictures. The individual chairmen and women of each design competition determined how certain AIGA materials looked, and the range was indeed quite wide. Nevertheless, by the early 1970s, Modernism and sixties-style eclecticism were the unofficial style of the AIGA, which meant that most alternative, or at that time New Wave, approaches were often nudged aside.

The New Wave, essentially a term of the late seventies and early eighties, was an amalgam of various loosely defined methods, including traces of British punk, Swiss punk, Memphis, and other strains of experimental fine and applied art. The style began to emerge in AIGA competitions around the late 1970s and soon skyrocketed, as work from regions outside New York and certain graduate schools began to appear in competitions. A surge in new AIGA members, particularly from California and Texas, where New Wave was prevalent, gave a voice to designers whose styles and methods rejected the once dominant design approaches. Gradually, as graphics were commissioned from these younger members, the look of the AIGA's posters acquired certain New Wave characteristics. Despite the preference for restraint by its more orthodox members,

CLOCKWISE FROM LEFT

Poster exhibition, AIGA/National, 1979. Designed by Richard Hess. "Issues and Causes," AIGA/Portland, 1994. Designed by Johnson & Wolverton. Photographed by Mark Hooper. "Designing a Life,"

AIGA/Baltimore, 1993. Designed and photographed by Dave Plunkert. AIGA National Design Conference, 1993. Designed by Joel Nakamura. "Design for the Public Good," AIGA/National, 1987. Designed by Lanny Sommese.

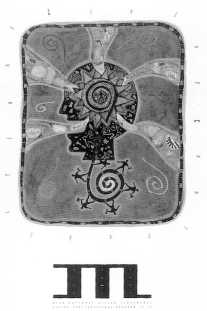

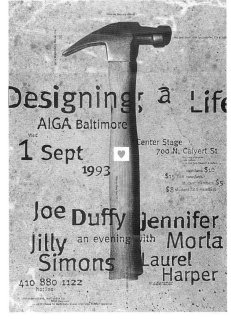

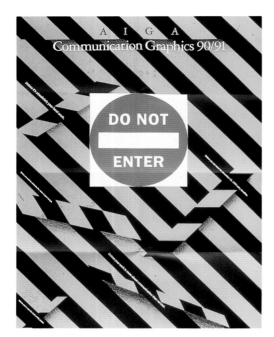

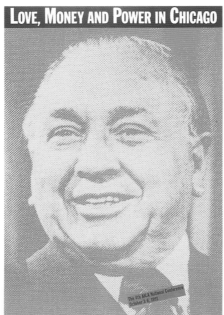

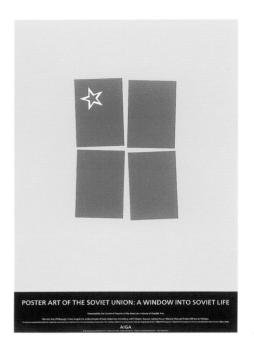

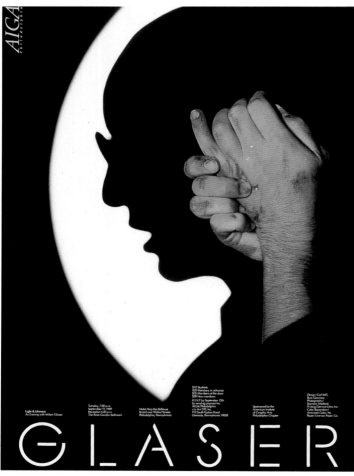

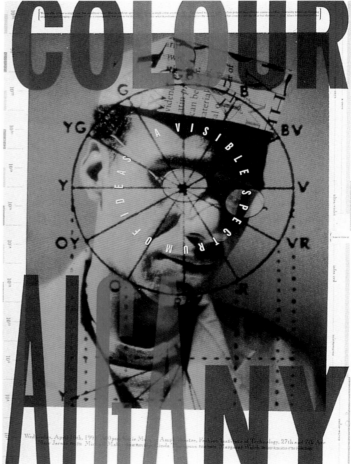

the AIGA did not officially enforce Swiss or American Modern approaches; standards were usually based on quality alone, which meant that exemplary work of even the most radical nature stood a chance of passing muster.

Although being invited to design an AIGA poster has always been an honor, it is also a declaration of trust between the institute and the designer. Graphic license, not money, has always been the implied payment for the commission. And usually this works well. Sometimes, however, conflicts can arise if a designer uses the AIGA poster as a platform for personal expression or experimentation: the balance between graphic design and expressive art can be easily be tipped, jeopardizing clear communications. On the other hand, as many designers believe, if design for a design organization cannot push boundaries, then where can one experiment? If a design audience cannot decipher new codes, where can new ideas be safely tested? In one example of conflict from the early 1980s, Paula Scher designed a poster for an AIGA photography competition call for entry, using an artful photographic tryptych of a woman, shown from the knees down, sitting on a toilet bowl. Although the subject matter was within the bounds of contemporary photography, it was not as indicative of hip advertising or editorial photography as it would have been today. Scher's poster was initially rejected, not for being in poor taste, but for lacking relevance to the subject at hand. And yet it was an

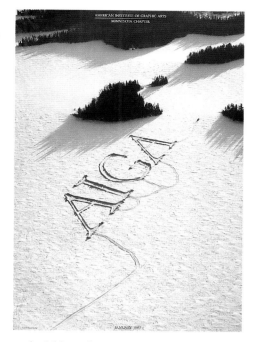

undeniably striking poster that eschewed the clichés of the typical photography competition. Balancing the fine line between propriety and progress is at times difficult. Scher's piece was eventually published and by today's standards the image is rather innocuous.

Before AIGA chapters started forming in the mid-1980s, only four or five posters were issued from the national headquarters each year. The shock waves emitting from the newer, more adventuresome images caused tempests that often contributed to changes in certain design conventions. With the advent of regional chapters, even *more* license was allowed in terms of legibility and appropriate imagery. Within the past five years AIGA chapters have launched a swelling number of annual programs, including lectures, exhibitions, clinics, workshops, and even "design camps," many of which are promoted through posters. And these posters are vehicles for designers to test their talent and push boundaries. Whether for a chapter event or a national conference, the AIGA poster is a stage on which a designer auditions and performs. Since designing for designers is the toughest test of all, the results are more closely scrutinized and criticized than any other.

But AIGA posters are not simply exercises. In cities where more than one design organization competes for membership or attendance, the poster is often the primary advertising medium, and so must be startling

or curious enough to attract the attention of a jaded community. This makes for high stakes, but there is another reason that AIGA posters exhibit such incredible energy. Between each chapter there is tension, a competition to see who can produce the most exciting visual materials. Each chapter's graphic communications are displayed and compared against the others at the annual chapter retreat, where the year's activities are celebrated.

Ironically, the AIGA has both contributed to the recent renaissance of poster art and discouraged further production. This time around, the AIGA is reconsidering its position on the poster not for reasons of aesthetics or craft but because posters consume great quantities of paper. In recognition of the need for increasing environ-mental awareness, the AIGA has been encouraging its members and chapters to consider less wasteful alternatives.

If posters add to the earth's junk heap and squander natural resources, then the form must be readdressed. But until electronic or digital imagery makes the poster obsolete, it is an important vehicle that should be used with restraint.

Whatever the future may hold, AIGA posters are significant in the history of poster design not for their quantity but for their diversity. These posters are a polyglot of late-twentieth-century design languages inspired by the past, present, and future, and influenced by new media and technology. They provide us with a lexicon of Modern, post-Modern, and alternative graphic design.

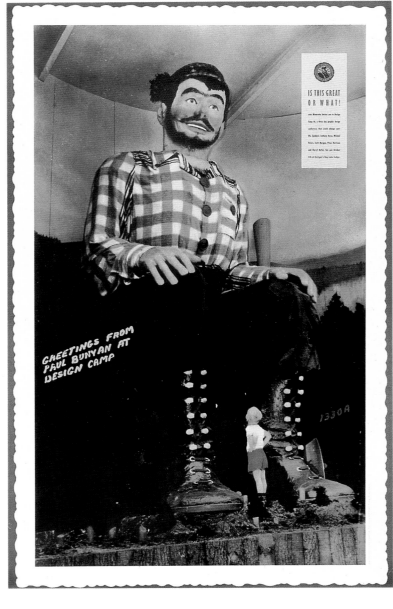

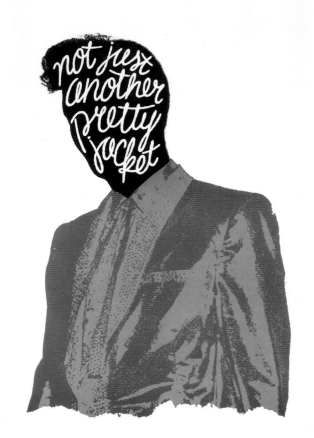

Over Here, Over There

AMERICAN INFLUENCE ON BRITISH

GRAPHIC DESIGNERS

By Rick Poynor

When Colin Forbes opened Pentagram's New York office at 251 Park Avenue South in 1978, he was putting the seal on a relationship that, from the British side at least, has done much to define graphic design in the post-war period. For Forbes, reflecting on the city's historical position within American graphic design, New York had always exerted a "gravitational pull." But this acknowledgment of Manhattan's — and by extension the country's — magnetism was just as true in a transatlantic sense. Both for Forbes and for many of his British contemporaries, America represented excitement, inspiration, opportunity, and the ultimate personal test. Even in 1978, as a partner in Britain's most lauded design firm, he could feel that he had achieved only "second division" success. "New York," he wrote in 1992, "was really the place to compete."

Forbes's Pentagram colleague, Alan Fletcher, had been one of the first to try. In 1956, a scholarship took the young Fletcher to Yale, where he studied with Herbert Matter, Bradbury Thompson, Josef Albers, and Paul Rand. In "Letter from America," published in a 1957 issue of *Ark*, the journal of the Royal College of Art (where he had been a student), Fletcher gives a near hallucinogenic account of the cultural vertigo

induced by sudden acquaintance with giant supermarket plazas, skyscrapers, drive-in restaurants, chrome and plastic drugstores, cascading neon, and cruising "dream-cars" after the post-war privations and grayness of life in 1950s Britain. There is little space in these first impressions for the minutiae of design, but Fletcher does commend the paperback graphics of Rand, Leo Lionni, Alvin Lustig, and Roy Kuhlman; alongside a tail-finned Plymouth and a copy of *Confidential* he shows a Grove Press cover by Kuhlman.

In America, Fletcher fell on his feet. He was given freelance work by Saul Bass in Los Angeles and Leo Lionni in New York and simply by being in the right place (the *Fortune* office) at the right time (the Russians had just launched Sputnik) landed a commission to carry out a last-minute redesign of the magazine's front cover. While staying with Fletcher during a summer visit to New York in 1958, Forbes met Aaron Burns, Brownjohn, Chermayeff & Geismar, Will Burtin, Gene Federico, and Paul Rand. And it was Burns who, in the early 1960s, gave Bob Gill an introduction to Fletcher and Forbes on his move to London — a meeting that led, in 1962, to the formation of Fletcher/Forbes/Gill, the partnership that later evolved into Pentagram.

By the end of the 1950s, British graphic design's tendency toward a genteel and bookish typography was in urgent need of reform. However elegantly applied, such conventions were no longer adequate to meet the more strident needs of competitive commercial communication. Writing in 1961, Allan Fleming, a Canadian who had worked for London advertising agencies in the 1950s, urged his British colleagues to think of themselves as journalists "who must constantly keep in touch with ... social patterns"; their typography, he advised, should take its inspiration from jazz, tabloid newspapers and burlesque shows, and he quoted Herb Lubabin's view that there could be typographic "warmth and charm in deliberate ugliness."

Fleming's words were prophetic. By acquaintance, example, or both, leading figures of the New York School such as Lubalin were to make a lasting impression on designers of Fletcher and Forbes's generation, such as Derek Birdsall, Brian Tattersfield, and Richard Hollis. In Fletcher/Forbes/Gill's influential book *Graphic Design: Visual Comparisons*, published in 1963, American examples — by Rand, Bass, Lou Dorfsman, George Tscherny, Lubalin, Brownjohn, Chermayeff & Geismar, Tony Palladino, Henry Wolf, and George Lois — outnumber British examples by a ratio of two to one (half of the British examples are, in any case, by American-influenced F/F/G). The book's opening sally, from Doyle Dane Bernbach, retains its iconic status to this day. "The Volkswagen campaign was to advertising what the Sistine chapel is to painting," one of Britain's leading admen, John Hegarty, said recently. "For me it was like having a switch turned on in a darkened room."

The influence of American conceptual graphics was reinforced by the presence in Britain during the 1960s of several leading figures (in addition to Bob Gill). Doyle Dane Bernbach opened a London office, as did Papert Koenig Lois, with Tony Palladino as art director. Lou Klein returned to London in 1964 as creative director of Charles Hobson & Grey and went on to set up Klein Peters with Michael Peters. After breaking up with his partners at Brownjohn, Chermayeff & Geismar, Robert Brownjohn moved to London in 1960. At Alan Fletcher and Colin Forbes's suggestion, he approached the British agencies and took up positions as art director at J. Walter Thompson, then design director at McCann Erickson. In 1965, he won a rarely awarded Design & Art Direction Gold for his *Goldfinger* film titles.

As an American designer who left New York and did not return — he died in London in 1970 — Brownjohn has only a walk-on part in American histories of the period. But the impact of his considerable talent (many still testify to his "genius") and outrageous personality on the London designers who knew him, saw his work, or attended lectures featuring "2,000 slides of unused ideas" cannot be overstated. Brian Tattersfield, co-founder of Minale Tattersfield, saw him speak at the Graphic Workshop run by Bob Gill in an agency basement. "We were all absolutely staggered by it," he recalled fifteen years later, "so much so that one friend was moved to tears, knowing he would never be able to equal it. That's how involved we were in those days."

By the end of the 1960s, the process of synthesis was complete. Something distinctively and recognizably British had emerged from these influences. In March 1969, the editors of *Print* were sufficiently impressed to devote a special issue to British graphic design. "British design today is uncommonly exciting and warrants examination in depth," runs its editorial. "To those who recall English graphic expression as being an uneasy mixture of Swiss and American tendencies, it may come as a surprise to learn that it has lately developed (or redeveloped) its own unique personality — one that is full of vitality, assertive and bold." In an article titled "The New Professionals," Edward Booth-Clibborn suggests (with a new note of national self-confidence that was to become more bullish in the years ahead), "British graphics are, if a distinction must be found, more personal than the American variety."

If the paths of influence are fairly well trodden up to this point, then they are much less clearly defined when it comes to the 1980s. In Britain, the lessons of the American canon were thoroughly internalized by the generation that followed Fletcher and Forbes. Secure in their own way of doing things — and beneficiaries, by the mid-1980s, of their very own design boom — the British no longer looked to the United States for leadership and, unless they traveled, or took part in international design events, had only a superficial knowledge of current American graphic design. What they did see of the newer work, from the candy-striped New Wave to the spiderwebs of deconstruction, they often neither liked nor understood. "Where have they gone, the geniuses and innovators that inspired our youth, and supplied the high octane fuel that powered British graphics in its early days?" asked James Beveridge of London design firm The Partners in the *AIGA Journal of Graphic Design* in 1993. "It seems the U.S. has forgotten the lessons it taught the U.K., to dig deeper in one's own creativity, and find more personal and individual expressions."

On the American side, the sentiment is less likely to be one of nostalgic dismay — if American graphic design publications are anything to go by — than lack of interest. Leading British design firms such as The Partners, Lewis Moberly, and Carroll Dempsey Thirkell are sometimes profiled glowingly in the pages of *Graphis* and other glossies, but it is doubtful that this is sufficient to make them household names among American designers, who have plenty of home-grown examples of painstaking professionalism to admire. In book publishing the story is much the same. Edward Gottschall's *Typographic Communications Today*, published in 1989, devotes three pages to Pentagram — "perhaps the epitome of typographic design in England since the 1960s" — and two more pages (somewhat arbitrarily) to Tom Eckersley, Ken Garland, and Michael Peters. Despite the topical promise of the book's title, this dated and truncated selection gives no sense of the fundamental changes that occurred during the 1980s in British typographic design.

It is in these changes, however, that Britain's few remaining claims to influence in the United States lie. Until the arrival of David Carson in the early 1990s, Neville Brody was perhaps the only designer to have emerged in the last fifteen years whose international fame and presence, through sheer force of publicity, exceeded that of any comparable American designer. Lower down the slopes of celebrity, other more experimentally driven British designers — Vaughan Oliver, Malcolm Garrett, The Thunder Jockeys, Why Not Associates, 8vo, Jon Barnbrook, Phil Baines, and Designers Republic — have attracted the attention of American publishers from *Emigre* to *Communication Arts*. And a similar thirst for the outré operates in reverse. British mainstreamers with a yearning for wit admire Tibor Kalman because M&Co's output recognizably belongs to the conceptual tradition, and design organizations invite Kalman to speak, along with favorite elder statesmen such as Milton Glaser, Saul Bass, and Paul Rand. But it is designer-as-rock-star types such as David Carson and Barry Deck who get mobbed at conferences by student autograph hunters. In Britain, Carson is the first graphic designer since Brody to break out of the design ghetto and appear in lifestyle magazines and on late-night arts television.

It was ironic that Carson's only critic during a ten-minute television profile on *The Late Show* was a Pentagram partner — David Hillman — who had been cast by the producers in the role of skeptical father. Whatever one's view of Carson's oeuvre, it was hard to avoid the feeling that in some fundamental sense, a torch had been passed — not directly from Pentagram to Carson, but in a more diffuse way from Britain back to America. Pentagram, uniquely, is the point at which the post-war histories of British and American graphic design are tied. In the 1990s, it is the American offices of the British interloper, one cannot help noticing, that are multiplying — most recently in Austin, Texas — and having the most success in trying new approaches and integrating new *American* partners.

Maximum Message/Minimum Means

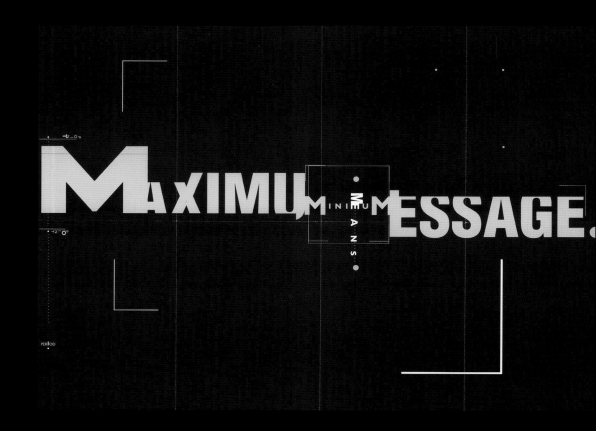

Call for Entry

Design Walter Kopec, Providence, RI
Printing Milocraft, Inc., New York, NY
Finishing Printers Bindery, New York, NY
Paper Potlatch Vintage Remarque,
Velvet 80# text, 50/10 recycled

The intent of the *Maximum Message/Minimum Means* show was to celebrate design as a cerebral or cognitive activity, focusing on the process of conceptualizing beyond the usual purpose of art as a "beautiful image," while not negating aesthetics. In the selection process, attempts were made to measure the success of the embedded design strategies. "Minimum Means" addressed the strategies of directness: conceptual, visual, and production economy, neither under-design nor over-design. The intention was not to select Minimalist work but to focus on the clear fit of message components, verbal and visual or aural, for the purpose of communicating to an intended audience. It was to acknowledge design as providing intellectual diplomacy between aspects of sociology and psychology, which act as constraints on cultural communications.

The task of judging, facilitated by the efficient AIGA staff, was done by an impartial jury — Judy Anderson, Barbara Glauber, and Walter Kopec. Their persuasive, carefully selected, and insightful rationales helped to clarify the designers' intentions in many cases. Although not all selections were made on a unanimous basis, split votes were rare. All judges brought broad knowledge to the task, and helped shape the rationales and final criteria for the overall judging.

In general, the entries provided too few surprises. In the same ways in which one could criticize Modernist design shows of the sixties as being too uniform in approach, using hard-edged iconography or modular typography, one could as easily recognize today's "group thinking" in the obvious nostalgia of old letterpress cuts and images, twine and cotton threads, or recycled papers of speckled and ersatz quality. Today, mainstream seems to mean corrugated cardboard, brown butcher paper, stamps, torn and perforated edges, and images made from office rubber stamps. Design history should not bind design to nostalgia but provide insight toward the future.

One favorable and totally encouraging trend, however, is that designers have given freely to a great number of social causes. It is here where they turn the idealism and inclusiveness of the social responsibility espoused by the early founders of design into contemporary social reality.

Dietmar Winkler
Chair

JURY

Judy Anderson
Professor of Design
University of Washington
Seattle, WA

Barbara Glauber
Principal/Designer
Heavy Meta
New York, NY

Walter Kopec
Design Consultant
Providence, RI

Dietmar Winkler
Professor
University of Massachusetts —
Dartmouth
North Dartmouth, MA

In March 1993, a jury of five graphic designers, their eyes glazed after four days of competition review, met for dinner in a mid-Manhattan restaurant and considered the products of their profession. Enough excess. The AIGA's next show, announced one weary juror, should laud design that says more with less.

Maximum Message/Minimum Means: The idea had promise and thus the AIGA's first show in 1994 was born.

"Effective," "essential," and "efficient" were watchwords as a pared-down nineties aesthetic began to take shape. Designers back from the budget bust of recent years rallied to the call. But "maximum minimum"? The syntax perplexed. Would that be time, money, people, production? What did the jury drawn from academe have in mind?

"We were trying to find work with impact — a clear, carefully considered concept within an intelligent context," said the chair of the competition. Were expectations met? "I was looking for a bit more marginalia, more Xeroxed flyers," admitted one juror, who was interested in seeing "how self-published work fit in the discourse." Said another juror, "I was interested in the designer's message. We do more than broadcast for someone else."

Entrants were asked to define each project's premise piece by piece. Few complied. But those who did offered a inspirational glimpse into process — hand-sewing, rubber stamping, kitchen table linoleum prints, and an inventive use of materials from manila envelopes, packing tape, florist's paper and mill ends to clip art, diazo blueprints, feed sacks,

antique typewriters, cake toppers, kraft and butcher paper, and secondhand chairs. Moving boxes were impulsively deconstructed to announce a firm's move; 4,000 out-of-date library books were de-jacketed, their pages selvedged and given new life.

Budgets ranged from the nonexistent to the undefinable; scheduling was overnight or unmeasurable; staffing meant studios, teams, graduate students, grade-schoolers, and solo acts. The computer was present, yet overall the sensibility evoked earlier times when the hand reigned unchallenged by the machine.

But at what price meaning? Content bested beauty but had "minimum" become a code for "shallow"— predictable solutions, missing metaphors? Jurors agreed: the socially responsible work had the greatest effect, though all had hoped for a wider range of entries from ethnic, grass-roots, and non-traditional designers outside the AIGA's professional sphere. Missing were the vital vernacular of alternative and community presses, the Kinko clan, and others who are making the most with what in conventional terms might be considered less.

Few pieces achieved the balance the competition's premise implied. In hindsight, could parameters have been clearer? Sure, the call may have been ambiguous, noted one juror. "But so is life."

Moira Cullen

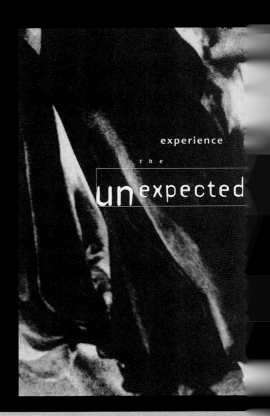

experience

the

un**expected**

Title *Dance Umbrella Season Brochure 93/94*
Design Firm *Moore Moscowitz, Boston, MA*
Art Directors *Tim Moore and Jan Moscowitz*
Designers *Tim Moore, Jan Moscowitz, and Michele Outland*
Photographers *Various*
Copywriter *Joanne Barrett/Dance Umbrella*
Client *Dance Umbrella*
Printer *Pride Printers, Inc.*
Paper *Champion Benefit*

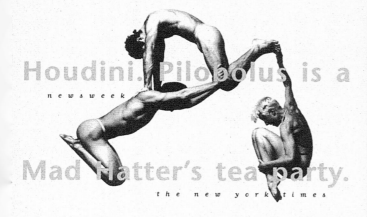

As zany as the Marx

Brothers, as clever as

Houdini. Pilobolus is a
newsweek

Mad Hatter's tea party.
the new york times

Full of daring, dazzle,

and physical prowess.
the daily news

Pilobolus Dance Theatre

If anybody
is out there taking risks,
it's AXIS dis/Abled Dance Troupe.

...a courageous exploration of
human potential.
the boston herald

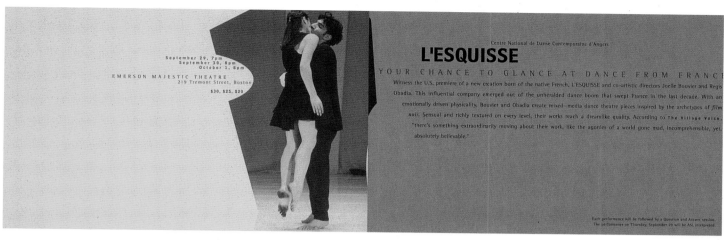

2

Title *Dance Umbrella Season Brochure 94/95*
Design Firm *Moore Moscowitz, Boston, MA*
Art Directors *Tim Moore and Jan Moscowitz*
Designers *Tim Moore, Jan Moscowitz,*
and Michele Outland
Photographers *Various*
Copywriter *Joanne Barrett/Dance Umbrella*
Client *Dance Umbrella*
Printer *Pride Printers, Inc.*
Paper *Champion Carnival*

3

Title *Holiday Book 1993*
Design Firm *Kali Nikitas, Chicago, IL*
Designer/Copywriter *Kali Nikitas*
Client *Kali Nikitas*
Printer *Xerox*

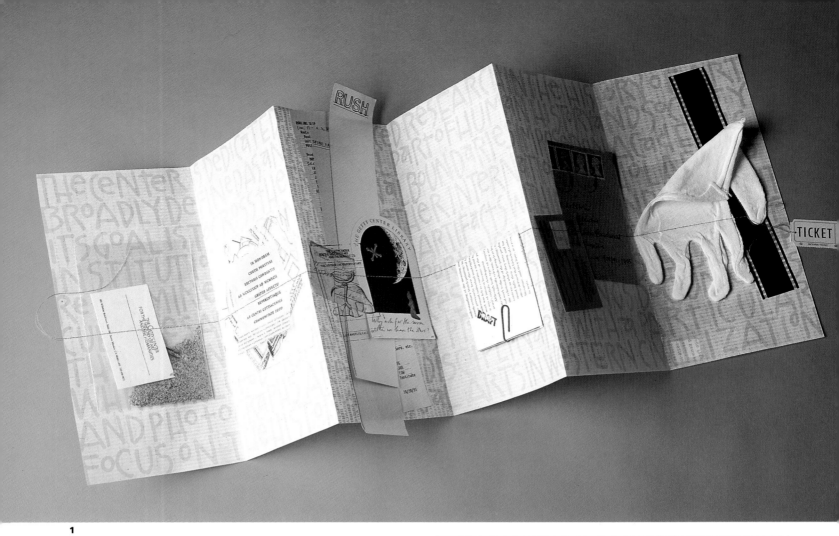

1

2

1
Title *The Getty Object*
Design Firm *Plus Design Inc., Boston, MA*
Art Director/Designer *Anita Meyer*
Client *The Getty Center for the History of Art and the Humanities*
Letterer *Jan Baker*
Sewer *Elissa Della-Piania*
Collage Artists *Anita Meyer, Nicole Juen, Carolina Senior, Veronica Majlona, Jan Baker, Matthew Monk, Daniels Printing Company, and Stacy Miyagawa*
Typographer *Monotype Composition Co.*
Printer *Aldus Press*
Paper *Various Reused Paper and James River Curtis Parchtext Riblaid*

2
Title *Rafael Viñoly Architects/Tokyo International Forum: A Work in Progress*
Design Firm *Plus Design Inc., Boston, MA*
Art Director/Designer *Anita Meyer*
Copywriters *Jay Bargmann and Jonathan Schloss*
Client *Rafael Viñoly Architects*
Typographer *Monotype Composition Company*
Printer *The Pikes Peak Lithography Company*
Paper *Supermax #80 Text, Chipboard Cover*

3

Title *The Steelcase Foundation 1993 Annual Report*
Design Firm *Square One Design, Grand Rapids, MI*
Art Director/Designer *Kevin Dean Budelmann*
Illustrator/Typographer *Kevin Dean Budelmann*
Copywriter *Polly Hewitt*
Client *The Steelcase Foundation*
Printer *D & D Printing Company*
Paper *Fox River Circa Select Warm White*

4

Title *Impressions Magazine, Winter 1994*
Design Firm *Visual Dialogue, Boston, MA*
Art Director *Fritz Klaetke*
Designers *Fritz Klaetke and Brenda Schertz*
Photographers *Kent Dayton, David Herwaldt,*
Jonathon Hart, John Rossi, and Bruce Spector
Copywriter *Dorene Dzuiba*
Client *Boston University, Goldman School*
of Graduate Dentistry
Printer *Pride Printers*
Paper *Monadnock Revue Recycled Uncoated*

3 The Steelcase Foundation 1993 Annual Report

4

CHOOSING DESIGN

HOW BUSINESSES,

INSTITUTIONS, AND

DESIGNERS SHAPE

THE WORLD WE SEE

LEFT L
ONLY
MUS
TURN L
MON-FRI

1

2

Le lundi 26 août 1991 / Monday, August 26, 1991	Entrée / Entrance

Inscription / Registration 0800-1600

Ouverture créative
0845-0915 Creative accessing — 407A
Karyn Boyer (Colombie/Colombia)

Ouverture officielle du congrès
0915-0930 Official opening of the congress — 407A

Présentation thématique Changer avec les réalités changeantes
0930-1015 Keynote speech Changing with changing realities — 407A
Dr. Vivian Rakoff (Canada)

Pause 1015-1045

Présentation La globalisation, la mosaïque du langage et de la culture
1045-1115 Presentation Globalization, the mosaic of language and culture — 407A
Felipe Taborda (Brésil/Brazil)

Présentation Le post-est rencontre l'ouest
1115-1145 Presentation Post East meets West — 407A
Ikko Tanaka (Japon/Japan)

Questionnaire sur l'écologie pour préparer les activités de jeudi
1145-1200 Questionnaire on ecology in preparation for — 407A
Thursday's activities

Déjeuner 1200-1400 Lunch

Forums interactifs
1400-1500 Doit-on travailler avec une conscience sociale? — 401A/B/C 403A/B/C 404A/B
15 groupes satellites*
Interactive forums — 405B 409A/B/C 410A/B/C
1400-1500 Should designers work with a social conscience?
15 satellite groups

Pause 1500-1530

Forums interactifs
1530-1630 Quel est le rôle du langage pour un designer? — 401A/B/C 403A/B/C 404A/B
15 groupes satellites*
Interactive forums — 405B 409A/B/C 410A/B/C
1530-1630 What role does language play in graphic design?
15 satellite groups

Graphisme Québec Vernissage de Graphisme Québec et
du Salon international de la communication visuelle
1800-2000 Opening of Graphisme Québec and the international — 407C
Visual Communication Exhibition

* forums de 50 à 100 personnes, groupées par langue.
Introduction de cinq minutes par l'animateur de chaque forum.

* Forums in groups of 50-100, by language.
* Five minute introduction by the animator of each forum.

ICOGRADA Montréal 1991 se réserve le droit de modifier le programme.
ICOGRADA Montréal 1991 reserves the right to modify the programme.

Convergence socio-culturelle
Socio-Cultural Convergence

icograda
montréal
1991

Du 25 au 31 août 1991
Palais des Congrès de Montréal,
Montréal, Canada

14e congrès et assemblée générale du Conseil international des associations de design graphique

14th Congress and General Assembly of the International Council of Graphic Design Associations

Montréal Convention Centre
Montréal, Canada
August 25 to 31, 1991

icograda

1
Title *"Choosing Design"*
Design Firm *Larsen Design Office, Inc., Minneapolis, MN*
Art Director *Tim Larsen*
Designers *Marc Kundmann and Mona Marquardt*
Illustrator *Marc Kundmann*
Photographers *David Corrigan and Sara Jorde*
Copywriter *Charlie Quimby*
Client *Minneapolis College of Art and Design*
Printer *Custom Color*
Paper *Weyerhaeuser Cougar Opaque*

2
Title *ICOGRADA Booklet*
Design Firm *Eskind Waddell, Toronto, Ontario*
Art Director *Malcolm Waddell*
Designers *Malcolm Waddell and Sandi King*
Copywriter *Cabana, Séguin Design Inc.*
Client *ICOGRADA Montreal 1991*
Typographer *Eskind Waddell*
Printer *Quebecor*
Paper *Gilbert Esse White-Green Smooth 80# and
Gilclear Bright 70#*

3
Title *1994 How Design Conference Brochure*
Design Firm *Sametz Blackstone Associates, Boston, MA*
Art Director/Designer *David Horton*
Photographer *Stuart Darsch*
Client *How Magazine*
Printer *Syracuse Colour Graphics, Ltd.*
Paper *Fox River Circa Select White, Neenah Classic
Crest Solar White, Mohawk Satin Cool White*

3

1

Title *Q2 Self-Promotion*
Design Firm *Sametz Blackstone Associates, Boston, MA*
Art Directors/Copywriters *John Kane and Roger Sametz*
Designer *John Kane*
Illustrators *Will Cook and John Kane*
Client *Sametz Blackstone Associates*
Printer *Nimrod Press*
Paper *Neenah Environment*

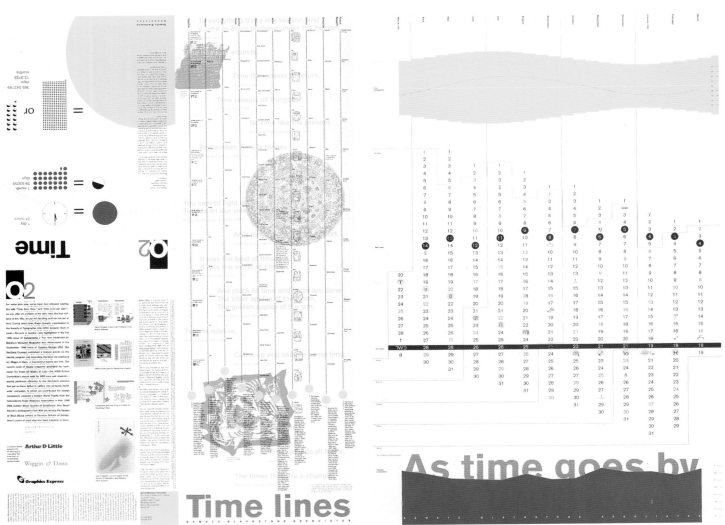

Added Visibility
Rock & Roll can serve as a springboard for an array of major promotional activities funded outside the television partnership that will keep the sponsor's investment active for years after the series' national broadcast. Possible options could include:

The *Rock & Roll* companion home video, featuring the sponsor's name and corporate logo, for distribution in national and international markets

A companion public radio series, providing on-air corporate credits at the beginning and end of each program

A lavishly illustrated companion book/CD package to be published in tandem with the series' national premiere.

Available for corporate sponsorship

NOW

For additional funding, WGBH's seasoned client services team will work with the sponsor and its advertising and public relations agencies to devise a menu of targeted audience- and image-building vehicles that could include:

VIP receptions and screenings for press and key corporate constituents

Tune-in ads, posters and viewer's guides

Merchandising tie-ins and point-of-purchase displays

Video exhibits at corporate headquarters.

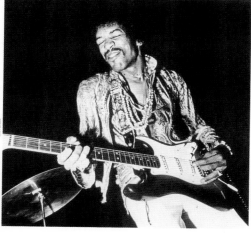

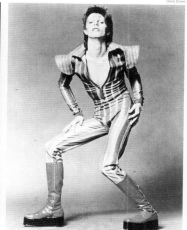

2

2

Title *Rock & Roll Funding Proposal*
Design Firm *WGBH Design, Boston, MA*
Art Directors *Gaye Korbet and Chris Pullman*
Designers *Gaye Korbet and Hisako Matsui*
Photographers *Various*
Copywriters *Alex Johnson and Cynthia Alperowicz*
Client *WGBH National Underwriting Dept.*
Typographer *Gaye Korbet*
Printer *Arlington Lithographer*
Paper *Eastern Opaque Smooth 70# Text*

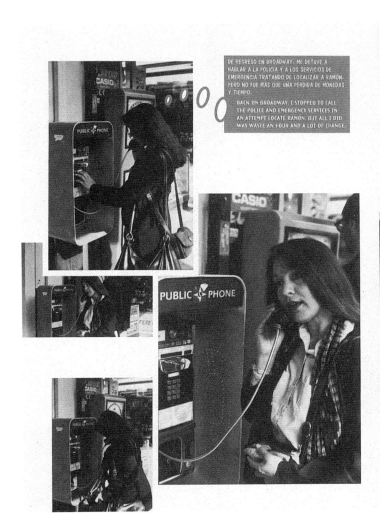

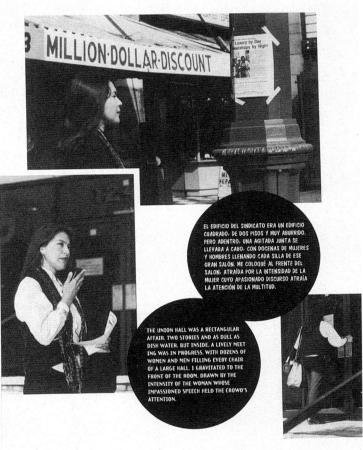

DE REGRESO EN BROADWAY, ME DETUVE A
HABLAR A LA POLICÍA Y A LOS SERVICIOS DE
EMERGENCIA TRATANDO DE LOCALIZAR A RAMÓN.
PERO NO FUE MÁS QUE UNA PÉRDIDA DE MONEDAS
Y TIEMPO.

BACK ON BROADWAY, I STOPPED TO CALL
THE POLICE AND EMERGENCY SERVICES IN
AN ATTEMPT LOCATE RAMÓN, BUT ALL I DID
WAS WASTE AN HOUR AND A LOT OF CHANGE.

EL EDIFICIO DEL SINDICATO ERA UN EDIFICIO
CUADRADO, DE DOS PISOS Y MUY ABURRIDO,
PERO ADENTRO, UNA AGITADA JUNTA SE
LLEVABA A CABO, CON DOCENAS DE MUJERES
Y HOMBRES LLENANDO CADA SILLA DE ESE
GRAN SALÓN. ME COLOQUÉ AL FRENTE DEL
SALÓN, ATRAÍDA POR LA INTENSIDAD DE LA
MUJER CUYO APASIONADO DISCURSO ATRAÍA
LA ATENCIÓN DE LA MULTITUD.

THE UNION HALL WAS A RECTANGULAR
AFFAIR, TWO STORIES AND AS DULL AS
DISH WATER. BUT INSIDE, A LIVELY MEET-
ING WAS IN PROGRESS, WITH DOZENS OF
WOMEN AND MEN FILLING EVERY CHAIR
OF A LARGE HALL. I GRAVITATED TO THE
FRONT OF THE ROOM, DRAWN BY THE
INTENSITY OF THE WOMAN WHOSE
IMPASSIONED SPEECH HELD THE CROWD'S
ATTENTION.

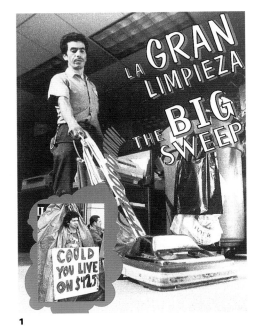

1

1
Title *The Big Sweep*
Design Firm *ReVerb, Los Angeles, CA*
Art Directors/Designers/Typographers *ReVerb*
Photographers *Stephen Callis, Leslie Ernst,*
Ruben Ortiz Torrez, and Sandra Ramirez
Copywriters *Stephen Callis and Leslie Ernst*
Clients *Stephen Callis, Leslie Ernst, Ruben Ortiz Torrez,*
and Sandra Ramirez
Printer *The Harman Press*
Paper *French Dur-o-tone Newsprint*

2
Title *GibbsBaronet Proposal Book*
Design Firm *GibbsBaronet, Dallas, TX*
Art Directors/Copywriters *Steve Gibbs*
and Willie Baronet
Designer *Steve Gibbs*
Client *GibbsBaronet*
Printer *Kwik Kopy*
Paper *Fox River Confetti, French Dur-o-Tone*

3
Title *Illustration Brochure*
Design Firm *High Design, Putnam Valley, NY*
Designer/Illustrator/Typographer *David High*
Riveter *Rusty*
Client *High Design*
Printer *Hewlett-Packard Laser Jet 4M 600 dpi*
Paper *Kaleidoskope Black 60# Text and Vellum*
for Laser Printer

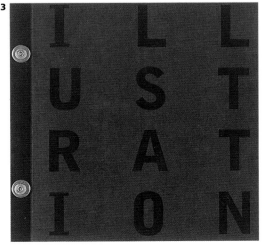

1

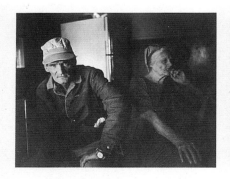

2

3

1

Title *North Carolina Literary Review (vol. I, nos. 1 and 2; vol. II, no. 1)*
Art Director *Eva Roberts*
Designers *Eva Roberts, Stanton Blakeslee, and Curt Wommack*
Cover Illustrators *Stanton Blakeslee (vol. I, no. 1), Catherine C. E. Walker (vol. I, no. 2), and Ray Elmore (vol. II, no. 1)*
Cover Photographer *Philip A. Burzynski (vol. I, no. 1)*
Publisher *East Carolina University English Department*
Typographer *Eva Roberts*
Printer *Morgan Printers*
Paper *Cross Pointe Torchglow Opaque Recycled Archival*

2

Title *VH-1 Honors Book*
Design Firm *Werner Design Werks, Minneapolis, MN*
Art Directors *Cheri Dorr and Sharon Werner*
Designer *Sharon Werner*
Client *VH-1/MTV Networks*
Typographer *Great Faces*
Printers *Diversified Graphics, Various Book Publishers*
Bindery *In a Bind*
Paper *Mohawk Vellum 70# Text*

3

Title *#2 Capital Letters*
Design Firm *The Post Press, Newark, DE*
Art Director/Designer/Typographer *Martha Carothers*
Copywriters *Beatrice Warde and Bradbury Thompson*
Publisher *The Post Press*
Printer *LaserWriter IIF*
Paper *Mohawk Superfine*

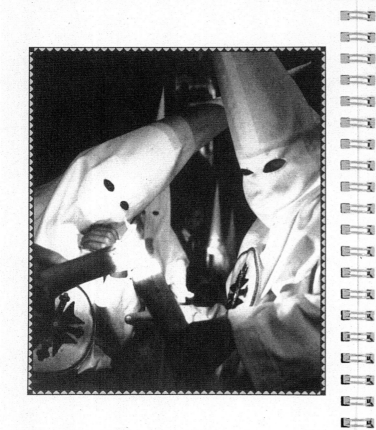

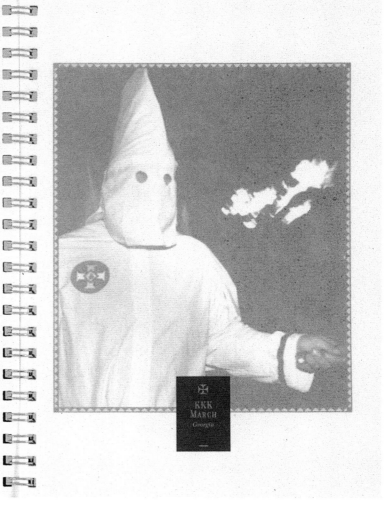

1

1
Title *"You Can't Say That!"*
Design Firm *Bernhardt Fudyma Design Group, New York, NY*
Art Directors *Craig Bernhardt, Janice Fudyma, and Iris A. Brown*
Designer *Iris A. Brown*
Photo Research *Natalie Goldstein, Inc.*
Photographers *Various*
Copywriter *Barry Bohrer*
Client *Gilbert Paper*
Printer *Tanagraphics, Inc.*
Paper *Gilbert Oxford 80# and 65# Cover and Gilbert Gilclear 17*

2
Title *"Spread Rumors" Brochure*
Design Firm *Johnson & Wolverton, Portland, OR*
Art Directors/Designers/Copywriters
Alicia Johnson and Hal Wolverton
Illustrator *Hal Wolverton*
Client *Amnesty International USA*
Printer *Irwin-Hodson Company*
Paper *Simpson Evergreen Matte*

3
Title *John Wong Promotion*
Design Firm *Peterson & Co., Dallas, TX*
Art Director/Designer/Copywriter *Bryan L. Peterson*
Photographer *John Wong*
Client *John Wong*
Printer *Hicks Printing*
Paper *Mohawk Superfine*

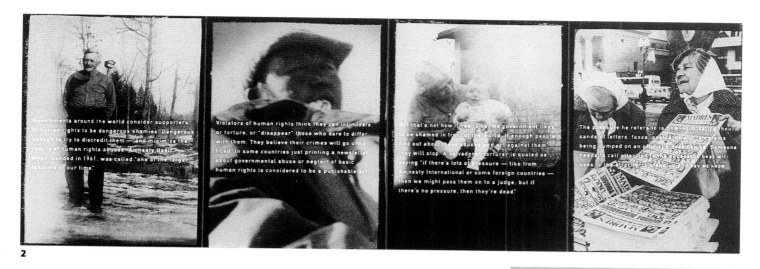

2

Governments around the world consider supporters of human rights to be dangerous enemies. Dangerous enough to try to discredit them — and minimize the reality of human rights abuses. Amnesty itself, when founded in 1961, was called "one of the larger lunacies of our time."

Violators of human rights think they can intimidate, or torture, or "disappear" those who dare to differ with them. They believe their crimes will go unnoticed. In some countries just printing a newsletter about governmental abuse or neglect of basic human rights is considered to be a punishable act

but that's not how it has to be. No government likes to be shamed in front of the world. If enough people find out about their abuses and act against them they will stop. A Salvadoran torturer is quoted as saying "if there's lots of pressure — like from Amnesty International or some foreign countries — then we might pass them on to a judge, but if there's no pressure, then they're dead."

The pressure he refers to is now intimidating thousands of letters, faxes, postcards and telegrams being dumped on an official's desk can do. Someone needs to call attention to injustice to bear witness to the abuses, to let them know WE KNOW

SPREAD "RUMORS"

3

1

2

3

4

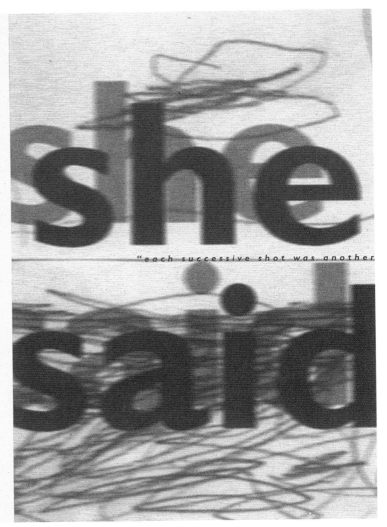

"each successive shot was another

1
Title *"Circular Reasoning"*
Design Firm *Steven McCarthy Design, Ft. Thomas, KY*
Designer *Steven McCarthy*
Illustrator *Alice McCarthy*
Printer *Sidney Printing Works*
Paper *Champion Benefit*

2
Title *"One Thousand Words" Brochure*
Design Firm *Segura Inc., Chicago, IL*
Art Director/Designer/Typographer *Carlos Segura*
Photographer *Geof Kern*
Client/Copywriter *John Cleland*
Printer *The Argus Press*
Paper *Mohawk Ultrafelt*

3
Title *The Matter of History: Selected Works by Annette Lemieux*
Design Firm *Plus Design Inc., Boston, MA*
Art Director/Designer *Anita Meyer*
Cover Designer *Annette Lemieux*
Photographers *Eric Shambroom and Ellen Page Wilson*
Client *Davis Museum and Cultural Center*
Typographer *Moveable Type Inc.*
Printer *Meridian Printing Company*
Paper *French Dur-o-tone Newsprint and Dur-o-tone Packing Gray Liner (cover)*

1

2

is each of them not just impor-
tant but essential? . . . *is every last
word* SHAPED, *cut, turned, ground,*
and POLISHED *so as to* EXPOSE *and*
CLARIFY, *with exacting tolerances,
the ideas the writing is intended to
impart to readers?* . . . but without
boring those readers?

Which leads to our second proposed
standard for evaluating scribo's work
product, reading theory.

3

1
Title *Keds Standards Manual*
Design Firm *Sametz Blackstone Associates, Boston MA*
Art Director/Designer/Copywriter *John Kane*
Photographer *Stuart Darsch*
Client *Keds Corporation*
Printer *Emco*
Paper *French Dur-o-tone and Mohawk Superfine*

2
Title *Your Benefits Program*
Design Firm *J.P. Morgan & Co. Inc., New York, NY*
Art Director *Gerben Hooykaas*
Designer *Tara Devereux*
Photographer *Susan Wides*
Client/Publisher *J.P. Morgan & Co. Inc.*
Typographer *Gretchen Geser*
Printer *Tanagraphics*
Binder *BOK Industries*
Paper *Mohawk Vellum Cover and Finch Casablanca Text*

3
Title *AIGA/NY "Money and Contracts"*
Design Firm *Wood Design, New York, NY*
Art Director *Tom Wood*
Designers *Tom Wood, Alyssa Weinstein, Nadine Hajjar,
Clare Ultimo, Mayda Freije, and Brynne Spohr*
Copywriter *Loring Leifer*
Client *AIGA/NY*
Paper Manufacturer *Gilbert Paper*

1

This

is the Keds logo—a blue rubber rectangle with the word 'Keds' embossed on it in a slightly condensed, rectilinear sans serif typeface. *Unlike most logos, the Keds mark exists as a real object.* It has specific, tactile, three-dimensional qualities that make it unique.

Of course, it's in the nature of our business and our products that we can't always use rubber—or blue, for that matter—when we want to say 'Keds'. So, on the next few pages, we'll show you the tools we've developed so that you can retain the essential, recognizable qualities of the Keds mark when you're working in other media.

KEDS STANDARDS • APRIL 1993

5

2

3

Title *"Little P in the Big O"*
Design Firm *Pentagram, New York, NY*
Designers *Paula Scher and Ron Louie*
Client *Oklahoma City and Tulsa Art Directors Clubs*
Typographer *Paula Scher*
Printer *Tulsa Litho*
Paper *Champion Benefit*

2

Title *The 33rd Southeast Regional Conference
Association for Asian Studies*
Design Firm *Seran Design, Harrisonburg, VA*
Art Director/Designer/Illustrator *Sang Yoon*
Client *Seran Design*
Printer/Typographer *Shenvalley Express*
Paper *Neenah Peppercorn 80# Text*

1

2

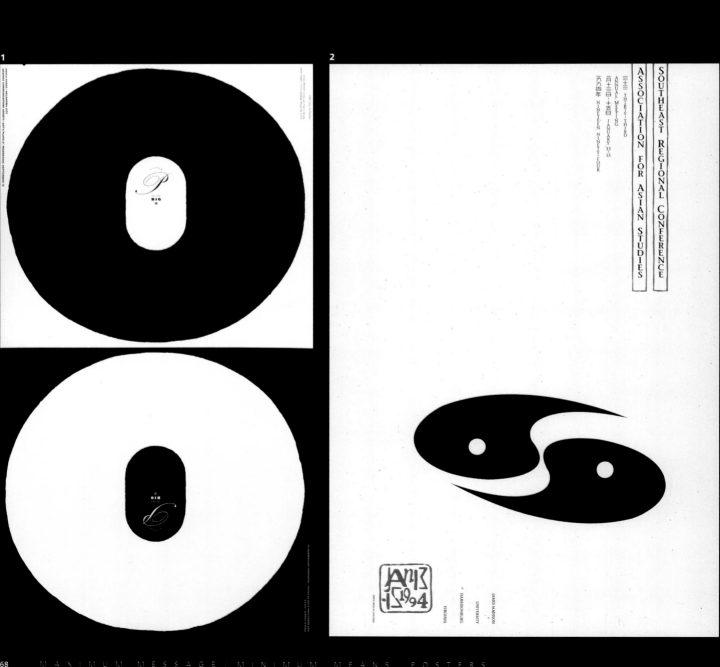

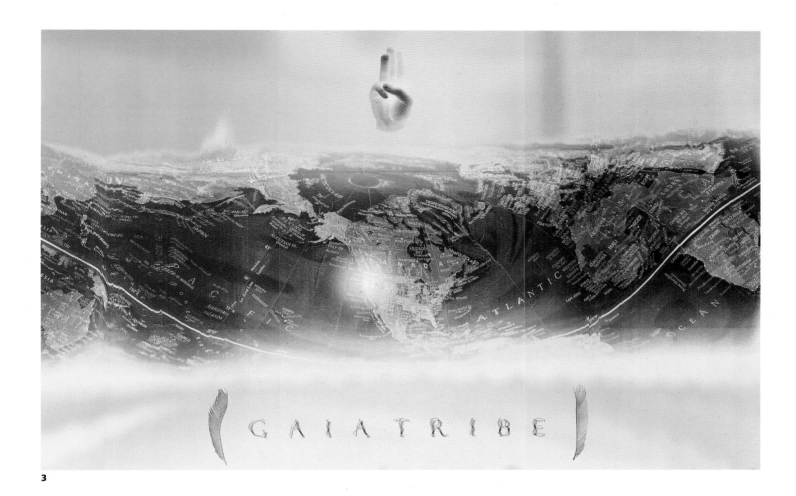

3

Title *GAIA Tribe Poster*
Design Firm *Johnson & Wolverton, Portland, OR*
Art Directors *Alicia Johnson and Hal Wolverton*
Designers *Hal Wolverton and Kat Saito*
Illustrator *Hal Wolverton*
Copywriter *Alicia Johnson*
Client *AIGA/Portland*
Printer *Bridgetown Printing*
Paper *French Dur-o-tone Newsprint*

4

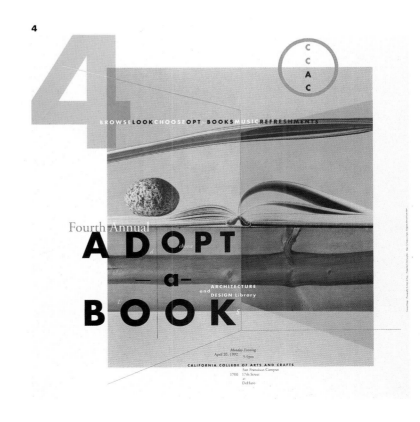

Title *1992 Adopt-a-Book Poster*
Design Firm *Tenazas Design, San Francisco, CA*
Art Director/Designer/Copywriter *Lucille Tenazas*
Photographer *Peter de Lory*
Client *California College of Arts & Crafts*
Printer *Color Graphics*
Paper *Simpson Evergreen 80# Almond Cover*

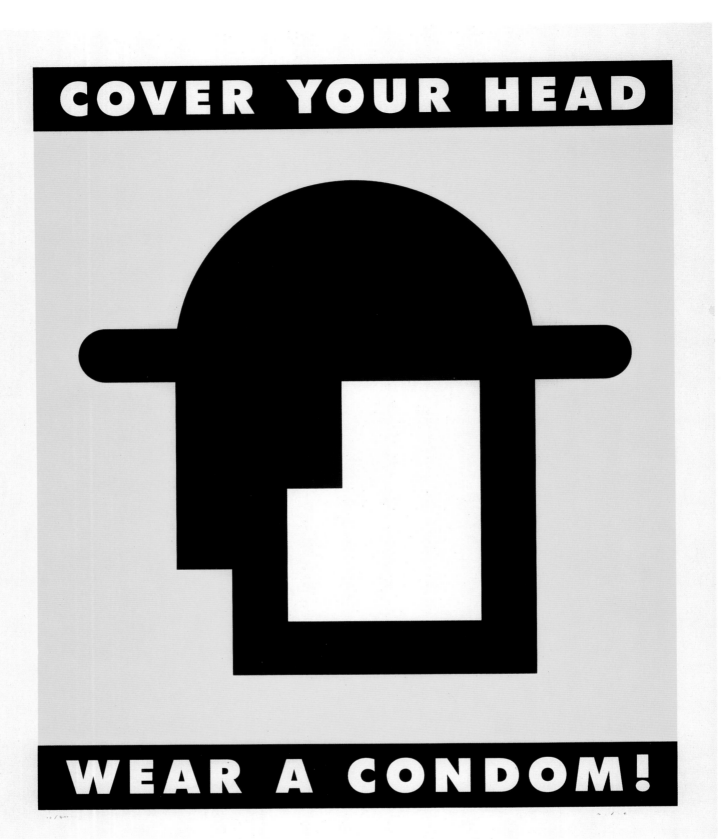

COVER YOUR HEAD

WEAR A CONDOM!

1

1
Title *"Wear a Condom!"*
Design Firm *BlackDog, San Rafael, CA*
Designer/Illustrator *Mark Fox*
Copywriter/Typographer *Mark Fox*
Client *ACT UP!/New York*
Printer *Wasserman Silk Screen Co.*
Paper *Rising Paper Mirage 100% Rag*

2

Title *Propaganda Faktory Condom Campaign*
Design Firm *Info Grafik, Honolulu, HI*
Art Director/Designer *Oren Schlieman*
Copywriter/Typographer *Oren Schlieman*
Photographer *Joe Solem*
Client *Propaganda Faktory*
Printer *11 x 17 Copier*

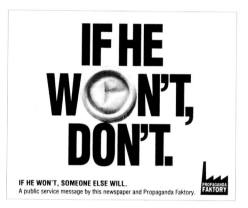

IF HE WON'T, SOMEONE ELSE WILL.
A public service message by this newspaper and Propaganda Faktory.

LOVE MEANS NEVER HAVING TO SAY YOU'RE SORRY.
A public service message by this newspaper and Propaganda Faktory.

WHY NOT USE A CONDOM AND ENJOY SAFER SEX?
A public service message by this newspaper and Propaganda Faktory.

WHY NOT WEAR A CONDOM? IT HELPS PREVENT AIDS.
A public service message by this newspaper and Propaganda Faktory.

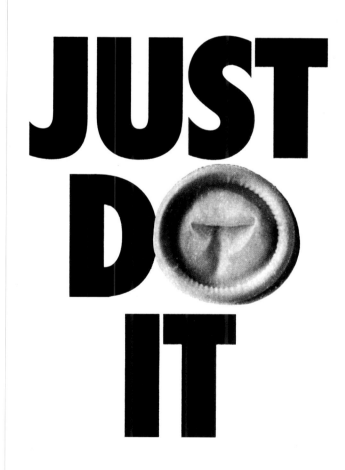

JUST WEAR A CONDOM AND HELP PREVENT AIDS.
A public service message by this newspaper and Propaganda Faktory.

1

Title *"Keely and Du" Poster*

Design Firm *Modern Dog, Seattle, WA*

Art Director/Designer/Illustrator *George Estrada*

Client *ACT Theatre*

Typographers *George Estrada and Robynne Raye*

Printer *Two Dimensions*

Hand Stenciling *Modern Dog*

Paper *Simpson Evergreen*

2

Title *Four-Part Promotional Poster*

Design Firm *Quinlivan/Werner, Minneapolis, MN*

Art Directors/Designers *Amy Quinlivan*
and Sharon Werner

Photographer *Michael Crousser*

Copywriter *Arnie Valentine*

Clients *Quinlivan/Werner, Great Faces Inc.,*
and Printcraft Inc.

Printer *Printcraft Inc.*

1

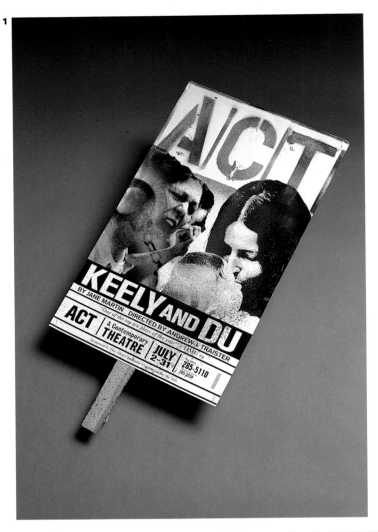

2

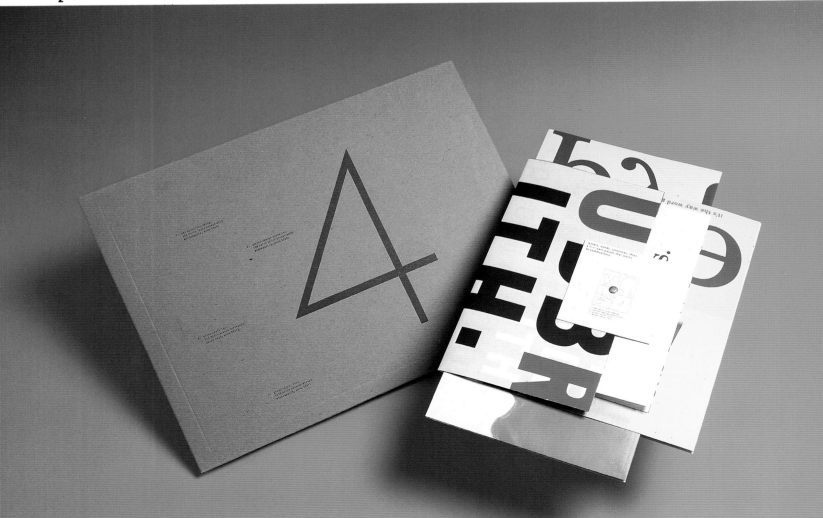

3
Title *Man's Best Friend*
Design Firm *Trudy Cole-Zielanski Design,*
Churchville, VA
Art Director/Designer *Trudy Cole-Zielanski*
Illustrator/Copywriter *Trudy Cole-Zielanski*

4
Title *Santa Clara County World AIDS Day Poster*
Design Firm *Joe Miller's Company, Santa Clara, CA*
Art Director/Designer *Joe Miller*
Photographer *Glenn Matsumura*
Copywriter/Typographer *Joe Miller*
Client *Santa Clara County World AIDS Day*
Committee
Printer *Great Impressions Plus and Shoreline Printing*
Paper *Potlatch Mountie Matte 65# Cover*

5
Title *"Peace"*
Design Firm *Ness Graphic Design, Oak Park, IL*
Designer/Photographer *Ness Feliciano*
Copywriter/Typographer *Ness Feliciano*
Printer *Torco*
Paper *Mohawk Satin Cool White 65# Cover*

3

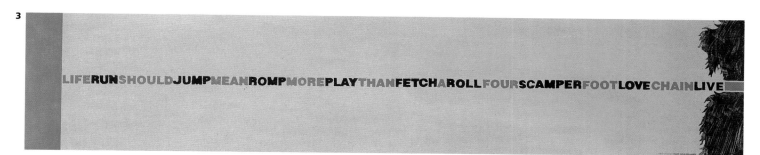

4

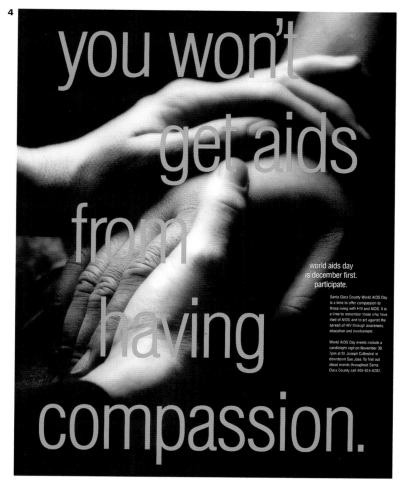

5

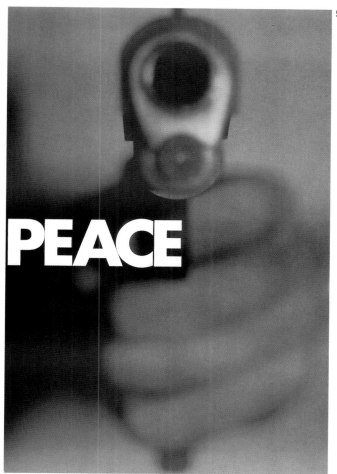

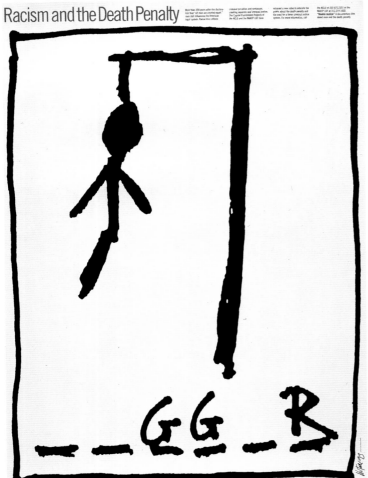

Racism and the Death Penalty

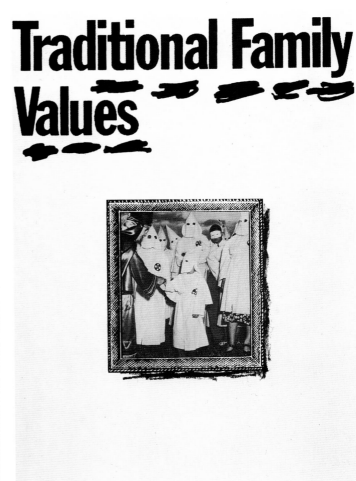

Traditional Family
Values

1

2

1
Title *"Double Justice" Poster*
Design Firm *Victore Design Works, New York, NY*
Art Director/Designer/Illustrator *James Victore*
Copywriter *Kica Matos*
Client *NAACP/ACLU*
Printer *Royal Offset*
Paper Manufacturer *Cougar*

2
Title *"Traditional Family Values" Poster*
Design Firm *Post No Bills, New York, NY*
Designers *Steven Brower, John Gall, Leah Lococo,*
Morris Taub, James Victore, and Susan Walsh
Publisher *Post No Bills*
Printer *Royal Offset*
Paper *Cougar White Uncoated*

3
Title *"Baby Bottle" Poster*
Design Firm *Post No Bills, New York, NY*
Designers/Copywriters *Steven Brower, John Gall,*
Leah Lococo, Morris Taub, James Victore, and Susan Walsh
Photographer *Steven Brower*
Publisher *Post No Bills*
Printer *Royal Offset*
Paper *Cougar White Uncoated*

ENERGY SOURCE
EDUCATION COUNCIL

PRODUCED BY ARCO · DESIGN: DAVID MELLIN DESIGN, SANTA MONICA CA · PHOTOGRAPHY: D'LIN JONES · PAPER: MOHAWK® DULCET SMOOTH TEXT, BASIS 100

BEHAVIOR

KNOWLEDGE

ENERGY SOURCE EDUCATION COUNCIL

CHANGING AMERICA'S ENERGY HABITS

1
Title *"Knowledge/Behavior" Poster*
Design Firm *David Mellen Design, Santa Monica, CA*
Designer *David Mellen*
Photographer *O. Tim Jones*
Client *Educational Development Specialists*
Printer *Wasserman Silkscreen*
Paper *Monadnock Dulcet Smooth Text, Basis 100*

2
Title *"One Tit, A Dyke, and Gin" Poster*
Design Firm *Fahrenheit, Boston, MA*
Art Directors/Designers/Typographers
Paul Montie and Caroline Montie
Illustrator *Paul Montie*
Client *Nora Theatre Company*
Printer *Aldus Press*
Paper *UK Paper Consort Royal Silk Tint*

3
Title *AIGA T-Shirt Contest Poster*
Design Firm *Charles S. Anderson Design Company, Minneapolis, MN*
Art Director *Charles S. Anderson*
Designers *Charles S. Anderson and Todd Piper-Hauswirth*
Illustrators *Various*
Copywriter *Lisa Pemrick*
Client *AIGA/New York*
Printer *Print Craft, Inc.*
Paper *French Butcher Off-White 80# Cover*

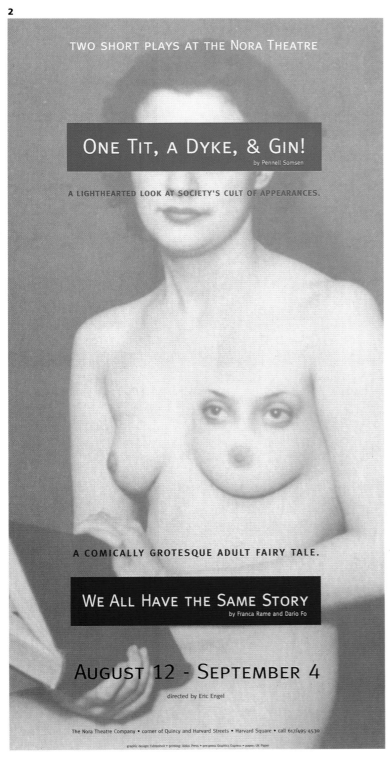

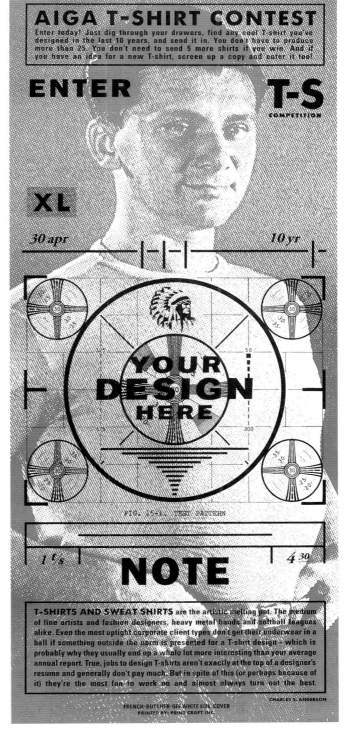

1

TRICKY OLLIE

1

Title "Tricky Ollie"

Design Firm BlackDog, San Rafael, CA

Designer/Collage Artist Mark Fox

Copywriter/Typographer Mark Fox

Client The People of the Commonwealth of Virginia

Printer Xerox

2

Title "The Power Laugh"

Art Director Mirko Ilic

Designer Corinne Myller

Illustrator Ruth Marten

Client/Publisher The New York Times

3

Title "The A.D.L. Under Fire"

Art Director Mirko Ilic

Designer Sam Reep

Client/Publisher The New York Times

4

Title Bush Poster

Design Firm Post No Bills, New York, NY

Designers Steven Brower, John Gall, Leah Lococo, Morris Taub, James Victore, and Susan Walsh

Publisher Post No Bills

Printer Royal Offset

Paper Cougar White Uncoated

hmmm...

POST NO BILLS ©1992

BUSH/QUAYLE'92

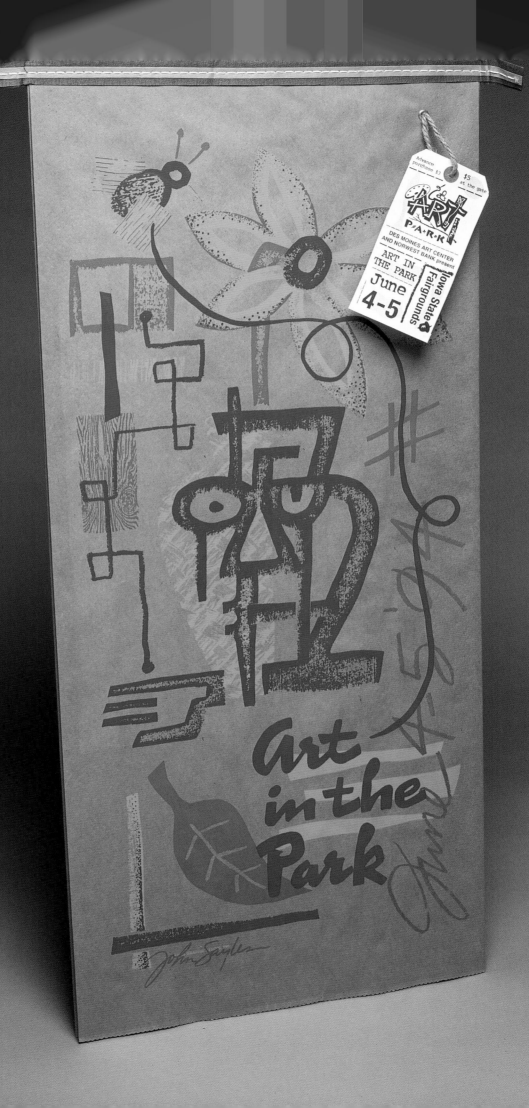

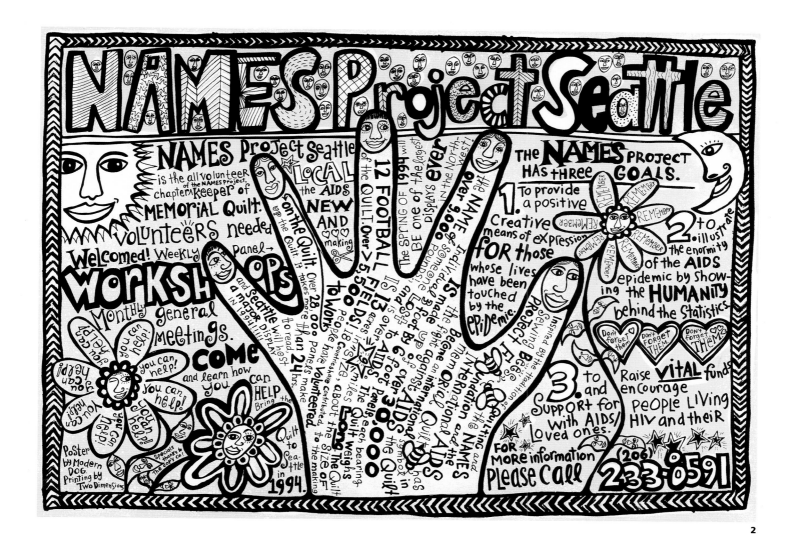

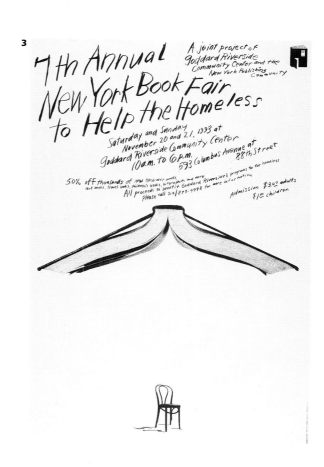

1

Title *"Art in the Park '94"*

Design Firm *Sayles Graphic Design, Des Moines, IA*

Art Director/Designer *John Sayles*

Illustrator/Typographer *John Sayles*

Client *Des Moines Art Center*

Printer *Image Maker*

Paper *Kraft Paper Feed Sacks*

2

Title *Seattle NAMES Project*

Design Firm *Modern Dog, Seattle, WA*

Art Directors *Robynne Raye and Dan Ripley*

Designer/Illustrator/Typographer *Robynne Raye*

Copywriters *Robynne Raye and Dan Ripley*

Client *NAMES Project, Seattle Chapter*

Printer *Two Dimensions*

3

Title *Book Fair to Help the Homeless*

Design Firm *Pentagram, New York, NY*

Designer *Michael Bierut*

Photographer *Reven T.C. Wurman*

Client *Goddard Riverside Community Center*

Printer *Ambassador Arts*

1

2

1

Title *"The Next Generation: Student Work from the United States, 1990"*
Design Firm *Tenazas Design, San Francisco, CA*
Art Director/Designer *Lucille Tenazas*
Photographer *Richard Barnes*
Client *Art and Architecture Exhibition Space*
Typographer *Eurotype*
Printer *Forman Leibrock*
Paper *Simpson Starwhite Vicksburg*

2

Title *"The Next Generation: Student Work from the United States, 1993"*
Design Firm *Tenazas Design, San Francisco, CA*
Art Director *Lucille Tenazas*
Designers *Lucille Tenazas and Todd Foreman*
Photographer *Richard Barnes*
Copywriters *Dan Pitera and Doug Thornley*
Client *Center for Critical Architecture*
Printer *Singer Printing*
Paper *Simpson Starwhite Vicksburg*

3

Title *"Last Dance"*
Art Director/Designer *Gail Swanlund*
Client *Cal Arts Dance School*
Printer *Gail Swanlund*
Paper *Diazo Blueprint*

LAST SCHOOL
DANCE OF DANCE
CONCERT

6 PM MAY 12—13
THEATRE 2 1993
FREE

CALIFORNIA
INSTITUTE OF THE ARTS
24700 MCBEAN PARKWAY, VALENCIA, CA 91355

2

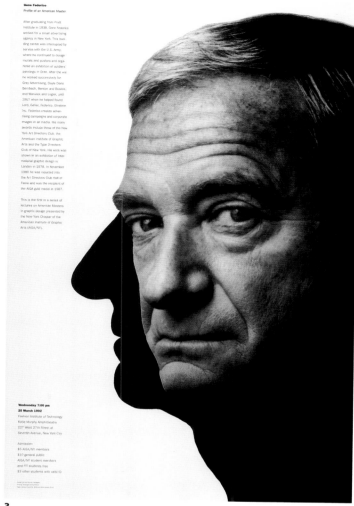

3

1
Title *Seattle Repertory Theatre 1993–94 Season Poster*
Design Firm *Modern Dog, Seattle, WA*
Art Director *Michael Strassburger*
Designers *Michael Strassburger and Robynne Raye*
Client *Seattle Repertory Theatre*
Typographer *Robynne Raye*
Printer *Two Dimensions*
Paper *Generic Butcher Paper*

2
Title *"Romeo & Juliet"*
Design Firm *Sommese Design, State College, PA*
Art Director/Designer/Illustrator *Lanny Sommese*
Client *Penn State University*
Printer *Graphic Design Practicomm*
Paper *French Speckletone White 80# Cover*

3
Title *"The Substance of Fire" Poster*
Design Firm *Modern Dog, Seattle, WA*
Art Directors *Robynne Raye and Douglas Hughes*
Designer/Typographer *Robynne Raye*
Client *Seattle Repertory Theatre*
Printer *The Copy Co.*
Paper *Simpson Evergreen*

1

SEATTLE
REP
1993/94 SEASON
· MAINSTAGE ·
IX DEGREES OF SEPARATION
HARVEY
OLEANNA
ERICLES, PRINCE OF TYRE
FLAW IN THE OINTMENT
OLIDAY HEART
· STAGE 2 ·
ORTHEAST LOCAL
LOVE, LANGSTON
LENCE, CUNNING, EXILE
143-2222

2

SHAKESPEARE SERIES, PAVILION THEATRE, JUNE 4 & 5, 8 PM.

SEATTLE REPERTORY THEATRE PRESENTS

THE
SUBSTANCE
OF FIRE

BY JON ROBIN BAITZ

OCTOBER 28 - NOVEMBER 15
ON STAGE 2 • TICKETS 443.2222

Poster by Modern Dog. Printed on recycled paper by The Copy Co.

1

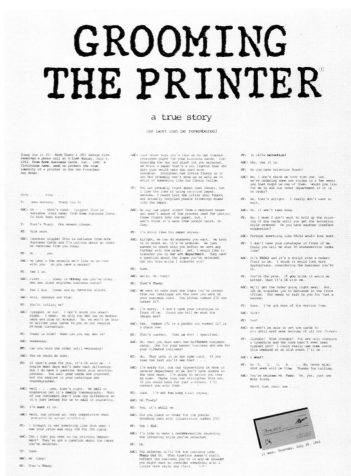

2

1
Title *"P"*
Design Firm *Pentagram, New York, NY*
Designer/Typographer *Paula Scher*
Client *Ambassador Arts*
Type *Telephone Book*
Printer *Ambassador Arts*
Paper *Champion Pageantry*

2
Title *Grooming the Printer*
Design Firm *Tharp Did It, Los Gatos, CA*
Art Director *Rick Tharp*
Designers *Rick Tharp and Colleen Sullivan*
Client *Tharp Did It*
Typographer *Smith & Corona*
Printer *Paradise Screen Printing*
Paper *Simpson Evergreen*

3
Title *"The North and the South*
(Is It the Rights Beer Now?)"
Design Firm *ATW Communications Group, Inc.,*
New York, NY
Art Director/Designer/Copywriter *Michael Lebrón*
Illustrator *Warren Chau*
Photographer *Jim Douglass*
Publisher *ATW Communications Group, Inc.*
Typographer *Mada Design*
Electronic Assembly *Tony Reinemann,*
Tartaro Slavin Inc.
Printer *Duggal Color*

3

4
Title *Human Rights Abuse Poster*
Design Firm *Johnson & Wolverton, Portland, OR*
Art Directors *Alicia Johnson and Hal Wolverton*
Designers *Hal Wolverton, Adam McIssac,*
and Kat Saito
Photographer *Rafael Astorga*
Copywriter *Alicia Johnson*
Client *Amnesty International USA*
Printer *Irwin-Hodson Company*
Paper *Simpson Evergreen Matte*

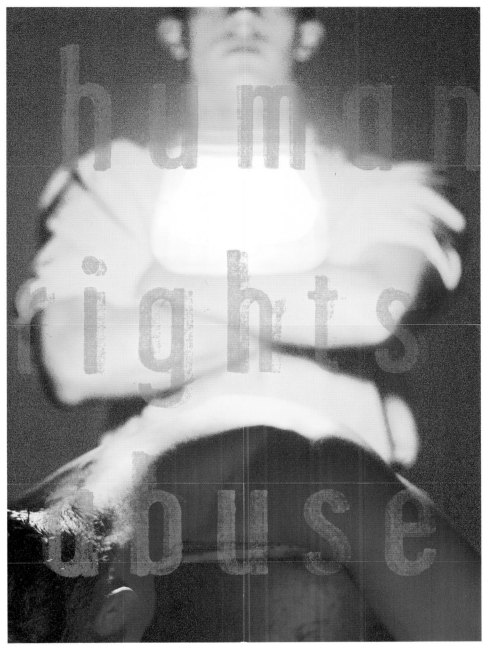

4

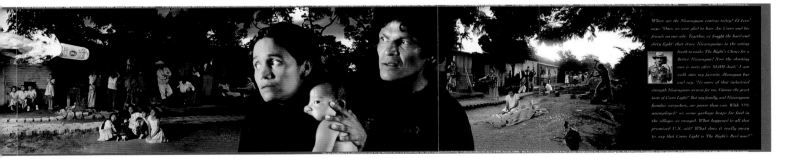

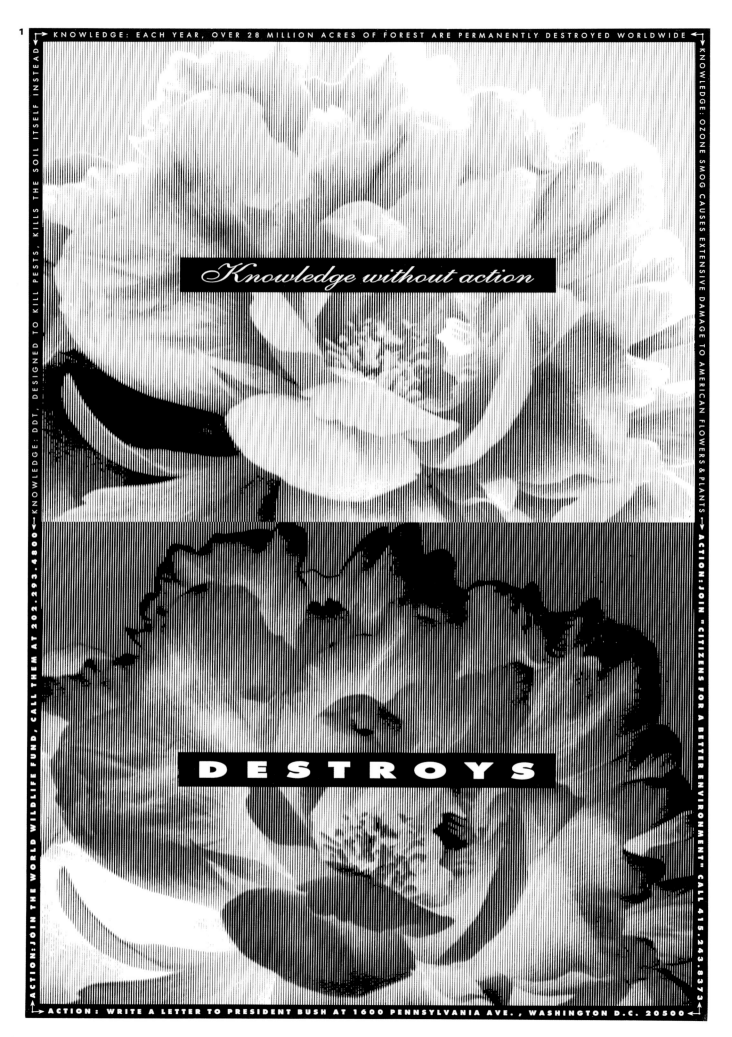

Knowledge without action

DESTROYS

1
Title *AIGA Environmental Awareness Poster*
Design Firm *Morla Design, San Francisco, CA*
Art Director *Jennifer Morla*
Designers *Jennifer Morla and Jeanette Aramburu*
Copywriter *Jeanette Aramburu*
Client *AIGA/San Francisco*
Printer *Ford Graphics*
Paper *Xerox Bond*

2
Title *"Save Our City"*
Design Firm *Pentagram, New York, NY*
Designer *Michael Bierut*
Client *Designing New York Committee*
Typographer *Typogram*
Printer *Ambassador Arts*

3
Title *"Save San Francisco Bay" Poster*
Design Firm *Akagi Remington Design, San Francisco, CA*
Art Director *Doug Akagi*
Designers *Doug Akagi and Kimberly Lentz Powell*
Illustrator *Hiroshi Akagi*
Copywriter *William T. Davoren*
Client *AIGA/San Francisco*
Printer *Hero Silkscreening*
Paper *Newsprint*

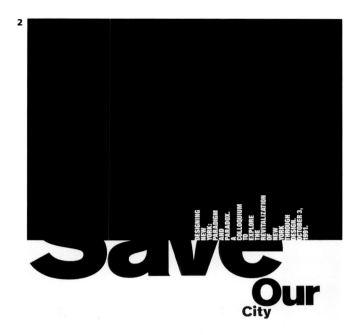

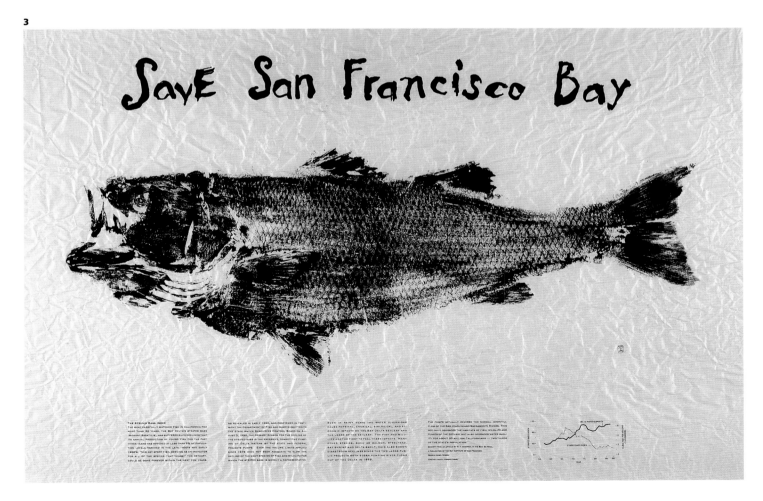

1
Title *Plus Design Inc. 1994 Gift*
Design Firm *Plus Design Inc., Boston, MA*
Art Directors/Designers *Anita Meyer, Karin Fickett, Matthew Monk, Dina Zaccagnini, and Jan Baker*
Client *Plus Design Inc.*
Letterer *Jan Baker*
Silkscreener *Arabesque Studio Ltd.*
Paper *Reused Printers' Press and Makeready Sheets (Pad), French Dur-o-tone Construction Gold (Tag), and Kraft Paper (Packaging)*

2
Title *"Common Cents" Coin Gift*
Design Firm *Ultimo Inc., New York, NY*
Art Director/Copywriter *Clare Ultimo*
Designers *Clare Ultimo and Joanne Obarowski*
Clients *Ultimo Inc. and Common Cents New York*
Printer *Cortleigh Press*
Die Cutter *Friedman Die Cutters*
Paper *Sorg Natural Astroparch*

1

2

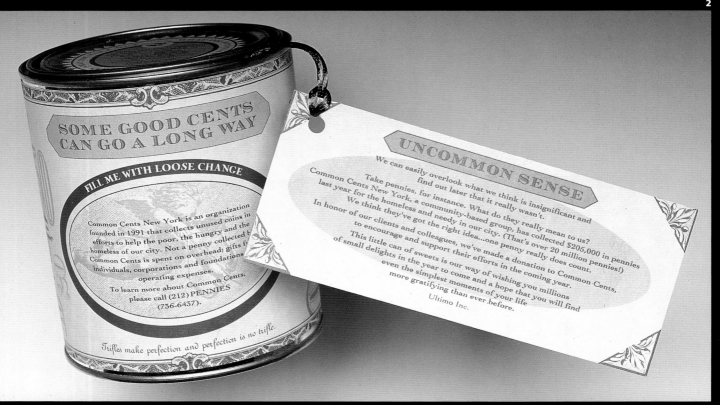

3

3
Title *Deluxe Designer Packaging Kit*
Design Firm *North American Packaging, New York, NY*
Art Director/Copywriter *John DeStefano*
Designers *John DeStefano and Walter Quick, Jr.*
Printer *Mystic*
Paper *Unbleached Natural Kraft UV Ultra 36#*

1

1
Title *Donovan and Green Moving Announcement*
Design Firm *Donovan and Green, New York, NY*
Art Directors *Michael Donovan and Nancye Green*
Designer/Typographer *Vanessa Ryan*
Photographer *Austin Hughes*
Copywriters *Various*
Client *Donovan and Green*
Printer *C.G.S. Inc.*
Paper *Monadnock Revue Smooth and
Champion Benefit Groove*

2
Title *Autumn Clothes Mailer*
Design Firm *Elixir Design Co., San Francisco, CA*
Art Director/Designer/Typographer *Jennifer Jerde*
Copywriter *William Carlos Williams*
Client *A Red Wheelbarrow*
Letterpress Printer *Julie Holcomb Printing*
Paper *Chipboard*

2

3

3
Title *L.U.L.A.C. Head Start Invitation*
Design Firm *Greaney Design, Baltimore, MD*
Art Director/Designer *Gerry Greaney*
Illustrators *Various Schoolchildren*
Client *L.U.L.A.C. Head Start*
Printer *Sirocco*
Paper *Chipboard*

4
Title *Alcan Architecture 1992*
Design Firm *Plus Design Inc., Boston, MA*
Art Director *Anita Meyer*
Designers *Anita Meyer, Matthew Monk,
and Jan Baker*
Client *Alcan Aluminum Ltd.*
Typographers *Anita Meyer, Matthew Monk, and
Nicole Juen (using antique typewriters and stencils)*
Printers *Silkscreen Arabesque Studio Ltd.(Poster),
Alpha Press (Tag Offset Overprint), and Daniels
Printing Company (Poster Assembly)*
Paper *Cardboard (Poster) and Recycled Alcan
Posters (Tag)*

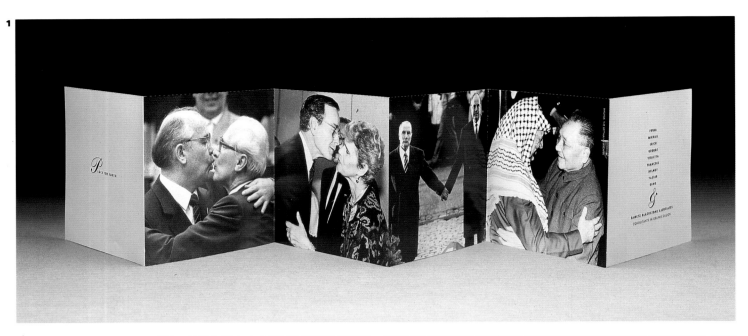

1

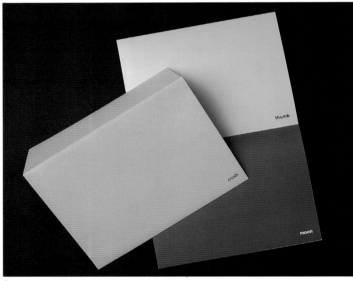

2

1
Title *Sametz Blackstone Associates Holiday Card*
Design Firm *Sametz Blackstone Associates, Boston, MA*
Art Director/Copywriter *John Kane*
Designer *David Horton*
Photographer *The Bettmann Archive*
Client *Sametz Blackstone Associates*
Printer *Reynolds DeWalt Printing, Inc.*
Paper *Warren Lustro Gloss*

2
Title *White Christmas Card*
Design Firm *Studio A, Alexandria, VA*
Art Director *Antonio Alcalá*
Designers *Antonio Alcalá, David Wiseman,*
and John Jackson
Publisher *Studio A*
Printer *Virginia Lithograph*
Paper *Karma*

3

Title *Hannah McCue's Birth Announcement*
Design Firm *GibbsBaronet, Dallas, TX*
Art Directors *Willie Baronet and Steve Gibbs*
Designers *Willie Baronet and Meta Newhouse*
Illustrator/Copywriter/Typographer *Willie Baronet*
Client *Wolford and Cheryl McCue*
Printer *Monarch Press*
Paper *Simpson Evergreen, Autumn Leaves*

4

Title *Parker Samata Birth Announcement*
Design Firm *Samata Associates, Dundee, IL*
Art Director *Pat Samata*
Designers/Copywriters *Pat Samata and Greg Samata*
Illustrator/Typographer *K.C. Yoon*
Photographer *Marc Norberg*
Client *Samata Associates*
Printer *Great Northern Design*
Paper *Champion Benefit, Consolidated, Reflections (Inserts), Letramax Super Black Presentation Mounting Board*

3

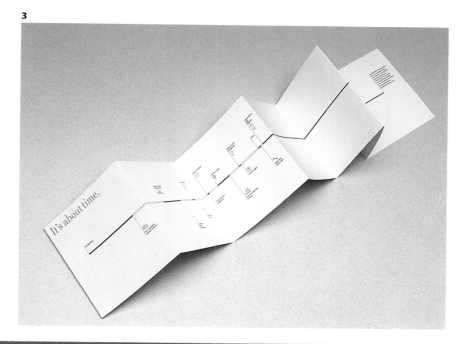

4

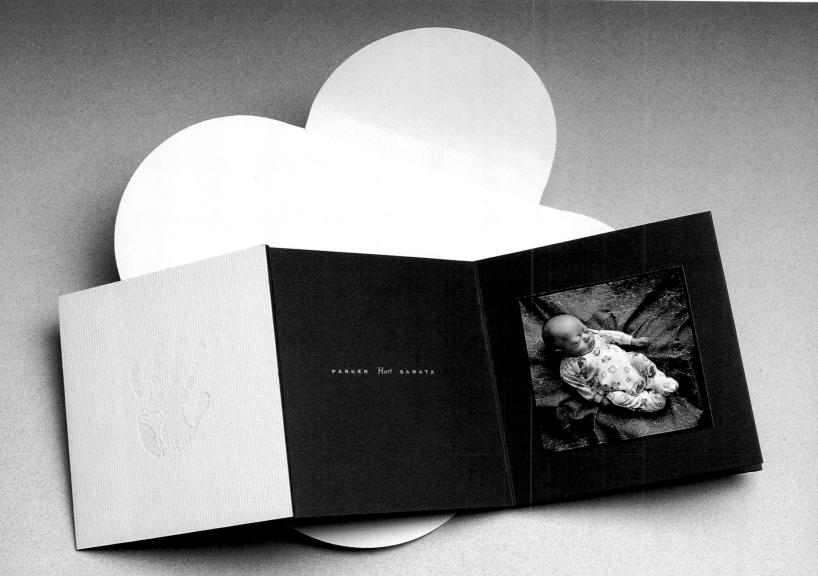

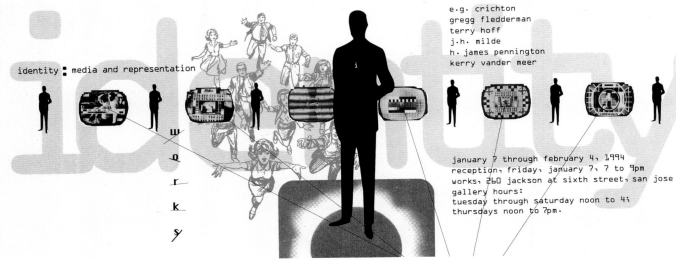

identity : media and representation

e.g. crichton
gregg fledderman
terry hoff
j.h. milde
h. james pennington
kerry vander meer

january 7 through february 4, 1994
reception, friday, january 7, 7 to 9pm
works, 260 jackson at sixth street, san jose
gallery hours:
tuesday through saturday noon to 4;
thursdays noon to 7pm.

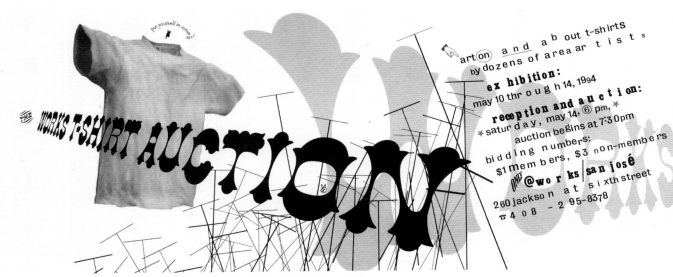

put yourself in some art!

THE WORKS T-SHIRT AUCTION

art on and about t-shirts
by dozens of area artists

ex hibition:
may 10 through 14, 1994

reception and auction:
saturday, may 14, 6 pm,
auction begins at 7:30pm
bidding numbers:
$1 members, $3 non-members
ONLY @works/san josé
260 jackson at sixth street
☎ 408 - 2 95-8378

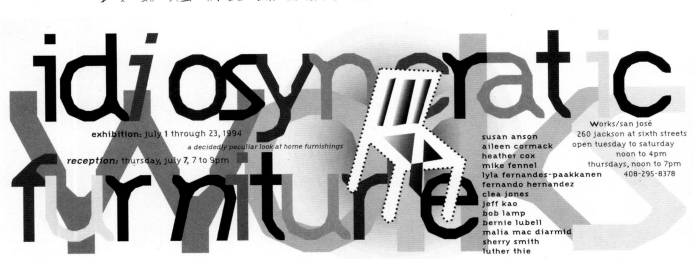

idiosyncratic furniture

exhibition: july 1 through 23, 1994

a decidedly peculiar look at home furnishings

reception: thursday, july 7, 7 to 9pm

susan anson
aileen cormack
heather cox
mike fennel
lyla fernandes-paakkanen
fernando hernandez
clea jones
jeff kao
bob lamp
bernie lubell
malia mac diarmid
sherry smith
luther thie

Works/san josé
260 jackson at sixth streets
open tuesday to saturday
noon to 4pm
thursdays, noon to 7pm
408-295-8378

1

Title *1994 Exhibition Postcards*
Design Firm *Joe Miller's Company, Santa Clara, CA*
Designer/Illustrator/Typographer *Joe Miller*
Photographers *Joe Miller, Eadweard Muybridge*
Client *Works/San José*
Printer *Design Print*
Paper *Wausau Exact Index, 140#*

women and the body
march 31 through
april 30, 1994
an exhibition juried by
new york artist kiki smith
opening reception:
thursday, march 31,
7 to 9pm at WORKs
260 jackson at sixth st.
san josé, 408-295-8378

ARTISTS INCLUDE:

jeanne basart
magi bollock
patricia j. brown
beth cameron-edwards
lorraine capparell
mimi chen ting
nancie crowley
starr davis
kathryn dunlevie
kalani engles
marjorie faris
sonia r. figueiredo
helen golden
monroe hodder
jackie kansky
patricia keefe
sandra khoury
ellen kieffer
karen laudon
marjorie law
sydell lewis

jean pell morton
kenna moser
betty o'hare
demetra paras
lynn pollock marsh
leah raim
jeannine redon
bettye roberts
roberta roth-patterson
chris sager
willy scholten
keesyk schwarz
pat sherwood
lois stuart
nancy tector
johanna tesauro
marta thoma
shelly thorene
deborah trilling
val valandani
wanda waldera
mary warshaw

dancing on the continuum:
a survey of bay area contemporary sculpture

exhibition: august 2 through 27, 1994
public reception: friday august 5, 7 to 9pm

works/san jose
260 jackson at sixth street
open tuesday to saturday
noon to 4pm
thursdays, noon to 7pm
408-295-8378

carolyn angleton
tor archer
jerry ross barrish
lynn beldner
tracey cockrell
prentiss cole
john ferdico
steven firestone
shelley gardner
steve gillman
allyson levy
jann nunn
peter b. olsen
ed osborn
mary parisi
walter robinson
dianne romaine
wang po shu
donna l. shumacher
teresa smith
tina wolfe

1
Title *Moto Announcement, 1994*
Design Firm *Tenazas Design, San Francisco, CA*
Art Director *Lucille Tenazas*
Designer *Todd Foreman*
Copywriters *Daniell Hebert and Gregor Berkowitz*
Client *Moto Development Group*
Printer *Expressions Lithography*
Paper *Simpson Starwhite Vicksburg*

2
Title *Moving Announcement*
Design Firm *After Hours Creative, Phoenix, AZ*
Art Director/Copywriter *Russ Haan*
Designer *Brad Smith*
Client *After Hours Creative*
Typographer *Arizona Die and Rubber Stamp*
Paper *Reused Moving Boxes*

3
Title *Haagen Seminar Invitation*
Design Firm *Puccinelli Design, Santa Barbara, CA*
Art Director/Illustrator/Copywriter
Keith Puccinelli
Designers *Keith Puccinelli and Heidi Palladino*
Client/Printer *Haagen Printing*
Paper *Potlatch Karma Dull White 80# Cover*

4
Title *"PG"*
Design Firm *Ness Graphic Design, Oak Park, IL*
Designer/Copywriter/Typographer *Ness Feliciano*
Printer *DiCianni Graphics*
Paper Manufacturer *Novelty*
Paper *White Offset 60# Uncoated*

2

3

4

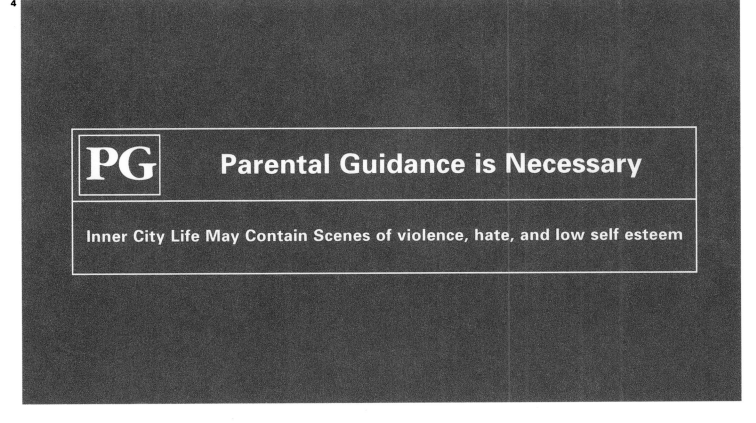

Title *Out of Hand Stationery*
Design Firm *Haley Johnson Design, Minneapolis, MN*
Designer/Illustrator/Typographer *Haley Johnson*
Client *Diane Hands, Out of Hand Tileworks*
Paper *Beveridge Railroad Board, Western Sulphite #9
Stock Envelopes, Gilbert Esse 80# text*

2
Title *Joanie Bernstein, Artist Representative*
Design Firm *Werner Design Werks, Inc.,
Minneapolis, MN*
Designer *Sharon Werner*
Illustrators *Sharon Werner and Lynn Schulte*
Client *Joanie Bernstein*
Typographer *Great Faces, Sharon Werner*
Printers *Printcraft Inc. and Torgerson Printing*
Paper *Mill-End Industrial Paper and
Scott Manila Tag*

3
Title *ACME Rubber Stamp Company*
Design Firm *Peterson & Company, Dallas, TX*
Art Directors *Bryan L. Peterson and Dave Eliason*
Designer *Dave Eliason*
Client *ACME Rubber Stamp Co.*
Printer *Monarch Press*
Paper *French Dur-o-tone Butcher*

1

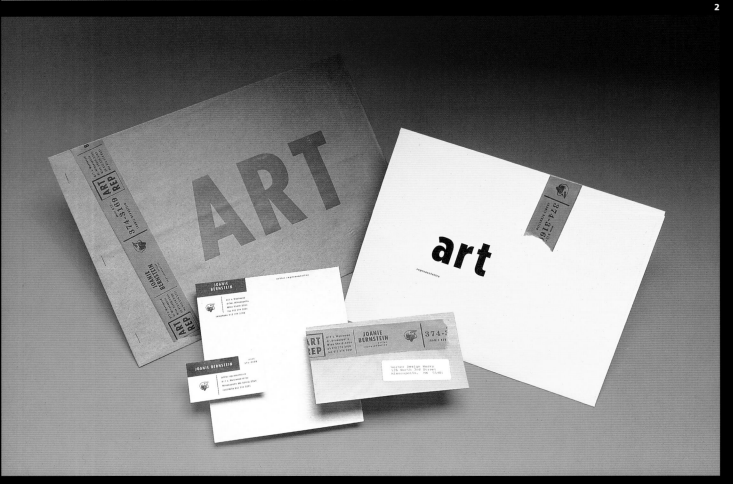

2

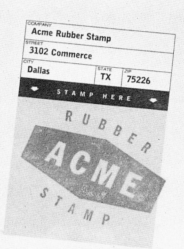

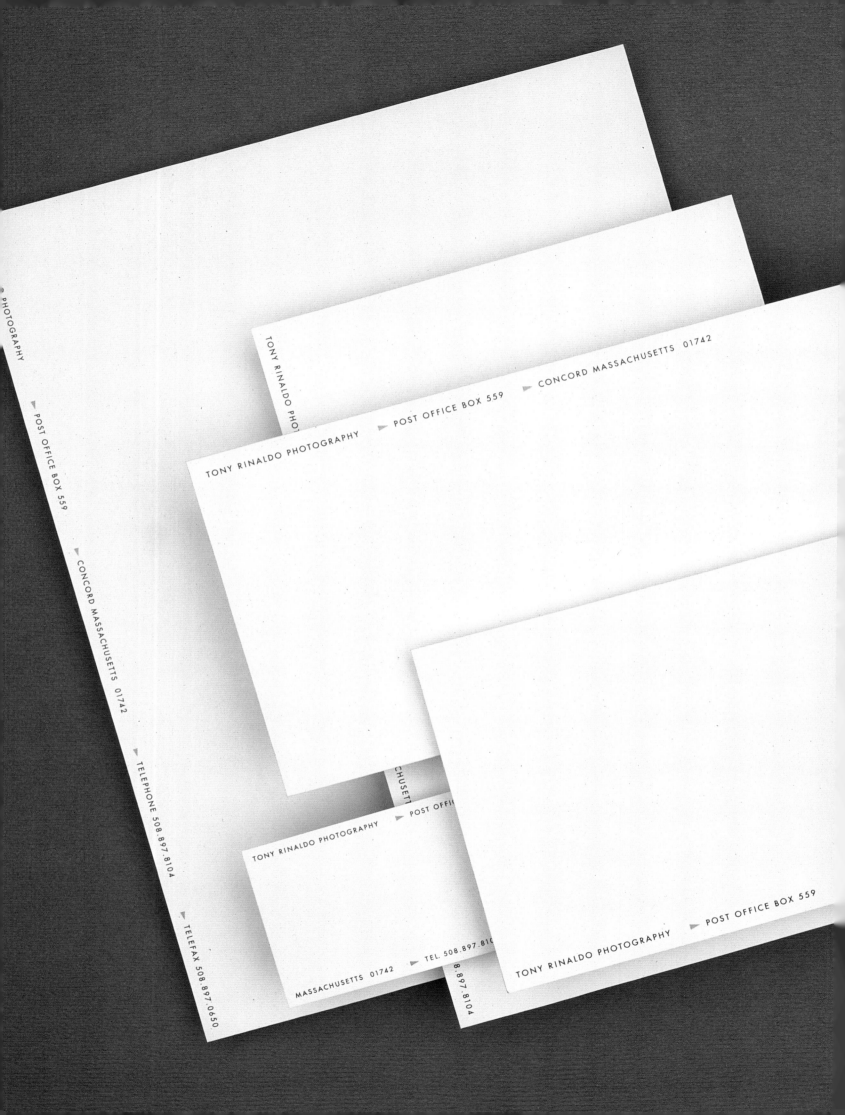

2

1
Title *Tony Rinaldo Photography Stationery*
Design Firm *Plus Design Inc., Boston, MA*
Art Director/Designer *Karin Fickett*
Client *Tony Rinaldo Photography*
Typographer *Monotype Composition Co.*
Printer *Alpha Press*
Paper *Monadnock Astrolite Smooth #80 Text*

2
Title *French Paper Company Stationery*
Design Firm *Charles S. Anderson Design Company,*
Minneapolis, MN
Art Director *Charles S. Anderson*
Designers *Charles S. Anderson and Todd Piper-Hauswirth*
Illustrator *CSA Archive*
Photographer *Darrell Eager*
Copywriter *Lisa Pemrick*
Client *French Paper Company*
Printer *Lunalux*
Paper *French Dur-o-Tone*

3
Title *Bewear Clothing Co. Logo*
Design Firm *BlackDog, San Rafael, CA*
Designer/Illustrator *Mark Fox*
Client *Bewear Clothing Co.*

™

3

Maximum Message/Minimum Means *Exhibition Graphics*

Title *"Entombed and Up For Sale"*
Design Firm *Graphic Design Program, University of Hawaii at Manoa, Honolulu, HI*
Art Directors/Designers *Anne Bush and Stuart McKee*
Copywriter *Robert Harbison*
Client *Art Department, University of Hawaii at Manoa*
Production/Installation *Anne Bush, Stuart McKee, and Typography Students, University of Hawaii at Manoa*

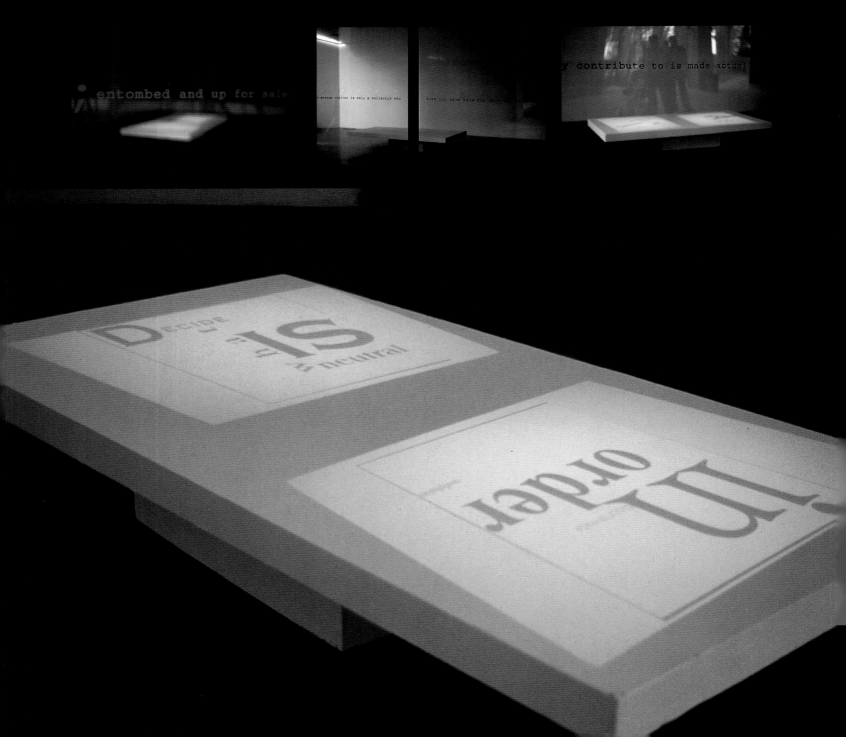

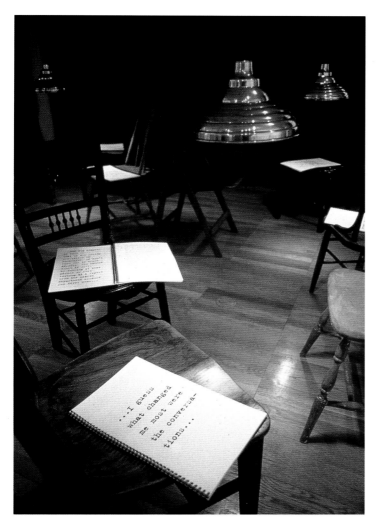

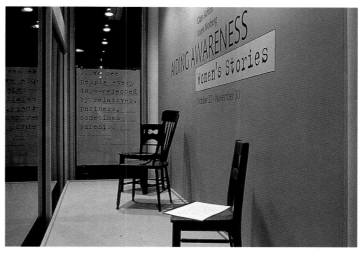

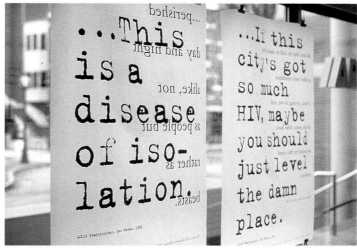

...This
is a
disease
of iso-
lation.

...If this
city's got
so much
HIV, maybe
you should
just level
the damn
place.

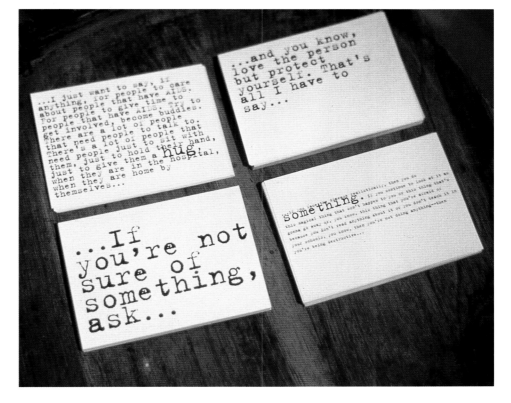

...I just want to say, if
anything, for people to care
about people that have AIDS.
For people to give time to
people that have AIDS. Try to
get involved, become buddies.
There are a lot of people
that need people to talk to.
There's a lot of people that
need people just to sit with
them, just to hold their hand,
just to give them a hug
when they are in the hospital,
when they are home by
themselves...

...and you know,
love the person
but protect
yourself. That's
all I have to
say...

...If
you're not
sure of
something,
ask...

...something.

Title *Aiding Awareness: Women's Stories*
Design Firm *Class Action, New Haven, CT*
Art Directors/Designers/Copywriters *Class Action*
Client *Artspace*

Title *"Good Diner"*
Design Firm *Pentagram, New York, NY*
Architect *James Biber*
Architect Assistant *Michael Zweck-Bronner*
Designers *Michael Bierut and Lisa Cerveny*
Illustrator *Woody Pirtle*
Photographer *Reven T.C. Wurman*
Client *Gotham Equities*

 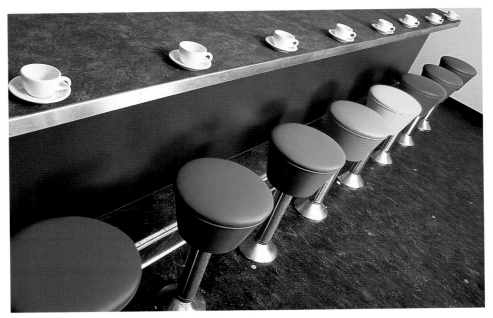

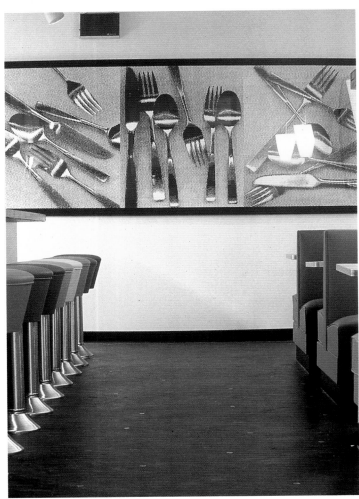

E GOOD DINER

THE
GOOD
DINER
BREAKFAST LUNCH
DINNER
TAKE-OUT
FREE DELIVERY
967-2661

Title *Hansen Design Company Lobby Signage*
Design Firm *Hansen Design Co., Seattle, WA*
Art Director *Pat Hansen*
Designers *Pat Hansen and Jeff Berend*
Client *Hansen Design Company*
Hand-Cut Paper Lettering *Jeff Berend*
Fabricator *Commercial Displayers*

Title *The Limited, Inc., 1994 Annual Meeting*
Design Firm *Frankfurt Balkind Partners, New York,*
Los Angeles, and San Francisco offices
Art Director *Kent Hunter*
Designers *Robert Wong and Arturo Aranda*
Photographers *Julie Powell and Brad Feinknopf*
Client *The Limited, Inc.*
Typographer *Frankfurt Balkind Partners*

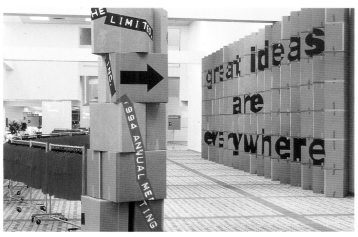

FIVE

This page and opposite
Title *Numerical Countdown Video:*
Fox Broadcasting Company
Design Firm *Morla Design, San Francisco, CA*
Art Director *Jennifer Morla*
Designer *Jennifer Morla and Craig Bailey*
Photographers *Holly Stewart and Craig Bailey*
Client *Fox Broadcasting Company*

Title *"Smoking"*
Design Firm *Samata Associates, Dundee, IL*
Art Director/Designer *Greg Samata*
Photographer *Gary Katz*
Copywriter *Patrice Boyer*
Client *American Heart Association of Metropolitan Chicago*

American Heart Association
of Metropolitan Chicago
1-800-AHA-USA1

Title *"Hypertension"*
Design Firm *Samata Associates, Dundee, IL*
Art Director/Designer *Greg Samata*
Photographer *Gary Katz*
Copywriter *Patrice Boyer*
Client *American Heart Association of Metropolitan Chicago*

American Heart Association
of Metropolitan Chicago
1-800-AHA-USA1

Bird-eating Spider

Leaf Insect

[Java]

Tiger Swallowtail

[North America]

At the Minnesota Zoo

[Opens May 28]

Title *Minnesota Zoo BUGS! Supers Television Spot*
Design Firm *Rapp Collins Communications,*
Minneapolis, MN
Art Director/Designer/Illustrator *Bruce Edwards*
Photographer *Buck Holzmer*
Copywriter *Chris Mihock*
Client *Minnesota Zoo*
Typographer *Great Faces, Bruce Edwards*

Title *"Sunburn Guy"*
Design Firm *Blue Brick, New York, NY*
Art Directors *Akiva Boker and Chris Wise*
Designer/Illustrator *Akiva Boker*
Programmer *David Oppenheim*
Client/Publisher *Blue Brick*
Typographer *Blue Brick*

Guarnaccia and Melinda Beck
hic Arts Center
Esse, 60% Recycled
Texture 80# Text

The *Objects of Design* show provided an alternative view of design activity, from the margins, as it were:

- stationery systems with hand-applied labels
- watches bedecked with comic-book heroes
- awards books made from other cut-up books
- soda cans for a multinational company that look like they were designed in an out-of-business stationery store's back room

The promotional/novelties world of Julius Knipl, Ben Katchov's comic strip real estate photographer, has seeped into the world of design. There were caps and calendars, lighters and beer coasters, refrigerator magnets and View-Master reels. This must have been the year of the watch (by the Swiss calendar, at least). We may have hit the saturation point in timepiece design. It's also the year that the beer mat came into its own as a design object.

Some of the entries tended toward the charming, the warm and fuzzy (literally, in one case — a backlit fur-edged box by Modern Dog that got warm when you turned it on, and fuzzy…well, you had to feel it). There was a lot of interesting use of materials in the entries (a lot were fun to handle) along with a healthy amount of humor.

By and large, the jury came to agreement pretty easily, perhaps lulled by the innate charm of the entries. Or maybe it was because we came from such different disciplines, a graphic designer and an illustrator. In a sense we were like the entries, all coming out of left field.

This was, then, a show that attracted and rewarded the "other," the piece that would have been the wallflower of the *Communication Graphics* show, the entry that had no place else to go.

Steven Guarnaccia
Chair

J U R Y

Steven Guarnaccia
Principal/Illustrator
Steven Guarnaccia Studio
Montclair, NJ

Esther K. Smith
Book Artist/Designer
Purgatory Pie Press
New York, NY

Tucker L. Viemeister
Co-founder/Designer
Smart Design
New York, NY

Sharon Werner
Principal/Designer
Werner Design Werks Inc.
Minneapolis, MN

Could it be? The call for entry invited indulgence and hinted at covetous compacts between creators, consumers, and the objects they crave.

Objects of Design set out to gather the goods — the treats of the trade — and explore the notion of designers as form-makers and gift-givers offering up diminutive delights for curatorial consumption.

Forgo the practical, abandon restraint, revel in the endearing dimensions of design. In an about face from the rigors of message and means, the competition posed few constraints, welcoming work from the past five years that, "beautifully crafted or humbly cobbled…feels like a gift, whatever it looks like," in the words of the chair.

The jurors were a multifaceted crew — an illustrator, book artist/designer, graphic designer, and product shaper — engaged in diverse pursuits of their own making. Each anticipated what the entries might yield. "I thought there'd be more hats, more matchbooks and sugar packs," remarked one juror. The chair, though pleased with the response, expected "more marginal stuff, one-offs and hand-crafted things (not macramé). But there was little of that." He mused, "Maybe people didn't think it appropriate."

Meanwhile, the objects arrived in boxes that belied their slight size. There were cool cans and bottled drinks, a View-Master product promo, magnets and a science kit for flawless skin, pins, stickers, postcards, business cards, greeting cards and coasters; CD's, calendars, flip books, pop-ups, and paper dolls. "What's all this retro stuff?" a juror exclaimed over mementos and merchandise marked "instant collectibles."

"It was like entering a gift shop," another said, recalling tables laden with bags of flavored coffees, chocolates,

scented soaps, and pungent oils. The pleasure principle prevailed but soon revealed an excessive use of good things. Ribbons and bows, twigs and twine, nostalgia and materials were not enough in and of themselves. "I'm sick of raffia, of overly packaged, overly recycled, multilayered biodegradable materials," proclaimed the juror, who, like her colleagues, sorted through warm, fuzzy feelings (including a fur-framed lamp) to discern the rare find.

But sensations aside, a larger question remained: What was an object? In the heretofore flat world of print-based graphics and ephemera, what invited interaction or transcended dimensions beyond clever cliché? Surprisingly, a pristine plastic colander (a salad spinner, actually) sparked controversy and challenged criteria not for form (which was beyond doubt beautiful), but because it was so, well, different.

Objects of Design had hoped to span the divide between disciplines — product designers, architects, craftspersons, and interface designers. But ultimately the nature of the entries determined the show. The result: 3-D from a graphic point of view, according to one juror, pointing at watches.

Nonetheless, as the chair commented, "This show allowed the wallflowers to come out and be front and center. The minor key — those shy, embarrassed objects that cluster in the corners, overlooked or inappropriate for other shows — was allowed to shine."

So, what is an object? Said one juror, "It's somewhere between a joke and a poem — a quiet quirk that stays with you, amuses you, delights you."

Moira Cullen

1

Title *Felix Limited Edition #3*
Design Firm *Fossil (In-House), Dallas, TX*
Art Directors *Brian Flynn and Bob Shema*
Designers *Brian Flynn and David Bates*
Client *Fossil Watch*
Printer/Fabricator *Fugo*
Paper *Craft Board*

2

Title *Roche Products*
Design Firm *Donovan and Green, New York, NY*
Art Directors *Nancye Green and Marge Levin*
Designers *Marge Levin and Lisa Yee*
Client *F. Hoffmann–La Roche Ltd.*

3

Title *Mobilzoo*
Design Firm *Product NV, New York, NY*
Art Director *Neil Cohen*
Designers *Neil Cohen, Stephen Moore, and M. Marzynski*
Fabricator *Product NV*
Paper *Strathmore 2-Ply Bristol*

4

Title *Boneyard Pencils*
Design Firm *Steven Guarnaccia Studio, Montclair, NJ*
Art Director *Dana Melnick*
Designer/Illustrator *Steven Guarnaccia*
Copywriter *David Burd/Overnight Inspirations*
Client *Pentech International Inc.*
Printer *Majestic Packaging*

1
Title *Wild Game Dinner Invitation*
Design Firm *Petrick Design, Chicago, IL*
Art Director *Robert Petrick*
Designer/Typographer *Laura Ress*
Copywriters *Various*
Client *Lake County Press, Inc.*
Printer/Fabricator *Lake County Press, Inc.*
Paper *Curtis Tuscan Antique*

2
Title *"Light Reading" Lamp*
Design Firm *Alchemy, Minneapolis, MN*
Designer/Fabricator *Geoffrey Warner*
Printing *Photocopy on Mylar*

3
Title *E-Bag*
Design Firm *Designframe Inc., New York, NY*
Art Director *James A. Sebastian*
Designers *James A. Sebastian and Frank Nichols*
Client/Printer/Fabricator *Modern Arts Packaging*

2

3

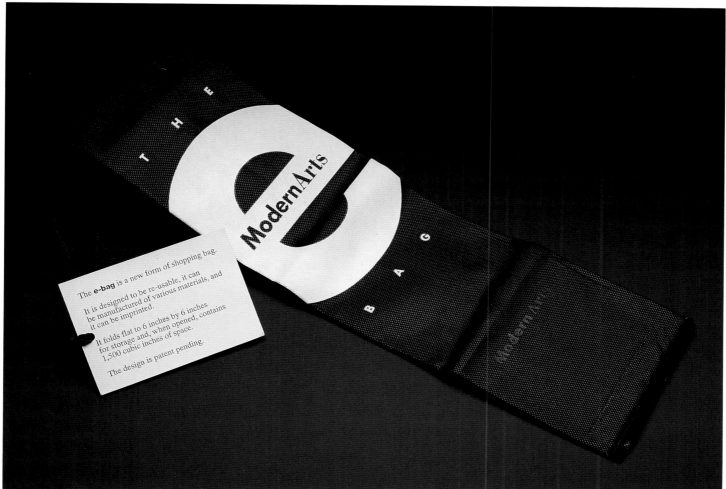

The **e-bag** is a new form of shopping bag. It is designed to be re-usable; it can be manufactured of various materials, and it can be imprinted.

It folds flat to 6 inches by 6 inches for storage and, when opened, contains 1,500 cubic inches of space.

The design is patent pending.

1

1

Title *"Screen Test"*

Design Firm *Hambly & Woolley Inc., Toronto, Ontario*

Art Directors *Bob Hambly and Barb Woolley*

Designers *Mercedes Rothwell and Gord Woolley*

Illustrators *Barry Blitt and Bob Hambly*

Copywriters *Bob Hambly, Barb Woolley,*
and Helen Battersby

Client/Printer/Fabricator *The Edge Screen Studio*

2

Title *Warner Bros. Records Holiday Card 1994*

Design Firm *Modern Dog Design, Seattle, WA*

Art Directors *Vito Costarella and Jeri Heiden*

Designer *Vito Costarella*

Copywriters *Linda Forman and Various*

Client *Warner Bros. Records*

Printer *Westland Graphics*

Paper *Simpson Evergreen White Matte 70# (Text),*
Champion Benefit Celery 70# Text (Envelope)

3

Title *"Set the Stage" MCA Holiday Greeting Card*

Design Firm *Studio SF, Los Angeles, CA*

Art Director/Designer/Illustrator *Sarajo Frieden*

Copywriter *Jonas Livingston*

Client *MCA Music Entertainment Group*

Typographer *Hand-Lettered and*
Macintosh-Generated by Sarajo Frieden

Printer *Westland Graphics*

Paper *Quintessence Gloss 100# Cover*

4

Title *Indecision '92 Kit*
Design Firm *Spot Design, New York, NY*
Art Director *Scott Wadler/MTV Networks*
Designer *Drew Hodges*
Illustrator *Mark Marek*
Copywriter *Sharon Glassman*
Client *MTV Networks*

5

Title *"A Clipping Companion"*
Design Firm *Stark Design, New York, NY*
Art Director *Adriane Stark*
Designer *Christine Licata*
Copywriter *Helene Silver*
Client/Publisher *Crown Arts & Letters*

4

5

1

Title *Champion Benefit Paper Promotion*
Design Firm *Drenttel Doyle Partners, New York, NY*
Creative Director *Stephen Doyle*
Designers *Mats Hakansson and Terry Mastin*
Client *Champion International Corporation*
Paper *Champion Benefit Recycled*

2

Title *"Save Our Planet" Soap*
Design Firm *Higashi Glaser Design,
Fredericksburg, VA*
Art Directors/Designers
Sandra Higashi and Byron Glaser
Illustrators/Copywriters
Sandra Higashi and Byron Glaser
Client *Zolo Inc.*
Typographers *Sandra Higashi, Byron Glaser,
and Jennifer Tatham*
Printer *Cardinal Press*
Fabricator *Zolo Inc.*
Paper *Papercon White Dry Wax Paper*

1

2

3

Title *1994 Holiday Gift Tag Series*
Design Firm *Pressley Jacobs Design, Inc., Chicago, IL*
Art Director *Susie McQuiddy*
Designers *Barbara Bruch, Jamie Gannon, William Johnson, Jennifer Kahn, Kim Kryszak, Amy McCarter, Susie McQuiddy, Mark Myers, Wendy Pressley-Jacobs, Pat Schab, and Craig Ward*
Illustrator *Jacki Gelb*
Photographers *Jim Imbrogno, Kevin Anderson, and Kipling Swehla*
Copywriter *Paul McComas*
Client *Pressley Jacobs Design*
Printer *Ace Graphics*
Paper *Hopper Proterra and Weyerhaeuser Cougar*

4

Title *Bio-Molecular Recovery Treatment PR Kit*
Design Firm *Aveda (in-house), Blaine, MN*
Art Director *Roger C. Remaley*
Designers *Roger C. Remaley and Lynn Schulte*
Illustrator *Lynn Schulte*
Copywriter *Liz Sela*
Publisher *Aveda*
Typographer *Dahl & Curry*
Printer *Heartland Printing*
Fabricator *Reynolds Guyer*

1

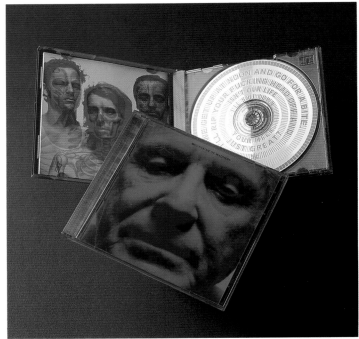

2

1

Title *The Velvet Underground Live MCMXCIII*
Special Limited-Edition CD Package
Design Firm *Just Design, New York, NY*
Art Directors *Sylvia Reed, Spencer Drate, and Jeff Gold*
Designers *Sylvia Reed, Spencer Drate, Jütka Salavetz,*
and Dennis Ascienzo
Photographer *Ted Chin*
Client *Sire/Warner Brothers Records*
Typographers *Dennis Ascienzo and Spencer Drate*
Printers *AGI (Peel-off Stickers), Ivy Hill (CD Booklets),*
and Specialty (Compact Disks)
Fabricator *AGI*
Paper *Gloss Black Vinyl Cover*

2

Title *H. P. Zinker "Mountains of Madness" Compact Disk Package*
Design Firm *Sagmeister Inc., New York, NY*
Art Director *Stefan Sagmeister*
Designers *Stefan Sagmeister and Veronica Oh*
Photographer *Tom Schierlitz*
Client *Energy Records*
Typographer *Veronica Oh*
Printer *Disc Graphics*
Fabricator *HMG*

3

Title *R.E.M. "Monster" Limited-Edition*
Special Compact Disk Package
Art Directors/Designers *Tom Reccion,*
Michael Stipe, and Chris Bilheimer
Photographers *Michael Stipe, Chris Bilheimer,*
Christy Bush, Jem Cohen, Brook Dillon,
and Michael Meister
Publisher *Warner Bros. Records*
Printer *Ivy Hill*

4

Title *Boingo "Boingo" Limited-Edition*
Special Compact Disk Package
Art Director/Designer *Deborah Norcross*
Font Designer (Ideoque) *Mike Diehl*
Photographers *Anthony Artiaga*
and Melodie McDaniels
Publisher *Giant Records*
Printer *Ivy Hill*

3

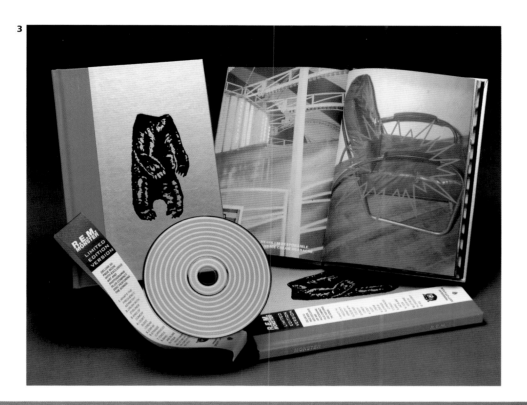

4

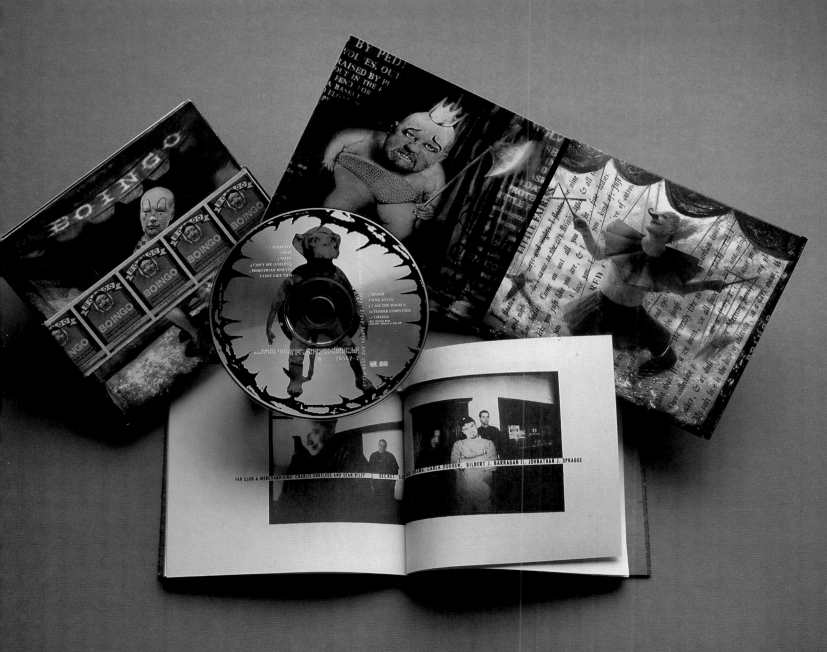

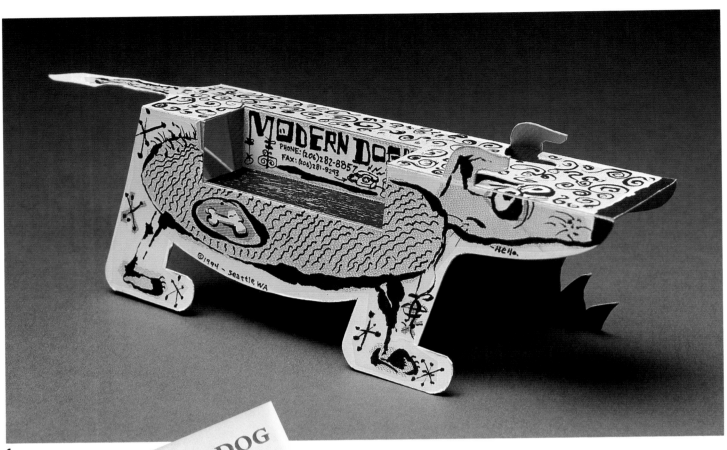

1
Title *Folding Dog Self-Promotion*
Design Firm *Modern Dog, Seattle, WA*
Art Director/Designer/Illustrator *Michael Strassburger*
Copywriter/Typographer *Michael Strassburger*
Client *Modern Dog*
Printer *Argentum (Canon Laser Copies)*
Paper *Simpson Starwhite Vicksburg*

2
Title *Modern Dog Refrigerator Art*
Design Firm *Modern Dog, Seattle, WA*
Art Directors/Designers *Michael Strassburger,*
Robynne Raye, and Vittorio Costarella
Illustrators/Copywriters *Michael Strassburger,*
Robynne Raye, and Vittorio Costarella
Client *Modern Dog*
Typographers *Michael Strassburger, Robynne Raye,*
and Vittorio Costarella
Printer *Argentum (Canon Laser Copies)*
Fabricator *Morris Magnets*
Paper *Simpson Starwhite Vicksburg*

3
Title *Kitty Condoms*
Design Firm *DeMuth Design, Cazenovia, NY*
Art Director/Designer *Roger DeMuth*
Illustrator/Copywriter/Typographer *Roger DeMuth*
Publisher *DeMuth Design*
Printer *Syracuse Litho*
Fabricator *DeMuth Design*

4
Title *Bulldog Cap*
Design Firm *AOR, Inc., Denver, CO*
Art Director *Melissa Harris*
Designer/Illustrator *Joan English*
Copywriter *Beth Wampler*
Client *AOR, Inc.*
Sewing *Ski Country Imports*

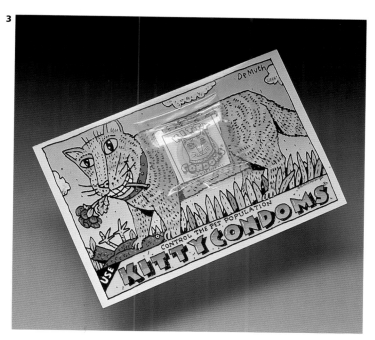

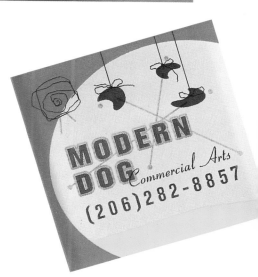

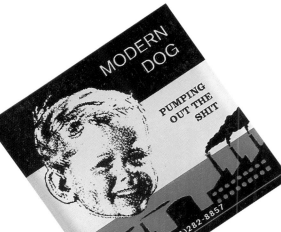

1

Title *Jiffy Pow Invitation*
Design Firm *Modern Dog, Seattle, WA*
Art Director *George Estrada*
Designer/Illustrator *Michael Strassburger*
Copywriters *Michael Strassburger and Hayley Martin*
Client *K2 Snowboards*
Printer *Argentum (Canon Laser Copies)*
Paper *Simpson Starwhite Vicksburg*

2

Title *Tupperware Double Colander*
Design Firm *Tupperware, Orlando, FL*
Art Director *Morison S. Cousins*
Manufacturer *Tupperware*
Material *Injection-Molded Polypropylene*

3

Title *"The Art of Refreshment" Perrier Bottles*
Design Firm *Lipson-Alport-Glass & Associates, Northbrook, IL*
Art Director *Sam J. Ciulla*
Designer *Tracy Bacilek*
Illustrators *Terry Allen ("The Drink")*
and Coco Masuda ("Lime Man")
Client *The Perrier Group of America*
Printer *Sleever International*

1

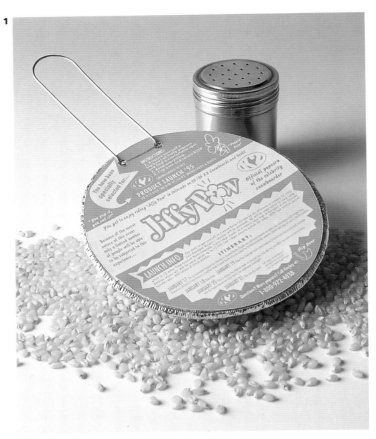

2

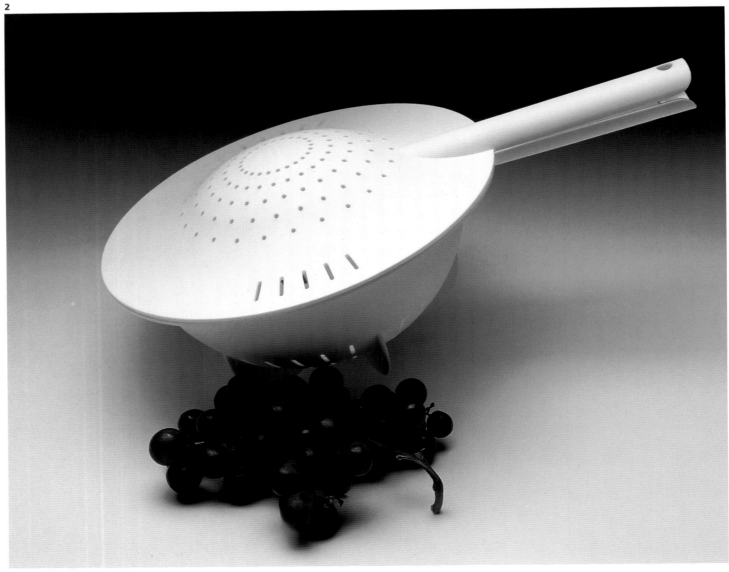

1

Title *Pivot Design Moving Announcement*
Design Firm *Pivot Design, Inc., Chicago, IL*
Art Director *Brock Haldeman*
Designer *Jim Larmon*
Client *Pivot Design, Inc.*
Printer *Ace Graphics, Inc.*
Fabricator *Graphic Finishing and Mailing, Inc.*
Paper *Simpson Starwhite Vicksburg*

2

Title *"Stefan Sagmeister Moved" Flip Book*
Design Firm *Sagmeister Inc., New York, NY*
Art Director/Designer *Stefan Sagmeister*
Illustrator/Typographer *Stefan Sagmeister*
Photographer *Adolf Bereuter*
Client *Sagmeister Inc.*
Printer *Nobertus*
Fabricator *Edgar Fontanari*
Paper *220g Coated Matte Stock*

1

3

Title *IBM 6090 Graphics System Flip Book*
Design Firm *Kensinger Studio, New York, NY*
Art Director/Designer *Ed Kensinger*
Illustrator *IBM Corporation*
Photographer *Jack Elness*
Copywriter *Ted Burtt*
Client *IBM Corporation*
Typographer *Pastore Depamphillis & Rampone*
Printer *S.D. Scott Printing Co.*

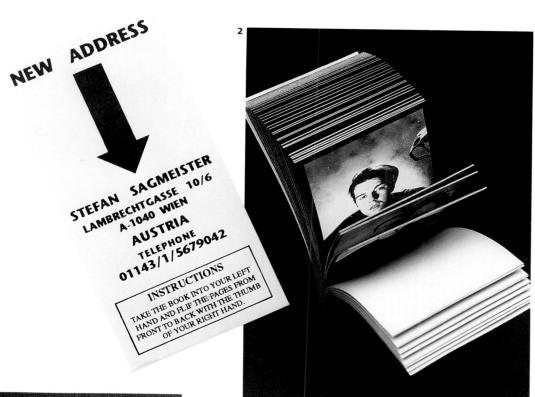

NEW ADDRESS

STEFAN SAGMEISTER
LAMBRECHTGASSE 10/6
A-1040 WIEN
AUSTRIA
TELEPHONE
01143/1/5679042

INSTRUCTIONS
TAKE THE BOOK INTO YOUR LEFT
HAND AND FLIP THE PAGES FROM
FRONT TO BACK WITH THE THUMB
OF YOUR RIGHT HAND.

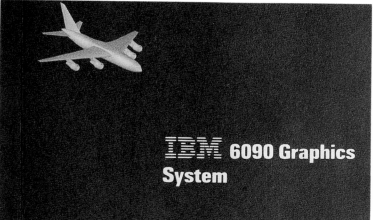

IBM 6090 Graphics System

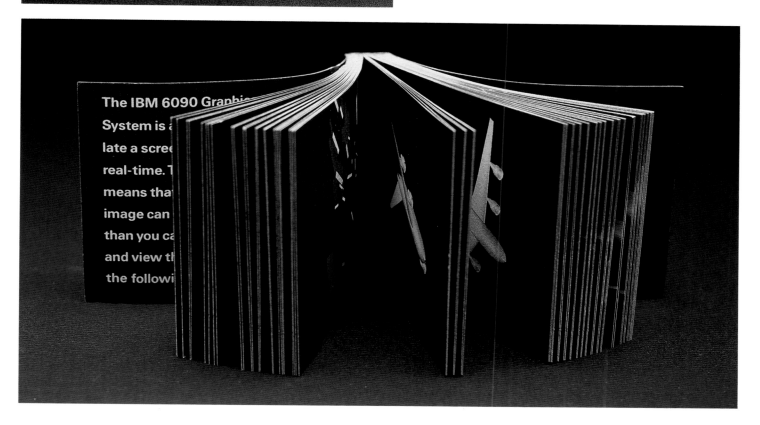

The IBM 6090 Graphics
System is a
late a scree
real-time. T
means that
image can
than you ca
and view th
the followi

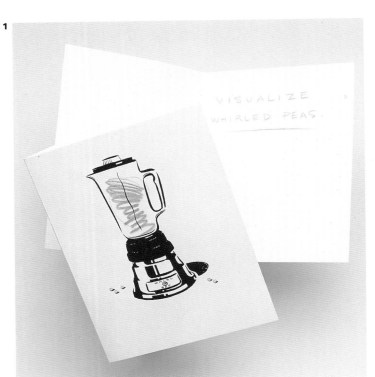

1
Title *"Visualize Whirled Peas" (Self-Promotion)*
Design Firm *Kara Fellows Illustration, Minneapolis, MN*
Art Director/Designer/Illustrator *Kara Fellows*
Copywriter/Typographer *Kara Fellows*
Client *Kara Fellows*
Printer *Quik Print*
Paper *Wausau Bright White 80# Cover*

2
Title *"Happy Shootin'"*
Design Firm *Industrial Strength Design, New York, NY*
Designer *Michael Calleia*
Client *Industrial Strength Design*

3
Title *Light Box Postcard Self-Promotion*
Design Firm *Modern Dog, Seattle, WA*
Art Director/Designer *Michael Strassburger*
Copywriter/Typographer *Michael Strassburger*
Client *Modern Dog*
Printer *Argentum (Canon Laser Copies)*
Paper *Simpson Starwhite Vicksburg*

4
Title *Emberama Christmas Card*
Design Firm *Morphix Design, Corona Del Mar, CA*
Designer/Copywriter *Matt Duncan*
Material *Mixed Media*

5
Title *1994 Christmas Card*
Design Firm *Don Emery, Chicago, IL*
Art Director/Designer/Fabricator *Don Emery*
Client/Copywriter *Don Emery*
Typographer *Labeling Machine*
Paper *Riegel Jersey Leatherette Cover, Spring Green*

4

5

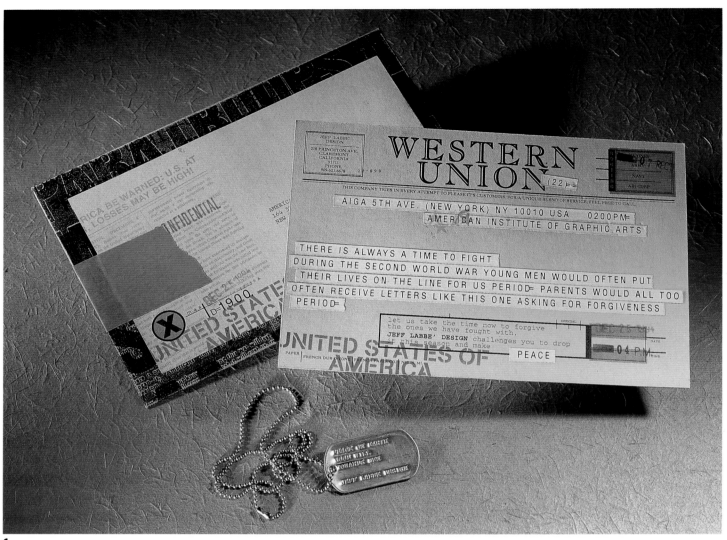

1

Title *"Peace" Christmas 1994 Self-Promotion*

Design Firm *Jeff M. Labbé Design, Claremont, CA*

Art Director/Designer/Copywriter *Jeff M. Labbé*

Client *Jeff M. Labbé Design*

Printer *Performance Group*

Paper *French Dur-o-tone: Newsprint White 70# Text,*
Packaging Brown 80# Cover, Construction Gold 80# Cover

2

Title *Invitation to Open House of APS*
Environmental Showcase Home

Design Firm *Smit Ghormley Lofgreen Design,*
Phoenix, AZ

Art Director *Art Lofgreen*

Designers *Art Lofgreen and Rod Whitney*

Copywriter *Steve Hutchison*

Client *APS*

Printers *Arizona Embossing & Die/Silkscreen Studio*

Paper (Materials All Reused)

French Dur-o-Tone 145# Packing Carton,
Old Newspaper, and Fasson Crack 'n' Peel Plus

3

Title *Visual Asylum Self-Promotion*
Design Firm *Visual Asylum, San Diego, CA*
Designers/Illustrators *MaeLin Levine,*
Amy Jo Levine, and Jason Janus
Client *Visual Asylum*
Printer *Jim's Typesetting, Visual Asylum*
Paper *Gilbert Gilcrest Recycled 65# Cream Cover*

4

Title *75th Anniversary ("A History of Hospitality")*
Design Firm *Sayles Graphic Design, Des Moines, IA*
Art Director/Designer *John Sayles*
Photographer *Archives*
Copywriter *Wendy Lyons*
Client *Hotel Fort Des Moines*
Typographer *The Printing Station*
Printer *Acme Printing*
Fabricator *Fisher Paper Box*
Paper *Curtis Linen and Curtis Graphika Parchment*

3

4

1
Title *Virtual Reality Promotion*
Design Firm *Fossil (In-House), Dallas, TX*
Art Directors *Drew Denoyer and Tim Hale*
Designer/Typographer *Drew Denoyer*
Photographer *Rick Bryant*
Copywriters *Drew Denoyer and Mark Harbour*
Client *Fossil Watch*
Printer *Apex*
Fabricator *Tyco, Inc.*
Paper *Chipboard and Simpson Quest*

2
Title *San Francisco Museum of Modern Art Beaux Arts Ball Mask*
Design Firm *BlackDog, San Rafael, CA*
Designer/Illustrator/Typographer *Mark Fox*
Client *San Francisco Museum of Modern Art*
Printer/Fabricator *Wasserman Silkscreen*
Material *Sheet Metal*

3
Title *Three Baseballs*
Design Firm *Greenberg Kingsley, New York, NY*
Designers *D. Mark Kingsley and Karen Greenberg*
Client *Guggenheim Museum*

1
Title *St. Modem Promotion*
Design Firm *Alexander Isley Design, New York, NY*
Art Director/Copywriter *Alexander Isley*
Designer *Alexander Knowlton*
Illustrator *Kam Mak*
Client *DX: Digital Exchange*
Printer *Zarett Graphics*

2
Title *Refrigerator Magnets*
Design Firm *Alexander Isley Design, New York, NY*
Art Director *Alexander Isley*
Designers *Eva Keller, Lourdes Bañez, and Gabrielle Dubois-Pellerin*
Photographer *Monica Stevenson*
Client/Fabricator *Blue Q*
Printers *Quality Printing and Excelsior Printing*

3
Title *Buckeye Bar Coaster*
Design Firm *BlackDog, San Rafael, CA*
Designer/Illustrator/Typographer *Mark Fox*
Client *Real Restaurants*

4
Title *"OK" Cans*
Design Firm *Wieden & Kennedy, Portland, OR*
Art Director/Designer/Typographer *Todd Waterbury*
Illustrators *Daniel Clowes, Charles Burns, and David Cowles*
Copywriter *Peter Wegner*
Client *The Coca-Cola Company*
Printer *Crown Cork & Seal*

5
Title *House of Spot Dress-Up Dolls*
Design Firm *Spot Design, New York, NY*
Art Director *Drew Hodges*
Designer *Vinny Sainato*
Copywriter *Cheryl Family*
Fabricator *Spotswood, Inc.*

1

2

1

Title *Duffy Inc. Stationery*

Design Firm *Duffy Design, Minneapolis, MN*

Art Director *Neil Powell*

Designers *Neil Powell and Kobe*

Photographer *Paul Irmiter*

Client *Duffy Design*

Printer *Alternatives*

Fabricator *St. Paul Metal & Stamp*

Materials *(Letterhead) French Dur-o-tone Off White and (Business Cards) Aluminum*

2

Title *Rip Saw Photography Identity*

Design Firm *Werner Design Werks, Minneapolis, MN*

Art Director/Designer *Sharon Werner*

Illustrator/Typographer *Sharon Werner*

Client *Rip Saw Photography*

Printer *Heartland Graphics*

Paper *Scott Manila, Mohawk Superfine*

3

Title *Concrete Calendar 1992*

Design Firm *Concrete Design Communications Inc., Toronto, Ontario*

Art Directors/Designers *John Pylypczak and Diti Katona*

Illustrator *Ross MacDonald*

Client *Concrete Design Communications Inc.*

Printer *Baker Gurney McLaren*

Paper *Mohawk Vellum*

4

Title *Concrete Calendar 1993*

Design Firm *Concrete Design Communications Inc., Toronto, Ontario*

Art Directors/Designers *John Pylypczak and Diti Katona*

Illustrator *Ross MacDonald*

Client *Concrete Design Communications Inc.*

Printer *Baker Gurney McLaren*

Paper *Mohawk Vellum*

5

Title *Concrete Calendar 1994*

Design Firm *Concrete Design Communications Inc., Toronto, Ontario*

Art Directors/Designers *John Pylypczak and Diti Katona*

Illustrator *Ross MacDonald*

Client *Concrete Design Communications Inc.*

Printer *Somerset*

Paper *Mohawk Vellum*

3

4

5

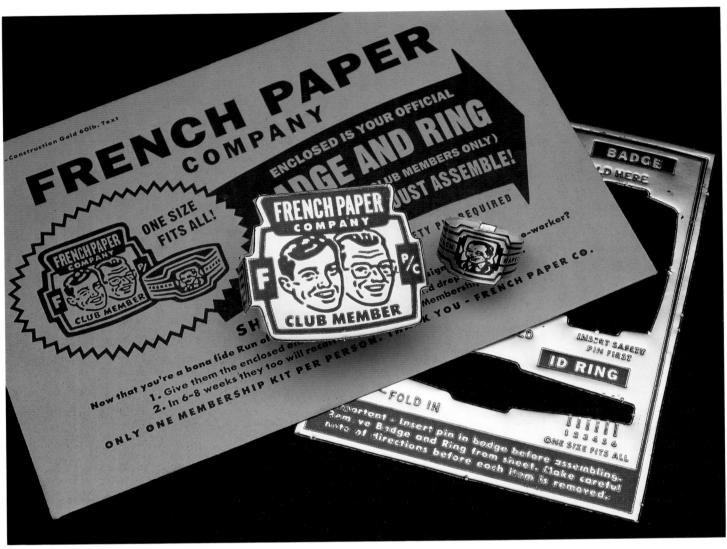

1

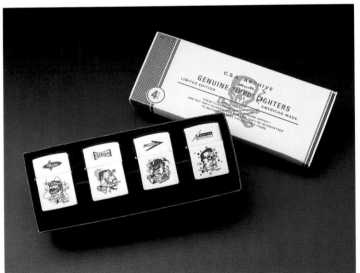

1
Title *French Run-of-the-Mill Ring and Badge*
Design Firm *Charles S. Anderson Design Co., Minneapolis, MN*
Art Directors *Charles S. Anderson and Todd Piper-Hauswirth*
Designer/Typographer *Todd Piper-Hauswirth*
Illustrator *CSA Archive*
Photographer *Paul Irmiter*
Copywriter *Lisa Pemrick*
Client *French Paper Company*
Printer *Midwest Badge and Novelty*
Paper *French Dur-o-Tone, Primer Gold (Envelope)*

2
Title *CSA Archive Lighters*
Design Firm *Charles S. Anderson Design Co., Minneapolis, MN*
Art Directors *Charles S. Anderson and Joel Templin*
Designer/Illustrator/Typographer *Joel Templin*
Copywriter *Lisa Pemrick*
Client *CSA Archive Products*
Printer *Zippo*

3

Title *Deadline Watch*
Design Firm *Charles S. Anderson Design Co., Minneapolis, MN*
Art Director *Charles S. Anderson*
Designers *Charles S. Anderson, Daniel Olson, and Todd Piper-Hauswirth*
Illustrator *CSA Archive*
Copywriter *Lisa Pemrick*
Client *CSA Archive Products*

4

Title *Oil Tin (Series of Two)*
Design Firm *Fossil (In-House), Dallas, TX*
Art Director/Designer *Tim Hale*
Copywriter/Typographer *Tim Hale*
Client *Fossil Watch*
Printer/Fabricator *Wai Lee Wai*

3

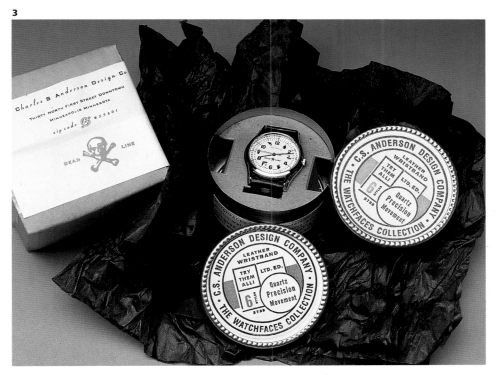

4

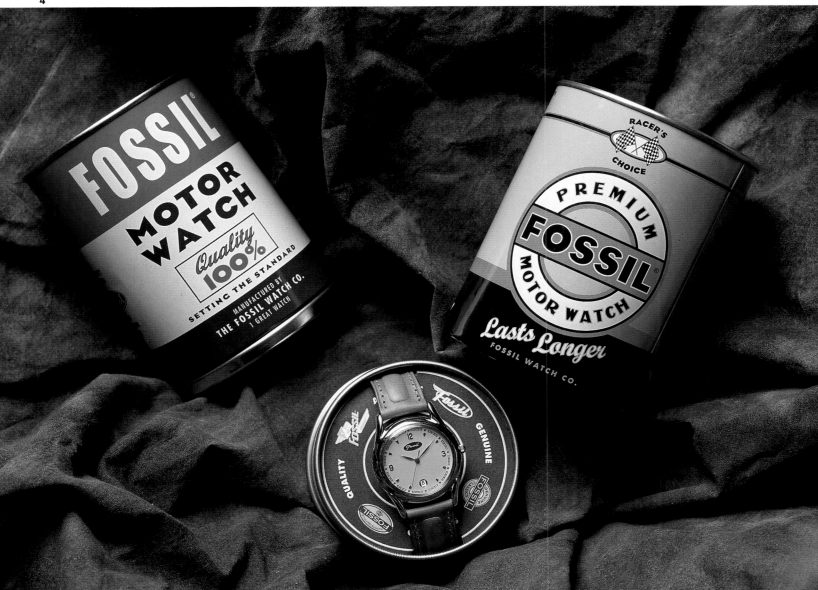

1
Title *"OK" Label Packet*
Design Firm *Wieden & Kennedy, Portland, OR*
Art Director/Designer/Typographer
Todd Waterbury
Illustrator *Daniel Clowes*
Copywriter *Peter Wegner*
Client *The Coca-Cola Company*
Printer *Williams Printing*
Paper *Mactac and Glassine*

2
Title *"Spot"*
Design Firm *Steven Guarnaccia Studio,*
Montclair, NJ
Art Director/Designer/Fabricator
Steven Guarnaccia

3
Title *Double Entendre Business Card*
Design Firm *Double Entendre, Seattle, WA*
Art Directors/Designers *Richard A. Smith*
and Daniel P. Smith
Illustrator *Richard A. Smith*
Client *Double Entendre*
Printer *Litho House*
Fabricator *Acu-line*
Paper *Neenah Classic Crest Solar White, Stainless Steel*

4
Title *"Trick or Treat"*
Design Firm *Industrial Strength Design, New York, NY*
Designer/Illustrator *Michael Calleia*
Client *Industrial Strength Design*
Paper *Simpson Evergreen*

1
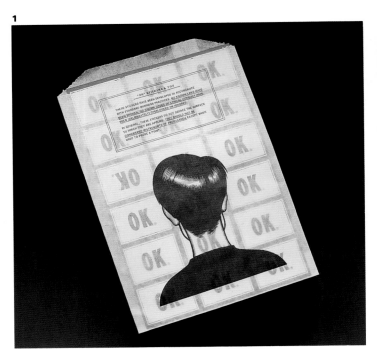

2
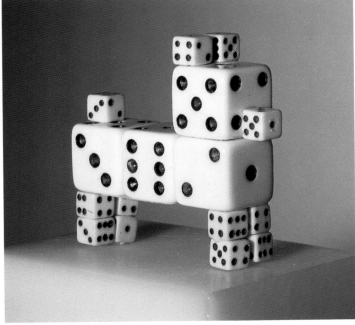

3
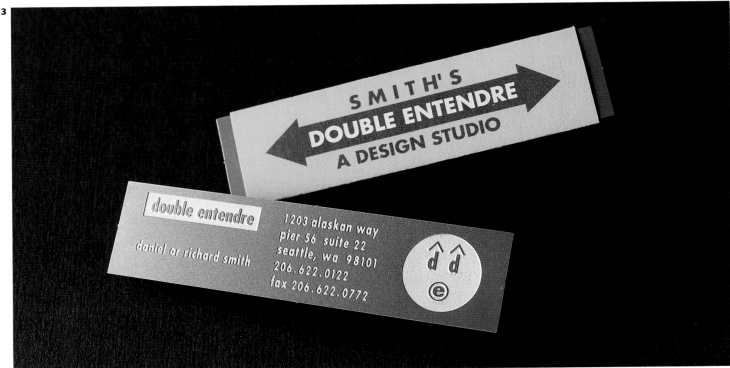

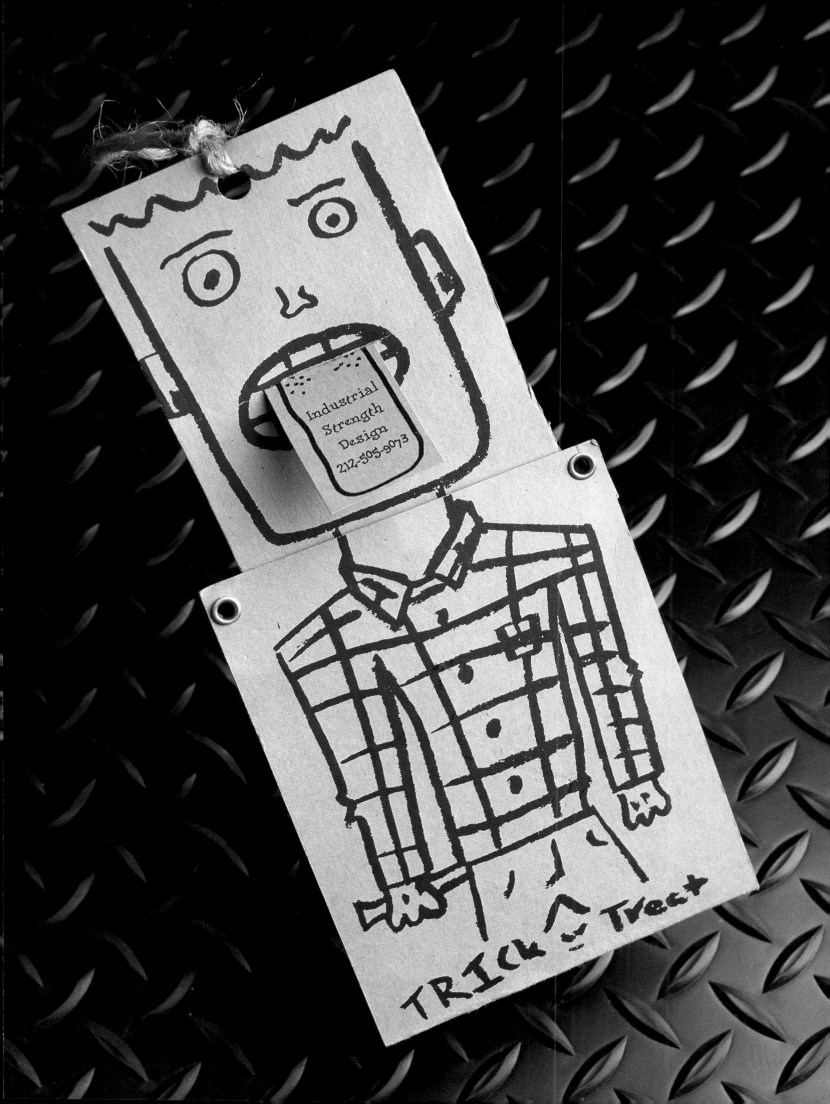

1

Title *Isley Architects Place and Trace Template*
Design Firm *Alexander Isley Design, New York, NY*
Art Director/Designer *Alexander Isley*
Client *Isley Architects Inc.*
Fabricator *Berol Inc.*

1

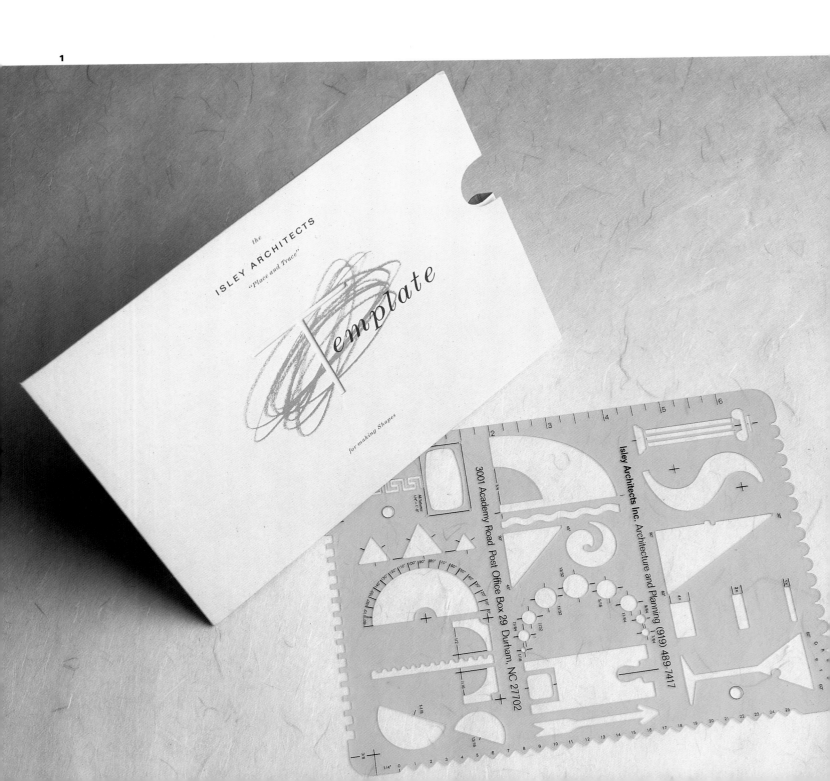

2

2
Title *Sagmeister Business Card*
Design Firm *Sagmeister Inc., New York, NY*
Art Director/Designer *Stefan Sagmeister*
Client *Sagmeister Inc.*
Typographer *Karin Kautzky*
Printer *Mondseer Druckerei/Dependable Printing*

3
Title *Sundial Postcard*
Design Firm *Sagmeister Inc., New York, NY*
Art Director/Designer *Stefan Sagmeister*
Illustrators *Stefan Sagmeister and Veronica Oh*
Copywriter *Stefan Sagmeister*
Client *Sagmeister Inc.*
Typographer *Veronica Oh*
Printer/Fabricator *Robert Kushner*
Paper *80# Matte Text Mounted on
20 pt. Chipboard*

3

1
Title *"Word" Self-Promotion*
Design Firm *Werner Design Werks, Inc. Minneapolis, MN*
Art Director/Designer *Sharon Werner*
Copywriters *Various*
Client *Werner Design Werks, Inc.*
Printer *Printcraft and Others*
Fabricator *Werner Design Werks, Inc.*
Paper *Consolidated and Various*

2
Title *Lino Graphics Price Guide*
Design Firm *KODE Associates, Inc., New York, NY*
Art Director/Designer *William Kochi*
Photographers *William Kochi and FPG Stock*
Client/Copywriter *Lino Graphics*
Printer *OTIS Graphics*
Fabricator *Riverside Group*
Paper *Neenah Buckskin (Cover), Strathmore Elements, Soft White Lines (Text)*

3

4

3

Title *"Welcome to the Edge"*
Design Firm *Spot Design, New York, NY*
Art Director *Elisa Feinman*
Designers *Naomi Mizusaki and Vinny Sainato*
Copywriter *Allison Villone*
Client *USA Networks*
Printer *Red Ink Productions*
Fabricator *Drew Hodges*

4

Title *"1995: A Year of Recipes"*
Design Firm *Shapiro Design Associates Inc.,*
New York, NY
Art Director/Designer *Ellen Shapiro*
Illustrator *Paul Hoffman*
Copywriter *Ellen Shapiro*
Client *Shapiro Design Associates Inc.*
Printer *Canfield Printing Co., Inc.*
Paper *Mohawk Satin 80# Leaf Cover,*
80# Cream White Text

1
Title *1993 Christmas Card*
Design Firm *Don Emery, Chicago, IL*
Art Director/Designer/Fabricator *Don Emery*
Client *Don Emery*
Printer *Quick Print*
Paper *Riegel Jersey Cover White*

2
Title *"Heart and Soul" Conference Packet*
Design Firm *Hallmark Cards, Inc., Kansas City, MO*
Art Director/Designer *Meg Cundiff*
Client/Publisher *Hallmark Cards, Inc.*

1

2

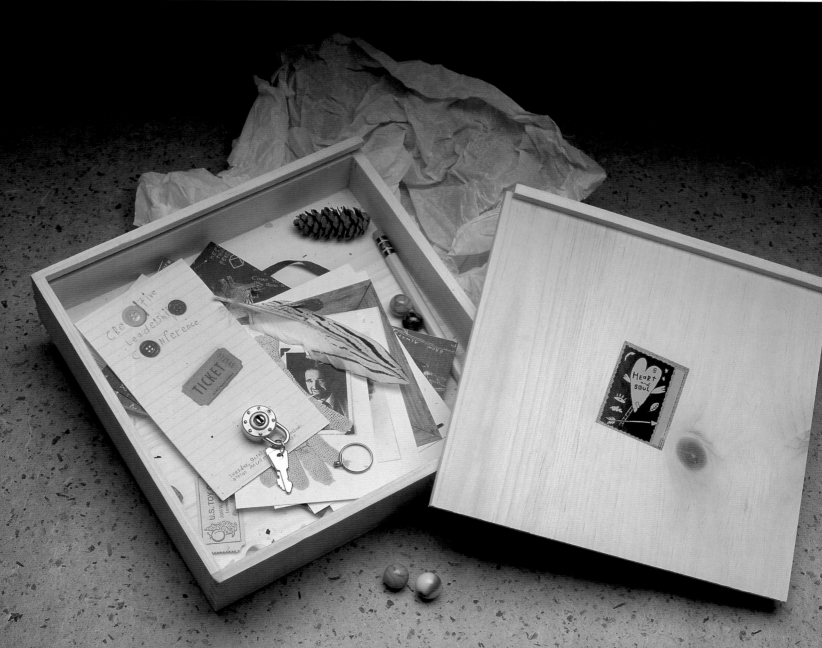

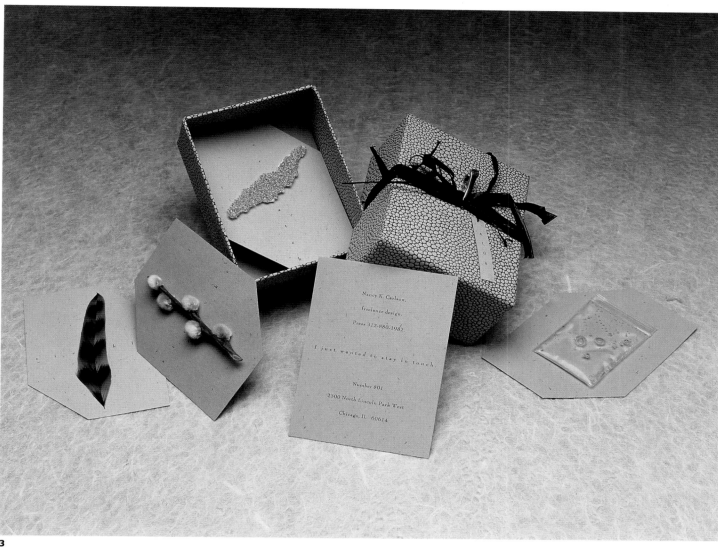

3

4

3

Title *"Staying in Touch"*
Design Firm *Nancy K. Carlson*
Graphic Designer, Chicago, IL
Art Director/Typographer *Nancy K. Carlson*
Copywriters *Nancy K. Carlson*
and Shawn M. Everitt
Client *Nancy K. Carlson Graphic Designer*
Printer *B&A Printing Inc.*
Fabricator *Unique Boxes Inc.*
Paper *Cross Pointe Genesis*

4

Title *Adopt-a-Book Bookplate Series*
Design Firm *Tenazas Design, San Francisco, CA*
Art Director *Lucille Tenazas*
Designer *Todd Foreman*
Copywriters *Various*
Client *California College of Arts & Crafts*
Printer *Expressions Lithography*

GAY GAMES IV & CULTURAL FESTIVAL

NYC

24
JUNE

DAY 7
DAY SEVEN DESIGN

GAY GAMES IV & CULTURAL FESTIVAL

NYC

25
JUNE

LIMITED EDITION
DAY EIGHT DESIG

GAY GAMES IV & CULTURAL FESTIVAL

NYC

22
JUNE

SATISFACTION

DAY 5
PINS
TED EDI
FIVE DE

GAY GAMES IV & CULTU

NYC

23
JUNE

ED EDITION COLLECT
IX DESIGNED BY CHERI

DAY 6
DAY PINS
OF 850

GAY GAMES IV & CULTURAL FESTIVAL

NYC

21
JUNE

DAY FOUR
Unity 94

DAY 4

LIMITED EDITION COLLECTIBLE DAY PINS
DAY FOUR DESIGNED BY STEVEN TURK • OF 850

GAY GAMES IV & CULTURAL FESTIVAL

NYC

20
JUNE

LIMITED EDITION COLLECTIBLE DA
DAY THREE DESIGNED BY JAMES SPINDLER

GAY GAMES IV & CULTURAL FESTIVAL

NYC

19
JUNE

DAY

LIMITED EDITION COLLECTIBLE DAY
DAY TWO DESIGNED BY CHIP WASS • OF 8F

GAY GAMES IV & CULTURAL FESTIVAL

NYC

18
JUNE

DAY

DAY 1

LIMITED EDITION COLLECTIBLE DAY PINS
DAY ONE DESIGNED BY DAVID HIGH • OF 850

1
Title *1994 Gay Games Collectible Pins*
Design Firm *Spot Design, New York, NY*
Art Directors *Drew Hodges and Vinny Sainato*
Designers *David High (Day One); Chip Wass (Day Two); James Spindler (Day Three); Steve Turk (Day Four); Tom Bonauro (Day Five); Cheri Dorr (Day Six); Spot Design (Day Seven); Chip Kidd (Day Eight)*
Client *Gay Games 4*

2
Title *"Warmest Wishes"*
Design Firm *Hambly & Woolley, Inc., Toronto, Ontario*
Art Directors *Bob Hambly and Barb Woolley*
Designer *Barb Woolley*
Illustrator *Bob Hambly*
Copywriter *Helen Battersby*
Client *Hambly & Woolley, Inc.*
Printer *Somerset Graphics*
Fabricator *Roy's Embroidery Ltd.*

3
Title *"Braindeer" Christmas Card*
Design Firm *Brainstorm, Inc., Dallas, TX*
Art Director/Designer/Copywriter *Ken Koester*
Illustrators *Chuck Johnson, Ken Koester, and Rob Smith*
Client *Brainstorm, Inc.*
Typographers *Ken Koester and Chuck Johnson*
Printer *Yaquinto Printing*
Paper *French Dur-O-Tone Packing Carton (Cover), Starwhite Tiara Vicksburg 100# Text*

2

3

Communication Graphics

Call for Entry

Design Deborah Sussman, Sussman/Prejza & Co. Inc.

Production Graphics Management

Printing Lithocraft

Paper Champion International, Benefit 70# Text,
100% Recycled

COMMUNICATION GRAPHICS

Judging a show is always rewarding, each in its own way. Every jury creates its own chemistry — this one, a somewhat eclectic and broad range of design personalities — reached consensus on almost all issues, even on the virtual exclusion of environmental graphics, since a paucity of submissions made this a non-category.

We saw a considerable amount of street-smart, tough, mid-nineties urban grit — rough, red, black, and gray. We noticed the recurrent presence of the "hand," yet we saw examples of elegant and sensitive typography, classically rooted, made possible only by the computer and generated with a swift grace that replaces days, even weeks, or painstaking, laborious manual surgery. And — as always — there are currents in the air, like the proliferation of rounded corners (die cut or printed). We were also happy to see that the marriage of words and images is still, occasionally, alive and well.

Of 3,341 entries (the most ever), we selected 183 (the least ever), respecting the AIGA tradition that only the very best work belongs in *Communication Graphics*.

Deborah Sussman
Chair

JURY

Laurie Haycock Makela
Design Director
Walker Art Center
Minneapolis, MN

John Plunkett
Co-Founder
Wired Magazine
San Francisco, CA

Inju Sturgeon
Creative Director
UCLA Extension Marketing
Department
Los Angeles, CA

Deborah Sussman
President and Founder
Sussman/Prejza & Co. Inc.
Culver City, CA

George Tscherny
Principal
George Tscherny Inc.
New York, NY

"As we race through the last half of the last decade of the second century before the millennium, the familiar has all but disappeared and tornadoes of change are routine." The chair's voice rose between hieroglyphs in sideways rows of entries to announce *Communication Graphics 16*.

Change? For decades, the competition stood virtually unchallenged as the paradigm of print — the AIGA's (indeed, the graphic design profession's) signature show. But after surveying the more than 3,000 responses to this year's call for entries, the chair concluded, "An explosion of design in a changing world created a dilemma for this show." A designer has many choices: what to enter, where, and why.

The jury (a mix of nationalities and generations, most from the West Coast) included designers of print and environmental graphics, creative directors for a university, a museum, a cyberchronicle (plus Web extensions) and a former AIGA president. Once convened, they cast about for concepts, discoveries, and creative solutions that, when compiled, would represent the whole of design — a mosaic of textures, styles, and spirit found in work completed in the previous year.

"So many pieces, so little time," cried one juror. But four days later, the group had agreed on 183 items (100 fewer than last year) from twenty-five states that collectively mirrored the mannerisms and graphic preferences of the times. Nineteen ninety-four was the year of rounded corners, fifties illustration, nostalgia, and type extruded, reversed, and boxed in frames. Courier was strong, as were baby announcements, tabs (and fake tabs), clever marginalia, and glassine, "another particularly beloved phenomenon." The "funny little man" was resurrected. Borders proliferated. Typography experimented. And the grid reemerged, superimposed for decorative use and renamed the "zone." One juror said, "It shows process."

It was the year of O.K. (soda, that is) and two palettes: one red, black, and gray; the other sea foam, mustard, and teal. The computer as a tool nearly rendered itself invisible while "the recent fascination" with layering seemed rather tame, mused the chair, who noticed a "spare — more bare" aspect in much of the work. "A very professional plateau," remarked one juror, who along with his colleagues noticed the absence of some designers and firms from the entries, more 3-D graphics, and edgy generational riffs (had these gone the way of other shows?).

Keenly aware of audience, client, and the roles of writing and marketing in communication design, the jury gave each entry a studied review. They searched for excellence of concept and execution, and compelling connections between image and text, laboring over those that dazzled solely with style. As one juror recalled of a series not chosen, "The work was so beautiful, but I wanted to ask the designer, What is the message? What is this for?"

Communication Graphics changed its name in 1968, forty-four years after its debut as *Printing for Commerce* and four years after Marshall McLuhan branded a new era "governed by the rule of images." With the new name, the AIGA entered the Age of Information. Media was currency and the medium was the message.

The design landscape has altered immeasurably since the competition began but the original intent remains. Tough, competitive, and selective, *Communication Graphics* has a heritage of excellence, leadership, and vision and sends a message neither easily missed nor made.

Moira Cullen

Communication Graphics
Magazines/Newsletters/Journals/Advertising

1
Title *American Center for Design Journal: Interact*
Design Firm *Tangram, Inc., Chicago, IL*
Art Director *Eric Wagner*
Designers *Eric Wagner, Anthony Ma, Lance Rutter, and Grant Davis*
Cover Illustrator *Eric Wagner*
Photographers *Various*
Client/Publisher *American Center for Design*
Typographer *Tanagram, Inc.*
Printer *Burton & Mayer, Inc.*
Paper *Neenah Classic Crest Natural White Cover and Champion Carnival Soft White Text*

2
Title *Colors 7: AIDS*
Art Director *Scott Stowell*
Designer *Leslie Mello*
Photographers *Various*
Copywriters *Danny Abelson and Alex Marashian*
Publisher *Colors Communications Srl.*
Printer *Elcograf SpA*

3
Title *Nissan Pathfinder Advertisements*
Design Firm *Charles S. Anderson Design Company, Minneapolis, MN*
Art Director *Charles S. Anderson*
Designers *Charles S. Anderson, Paul Howalt, Erik Johnson, Joel Templin, and Todd Piper-Hauswirth*
Client *Chiat Day*
Paper *French Butcher White*

yellow fever

YELLOW FEVER IS PLEASED TO ANNOUNCE A NEW CARRIER. Yellow Fever tends to attack the brain and liver tissue. Once inside the body, the virus spreads quickly, eating its way into organs and causing widespread internal bleeding. Victims undergo two 'colorful' stages. In the red stage their faces and necks flush, their tongues turn red, and their noses and gums bleed; the yellow stage is brought on when the virus attacks the liver, causing jaundice. The virus kills 30,000 in Africa annually. A new carrier, the Asian tiger mosquito, could spread the virus around the world.

LA FEBBRE GIALLA È LIETA DI ANNUN-CIARE UN NUOVO VETTORE. La Febbre Gialla tende ad attaccare i tessuti del cervello e del fegato. Una volta che si trova nel corpo, il virus si diffonde velocemente, divorando gli organi e provocando emorragie interne. Le vittime passano attraverso due stadi 'cromatici'. Durante la fase rossa il volto e il collo sono paonazzi, la lingua diventa rossa e naso e gengive sanguinano; la fase gialla subentra quando il virus attacca il fegato, provocando l'itterizia. In Africa il virus uccide 30.000 persone l'anno. Un nuovo mezzo di trasmissione, la zanzara tigrata asiatica, potrebbe diffondere il virus in tutto il mondo.

hanta

HANTA MAY BE EVOLVING TOO QUICKLY TO BE STOPPED. This virus, named after the Hantaan river in Korea, causes high fever, swelling of the face, neck and extremities, and hemorrhaging. The symptoms, often initially confused with flu symptoms, can last for months. Hanta usually attacks the kidneys, infecting an estimated 200,000 every year and killing 5 to 10%. A new strain that attacks the lungs, with a mortality rate of 70 to 75%, emerged in New Mexico, USA, last year. One patient was sitting up eating breakfast in the morning, on a respirator in the afternoon and dead that night.

L'HANTA PUÒ EVOLVERSI TANTO RAPIDA-MENTE CHE È IMPOSSIBILE FERMARLO. Il virus, prende il nome dal fiume Hantaan in Corea, provoca febbre alta, gonfiore del viso, del collo e delle estremità e perdita di sangue. I sintomi vengono spesso confusi con quelli dell'influenza e possono durare mesi. L'Hanta di solito attacca i reni, infettando circa 200.000 individui ogni anno e uccidendone il 5-10%. Un nuovo ceppo che attacca i polmoni, con una mortalità del 70-75%, è stato riscontrato lo scorso anno negli USA, nel Nuovo Messico. Una delle vittime si era tranquillamente alzata per fare colazione la mattina, si era ritrovata in un respiratoreartificiale il pomeriggio ed è morta la notte stessa.

lassa

LASSA CAN BE TRANSMITTED BY A RAT'S SNEEZE. Symptoms begin with a chill, a headache and redness and inflammation of the eyes. The virus attacks most organs of the body, causing severe vomiting, and rapidly leads to coma and death. In 1989 alone, it killed 5,000 people in western Africa. The virus, which is spread by rats, is so contagious that it can be transmitted by a sneeze. It enters the body through breaks in the skin. In Nigeria the virus is so feared that people suspected of infection are not admitted to some hospitals.

IL LASSA PUÒ ESSERE TRASMESSO CON LO STARNUTO DI UN TOPO. I sintomi iniziano con un brivido, un mal di testa, e rossore e infiammazione degli occhi. Il virus attacca la maggior parte degli organi del corpo, provocando gravi attacchi di vomito, e porta rapidamente al coma e alla morte. Solo nel 1989 ha ucciso 5.000 persone nell'Africa occidentale. Il virus, che si trasmette con i topi, è così contagioso da essere trasmesso con uno starnuto. Entra nel corpo attraverso ferite della pelle. In Nigeria il virus è così temuto che in certi ospedali i malati sospetti non vengono ammessi.

marburg

MARBURG IS TOO DANGEROUS TO BE INVESTIGATED. It begins with a headache, followed by a fever and a rash. Then white, bubbly blisters cover the body. Victims may become deranged and psychotic as their brains face with hemorrhages. Other symptoms are an expressionless face and zombie-like behavior. The virus was first diagnosed in Marburg, Germany, where 31 people working in a research laboratory contracted it from African green monkeys. Today the Marburg virus is kept frozen in maximum-safety laboratories around the world. It is so contagious that scientists cannot investigate it. The natural home of the virus is still unknown.

IL MARBURG È TROPPO PERICOLOSO PER ESSERE STUDIATO. Inizia con un mal di testa, seguito da febbre e da un'orticaria. Poi il corpo si ricopre di verruche e bolle bianche. Le vittime possono impazzire in quanto il cervello perde sangue. Altri sintomi sono volto inespressivo e comportamento da zombie. Il virus è stato diagnosticato per la prima volta a Marburg, in Germania, dove 31 persone che lavoravano in un laboratorio di ricerca lo avevano contratto dalle scimmie verdi africane. Oggi il virus Marburg viene tenuto congelato nei laboratori di massima sicurezza di tutto il mondo. È così contagioso che gli scienziati non possono studiarlo. L'habitat naturale del virus è ancora sconosciuto.

COLORS

3

a magazine about the rest of the world una rivista che parla del resto del mondo

COLORS n.7

Let's talk about fashion.
Let's talk about sex.
Let's talk about death.
Let's really talk about Aids.

Parliamo di moda.
Parliamo di sesso.
Parliamo di morte.
Parliamo di AIDS.

2

HIDDEN IN THE FOLDS

THE LANGUOR OF DRAPERY
IN THE CLASSICAL MODE

Velvet-and-metal collar, above, by Anat Grozavsky, about $350.
At Anat Grozavsky, 28 rue Sedaine, Paris. Bronze chiffon coat, Bill Blass, $1,350.
At Saks Fifth Avenue. Right: Rayon dress, about $705, and peplum, about $715,
both by Comme des Garçons. At Barneys New York.

PHOTOGRAPHS BY SARAH MOON

1

1

Title *"Hidden in the Folds"*
Design Firm *The New York Times Magazine,*
New York, NY
Art Director *Janet Froelich*
Designer *Cathy Gilmore-Barnes*
Stylist *Franciscus Ankoné*
Photographer *Sarah Moon*
Publisher *The New York Times Company*

2
Title *"The Custom of the Country"*
Design Firm *The New York Times Magazine,*
New York, NY
Art Director *Janet Froelich*
Designer *Nancy Harris*
Illustrator *Mats Gustafson*
Publisher *The New York Times Company*

2

Les femmes s'habillent bien dans les pays où elles se déshabillent souvent.

Women dress well in countries where they undress often.
—FRENCH SAYING

African-print cotton shawl with raffia fringes by Christian Lacroix, left. About $500. To order through Boutique Christian Lacroix, Paris. Far left: Philippe Model's "cloud" hat in cotton organza.

The Custom of the Country

DRAWINGS BY
MATS GUSTAFSON

1

Title *"Generation X"*
Design Firm *The New York Times Magazine, New York, NY*
Art Director *Janet Froelich*
Designer *Joel Cuyler*
Photographer *Leon A. Borensztein*
Photo Editor *Kathy Ryan*
Publisher *The New York Times Company*

2

Title *"The Killer in the Next Tent"*
Design Firm *The New York Times Magazine, New York, NY*
Art Director *Janet Froelich*
Designer *Petra Mercker*
Photographer *Sebastiao Salgado*
Photo Editor *Kathy Ryan*
Publisher *The New York Times Company*

1

GENERATION 未知

TEXT BY KARL TARO GREENFELD

With the bubble economy of the 80's came the Speed Tribes — bikers, porn stars, club girls — subcultures more gritty, more sexy, more *Western* than Japan has ever seen before.

PHOTOGRAPHS BY LEON A. BORENSZTEIN

I AM HALF-JAPANESE, BORN IN KOBE OF AN American father and a Japanese mother. A few years ago I moved to Tokyo, where I began dating a 20-year-old Englishwoman. Nina had short blond hair and the pale, blemish-free skin Japanese men are very fond of. She was what they call a "hostess." For five hours a night, six nights a week, she poured drinks for, batted eyelashes at and made small talk with Japanese businessmen at a popular hostess bar. She was paid handsomely for her services — $65 an hour, plus tips of about $200 a night. Altogether, more than $10,000 a month. I saw her late at night, at the earliest around 1 A.M., usually later. Some nights, she never showed up at all. If our relationship was to work, no jealousy was allowed.

But then I saw the four-carat diamond pendant dangling from Nina's neck, sparkling brightly in the white light of a street lamp. It was 2 A.M. and I was standing just inside Sunset Strip, a bar on Roppongi Dori in central Tokyo. As Nina climbed out of a dark blue Bentley convertible, its pompadoured owner and I exchanged glances, his laced with contempt and mine with jealousy. The smirking owner was three years younger than his 22-year-old driver. The driver was three years younger than I.

When I saw that four-karat diamond — big and hard enough to cut glass, flesh, soul or whatever you put in its path — I felt pangs of jealousy, anger and resentment, first toward the smug Japanese guy who had given it to her and then toward Nina herself. When she entered the bar I told her I wanted to leave, and she shrugged and said, "Fine."

Nina walked ahead of me. She was wearing a tight, short black dress and, as usual, flat shoes; she didn't want to appear taller than her Japanese customers. We passed a shuttered vegetable shop, a small hotel and a convenience store before she turned to me and said, in her Cockney accent, "And what the hell's wrong with you?"

This article is adapted from "Speed Tribes: Days and Nights With Japan's Next Generation," to be published this fall by HarperCollins. Copyright © 1994 by Karl Taro Greenfeld.

In the nanosecond before we were going to have it out, a throaty chorus of engine growls came up behind us. A motorcycle gang of 25 Japanese kids with permed hair and mirrored sunglasses, dressed in the green aviator suits of kamikaze pilots, roared past. From their bikes flew Rising Sun flags.

The gang rode slowly, taking up all three westbound lanes. Their small-engine bikes had been modified beyond recognition with chrome handlebars, decorative mirrors and triple-header tailpipes that increased exhaust noise to ear-splitting volume. They looked at Nina and me and revved their motors, waved their flags, hit their four trumpet horns, swerved from side to side and made sparks by striking the pavement with their kickstands. A few of the bikers catcalled or gave us the finger. Most of them just stared impassively and gunned their fantastically loud machines.

At that moment, with the bikes roaring and my hostess girlfriend beside me, I realized that the Japan I was reading about and writing about had nothing to do with the Japan I was living. Microchip dumping, trade disputes and the legendary $20 cups of coffee were real, but there was a Japan that was more real to me, grittier and sexier. Out of the prosperity of the 1980's bubble economy there had emerged a dazzling variety of new youth subcultures and rich pop cultures; gangsters, rock musicians, hostesses, porn stars, junkies, computer hackers, nightclubbers, drug dealers and bikers. I came to call them Speed Tribes.

These vibrant and predatory subcultures have survived into the depressed 90's and are reshaping Japan. Drawn from the ranks of the 25 million Japanese between the ages of 15 and 30, they bear little resemblance to the world of 12-hour-day salarymen or kimono-clad geishas familiar to Westerners. The children of the industrialists, executives and laborers who built Japan Inc. are as accustomed to hamburgers as to *onigiri* (rice balls) and are often more adept at folding a bindle of cocaine or heroin than creasing an origami crane. They are by no means the majority, but if you're looking you can see them everywhere.

Nina and I didn't break up that night; our particular bubble burst a few weeks later. What finally did us in was an argument about money. I borrowed 50,000 yen, about $400 at the time, and was a little slow paying her back. That annoyed her, so she dumped me.

And began dating the guy in the Bentley.

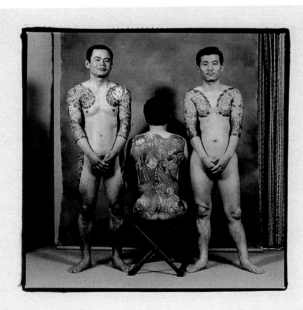

YAKUZA • GANGSTERS

These are *kobun* (soldiers) in the Nakajima-kai, an affiliate of the powerful Kyoto-based Aizu Kotetsu. Like most Japanese gangsters, Mutsuro N. (30), Yasuaki U. (31) and Ken I. (41), left to right, sport extensive body tattoos. The tattoos are acquired over the years in a painful initiation process that Ken I. likens to "being whipped slowly." The images vary widely, from the mythical boy warrior Kintaro on Yasuaki U.'s back to the intricate floral pattern on Ken I.'s chest. Younger gangsters prefer more violent themes: one junior associate had barbed wire engraved on his arm. In the 80's, the Yakuza moved beyond the traditional venues of gambling, extortion and prostitution. The younger ones began dealing drugs — something the older members wouldn't touch — and they all got into real estate and stock market speculation. Numerous gang bosses also bought their way onto the boards of legitimate businesses. But on the street, Yakuza business remains brutally simple. After this picture was taken, the three left on an urgent matter: a "client" was three weeks late repaying a million-yen loan (about $10,000). It was time to collect.

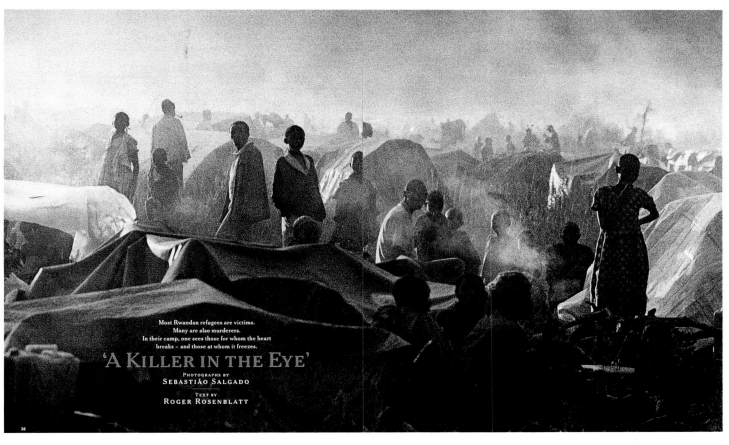

Most Rwandan refugees are victims.
Many are also murderers.
In their camp, one sees those for whom the heart
breaks – and those at whom it freezes.

'A KILLER IN THE EYE'

PHOTOGRAPHS BY
SEBASTIÃO SALGADO

TEXT BY
ROGER ROSENBLATT

'Bodies appear in an explosion of spray at the top of a steep falls, and then spin and tumble down like logs on the way to a mill.'

'It is a marketplace, perhaps the largest in the world. One man sells radio parts, another beer made from maize. A medicine man has hung up his shingle.'

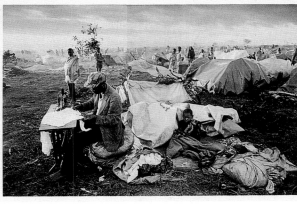

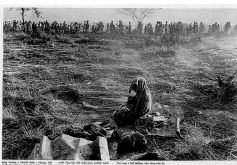

'The killers sleep and eat with the others, and brush alongside them as they walk, and, possibly, wait for another opportunity to strike.'

'A new pump is being installed in the brown lake, but it's too late. An epidemic awaits.'

1

Title *Treasures Dreamt Of, Wishes Answered*
Design Firm *M/W Design, New York, NY*
Art Directors *Allison Muench and J. P. Williams*
Photographer *Carton Davis*
Copywriter *Laura Silverman*
Client *Takashimaya NY*
Printer *Diversified Graphics*
Paper *Fox River Winstead Glo-brite 120# Cover, Karma Matte Text, Champion Benefit Envelope*

1

clearly unusual

THE TERRACE SHOP ON THE MAIN LEVEL
An object of beauty, to gracefully
adorn a boudoir, a dining table.
Exclusively ours in New York.
Square glass vase holds 5 handblown
buoys to float flowers.
10" x 10" x 5". France, {4a} $185.
Extra bouys, {4b} $18/ea.
HOME FURNISHINGS ON THREE
Ethereal metal frames hold your
photographs suspended
between glass panes. Two frames
are hinged together with a
spring and stand upright without
additional support.
Small, 2$^1/_2$" x 2$^1/_2$", {5a}, $45.
Large, 3$^1/_2$" x 3$^1/_2$", {5b} $50.

1.800.753.2038

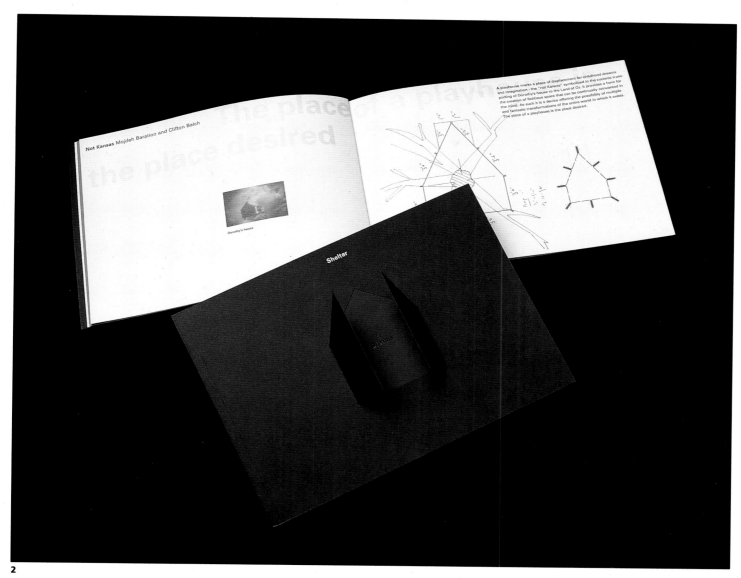

Not Kansas Mojdeh Baratloo and Clifton Balch

Dorothy's house

the place of a playh

the place desired

Shelter

A playhouse marks a place of displacement for childhood dreams and imagination - the "not Kansas" symbolized in the cyclonic transporting of Dorothy's house to the Land of Oz. It provides a form for the creation of fictitious space that can be continually reinvented in the mind. As such it is a device offering the possibility of multiple and fantastic transformations of the entire world in which it exists. The place of a playhouse is the place desired.

2

2
Title *"Shelter & Dreams"*
Design Firm *Context, Inc., South Norwalk, CT*
Art Director *Thomas Morin*
Designer/Typographer *Daphne Geismar*
Photographer *Bill West*
Client *Katonah Museum of Art*
Printer *Finlay Brothers Printing*
Paper *Hopper Kiana*

3

3
Title *Olson Sundberg Promotional Mailer*
Design Firm *The Traver Company, Seattle, WA*
Art Director *Ann Traver*
Designers *Ann Traver and Wendy Gerard*
Photographers *Dick Busher, Robert Pisano, and Michael Jensen*
Copywriter *Jim Olson*
Printers *Ink on Paper, Printing Control*
Paper *Strathmore*

1
Title *"Making Order Out of Chaos" Brochure*
Design Firm *Frazier Design, San Francisco, CA*
Art Director *Craig Frazier*
Designers *Craig Frazier and Rene Rosso*
Illustrator/Copywriter *Craig Frazier*
Photographers *Various*
Client *Frazier Design*
Typographer *Frazier Design*
Printer *Watermark Press*

2
Title *Annual Report Myths (Self-Promotion)*
Design Firm *Corporate Reports, Inc., Atlanta, GA*
Art Director/Designer/Illustrator *Brant Day*
Copywriter *Sandra Dempsey Furbish*
Client *Corporate Reports, Inc.*
Typographer *Drew Blackeney*
Printer *Williams Printing*
Paper *Simpson Starwhite Vicksburg*

1

2

3

3
Title *San Francisco Airport Catalogs*
Design Firm *Carbone Smolan Associates, New York, NY*
Art Director *Leslie Smolan*
Designer *Jennifer Domer*
Photographers *Peter Medilek, Lynton Gardiner,*
John Paul Endress
Client *San Francisco Inernational Airport Commission,*
Bureau of Exhibitions
Printer *D. L. Terwilliger, Sterling-Roman*
Paper *Champion Kromekote Recycled,*
Champion Carnival Felt

4

4
Title *Between Paris and Tokyo*
Design Firm *M/W Design, New York, NY*
Art Directors *Allison Muench and J. P. Williams*
Illustrator *J. P. Williams*
Photographer *Lisa Charles Watson*
Copywriter *Laura Silverman*
Client *Takashimaya NY*
Printer *Daniels Printing*
Paper *Monadnock Dulcet*

1

Title *"Elements of Time" Perpetual Calendar*
Design Firm *Designframe, Inc., New York, NY*
Art Directors *James A. Sebastian and Michael McGinn*
Designers *James A. Sebastian and Frank Nichols*
Client *Strathmore Paper*
Typographer *James Lung*
Printer/Fabricator *Diversified Graphics*
Paper *Strathmore Elements Text*

2

Title *Expressionizm*
Design Firm *Higashi Glaser Design, Fredericksburg, VA*
Art Directors/Illustrators *Sandra Higashi and Byron Glaser*
Designers/Typographers *Sandra Higashi, Byron Glaser, and Jennifer Tatham*
Photographers *Don Chiappinelli and Peter Kaplan*
Client/Fabricator *Zolo Inc.*
Paper *French Butcher White, Riverside Construction, Dry Waxed Kraft, and Newsprint*

1

2

3

3
Title *Artistic Aspects of Color*
Design Firm *Designframe, Inc., New York, NY*
Art Directors *James A. Sebastian and Margaret Biedel*
Designers *Margaret Biedel and Sarah Kloman*
Photographers *Christopher Gallo, Pete McArthur, Nicholas Everleigh, David Sawyer, Geoff Spear, David Stewart, Taka, Max Schulz, Kenji Toma, Neal Farris, Charles Maraia*
Copywriter *Augustine Hope*
Client *Strathmore Paper*
Typographer *Terence Foley*
Printer *Diversified Graphics*
Paper *Strathmore Grandee Cover, Strathmore Renewal Cover, Strathmore Elements Cover*

4
Title *Weyerhaeuser Remembering the WPA*
Design Firm *Sibley/Peteet Design, Dallas, TX*
Art Director/Designer *Don Sibley*
Illustrators *Various*
Photographers *Various*
Copywriter *Kevin Johnson*
Client *Weyerhaeuser Paper*
Typographer *Sibley/Peteet Design*
Printer *Woods Lithographics*
Paper *Weyerhaeuser Recycled Jaguar*

4

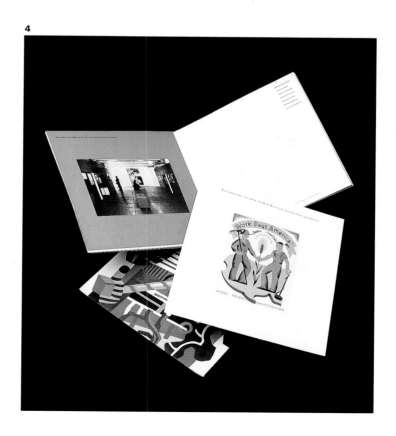

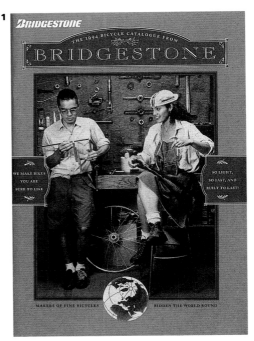

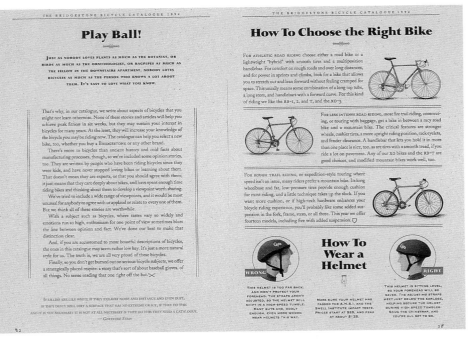

Play Ball!

JUST AS NOBODY LOVES PLANTS AS MUCH AS THE BOTANIST, OR BIRDS AS MUCH AS THE ORNITHOLOGIST, OR BAGPIPES AS MUCH AS THE FELLOW IN THE DOWNSTAIRS APARTMENT, NOBODY LOVES BICYCLES AS MUCH AS THE PERSON WHO KNOWS A LOT ABOUT THEM. IT'S EASY TO LOVE WHAT YOU KNOW.

That's why, in our catalogue, we write about aspects of bicycles that you might not learn otherwise. None of these stories and articles will help you achieve peak fitness in six weeks, but they may sustain your interest in bicycles for many years. At the least, they will increase your knowledge of the bicycle you may be riding now. The catalogue can help you select a new bike, too, whether you buy a BRIDGESTONE or any other brand.

There's more to bicycles than ancient history and cold facts about manufacturing processes, though, so we've included some opinion stories, too. They are written by people who have been riding bicycles since they were kids, and have never stopped loving bikes or learning about them. That doesn't mean they are experts, or that you should agree with them; it just means that they care deeply about bikes, and have spent enough time riding bikes and thinking about them to develop a viewpoint worth sharing.

We've tried to include a wide range of viewpoints, and it would be most unusual for anybody to agree with or applaud or relate to every one of them. But we think all of these stories are worthwhile.

With a subject such as bicycles, where tastes vary so widely and emotions run so high, enthusiasm for one point of view sometimes blurs the line between opinion and fact. We've done our best to make that distinction clear.

And, if you are accustomed to more boastful descriptions of bicycles, the ones in this catalogue may seem rather low key. It's just a more natural style for us. The truth is, we are all very proud of these bicycles.

Finally, so you don't get burned out on serious bicycle subjects, we offer a strategically placed respite: a story that's sort of about baseball gloves, of all things. No sense reading that one right off the bat.

IF LILLIES ARE LILY WHITE IF THEY EXHAUST NOISE AND DISTANCE AND EVEN DUST, IF THEY DUSTY WILL DIRT A SURFACE THAT HAS NO EXTREME GRACE, IF THEY DO THIS AND IT IS NOT ALL IT IS NOT AT ALL NECESSARY IS THEY DO THIS THEY NEED A CATALOGUE.
— Gertrude Stein

How To Choose the Right Bike

FOR ATHLETIC ROAD RIDING choose either a road bike or a lightweight "hybrid" with smooth tires and a multiposition handlebar. For comfort on rough roads and over long distances, and for power in sprints and climbs, look for a bike that allows you to stretch out and lean forward without feeling cramped for space. This usually means some combination of a long top tube, a long stem, and handlebars with a forward curve. For this kind of riding we like the RB-1, 2, and T, and the XO-3.

FOR LESS INTENSE ROAD RIDING, most fire trail riding, commuting, or touring with baggage, get a bike in between a racy road bike and a mountain bike. The critical features are stronger wheels, cushier tires, a more upright riding position, rack eyelets, and fender clearance. A handlebar that lets you hold it in more than one place is nice, too, as are tires with a smooth tread, if you ride a lot on pavement. Any of our XO bikes and the RB-T are good choices, and modified mountain bikes work well, too.

FOR ROUGH TRAIL RIDING, or expedition-style touring where speed isn't an issue, many riders prefer a mountain bike. Its long wheelbase and fat, low-pressure tires provide enough cushion for most riding, and a little technique takes up the slack. If you want more cushion, or if high-tech hardware enhances your bicycle riding experience, you'll probably like some added suspension in the fork, frame, stem, or all three. This year we offer fourteen models, including five with added suspension.

How To Wear a Helmet

WRONG

THIS HELMET IS TOO FAR BACK, AND WON'T PROTECT YOUR FOREHEAD. THE STRAPS AREN'T ADJUSTED, SO THE HELMET WILL SHIFT IN A HIGH-SPEED TUMBLE. MANY GUYS AND, ODDLY ENOUGH, EVEN MORE WOMEN WEAR HELMETS THIS WAY.

MAKE SURE YOUR HELMET HAS PASSED THE A.N.S.I. AND THE SNELL INSTITUTE IMPACT TESTS. PRICES START AT $25, AND PEAK AT ABOUT $125.

RIGHT

THIS HELMET IS SITTING LEVEL, SO YOUR FOREHEAD WILL BE SAVED. THE ADJUSTING STRAPS MEET JUST BELOW THE EARLOBE, HELPING SECURE THE HELMET DURING HIGH-SPEED TUMBLES. SNUG THE CHINSTRAP, AND YOU'RE ALL SET TO GO.

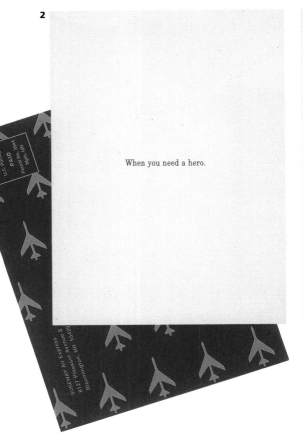

When you need a hero.

Sure way to make a withdrawal.

Jesse James

1

Title *1994 Bridgestone Bicycle Catalog*

Design Firm *DeFrancis Studio, Norwich, VT*

Art Directors *Greg Galvan and Lisa DeFrancis*

Designer *Greg Galvan*

Illustrator *George Retsek*

Photographer *Bob Schenker*

Copywriters *Grant Petersen, Various*

Client *Bridgestone Cycle (USA), Inc.*

Typographer *DeFrancis Studio*

Printer *Anderson Lithograph*

Paper *Domtar Sandpiper 100% Post-Consumer Waste*

2

Title *Sureway Air Express Direct Mail Brochure*

Design Firm *Woychick Design, Minneapolis, MN*

Art Director/Designer *Dan Woychick*

Photographer *Mark LaFavor*

Copywriter *Tim Naylor*

Client *Sureway Air Express*

Printer *Shapco Printing*

Paper *Potlatch Vintage Remarque*

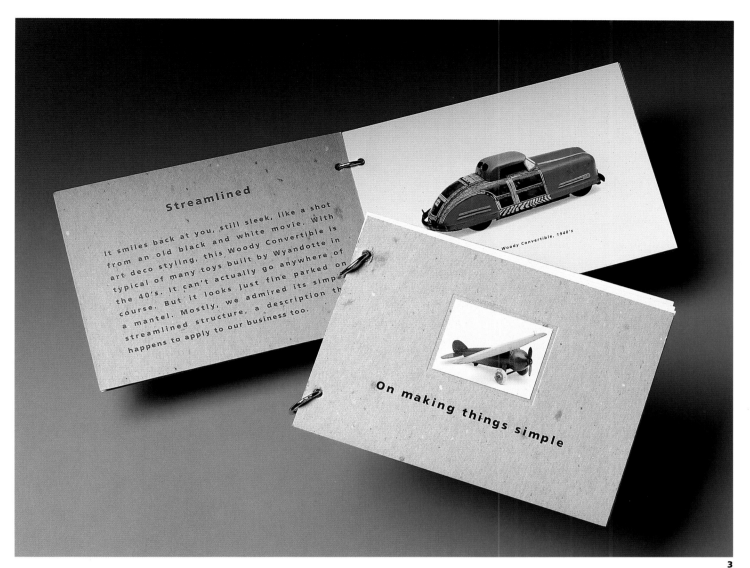

Streamlined

It smiles back at you, still sleek, like a shot from an old black and white movie. With art deco styling, this Woody Convertible is typical of many toys built by Wyandotte in the 40's. It can't actually go anywhere of course. But it looks just fine parked on a mantel. Mostly, we admired its simp... streamlined structure, a description th... happens to apply to our business too.

Woody Convertible, 1940's

On making things simple

3

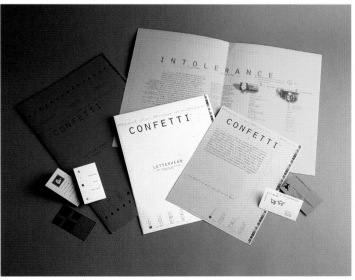

4

3
Title *"Keep It Simple" Brochure*
Design Firm *P. S. Studios, Phoenix, AZ*
Art Directors/Designers *Peter Shikany and Judy Smith*
Photographer *Bob Carey*
Copywriter *Jill Spear*
Client/Printer *Ben Franklin Press*
Paper *French Dur-o-tone, Springhill C/S Bristol*

4
Title *Confetti self-promotion*
Design Firm *Tolleson Design, San Francisco, CA*
Art Directors/Designers *Steven Tolleson and Jennifer Sterling*
Copywriter *Lindsay Beaman*
Client *Fox River Paper Company*
Typographer *Tolleson Design*
Printer *Neenah Printing*
Paper *Fox River Confetti*

1
Title *Fall 1995 Women's Apparel Catalog*
Design Firm *Nike Design, Beaverton, OR*
Art Director/Designer *Carol Richards*
Photographer *John Huet (Cover)*
and Gary Hush (Products)
Copywriters *Bob Lambie and Stanley Hainsworth*
Client *Nike, Inc.*
Typographer *Terrie Thompson*
Printers *Irwin-Hodson, Graphic Arts Center,*
Anderson Litho
Paper *Kirk Brilliant Art Gloss Cover and Potlatch*
Northwest Gloss Text

2
Title *Fall 1995 Footwear Catalog*
Design Firm *Nike Design, Beaverton, OR*
Art Director/Designer *Carol Richards*
Photographers *Lars Topelmann (Cover)*
and Gary Hush (Products)
Copywriters *Bob Lambie and Stanley Hainsworth*
Client *Nike, Inc.*
Typographer *Terrie Thompson*
Printers *Irwin-Hodson, Graphic Arts Center,*
Anderson Litho
Paper *Kirk Brilliant Art Gloss Cover and Potlatch*
Northwest Gloss Text

3
Title *Fall 1995 Men's Apparel Catalog*
Design Firm *Nike Design, Beaverton, OR*
Art Director/Designer *Carol Richards*
Photographers *John Huet (Cover)*
and Gary Hush (Products)
Copywriters *Bob Lambie and Stanley Hainsworth*
Client *Nike, Inc.*
Typographer *Terrie Thompson*
Printers *Irwin-Hodson, Graphic Arts Center,*
Anderson Litho
Paper *Kirk Brilliant Art Gloss Cover and Potlatch*
Northwest Gloss Text

4
Title *Volkswagen Concept 1 Car Brochure*
Design Firm *SHR Perceptual Management,*
Scottsdale, AZ
Art Directors/Designers *Dennis Merritt*
and Karin Burklein Arnold
Photographer *Rodney Rascona*
Copywriter *Steve Hutchison*
Client *Volkswagen of America*
Printer *Clark Graphic Service*
Paper *Potlatch Eloquence 110# Text and Cover*

5
Title *Jordan Jumpman Brochure*
Design Firm *Nike Inc., Beaverton, OR*
Art Director/Designer *Katy Tisch*
Illustrator *Ken Black*
Photographer *John Huet*
Copywriter *Neil Webster*
Client *Nike, Inc.*
Typographer *Margaret Spenser*
Printer *Irwin-Hodson*
Paper *Gilbert Gil Clear Light (Flysheet),*
80# Teton White Cover, and 80# Karma Text

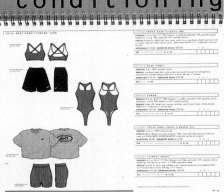

4

INNOVATION EMBODIED IN TRADITION.

A NEW VOLKSWAGEN CONCEPT.

ONE LOOK AND

IT ALL COMES BACK. BUT THEN, IT NEVER REALLY

LEFT. THE LEGEND REBORN. A FRIENDSHIP REKINDLED.

5

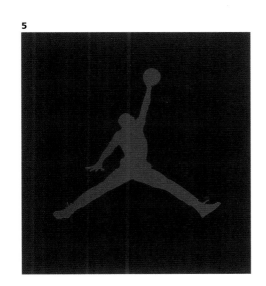

JUMPMAN IS NIKE'S MICHAEL JORDAN SIGNATURE LINE OF TOPFLIGHT HOOP APPAREL.

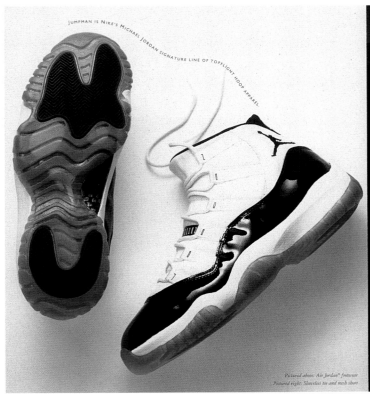

Pictured above: Air Jordan® footwear
Pictured right: Sleeveless tee and mesh short

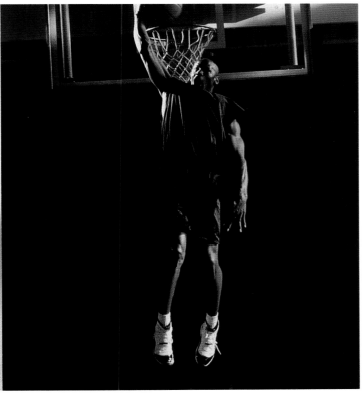

1

2

1
Title *LinoGraphics Price Guide '94*
Design Firm *KODE Associates, Inc., New York, NY*
Art Director/Designer *William Kochi*
Photographers *William Kochi and FPG International*
Client *LinoGraphics Corporation*
Typographer *KODE Associates, Inc.*
Printer *Otis Graphics*
Binder *Riverside Group*
Paper *Neenah Buckskin Cover, Strathmore Elements Lines Text*

2
Title *Sci-Fi Channel Sales Brochure*
Design Firm *Spot Design, New York, NY*
Art Directors *Drew Hodges and Elisa Feinman*
Designers *Naomi Mizusaki and Vincent "Boom Boom" Sainato*
Copywriter *Allison Villone*
Client *Sci-Fi Channel*
Printer *Red Ink Productions*

3

Title *Pushpin Jr. Self-Promotion*
Design Firm *The Pushpin Group, Inc., New York, NY*
Art Director/Illustrator *Seymour Chwast*
Designer *Roxanne Slimak*
Copywriter *Seymour Chwast*
Client *The Pushpin Group, Inc.*
Printer *Berman Printing Company*
Paper *Frostbrite Matte 80# Cover*

4

Title *Cliché Self-Promotional Brochure*
Design Firm *The Pushpin Group, Inc., New York, NY*
Art Director/Illustrator *Seymour Chwast*
Designer *Roxanne Slimak*
Photographers *Ed Spiro and Peter Bittner*
Copywriter *Moira Cullen*
Client *The Pushpin Group, Inc.*
Printer *Berman Printing Company*
Paper *Domtar Fusion 80# Medium Goldenrod Text,
Domtar Plainfield Plus 65# Antique Finish Cover, and
Domtar Plainfield Plus 100# Text, Smooth Finish*

3

4

1

1
Title *Crane A6*
Design Firm *The Office of Eric Madsen,*
Minneapolis, MN
Art Director/Designer *Eric Madsen*
Illustrator *Lynn Schulte*
Copywriter *Words at Work*
Client *Crane Business Papers*
Typographer *Kim Feldman*
Printer *Fine Arts Engraving Company*
Paper *Crane Crest, Bond, and Parchment*

2
Title *Environmental Responsibilities Update*
Design Firm *Tolleson Design, San Francisco, CA*
Art Director *Steven Tolleson*
Designers *Steven Tolleson and Jean Orlebeke*
Photographers *Tom Tracy and David Magnusson*
Copywriter *Diane Olberg*
Client *Potlatch Corporation*
Typographer *Tolleson Design*
Printer *Alan Litho*
Paper *Potlatch Vintage Velvet Recycled*

2

Ergonomists agree that the most healthful position for the body is the one it assumes in a weightless state, when no other forces (chairs, gravity, high-heeled shoes) are acting on it. This natural posture has open angles between the trunk and the thighs as well as between the thigh and the lower leg.

It can be achieved in an upright chair with a seat that tilts forward slightly to open the trunk-to-thigh angle and that can be raised high enough to permit an open angle at the knee. This forward-bias position is advocated by Danish surgeon A. C. Mandal.

A natural, open posture can also be attained in a reclining chair adjusted low enough to prevent undue pressure on the backs of the thighs when the legs are slightly extended. This semi-reclined position was observed by Swiss ergonomist Etienne Grandjean in his studies of VDT workers.

The Aeron chair's broad range of seat-height adjustment allows its users to choose either the forward-bias or semi-reclined position—or anywhere in between—over the course of a long day and through a variety of tasks. Its smooth-riding Kinemat tilt mechanism allows people to move between the two extremes with ease while maintaining proper geometric relationships among seat, back, and armrests.

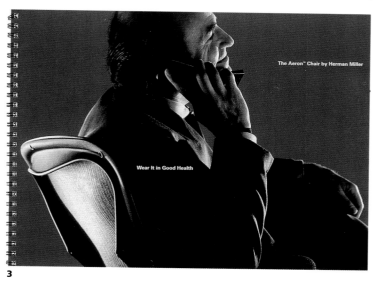

3

The Aeron™ Chair by Herman Miller

Wear It in Good Health

3

3
Title *"Wear It in Good Health: The Aeron Chair by Herman Miller"*
Design Firm *Herman Miller, Inc. (In-house)*
Art Director *Michael Barile*
Designers *Michael Barile and Yang Kim*
Illustrator *Gould Design*
Photographers *Nick Merrick and Jim Hedrich*
Copywriters *Deb Wierenga and Dick Holm*
Client *Herman Miller, Inc.*
Printer *Etheridge Company*
Paper *Consolodated 85# Reflections Cover*

4
Title *Art Center College of Design Catalog 1995–1996*
Design Firm *Art Center College of Design, Pasadena, CA*
Art Directors *Stuart I. Frolick and Rebeca Méndez*
Designers *Darin J. Beaman and Chris Haaga*
Photographer *Steven A. Heller*
Client/Publisher *Art Center College of Design*
Printer *Typecraft, Inc.*
Paper *100# Matrix Dull Text*

4

ART CENTER COLLEGE OF DESIGN CATALOG 1995-96

1
Title *Strathmore Elements Advertising Campaign*
Design Firm *Bailey Lauerman & Associates, Lincoln, NE*
Art Director *Carter Weitz*
Copywriter *Mitch Koch*
Client *Western Paper Company*
Paper *Strathmore Elements*

2
Title *Sundial*
Design Firm *Sagmeister Inc., New York, NY*
Art Director *Stefan Sagmeister*
Designer/Illustrators *Stefan Sagmeister and Veronica Oh*
Copywriter *Stefan Sagmeister*
Typographers *Stefan Sagmeister and Veronica Oh*
Printer/Fabricator *Robert Kushner*
Paper *80# Matte Coated Text Mounted on 20 pt. Chipboard*

3
Title *Rhymes and Reasons*
Design Firm *CFD Design, Phoenix, AZ*
Art Director/Designer *Steve Ditko*
Photographer *Rick Rusing*
Copywriter *Jill Spear*
Client *Uh Oh Clothing Boutique*
Printer *AZ Dryography*

1

2

3

4
Title *DGI Business Presentation Kit*
Design Firm *Shannon Designs, Minneapolis, MN*
Designer *Alyn Shannon*
Photographers *Craig Perman and Peter Caley*
Copywriter *Debby Kuehn*
Client *Diversified Graphics Inc.*
Typographer *Shannon Designs*
Printer *Diversified Graphics Inc.*
Paper *Custom Color Curtis Tweedweave Cover, Canson
Satin and Prairie Flex, Trophy Gloss Text,
and Strathmore Grandee*

5
Title *Dallas Opera Guild Wine Auction Invitation*
Design Firm *Joseph Rattan Design, Dallas, TX*
Art Director *Joseph Rattan*
Designer/Typographer *Greg Morgan*
Client *Dallas Opera Guild*
Printer *Padgett Printing*
Paper *Simpson Evergreen Birch and Kraft (Envelope),
Simpson Evergreen Matte Natural Cover (Reply Card),
Simpson Evergreen Matte Natural Book (Booklet)*

6
Title *Pleasure Place Direct Mailer*
Design Firm *Graffito, Baltimore, MD*
Art Director/Designer *Morton Jackson*
Photographer *Martin Schulman*
Client *Pleasure Place*
Typographer *Grafitto*
Printer *Schmitz Press*
Paper *100# Productolith Dull Cover*

4

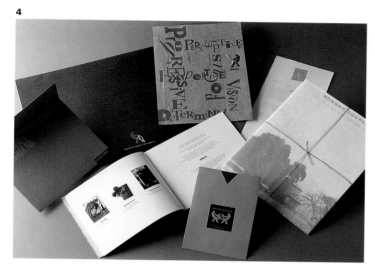

5

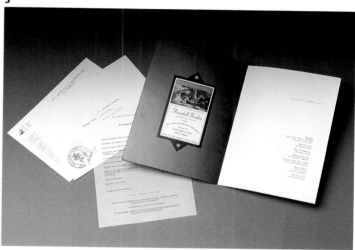

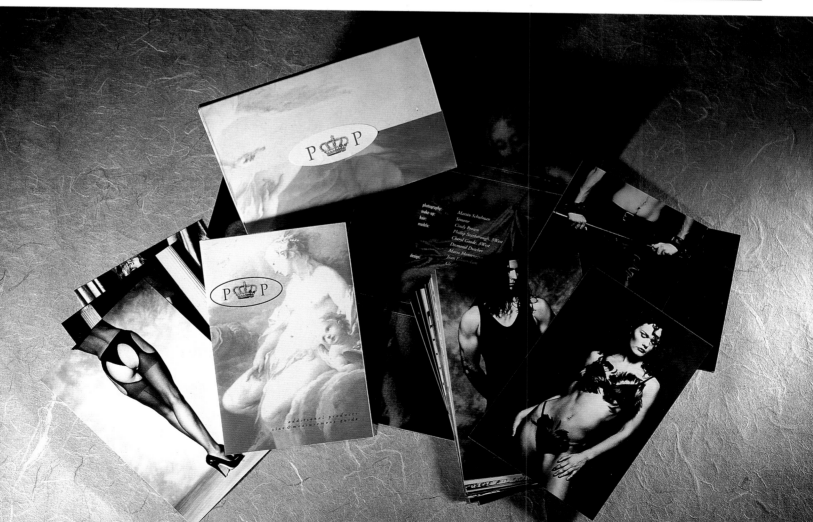

1

Title *Dynagraf Pre-press Envelope*
Design Firm *Lee Allen Kreindel, West Newton, MA*
Art Director/Designer *Lee Allen Kreindel*
Copywriter *Roy Fischer*
Client *Dynagraf, Inc.*
Typographer *Lee Allen Kreindel*
Printer/Fabricator *Dynagraf, Inc.*
Paper *Simpson Starwhite Vicksburg Tiara Cover*

2

Title *1995 Bauer In-Line Skate Catalog*
Design Firm *Visual Marketing Associates, Dayton, OH*
Art Directors *Christopher Barcelona and Steve Goubeaux*
Designer *Christopher Barcelona*
Photographer *AGI Photographic Imaging*
Client *Canstar Sports Group, Inc.*
Printer/Fabricator *The Central Printing Co.*
Paper *French Dur-o-Tone*

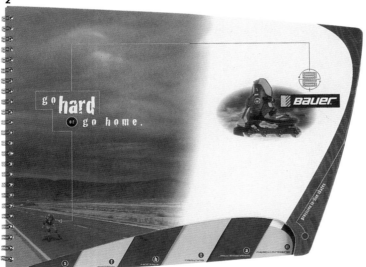

3
Title *Maryland Institute College of Art Student Catalog*
Design Firm *Franek Design Associates, Inc.*
Washington, DC
Art Director *David Franek*
Designers *David Franek, Jeff Wilt, and*
Marvin McNeil
Photographer *Joe Rubino*
Copywriter *Debra Rubino*
Client *Maryland Institute College of Art*
Typographer *Franek Design Associates, Inc.*
Printer *Strine Printing Co.*
Paper *Fridaflack Gray 18 pt. Recycled Book (Slipcase)*
and Mohawk Opaque White Smooth 80# Cover,
70# Text Recycled

4
Title *Caterpillar Diversity Brochure*
Design Firm *Mark Oldach Design, Chicago, IL*
Art Director *Mark Oldach*
Designer *Jennifer Wyville*
Copywriters *Kelly Geier and Emmy Wright*
Client *Caterpiller Inc., Wheel Loaders*
and Excavators Division
Printer *Active Graphics, Inc.*
Paper *French Dur-o-tone White Newsprint*

3

4

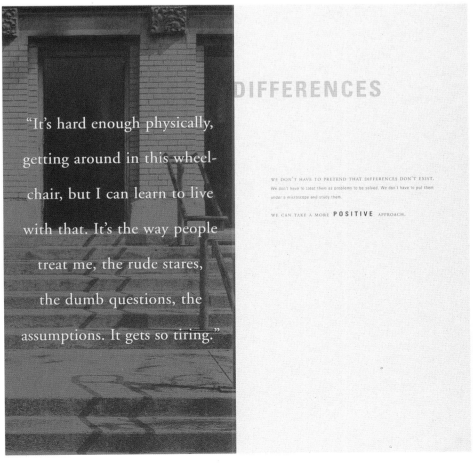

el•e•ments n, 1. any of the 103 things on the periodic table. 2. any of the two or three things on the periodic credenza. *e.g.; Graves picture frame, Braun calculator.*

1
Title *Keilhauer Designer Dictionary*
Design Firm *Vanderbyl Design, San Francisco, CA*
Art Director/Designer *Michael Vanderbyl*
Illustrator *Eric Donelan*
Copywriter *David Betz*
Client *Keilhauer*
Printer *Campbell Graphics*

2
Title *Crane's Global Guide*
Design Firm *Chermayeff & Geismar Inc., New York, NY*
Art Director *Steff Geissbuhler*
Designer *James D. McKibben*
Copywriter *Lisa Freidman*
Client *Crane & Co.*
Typographer *Chermayeff & Geismar Inc.*
Printer *Milocraft*
Paper *Crane's Parchment Fluorescent White 67#, Crane's Crest Fluorescent White 28#*

3

Title *"What Goes Into Making Paper?" Self-Promotion*
Design Firm *Carlson Design, Des Moines, IA*
Art Director/Designer *Ken Carlson*
Copywriter *Lisa Kingsley*
Client *Jerusalem Paperworks*
Printer *Lunalux/Pat McCall*
Paper *Hand Made from Cornstalks, Coffee, and Junk Mail*
Paper Fabricator *Alan Potash/Jerusalem Paperworks*

4

Title *Oh Boy Self-Promotion 2*
Design Firm *Oh Boy, A Design Company,*
San Francisco, CA
Art Director *David Salanitro*
Designers/Illustrators *David Salanitro*
and Lisa Weston
Photographer *Sharon Beals*
Copywriter *Laura Ellen Smith*
Printer *Expressions Lithography*
Fabricator *Brake Manufacturing*
Paper *Fox River Confetti 80# Brown Cover,*
Potlatch Karma 80# White Cover, and Neenah UV
Ultra 36# Radiant White

3

4

Design Firm *Thomas Ryan Design, Nashville, TN*
Art Director/Designer *Thomas Ryan*
Illustrator *Paul Ritscher*
Photographer *McGuire*
Copywriter *John Baeder*
Client *Cracker Barrel Old Country Store, Inc.*
Typographer *Thomas Ryan Design*
Printer *Buford Lewis Company*
Paper *French Dur-o-Tone Cover and Text*

2
Title *Greater Pittsburgh Council Boy Scouts
of America 1993 Annual Report*
Design Firm *John Brady Design Consultants,
Pittsburgh, PA*
Art Director *John Brady*
Designers/Illustrators *John Brady
and Rick Madison*
Photographer *Christopher Caffee*
Copywriter *Greater Pittsburgh Council*
Client *Greater Pittsburgh Council*
Typographer *John Brady Design Consultants*
Printer *Reed and Witting*
Fabricator *Boy Scouts*
Paper *Special Cotton "Linter" Pulp Cover,
Simpson Quest 80# Putty and Moss Text, and
Fasson 70# Premium Uncoated Soft Cream Text*

1

2

highlights:
membership 1994

Baltimore Area Council
Registered Members December 31, 1994

cub scouting		
Total Available Boys (ages 7-10)	89,305	
Registered Tiger Cubs (age 7)	2,899	
Registered Cub Scouts (ages 8-10)	16,735	
Total Cub Scouts	19,634 (+2.0%)*	
Market Penetration	22%	
Total Cub Scout Packs	420	

boy scouting		
Total Available Boys (ages 11-13)	48,089	
Registered Boy Scouts	7,966	
Registered Varsity Scouts	106	
Total Boy Scouts	8,072 (+2.8%)*	
Market Penetration	17%	
Total Troops & Teams	345	

exploring		
Total Available Youth (Males & Females ages 14-17)	84,790	
Learning For Life	7,170	
Traditional Explorers	1,003	
Total Explorers	8,173 (+4.0%)*	
Market Penetration	10%	
Total Posts	96	

total youth		
Total Available Youth	222,184	
Registered Youth Members	35,879 (+2.6%)*†	
Market Penetration	16%	
Total Units	861 (+3.0%)*	

Total Youth Served	57,365

*Growth over prior year.

SCHOOL NIGHT

The council's annual School Night for Scouting was held September 22, 1994, at over 350 elementary schools throughout central Maryland. Nearly 5,000 new youth joined Scouting's ranks.

URBAN SCOUTING

Urban Scouting uses fun, competition and achievement as a real antidote for the serious socio-economic problems facing youth in depressed communities. The Baltimore Area Council's commitment to Urban Scouting continued and expanded during 1994.

The effort to bring Scouting to disadvantaged youth in the city is crucial and important. It brings the program to youth who live in some of the most troubled areas which the council serves.

The emphasis of this program is twofold. The first is to provide effective role models for youth. The second is teaching youth that Scouting builds character and self-worth.

Scouting continued at such locations as Echo House, Flag House and Murphy Homes. Additional programs were launched at Hollander Ridge Apartments, Orchard Street Mews and Boy's Home Society. The Abell Foundation grant, now in its fifth year, supported the continuation of the five Cub Scout packs that began this special program. In the fall of 1994, these packs and their members became Boy Scout troops and Boy Scouts. Many of the original members have moved through the program, continuing their Scouting careers.

The Baltimore Area Council began another special urban initiative in 1994 called "Scoutreach," to bring further Scouting programs to neighborhoods in decay. Scoutreach is an "early intervention" approach, using traditional program methods along with part-time staff that will help to develop youth in a comprehensive way. Corporate sponsors have signed on to provide the financial resources necessary to make the program a success.

3

3
Title *Boy Scouts of America,*
Baltimore Area Council, 1994 Annual Report
Design Firm *GKV Design, Baltimore, MD*
Art Director/Designer *Gene Valle*
Photographer *Boy Scouts of America Archives*
Client *Boy Scouts of America, Baltimore Area Council*
Typographer *Gene Valle*
Printer *Eichhorn Printing*
Fabricator *Opportunity Builders*
Paper *Champion Benefit 80# Ochre Cover*
and 70# Chalk Text

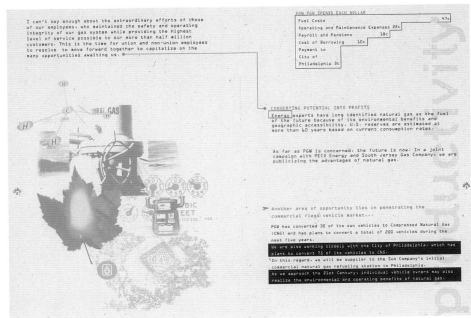

1
Title *The Progressive Corporation 1993 Annual Report*
Design Firm *Nesnadny & Schwartz, Cleveland, OH*
Art Directors *Mark Schwartz and Joyce Nesnadny*
Designers *Joyce Nesnadny, Michelle Moehler,*
and Mark Schwartz
Illustrator *Merriam-Webster, Inc.*
Photographer *Zeke Berman*
Copywriter *Peter B. Lewis*
Client *The Progressive Corporation*
Typographer *Nesnadny & Schwartz*
Printer *Fortran Printing, Inc.*
Paper *French Speckletone Black 80# Uncoated Cover,*
French Dur-o-Tone Newsprint Aged 70# Coated Text,
S. D. Warren Lustro Gloss Recycled 100# Uncoated Text,
and French Dur-o-Tone Newsprint White 70# Text

2
Title *Philadelphia Gas Works 1993 Annual Report*
Design Firm *L. F. Banks and Associates,*
Philadelphia, PA
Art Director *Lori F. Banks*
Designer *Stacie Hampton*
Photographer *Charles Baltimore*
Copywriter *David Shrieber*
Client *Philadelphia Gas Works*
Typographer *L. F. Banks and Associates*
Printer *Baker Printing*
Paper *Fox River Confetti Red Cover,*
Champion Benefit Natural Flax Text

3

Title *DuPont Merck Pharmaceutical Company
1993 Employee Annual Report*
Design Firm *Michael Gunselman Inc., Wilmington, DE*
Art Director/Designer *Michael Gunselman*
Photographer *Ed Eckstein*
Copywriter *Maureen Maloney*
Client *DuPont Merck Pharmaceutical Co.*
Typographer *Michael Gunselman Inc.*
Printer *E. John Schmitz and Sons*
Fabricator *Oxford Bookbinding Co.*
Paper *Fox River Confetti Red 80# Cover and Potlatch
Karma Natural 100# Text*

4

Title *Today's Bancorp 1994 Annual Report*
Design Firm *The Larson Group, Rockford, IL*
Art Director *Scott Dvorak,
Keith Christenson, Jeff Larson*
Designer *Scott Dvorak*
Photographer *Steve Pitkin*
Client *Today's Bancorp*
Printer *Litho Productions*
Paper *Mohawk Superfine and
Potlatch Eloquence Silk*

3

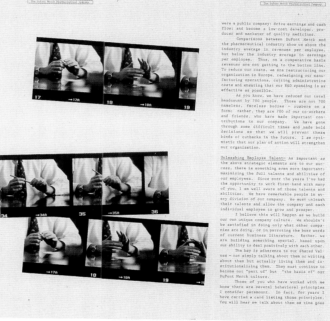

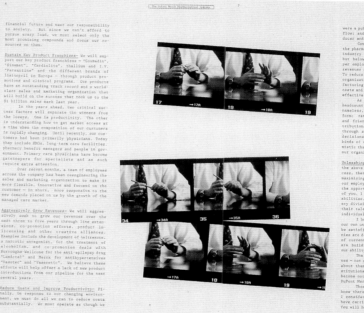

4

1

DURACELL

*One World
One Brand*

1
Title *Duracell 1994 Annual Report*
Design Firm *Addison Corporate Annual Reports,*
New York, NY
Art Director *David R. Kohler*
Designers *David R. Kohler and Margaret McGee*
Illustrators *David R. Kohler, Margaret McGee,*
and American Bank Note Company
Photographer *Mike Goldwater*
Copywriter *Jim Donahue*
Client *Duracell International, Inc.*
Typographer *Mike Sullivan/Addison Production Services*
Printer *Innovation Printing*
Fabricator *Empire Stamp Company*
Paper *Holyoke Special Duplex (Kroydon) Cover,*
Simpson Coronado 80# Text

Asia/Pacific Rim *Asia/Pacific Rim*

Entries/Entrées 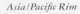 *Results/Résultats*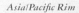

No part of the world holds greater promise for developing Duracell's "One World, One Brand" vision than does Asia—an area accounts for more than half the world's battery users, most of whom today use old-fashioned zinc carbon batteries. Within Asia, Duracell enjoys a 39 percent share of the alkaline category in Hong Kong, where annual battery consumption is estimated at 100 million units; in Taiwan, Duracell has a 59 percent share of the alkaline category. In Japan—the third largest battery market in the world after China and the United States—Duracell is broadening its distribution. And in Thailand and Indonesia, where consumers use more than one billion batteries annually, alkaline penetration is less than five percent.

Duracell this year began expanding into China, the world's single largest battery market, where consumers buy about four billion batteries every year. Yet the category there is fragmented, with no dominant brand, and an alkaline segment that barely exists.

At the heart of Duracell's China expansion plan is a joint venture formed in June, 1994 with the Dongguan Huaxin Industry and Commerce Corporation to manufacture DURACELL alkaline batteries. A 150,000-square-foot state-of-the-art facility will soon be under construction in Guangdong province, about 60 miles from Hong Kong. The facility will serve the needs of the Chinese market, while also producing DURACELL alkaline batteries for export. Consistent with its "One World, One Brand" philosophy, the DURACELL brand batteries manufactured in China will be of the same high quality as those made elsewhere, and the plant will operate with all the environmental and employee health and safety controls that Duracell demands in each of its facilities.

At the same time, Duracell is developing a China-wide sales and marketing team whose objective is to build distribution in the Pearl River delta, and in Shanghai, Beijing, and other major metropolitan areas.

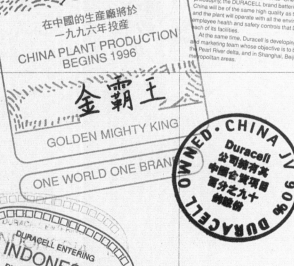

Nº DUR1994

中國潛在的需求量可達四十億個單位數
DURACELL ENTERING CHINA
MARKET POTENTIAL
4 BILLION UNITS

在中國的生産廠將於
一九九六年投産
CHINA PLANT PRODUCTION
BEGINS 1996

金霸王
GOLDEN MIGHTY KING

ONE WORLD ONE BRAND

OWNED · CHINA JV 90%
Duracell
公司擁有其
中國合資項目
百分之九十
股權
DURACELL

DURACELL ENTERING
INDONESIA
DURACELL ENTERING

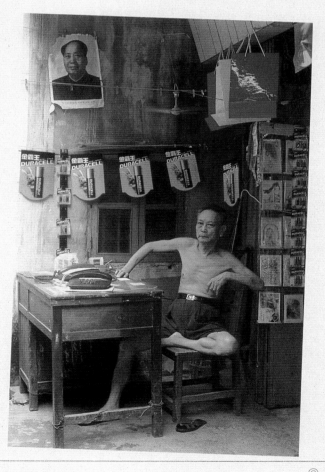

⑨

2

Title *Transamerica 1993 Annual Report*
Design Firm *Pentagram Design, San Francisco, CA*
Art Director *Kit Hinrichs*
Designer *Piper Murakami*
Illustrator *Jeffery West*
Photographers *Jeff Corwin (Cover),*
Doug Menuez, and Nikolay Zurek
Client *Transamerica Corporation*
Typographer *Quad 48*
Printer *Anderson Lithograph*
Paper *Potlatch 100# Vintage Remarque*
Gloss Cover and 80# Vintage Remarque Velvet Text

3

Title *Neurex Corporation 1994 Annual Report*
Design Firm *Cahan & Associates, San Francisco, CA*
Art Director *Bill Cahan*
Designer/Illustrator *Bob Dinetz*
Photographers *David Robin and Robert Schlatter*
Copywriter *Bruce Voss*
Client *Neurex Corporation*
Typographer *Cahan & Associates/Blue Friday*
Printer *Lithographix*
Paper *Kashmir 80# Cover and 100# Text*

1 autocam

1994 annual report

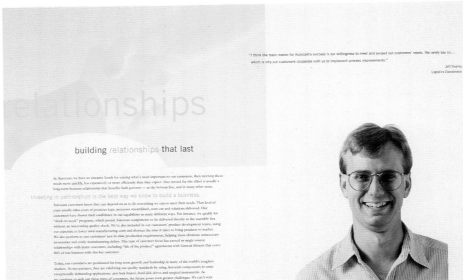

relationships

"I think the main reason for Autocam's success is our willingness to meet and exceed our customers' needs. We rarely say no.... which is why our customers cooperate with us to implement process improvements."

Jeff Duprey
Logistics Coordinator

building relationships that last

At Autocam, we have an uncanny knack for sensing what's most important to our customers, then meeting those needs more quickly, less expensively or more efficiently than they expect. Our reward for this effort is usually a long-term business relationship that benefits both partners — at the bottom line, and in many other areas.

investing in partnerships is the best way we know to build a business.

Autocam customers know they can depend on us to do everything we can to meet their needs. That level of trust usually takes years of promises kept, processes streamlined, costs cut and solutions delivered. Our customers have shown their confidence in our capabilities in many different ways. For instance, we qualify for "dock-to-stock" programs, which permit Autocam components to be delivered directly to the assembly line without an intervening quality check. We're also included in our customers' product development teams, using our expertise to lower total manufacturing costs and shorten the time it takes to bring products to market. We also perform in our customers' just-in-time production requirements, helping them eliminate unnecessary inventories and costly manufacturing delays. This type of customer focus has earned us single-source relationships with many customers, including "life of the product" agreements with General Motors that cover 86% of our business with this key customer.

Today, our customers are positioned for long-term growth and leadership in many of the world's toughest markets. As our partners, they are validating our quality standards by using Autocam components in some exceptionally demanding applications: anti-lock brakes, hard disk drives and surgical instruments. As we continue to seek out these types of customers, the future poses even greater challenges. We can't wait.

14

15

2

Technology
Solutions
C o m p a n y
1 9 9 4
Annual Report

Change Management

The companies that realize the full benefits of new systems are those that learn to reorganize methods of performing work in order to unleash the considerable intelligence and skill of their employees. Technology can be a powerful competitive tool, a source of tremendous gains in productivity and profits, but only if used effectively. The key to a successful system is excellent design and capable implementation, supported by a skilled, motivated work force. → Companies that rely on technology alone to increase productivity are often disappointed. The most visionary system, designed with consummate skill and ideally suited to a company's business, will never be a success unless the people using it are involved and committed to the changes required to make the system function properly. → Sophisticated computers and well-designed systems enable companies and people to use information to work far more effectively than they could otherwise. New systems often mean dramatic changes in the nature of jobs. People must learn entirely new ways of approaching their work. For most people, change is uncomfortable. Thus, managing the people side of technological change — helping our clients make new systems work for them in the real world of the factory floor, the customer call center or the purchasing department – is an important part of what TSC does. This is called change management. → Barbara Allendorf, responsible for change management at TSC, explains, "It is obvious that training is necessary to provide the functional skills specific to using a system. But if people are uncomfortable with change, technical training alone is not likely to succeed; it must be

accompanied by education. Education is different from training. It gives people an understanding of the reasons behind changes in the ways they are accustomed to working. By helping employees feel comfortable with new technology as a tool to improve their productivity, a successful education program provides the motivation to tolerate change and possibly to welcome it. Managing the changes in the ways people work is imperative to ensure a successful business system implementation. Too often companies attempt to make major changes without taking into account the existing culture. → "Devising a plan for organizational change requires an approach just as specialized as developing the right technical solution," Allendorf continues. "Each company has its own unique written and unwritten rules, leadership and communication styles, values regarding education and training, work ethics and expectations about technology. Using a well-designed, structured methodology, we provide educational programs focused on project management, communication and performance improvement. Our goals are to minimize communication gaps, eliminate or work around pockets of resistance, and help build the teams necessary to manage the project effectively. → "We have learned through experience that it is people, not systems, that really create benefits. That is why we accompany our technological solutions with the education that is essential for people to work effectively with systems."

→

When she is not helping clients manage change, Barbara Allendorf enjoys training winning show dogs.

creative
guidance
practical
knowhow

19

1

Title *The 1994 Autocam Annual Report*
Design Firm *Square One Design, Grand Rapids, MI*
Designer/Typographer *Leslie Black*
Photographer *Craig Vanderlende*
Copywriter *Polly Hewitt*
Client *The Autocam Corporation*
Printer *Wace*

2

Title *Technology Solutions Company 1994 Annual Report*
Design Firm *Hartford Design, Chicago, IL*
Art Director *Tim Hartford*
Designers *Tim Hartford and Chuck Gomez*
Photographers *Tom Lindfors and Kipling Swehla*
Copywriters *Patty Delony and Andrea Stack*
Client *Technology Solutions Company*
Typographers *Tim Hartford and Chuck Gomez*
Printer *Columbia Graphics Corporation*
Paper *Consolidated Centura Dull Cover and Text, James River Graphika 100, Sihl Paper SihlClear Print*

3

Title *Radio Active*
Design Firm *Petrick Design, Chicago, IL*
Art Director *Robert Petrick*
Designer *Laura Ress*
Copywriters *Kirk Brewer and Randy Michaels*
Client *Jacor Communications, Inc.*
Typographer *Henderson Typography, Inc.*
Printer/Fabricator *The Hennegan Company*
Paper *Simpson Starwhite Vicksburg Tiara*

4

Title *Molecular Dynamics 1993 Annual Report*
Design Firm *Cahan & Associates, San Francisco, CA*
Art Director *Bill Cahan*
Designer *Bob Dinetz*
Photographer *Mark Hanauer*
Copywriter *Carole Melis*
Client *Molecular Dynamics*
Typographer *Cahan & Associates/Blue Friday*
Printer *Graphic Arts Center*
Paper *Kashmir 80# Cover and*
Gilbert Gilclear 100# Text

3

clusters of stations with each station concentrating on narrower, niche formats. That clustering makes us able to provide a broad, powerful spectrum of listeners to advertisers. Focused stations can fill demographic holes missed—or mismanaged—by the competition.

Jacor approaches each of its markets with a game plan focused on generating high-impact, high-profile, difficult-to-duplicate programming. We want to be foreground radio with an actively involved audience. So we focus on

4

"The FluorImager is likely to become a key component in our efforts to produce a detailed and integrated gene map of the human genome, to complement the first-generation physical map published by CEPH and Généthon in late 1993."

THE TOLLWAY BEGAN IN 1953 WITH A MANDATE AND A VISION. BY THE END OF THE
DECADE, WE HAD OPENED OUR FIRST ROADS AND EMPLOYED 124 FULL-TIME TOLL
COLLECTORS. IN 1993, OUR GREATLY EXPANDED AND MODERNIZED SYSTEM
OPERATED SMOOTHLY 24 HOURS A DAY THANKS TO

1,960 DEDICATED MEN AND WOMEN,
INCLUDING 823 TOLL COLLECTORS.

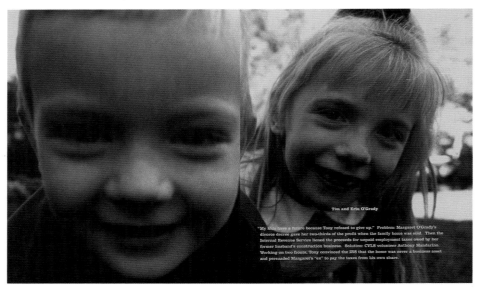

Tim and Erin O'Grady

"My kids have a future because Tony refused to give up." Problem: Margaret O'Grady's
divorce decree gave her two-thirds of the profit when the family home was sold. Then the
Internal Revenue Service liened the proceeds for unpaid employment taxes owed by her
former husband's construction business. Solution: CVLS volunteer Anthony Mandarino.
Working on two fronts, Tony convinced the IRS that the home was never a business asset
and persuaded Margaret's "ex" to pay the taxes from his own share.

1

Title *Illinois State Toll Highway Authority*
1993 Annual Report
Design Firm *VSA Partners, Inc., Chicago, IL*
Art Directors *Chris Froeter and Ted Stolk*
Designer *Chris Froeter*
Illustrator *Marc Rumaner*
Photographer *Tony Armour*
Copywriter *Jeanette Lo Curto*
Client *Illinois State Toll Highway Authority*
Printer *Rider Dickerson*
Paper *Simpson Starwhite Vicksburg Tiara*

2

Title *HOPE/Chicago Volunteer Legal Services*
1994 Annual Report
Design Firm *VSA Partners, Inc., Chicago, IL*
Art Directors *Chris Froeter and Ted Stolk*
Designer *Chris Froeter*
Photographer *Tony Armour*
Copywriter *M. Lee Witte*
Client *Chicago Volunteer Legal Services*
Typographer *Chris Froeter*
Printer *HM Graphics, Inc.*
Paper *Buckskin Cover and Mohawk Superfine Text*

3

Title *American Heart Association of*
Metropolitan Chicago 1994 Annual Report
Design Firm *Samata Associates, Dundee, IL*
Art Directors *Greg Samata and Pat Samata*
Designer *Erik Cox*
Photographers *Marc Norberg and Jack Jacobi*
Copywriter *Liz Horan*
Client *American Heart Association of Metropolitan Chicago*
Typographer *Erik Cox*
Printer *Columbia Graphics Corporation*
Paper *Simpson Coronado SST Recycled White 80# Cover*

4

Title *UNIFEM 1993 Annual Report*
Design Firm *Emerson, Wajdowicz Studios, Inc.,*
New York, NY
Art Director *Jurek Wajdowicz*
Designers *Lisa LaRochelle and Jurek Wajdowicz*
Photographer *Sebastiao Salgado*
Client *UNIFEM*
Typographer *Emerson, Wajdowicz Studios, Inc.*
Printer *H. MacDonald Printing*
Paper *Strathmore Elements*

3

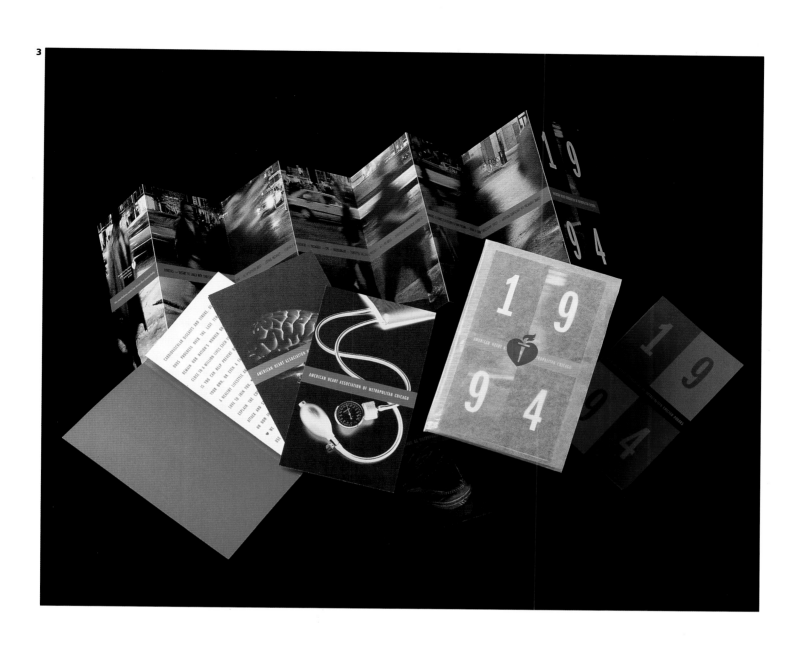

4

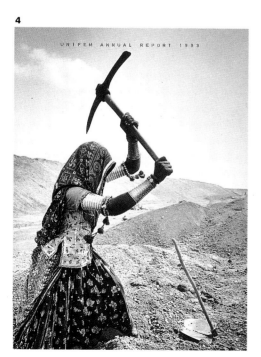

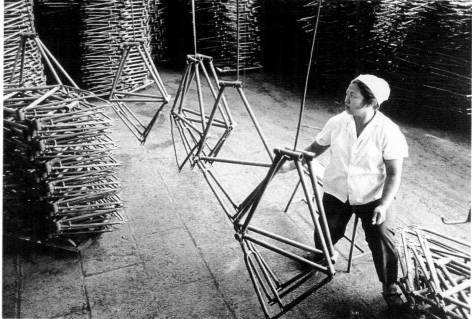

1
Title *AIGA/Seattle 1993 Annual Report*
Design Firm *Van Dyke Company, Seattle, WA*
Art Director/Designer *John Van Dyke*
Photographer *Abrams/Lacagnina*
Copywriter *Karen Wilson*
Client *AIGA/Seattle*
Typographer *Van Dyke Company*
Printer *George Rice & Sons*
Paper *Simpson Coronado SST 80# Text*

2
Title *The Bishop's School Annual Report*
Design Firm *Tyler Blik Design, San Diego, CA*
Art Director *Tyler Blik*
Designer *Todd St. John*
Illustrator *Gary Benzel*
Photographers *Students with Disposable Cameras*
Copywriter *Suzanne Baral Weiner*
Client *The Bishop's School*
Printer *Vanguard Litho*
Paper *Regal Jersey Leatherette Cover,
Simpson Evergreen, Aspen Text*

1

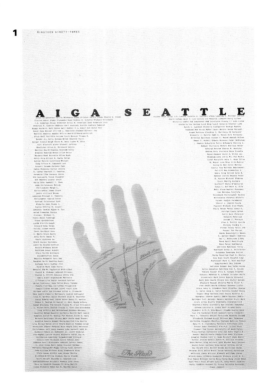

2

3

Title *Listening for Tomorrow: 1993 Annual Report
of the Recording Industry Association of America*

Design Firm *Recording Industry
Association of America, Washington, DC*

Art Director/Designer *Neal Ashby*

Illustrator *Dave Plunkert*

Photographer *Steve Biver*

Copywriters *Neal Ashby and Fred Guthrie*

Client *Recording Industry Association of America*

Typographer *Neal Ashby*

Printer *Steckel Printing*

Paper *Simpson Starwhite Vicksburg*

4

Title *Trident Microsystems 1994 Annual Report*

Design Firm *Cahan & Associates, San Francisco, CA*

Art Director *Bill Cahan*

Designer *Bob Dinetz*

Photographer *Holly Stewart*

Copywriter *Tim Peters*

Client *Trident Microsystems*

Typographer *Cahan & Associates/Blue Friday*

Printer *Forman Liebrock*

Paper *Kashmir 80# Cover and 100# Text*

1

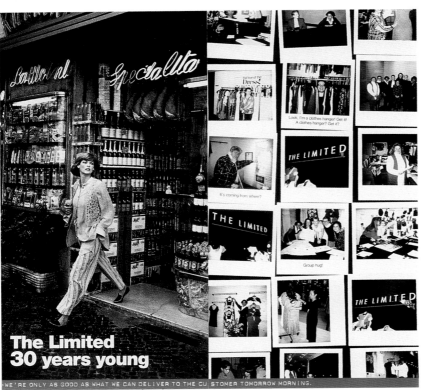

If you think we're a 30 year old women's

apparel company –

think again.

The Limited, Inc. 1993 Annual Report

The Limited
30 years young

2

EARTH TECH NOTES FROM THE ENVIRONMENT ANNUAL REPORT 1994

GROWTH

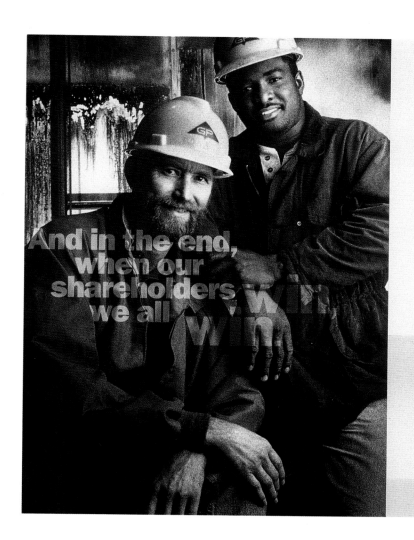

And in the end, when our shareholders win, we all win

Building Products

Georgia-Pacific is the leading manufacturer and distributor of building products in the United States. The company produces plywood, oriented strand board and other wood panels, lumber, gypsum wallboard, chemicals and other products at 136 facilities in the U.S., one in Canada and two in Mexico. Exports for this segment in 1994 were $198 million.

The company's building products business is primarily affected by the level of housing starts; the level of repairs, remodeling and additions; commercial building activity; the availability and cost of financing; and changes in the industry's capacity.

Building products profits remained at record levels in 1994. Rising interest rates had a muted impact on the construction industry, as they were offset by stronger consumer confidence, employment and income growth.

Distribution Georgia-Pacific is the leading wholesaler of building products in the U.S. During 1994, the company announced plans to restructure its Distribution Division to improve customer service, grow the business and reduce costs by implementing better organizational, logistical and information systems. The effort began with a prototype reconfiguration of the current branch network in the Southern region that will include a sales center supported by strategically located warehousing/delivery locations. The new delivery network will provide more reliable service and an increased breadth of inventory.

To supplement Georgia-Pacific's production and to offer customers a broader line of building products, we also purchase products from other manufacturers. In 1994, these purchases totalled $2.9 billion.

Our largest export markets are in the Caribbean and Europe. We also have

23

1

Title *The Limited, Inc., 1993 Annual Report*
Design Firm *Frankfurt Balkind Partners,*
New York, NY
Art Directors *Kent Hunter and Aubrey Balkind*
Designers *Robert Wong and Arturo Aranda*
Photographers *Various*
Client *The Limited, Inc.*
Typographer *Frankfurt Balkind Partners*
Printer *Heritage Press*
Paper *Domtar Kraft 65# Cover and*
Sterling Matte Recycled 70# Text

3

2

Title *Earth Tech 1994 Annual Report:*
Notes from the Environment
Design Firm *Rigsby Design, Inc., Houston, TX*
Art Director *Lana Rigsby*
Designers *Lana Rigsby and Troy S. Ford*
Illustrator *Andy Dearwater*
Copywriter *JoAnn Stone*
Client *Earth Tech*
Typographer *Troy S. Ford*
Printer *Heritage Press*
Paper *Simpson Starwhite Vicksburg 88# Cover*
and Tiara Vellum 65# Cover

3

Title *Georgia-Pacific 1994 Annual Report*
Design Firm *Samata Associates, Dundee, IL*
Art Director *Jim Hardy*
Designers *Jim Hardy and Jack Jacobi*
Photographer *Marc Norberg*
Copywriters *Dick Perkins, Kelly Lee,*
and Sheila Weidman
Client *Georgia-Pacific*
Typographer *Fine Print Typography*
Printer *George Rice and Sons*
Paper *Hopper Kiana Smooth White 100# Cover*
and 80# Text, Hopper Proterra Flecks Stucco 70# Text

1
Title *ARIAD Pharmaceuticals, Inc. 1993 Annual Report*
Design Firm *Pentagram Design, New York, NY*
Art Director *Woody Pirtle*
Designers *John Klotnia and Ivette Montes de Oca*
Illustrator *Ivette Montes de Oca*
Photographer *John Paul Endress*
Copywriter *Charles C. Cabot III*
Client *ARIAD Pharmaceuticals, Inc.*
Calligrapher *Ivette Montes de Oca*
Printer *Toppan Printing Company*
Paper *Simpson Kraft Evergreen 80# Cover, Starwhite Tiara Smooth 100# Text*

2
Title *The Steelcase Foundation 1993 Annual Report*
Design Firm *Square One Design, Grand Rapids, MI*
Designer/Illustrator *Kevin Budelmann*
Copywriter *Polly Hewitt*
Client *The Steelcase Foundation*
Typographer *Kevin Budelmann*
Printer *D & D Printing*

3
Title *The Alan Guttmacher Institute 1993 Annual Report*
Design Firm *Emerson, Wajdowicz Studios, Inc., New York, NY*
Art Director *Jurek Wajdowicz*
Designers *Lisa LaRochelle and Jurek Wajdowicz*
Photographers *Various*
Client *The Alan Guttmacher Institute*
Typographer *Emerson, Wajdowicz Studios, Inc.*
Printer *Van Dyke Columbia*
Paper *Mohawk Superfine*

4
Title *Asyst Annual Report*
Design Firm *Tolleson Design, San Francisco, CA*
Art Director *Steven Tolleson*
Designers *Steven Tolleson and Jean Orlebeke*
Illustrator *Jonathan Rosen*
Photographer *Luis Delgado*
Copywriters *Lindsay Beaman and John Rizzo*
Client *Asyst Technologies*
Typographer *Tolleson Design*
Printers *Digital Engraving and Macdonald Printing*
Paper *Simpson Starwhite Vicksburg Tiara*

1

2 The Steelcase Foundation 1993 Annual Report

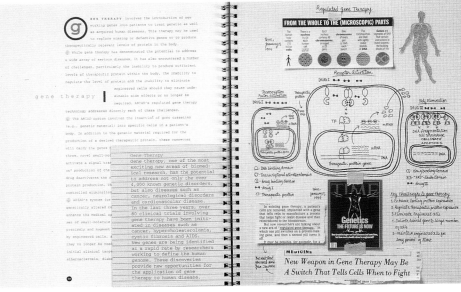

3

4

Title *Numbers Watch*
Design Firm *Greenberg Kingsley, New York, NY*
Designers *D. Mark Kingsley and Karen Greeenberg*
Client *The Guggenheim Museum*
Fabricator *Endura, USA*

2
Title *Pro Form Smart Card Packaging*
Design Firm *Paragon Design, Salt Lake City, UT*
Art Directors *Brent Watts and Rick Allenbach*
Designer/Typographer *Danell Murdock*
Photographer *Gary Hush Photography*
Copywriter *John Crowley*
Client *Pro Form Fitness Products*
Printers *Warneke Paper Box Company and American Packaging Group, Inc.*
Fabricator *Warneke Paper Box Company*
Paper *Paperboard Box Stock*

3

4

5

3
Title *"Voodoo: Not Just Another Doll"*
Design Firm *TonBo Designs, Palo Alto, CA*
Art Director/Designer *Lori Barra*
Illustrator *John Ritter*
Copywriter *Bernard Ohanian*
Clients *Lithomania, Inc. and TonBo Designs*
Printers *Anderson Lithograph and Advanced Lith*
Fabricator *Amy Noel/Wood Associates, Inc.*
Paper *Eloquence Gloss 100# Cover*

4
Title *OK Cans*
Design Firm *Wieden & Kennedy, Portland, OR*
Design Director/Designer *Todd Waterbury*
Creative Directors *Peter Wegner,*
Todd Waterbury, Charlotte Moore, and John Jay
Illustrators *Daniel Clowes, Calef Brown,*
Charles Burns, and David Cowles
Copywriter *Peter Wegner*
Client *The Coca-Cola Company*
Typographer *Todd Waterbury*
Printer *Crown Cork and Seal*

5
Title *MCS R-5 Nut Box Promotion*
Design Firm *Kilter Inc., Minneapolis, MN*
Art Director/Designer *Tim Schumann*
Copywriter *Kevin Fenton*
Client *SQL Systems*
Printer/Fabricator *Maximum Graphics*
Paper *Fox River, Winstead Globrite, Bristol*

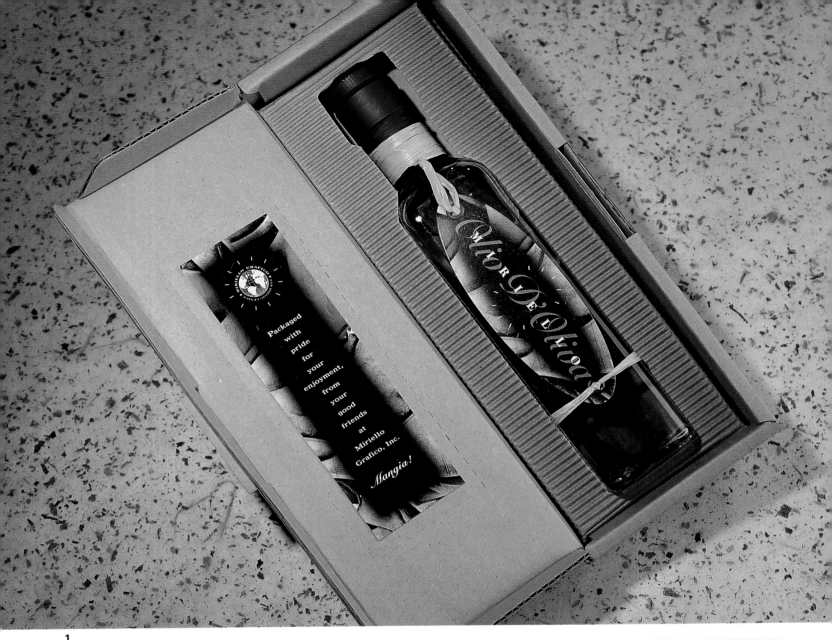

1

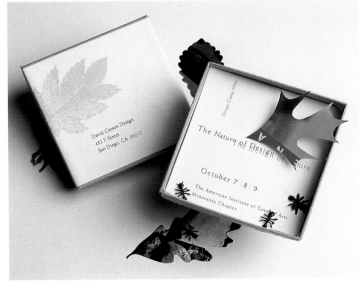

2

1
Title *Miriello Olio d'Olivo*
Design Firm *Miriello Grafico, Inc., San Diego, CA*
Art Director *Ron Miriello*
Designers *Ron Miriello, Dean Amstutz,*
and Michelle Aranda
Illustrator *Dean Amstutz*
Photographer *Sanford Roth*
Client *Miriello Grafico, Inc.*
Typographer *Miriello Grafico, Inc.*
Printer *Spectrum Printing*
Fabricator *San Diego Die Cutting*
Paper *Kraft Corrugated Board, 100# Coated Cover, Mactac*
Permanent

2
Title *"The Nature of Design/The Design of Nature"*
Design Firm *Rubin Cordaro Design, Minneapolis, MN*
Art Director *Ruth Christian*
Designers *John Haines, John Sticha, and Ruth Christian*
Photographer *Marty Berglin/Willette Photography*
Copywriters *Adheide Fischer, Elaine Ellis, and John Haines*
Client *AIGA/Minnesota*
Typographer *Rubin Cordaro Design*
Printer *Meyers Printing*
Paper *Strathmore Elements, Soft Natural Squares and Lines*

3
Title *Smith Sport Optics P.O.P. Rock*
Design Firm *Hornall Anderson Design Works,*
Seattle, WA
Art Director *Jack Anderson*
Designers *Jack Anderson, David Bates, and Cliff Chung*
Client *Smith Sport Optics, Inc.*
Typographer *Hornall Anderson Design Works*
Printer *Foley Sign/Glassworks*
Material *River Rock*

4
Title *Smith & Hawken Botanicals*
Design Firm *Barbara Vick Design, San Francisco, CA*
Art Directors *Louise Kollenbaum,*
Bonnie Dahan, and Mata Benson
Designer *Barbara Vick*
Illustrator *David Stevenson*
Copywriter *Deborah Courtenay Bishop*
Client *Smith & Hawken*
Typographer *Barbara Vick Design*
Printer *AC Label*

3

4

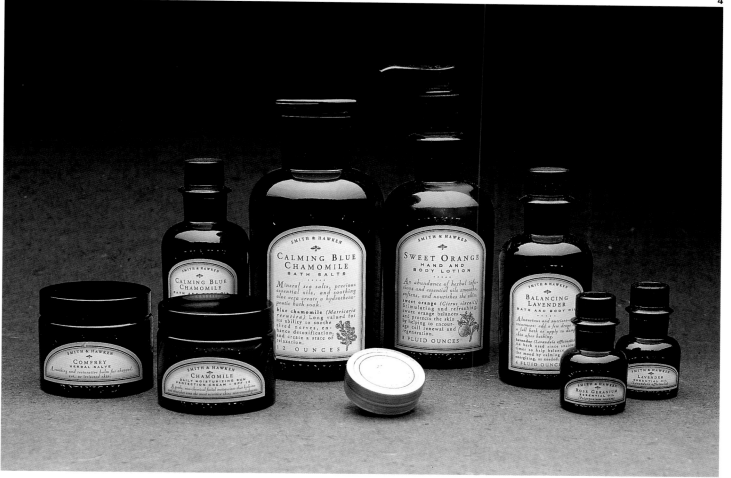

1

2

1
Title *David Byrne Limited-Edition Special Package*
Designer *Robert Bergman-Ungar*
Photographer *Jean Baptiste Mondino*
Client *Sire Records*

2
Title *BonePony: Live From the Southern Belt CD*
Design Firm *Capitol Records (In-house)*
Art Director/Designer *Jeffery Fey*
Client *Capitol Records, Inc.*
Typographers *Jeffery Fey and Hatch Show Print*

3

Title *H. P. Zinker CD*
Design Firm *Sagmeister Inc., New York, NY*
Art Director *Stefan Sagmeister*
Designers *Stefan Sagmeister and Veronica Oh*
Photographer *Tom Schierlitz*
Copywriter *Hans Platzgummer*
Client *Energy Records*
Typographers *Stefan Sagmeister and Veronica Oh*
Printer *Disc Graphics*
Fabricator *HMG*
Paper *100# Coated Gloss*

4

Title *Eternal Chant*
Design Firm *Stain, New York, NY*
Art Director/Designer *Darren Crawforth*
Illustrator *Malcolm Tarlofsky*
Photographer *Jean-Marc Coudour*
Client *Atlantic Recording Corporation*

3

4

Communication Graphics *Posters*

1

Title *Jones Affiliate Kit Tricycle Poster*
Design Firm *Vaughn Weeden Creative Inc.,*
Albuquerque, NM
Art Director/Designer *Steve Wedeen*
Photographer *Dan Sidor*
Copywriter *Foster Hurley*
Client *Jones Intercable*
Printer *Graphics Group*
Paper *Cougar Opaque 80# Writing Paper*

2

Title *XXX Snowboards*
Design Firm *Segura Inc., Chicago, IL*
Art Director/Designer *Carlos Segura*
Illustrators *Tony Klassen and Carlos Segura*
Photographer *Jeff Sciortino*
Client *XXX Snowboards, B.T.B.*
Typographer *Segura Inc.*
Printer *Bradley*

3

Title *Chris Webber/Arachnophobia*
Design Firm *Nike Inc., Beaverton, OR*
Art Director/Designer *Guido Brouwers*
Photographer *Everard Williams, Jr.*
Copywriter *Bob Lambie*
Printer *T. Wolf Printing*
Fabricator *Harry Nits*
Paper *Productolith 100#*

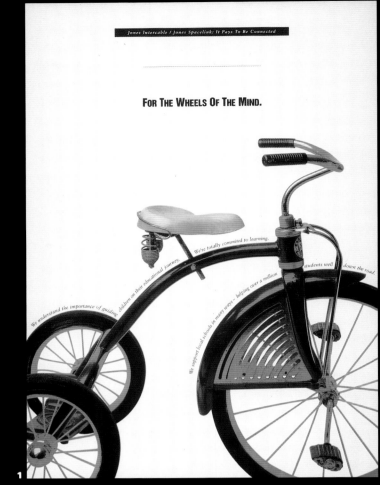

1

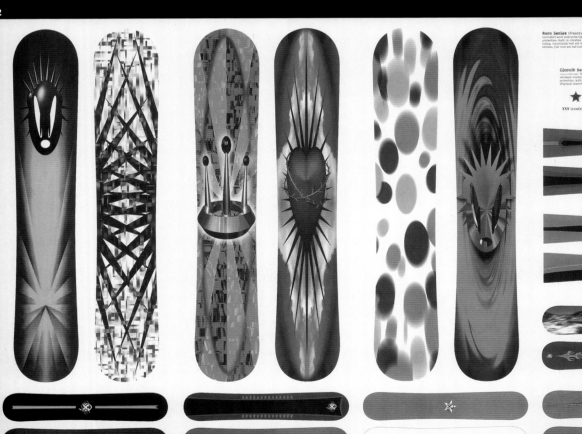

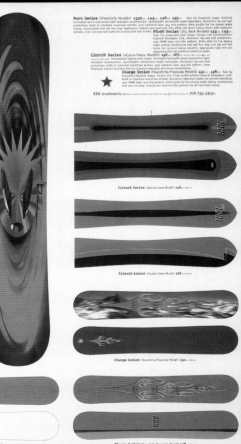

2

arachnophobia /ə-ˋrak-nə-fo-be-ə / *n* [from the Greek *spiderum leapis* or dunking spider] **1**) an unpleasant often strong feeling of impending doom **2**) a fear of being dunked on, juked or rejected **3**) emotional horror when entangled, ensnared or controlled **4**) explosion anxiety *syn* **C. Webb**

NIKE

CHRIS WEBBER

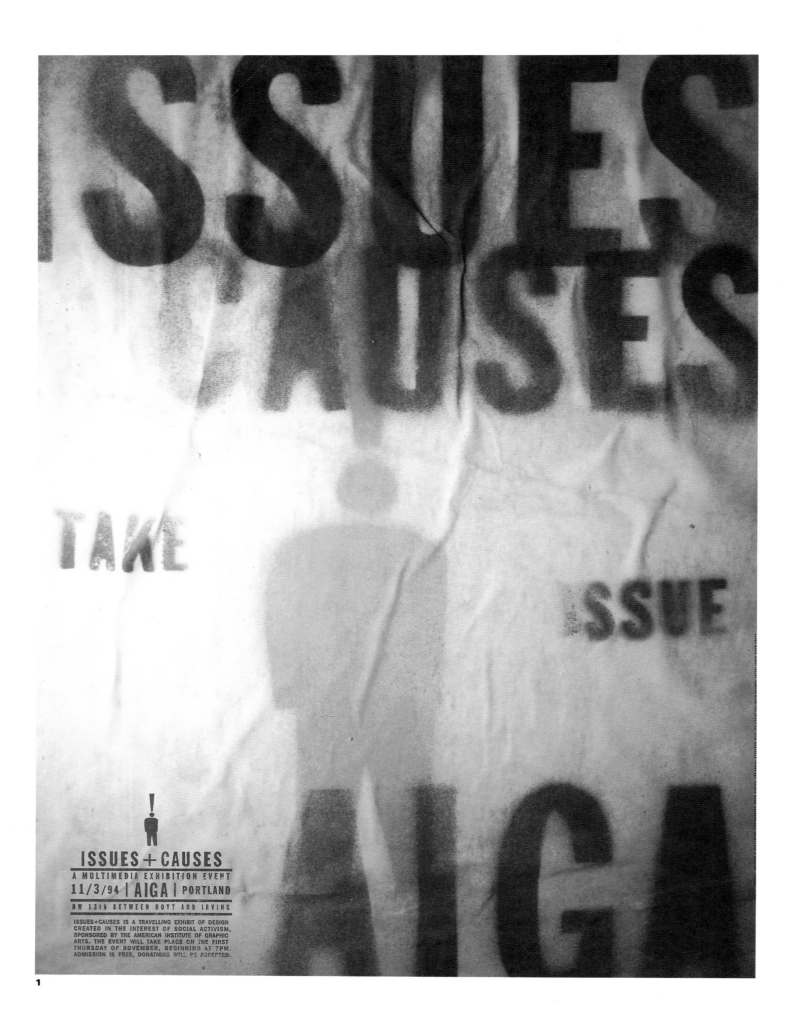

ISSUES + CAUSES

A MULTIMEDIA EXHIBITION EVENT

11/3/94 | AIGA | PORTLAND

NW 13th BETWEEN HOYT AND IRVING

ISSUES+CAUSES IS A TRAVELLING EXHIBIT OF DESIGN
CREATED IN THE INTEREST OF SOCIAL ACTIVISM,
SPONSORED BY THE AMERICAN INSTITUTE OF GRAPHIC
ARTS. THE EVENT WILL TAKE PLACE ON THE FIRST
THURSDAY OF NOVEMBER, BEGINNING AT 7PM.
ADMISSION IS FREE, DONATIONS WILL BE ACCEPTED.

1

1

Title *AIGA "Issues & Causes" Traveling Exhibition*
Design Firm *Johnson and Wolverton, Portland, OR*
Art Directors *Alicia Johnson and Hal Wolverton*
Designers *Hal Wolverton, Geoffrey Lorenzen, and Gena Gloar*
Photographer *Mark Hooper*
Client *AIGA/Portland*
Printers *The Irwin-Hodson Company (Poster) and Bridgetown Printing (Program and Invitation)*
Paper *James River, Various*

2

Title *AIDS Poster (White)*
Design Firm *Boelts Bros., Tucson, AZ*
Art Directors/Designers *Jackson Boelts and Eric Boelts*
Photographers/Typographers *Eric Boelts and Jackson Boelts*
Client *Pact for Life*
Printer *Fabe Litho*
Paper *Producto Lith Gloss*

3

Title *AIDS Poster (Black)*
Design Firm *Boelts Bros., Tucson, AZ*
Art Directors/Designers *Jackson Boelts and Eric Boelts*
Photographers/Typographers *Eric Boelts and Jackson Boelts*
Client *Pact for Life*
Printer *Fabe Litho*
Paper *Producto Lith Gloss*

2

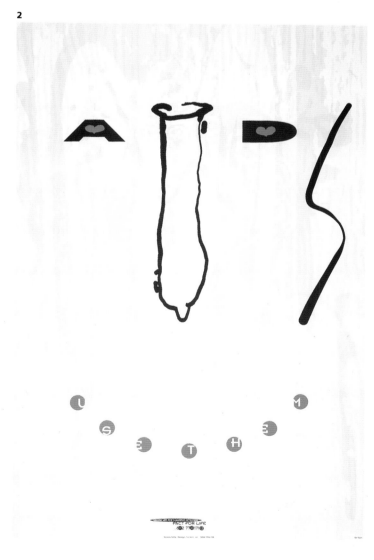

3

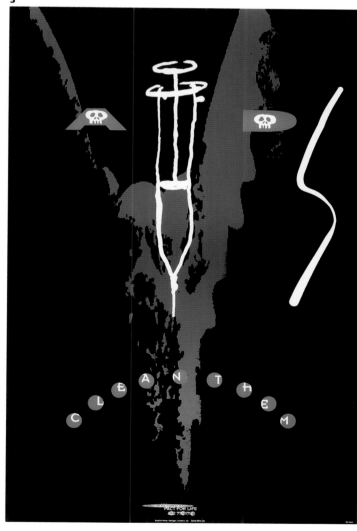

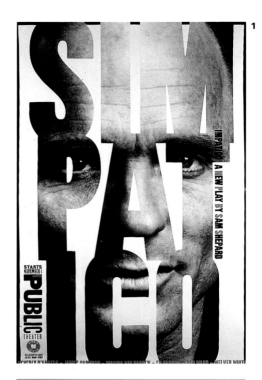

1

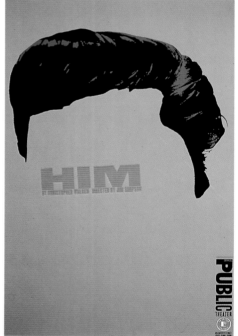

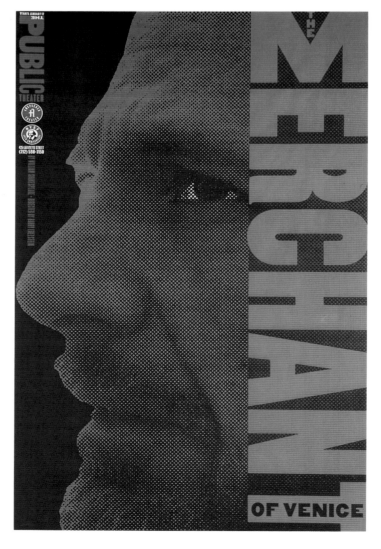

1
Title *The Joseph Papp Public Theater Poster Series*
("Simpatico," "Him," "Merchant of Venice,"
and "Some People")
Design Firm *Pentagram Design, New York, NY*
Art Director *Paula Scher*
Designers *Paula Scher, Ron Louie, and Lisa Mazur*
Client *The Joseph Papp Public Theater*
Printer *Ambassador Arts, Inc.*

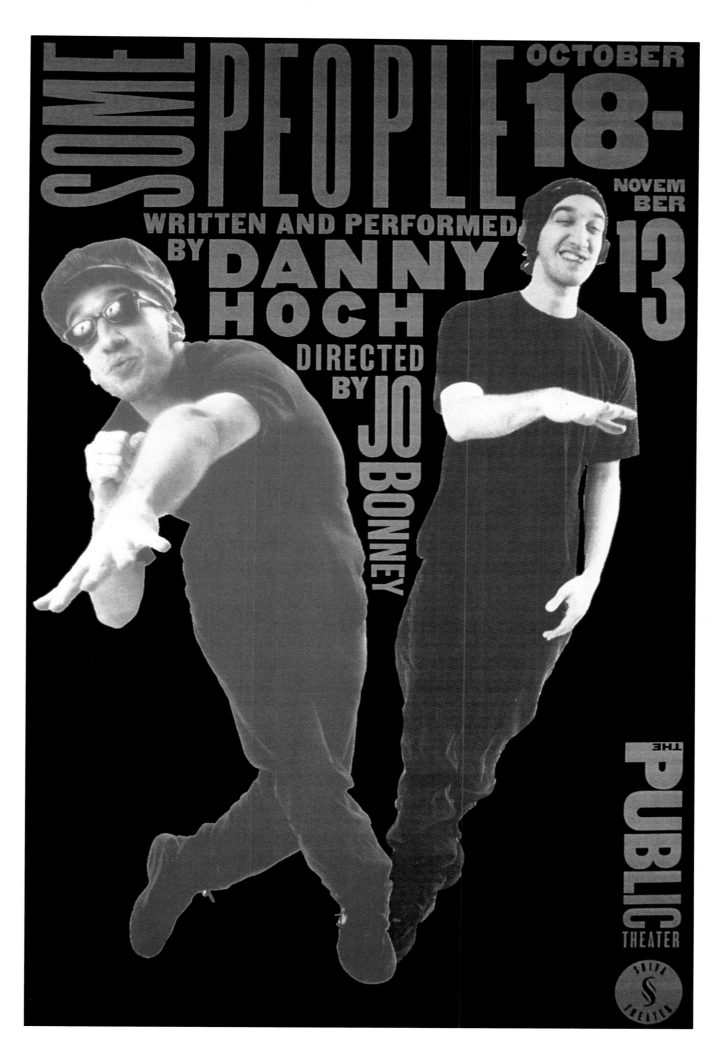

SOME PEOPLE

OCTOBER 18 - NOVEMBER 13

WRITTEN AND PERFORMED BY DANNY HOCH

DIRECTED BY JO BONNEY

THE PUBLIC THEATER

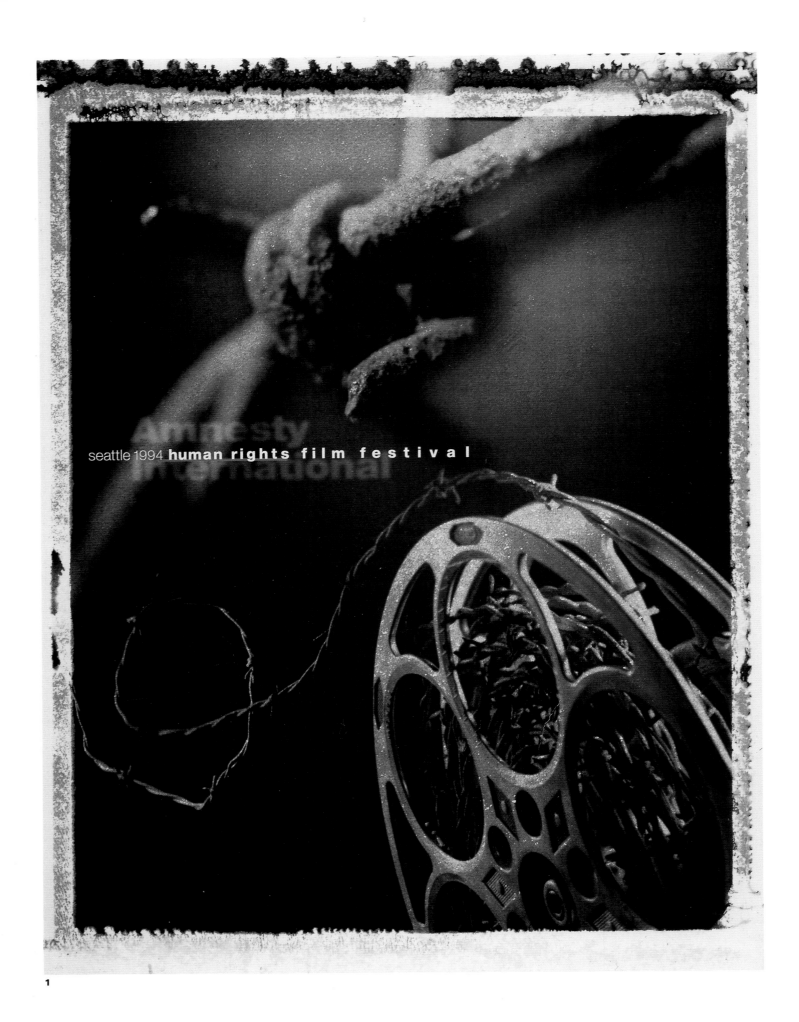

seattle 1994 **human rights film festival**

1
Title *1994 Seattle Human Rights Film Festival poster*
Design Firm *Werkhaus Design, Seattle, WA*
Art Director *John Burgess*
Designer *Stephen Barrett*
Photographer *Doug Landreth*
Client *Seattle Human Rights Film Festival*
Typographer *Werkhaus Design*
Printer *Overlake Press*
Paper *Spicers Encore Gloss*

2
Title *Twelfth Night*
Design Firm *Victore Design Works, New York, NY*
Art Director/Designer/Illustrator *James Victore*
Client *The Shakespeare Project*
Typographer *James Victore*
Printer *Royal Offset/Rosepoint*

3
Title *The Rainy States Film Festival Poster*
Design Firm *Modern Dog, Seattle, WA*
Art Directors *Vittorio Costarella and Christine Phillips*
Designer/Illustrator *Vittorio Costarella*
Client *The Rainy States Film Festival*
Printer *Two Dimensions*

2

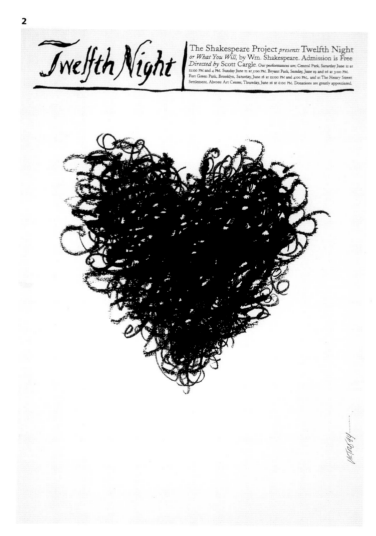

3

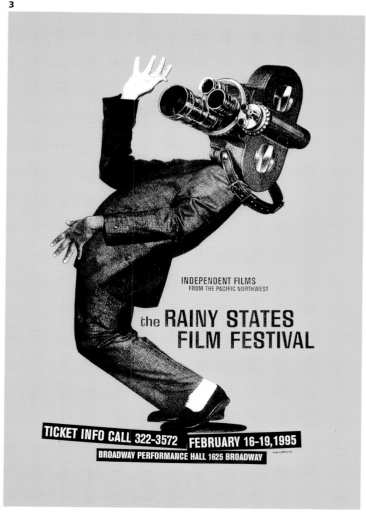

1
Title *"Censorship and Silencing"*
Design Firm *Adams/Morioka, Beverly Hills, CA*
Art Director *Sean Adams*
Designers *Sean Adams and Noreen Morioka*
Photographer *Noreen Morioka*
Client *The Getty Center for the History of Art and the Humanities*
Printer *Alan Litho*
Paper *Strathmore Writing Paper*

2
Title *Dorcas Place Parent Literacy Center*
Design Firm *Rivers, Doyle, Walsh & Co., Providence, RI*
Art Director/Designer *Thomas Rothermel*
Illustrator *Glenn Britland*
Copywriter *Craig Johnson*
Client *Dorcas Place*
Printer *United Press*
Paper *Loe 80# Dull Cover*

3
Title *Sexual Identity Forum Poster*
Design Firm *Bielenberg Design, San Francisco, CA*
Art Director *John Bielenberg*
Designers *Allen Ashton, John Bielenberg, and Teri Vasarhelyi*
Client *Youth and Family Assistance*
Printer *Robb Murray*
Paper *Simpson Kashmir 80# Cover*

4
Title *"Change/Chance" Poster*
Design Firm *Peter Good Graphic Design, Chester, CT*
Art Directors *Peter Good and Janet Cummings Good*
Designer/Illustrator *Peter Good*
Photographer *Jim Coon*
Copywriters *Peter Good and Janet Cummings Good*
Client *Unisource*
Typographer *Peter Good*
Printer *Emco Printers, Inc.*
Paper *Potlatch Eloquence*

1

2

Imagine how hard it would be to find a job if you couldn't read.

Illiteracy is a tremendous obstacle, but it's not insurmountable. At Dorcas Place, we teach parents reading and other important skills. If you'd like to donate your time or money, just call us at 273-8866. Because we're all born illiterate, but none of us should have to stay that way.

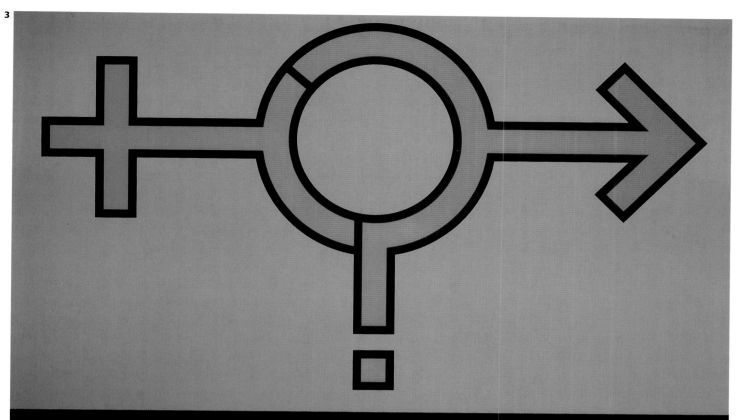

IN EVERY CLASS, IN EVERY SCHOOL, IN EVERY CITY, IN EVERY STATE. GAY, LESBIAN, BISEXUAL, TRANSGENDER AND QUESTIONING YOUTH ARE EVERYWHERE. YOU COUNT. REACH OUT. GET SUPPORT.

THE SEXUAL IDENTITY FORUM IS A SAFE, SUPPORTIVE AND CONFIDENTIAL DROP IN GROUP FOR GAY, LESBIAN, BISEXUAL, TRANSGENDER AND QUESTIONING YOUTH IN SAN MATEO COUNTY. (415) 572-0535

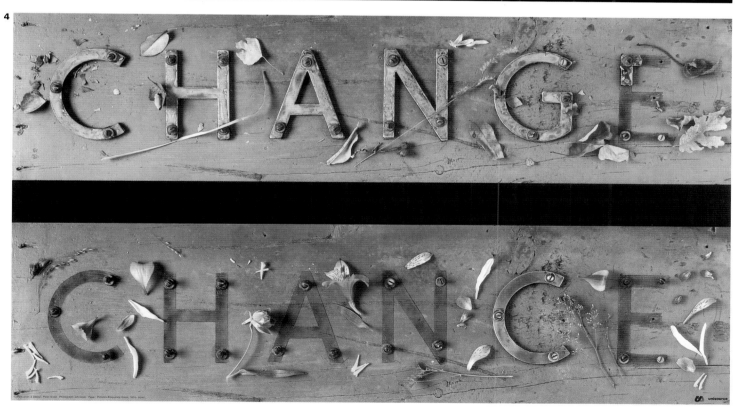

1

Title *Herman Miller Design Position Recruitment Poster*
Design Firm *Herman Miller, Inc. (In-house)*
Art Director/Designer/Illustrator *Yang Kim*
Copywriter *Clark Malcolm*
Client *Herman Miller, Inc.*
Printer *Etheridge Company*
Paper *Beckett 80# Expressions Cover Iceberg*

2

Title *Paul Rand Poster*
Design Firm *Joel Katz Design Associates, Philadelphia, PA*
Art Director/Designer *Joel Katz*
Illustrator *David E. Schpok*
Client/Publisher *AIGA/Philadelphia*
Printer *Strine Printing Co., Inc.*
Paper *Simpson Starwhite Vicksburg Tiara*

3

Title *AIGA/Portland Book Show Poster*
Design Firm *Group Z, Portland, OR*
Designer/Illustrator *Greg Holly*
Client *AIGA/Portland*
Copywriter/Typographer *Greg Holly*
Printer *Dynagraphics*
Paper *Gilbert Esse*

4

Title *Breakfast Seminars*
Design Firm *Designframe, Inc., New York, NY*
Art Director *Michael McGinn*
Designers *Michael McGinn and Sarah Kloman*
Copywriters *Michael McGinn and Beth Player*
Client *AIGA/NY*
Typographer *Sarah Kloman*
Printer *Wace/NY*
Paper *Finch Opaque*

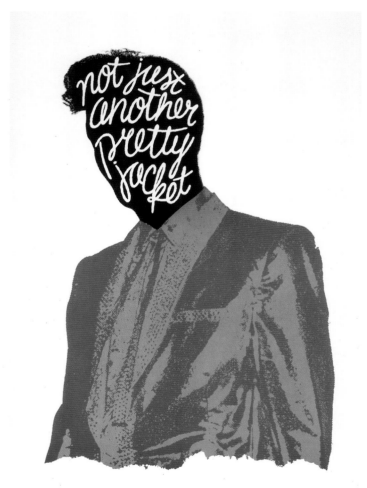

THE AIGA BOOK SHOW

AN EXHIBITION OF DESIGN AND CRAFT
ON DISPLAY MAY 2 THROUGH MAY 29
AT CONANT & CONANT BOOKSELLERS
1001 SW TENTH AVENUE IN PORTLAND
THE AMERICAN INSTITUTE OF GRAPHIC ARTS

Partnerships

Seminar 1

Wednesday
November 2, 1994
The Cornell Club
6 East 44th Street
7:30 am – 9:00 am

Sharing. The premise of busi-
ness partnership is
that each partner brings his
or her own strength to the
relationship, thereby
profiting together while
covering one another's
weaknesses. Partnerships
appear to be a popular
form of business today. How
do you know if it is a viable
and pratical way to run
your design business? Is
there an ideal partner? How do
you 'find' a partner?
What does it take to make
it work? Why might it fail?
Should your partner
be a designer? a salesperson?
your spouse?

Howard Belk
Belk Mignogna Associates

Anthony Russell
Anthony Russell Inc.

Maruchi Santana
Parham-Santana Inc.

Selling

Seminar 2

Thursday
November 3, 1994
The Cornell Club
6 East 44th Street
7:30 am – 9:00 am

New business. Somewhere
along the way most of us have
to convince a would-be client to
hire us. However, most of us
didn't get into the design
business because we were good
salespersons. What do you do
when faced with a cold call?
How do you differentiate your
services from all those other
designers fighting
for the same work? Do
you sell by yourself or hire
someone to do it for you? Can
design be effectively "sold" by a
salesperson? How do you
improve your success rate?

Danny Abelson
The Abelson Company

Carla Hall
Carla Hall Design Group

Arnold Wechsler
Wechsler and Partners Inc.

The mission of the New York Chapter of the American Institute of Graphic Arts (AIGA/NY) is to identify and define critical issues to the membership and the graphic design profession; to explore and clarify these issues for the purpose of helping to elevate the standards of graphic design business practice and the art of graphic design; to create a forum for the exchange of information, views, styles and techniques among those engaged in the profession.

Breakfast Seminars

AIGANY

1
Title *"Stop the Violence"*
Design Firm *Sommese Design, State College, PA*
Art Director/Designer/Illustrator *Lanny Sommese*
Publisher *Sommese Design*
Typographer *Lanny Sommese*
Printer *Penn State Design Practicomm*
Paper *Ward Paper Bright Hue Red Cover*

2
Title *"Eco Crime"*
Art Director/Designer/Illustrator *Luba Lukova*
Client *The Living Theater*
Typographer *Luba Lukova*
Printer *Rosepoint*
Paper *Stonehenge*

3
Title *"War Crime"*
Art Director/Designer/Illustrator *Luba Lukova*
Client *The Living Theater*
Typographer *Luba Lukova*
Printer *Rosepoint*
Paper *Stonehenge*

4
Title *"Hunger Crime"*
Art Director/Designer/Illustrator *Luba Lukova*
Client *The Living Theater*
Typographer *Luba Lukova*
Printer *Rosepoint*
Paper *Stonehenge*

1

Title *Capp Street Announcement: Willie Cole*

Design Firm *Morla Design, San Francisco, CA*

Art Director *Jennifer Morla*

Designers *Jennifer Morla and Craig Bailey*

Client *Capp Street Project*

Typographer *Morla Design*

Printer *Pacific Financial Printing*

Paper *Offset Incentive 50# Book Uncoated*

Title *Republican Contract Poster*
Design Firm *BlackDog, San Rafael, CA*
Designer/Illustrator *Mark Fox*
Client *BlackDog*
Typographer *Mark Fox*
Printer *Acme*

3

Title *"Politicians Are Scum..."*
Design Firm *Morris Taub Illustration/Design, New York, NY*
Art Director/Designer *Morris Taub*
Photographer *Barnaby Hall*
Copywriter *Morris Taub*
Printer *Royal Offset Company Inc.*

4

Title *"Tricky Ollie" Poster*
Design Firm *BlackDog, San Rafael, CA*
Designer/Illustrator *Mark Fox*
Client *The People of the Commonwealth of Virginia*
Typographer *Mark Fox*
Printer *Kinko's*

2

REPUBLICAN CONTRACT ON AMERICA

Bob Dole Ralph Reed

Newt Gingrich

Rush Limbaugh

Jesse Helms

Bob Packwood

"When I hear anyone talk of culture,
I reach for my revolver."—Hermann Goering

Politicians are scum...only looking out for their jobs. Don't take the bait. These jerks are supposed to be working for us. We pay them. How is it they are leading this cush life of privilege, parties and elitism? They play their political games while we wait for them to act. Let's take the parties out of our government. More governing and concern couldn't hurt. They keep talking about traditional family values...whose traditional family values? Politicians telling us how to live our lives while they sit back and eat gourmet meals? If our government is allowed to continue as is we are all in trouble. I don't care if you're Black, White, Oriental, Latin, American Indian, man, woman, child,...they will try and tell you what to value, what you can and can't do with your own body, what is appropriate family behavior. Special interest groups, religious groups especially, must be outlawed if government is ever to be for all of us. I don't want to live my life according to the religious beliefs of anyone! Do you? These political mouthpieces lie to us while they smile and pat us on the back. Only 36 percent of voters voted when these republicans were all elected. Not all America. It is depressing that our politicians have beat us into the ground for so many years. They lie, cheat, steal. We must not let them win. We must all start to vote again. If we don't we will soon be living lives according to the whim of special interest groups, living lives according to the religious right or some other cult group. Please think about taking the time to vote. If you don't care enough to look out for the fanatics we will all go down together. Our government today caters to wealthy companies and the special interest groups that will help them get elected again. They only care about their own jobs. If you don't start taking care of business soon...they will take care of your business for you. Our ruling class is getting out of control. Politics...thoroughly foul, rotten. It debases everything. Politicians...ready and willing to see people sacrificed, slaughtered for the sake of an idea, good or bad.

©1995 Art for the Masses Photo: Barnaby Hall Design: Morris Taub

3

4

TRICKY OLLIE.

1

Title *Women's Humane Society*
Design Firm *Scorsone/Drueding, Jenkintown, PA*
Art Directors/Designers *Joe Scorsone/Alice Drueding*
Illustrator *Alice Drueding*
Client *Women's Humane Society*
Typographer *Alice Drueding*
Paper *Mohawk Superfine*

2

Title *MBF/Man's Best Friend*
Design Firm *Nike Inc., Beaverton, OR*
Art Director *Guido Brouwers*
Designers *Guido Brouwers and Morgan Thomas*
Photographer *George Fry*
Copywriter *Frank Rizo*
Client *Nike/S.W.A.T.*
Printer *Premier Press*
Fabricator *S. Rosenburg*

3

Title *Lisa Means Portrait Poster*
Design Firm *Sibley/Peteet Design, Dallas, TX*
Art Director/Designer *David Beck*
Photographer *Lisa Means*
Client *Lisa Means Photography*
Typographer *Sibley/Peteet Design*
Printer *Padgett Printing*
Paper *Zanders Ikonofix*

1

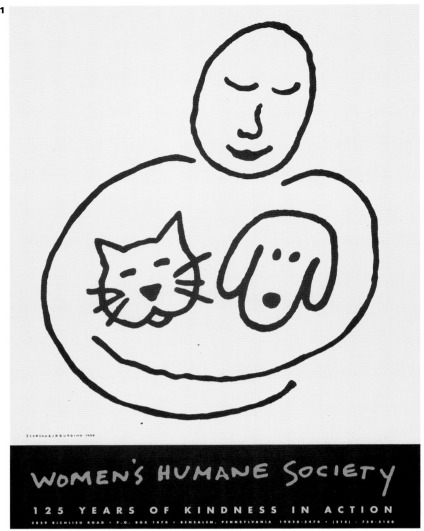

2

LISA MEANS Portraits

A Portrait Exhibit of Pets
and Their Art Directors

Opening Friday, April 22, 7-9 pm
Pinnacle Studios, 2410 Farrington

"ANIMALS of ADVERTISING"
Vol. I
APRIL 22-JUNE 11, 1994

Poster design: David Beck. Sibley/Peteet Design 300 Line Waterless Printing System: Padgett Printing Paper: 80# Monadle Gloss Text. Clampett Paper Exhibit prints: BWC Imaging Labs

1

Title *Day By Day Poster*

Design Firm *Duffy Design, Minneapolis, MN*

Art Director/Designer/Illustrator *Neil Powell*

Photographer *Parallel Productions*

Copywriter *Neil Powell*

Client *Graphic Communication Society of Oklahoma*

Typographer *Duffy Design*

Printer *Semco Color Press*

Paper *Domtar Paper — Wet Strength Blotting*

2

Title *Neo Dada Exhibition Poster*

Design Firm *Matsumoto Inc., New York, NY*

Art Director/Designer *Takaaki Matsumoto*

Client *The Equitable Gallery*

Typographer *Matsumoto Inc.*

Printer *Monarch Press*

Paper *Newsprint*

3

Title *"100 Years of Work, Workers, and Workplaces"*

Design Firm *Herman Miller, Inc. (In-house)*

Designer *Betty Hase*

Illustrator *Lyn Boyer-Nelles*

Copywriter *Betty Hase*

Client *Herman Miller, Inc.*

Printer *Veenstras Reproduction*

Paper *Blackline Paper*

4
Title *Cannonball Graphics*
Design Firm *Michael Schwab Design, Sausalito, CA*
Art Directors *Dave Payne and Darren Briggs*
Designer/Illustrator *Michael Schwab*
Client/Printer *Cannonball Graphics*

5
Title *CSA Line Art Archive Book Poster*
Design Firm *Charles S. Anderson Design Company,*
Minneapolis, MN
Art Director *Charles S. Anderson*
Designers *Charles S. Anderson, Todd Piper-Hauswirth,*
Joel Templin, and Paul Howalt
Photographer *Darrell Eager*
Copywriter *Lisa Pemrick*
Client *CSA Archive*
Printer *Litho, Inc.*
Paper *French Dur-o-Tone Newsprint Aged*

4

CANNONBALL GRAPHICS

408 943 9511

TRADE SHOW GRAPHICS

5

1

Title *Emigre Poster*

Design Firm *Charles S. Anderson Design Company, Minneapolis, MN*

Art Director *Charles S. Anderson*

Designers *Charles S. Anderson and Joel Templin*

Copywriter *Lisa Pemrick*

Client *French Paper Company*

Printer *Albinsons*

Paper *French Dur-o-Tone Newsprint Extra White*

2

Title *OK Transit Posters*

Design Firm *Wieden & Kennedy, Portland, OR*

Design Director/Designer *Todd Waterbury*

Creative Directors *Peter Wegner, Todd Waterbury, and Charlotte Moore*

Illustrators *Daniel Clowes, Calef Brown, Charles Burns, and David Cowles*

Copywriter *Peter Wegner*

Client *The Coca-Cola Company*

Typographer *Todd Waterbury*

Printer *Color Magic*

Paper *Springhill C1S*

2

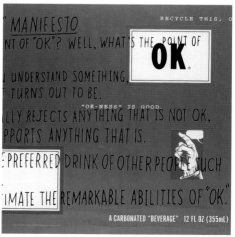

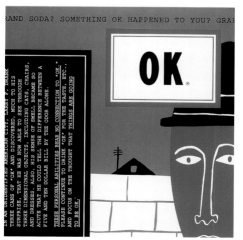

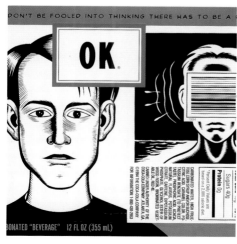

Title *"Notte di Venezia" Poster*
Design Firm *Giles Design, San Antonio, TX*
Art Director *Cindy Greenwood*
Designers *Jill Giles and Barbara Schelling*
Calligrapher *Jack A. Molloy*
Client *St. Luke's Hospital Foundation*
Printer *Padgett Printing*
Paper *Karma Natural*

1
Title *"Best Intentions"*
Design Firm *Chermayeff & Geismar Inc.,*
New York, NY
Art Director *Ivan Chermayeff*
Designer *Chuck Rudy*
Photographer *Bengt Wanselius*
Client *Mobil*
Typographer *Chermayeff & Geismar Inc.*
Printer *Actualizers*
Paper *Astrolite*

2
Title *"I" from the Ambassador Arts Alphabet Poster Series*
Design Firm *Pentagram Design, New York, NY*
Series Art Director *Paula Scher*
Designer/Illustrator *Paula Scher*
Clients *Ambassador Arts and Champion International*
Printer *Ambassador Arts, Inc.*
Paper *Champion Pageantry*

3
Title *"T" from the Ambassador Arts Alphabet Poster Series*
Design Firm *Pentagram Design, New York, NY*
Series Art Director *Paula Scher*
Designer *Woody Pirtle*
Photographer *John Paul Endress*
Clients *Ambassador Arts, Inc. and Champion International*
Printer *Ambassador Arts, Inc.*
Paper *Champion Pageantry*

ST. LUKE'S FOUNDATION

Notte di Venezia

1994
CANDLELIGHT BALL

for more information, call 692-8709.

4

Communication Graphics
Invitations/Announcements/Cards/Programs

1
Title *Chip Kidd Lecture Postcard*
Design Firm *Visual Dialogue, Boston, MA*
Art Director/Designer *Fritz Klaetke*
Photographer *William Huber*
Copywriter *Fritz Klaetke*
Client *AIGA/Boston*
Printer *Pride Printers*
Paper *Crusader Newsback*

2
Title *Office Opening Card*
Design Firm *Sagmeister Inc., New York, NY*
Art Director/Designer *Stefan Sagmeister*
Photographer *Tom Schierlitz*
Copywriter *Stefan Sagmeister*
Client *Sagmeister Inc.*
Printer *The Postcard Printer*
Paper *Postcard Stock with Hand-Applied Stickers*

1

2

3

4

Through lips that opened like a dove's wing—the color of rusted bone—a tongue snaked upwards to moisten time-cracked skin. The mouth (offered like a gift, like witchcraft) moved with insect precision

"You just don't get it," she said

"Don't try to bring tears to a glass eye," he said

"Can't you see the contrails of my nonlinear free-fall from grace?" she said

"Sin is addictive," he said

"Yes, but my gift will be wrapped with the salvation of love," she said

3

Title *Movie Awards Program Guide*
Design Firm *MTV Off-Air Creative, New York, NY*
Art Director/Designer *Johan Vipper*
Copywriter *David Lanfair*
Client *MTV: Music Television*
Printer/Fabrictor *DJ Litho*
Paper *Strathmore Pastelle 80# Fluorescent White Text*

4

Title *Video Music Awards Program*
Design Firm *MTV Off-Air Creative, New York, NY*
Designers *Stacy Drummond, Jeffrey Keyton, Tracy Boychuk, David Felton, and Johan Vipper*
Client *MTV: Music Television*
Printer/Fabricator *Northstar*
Paper *Mead Fine Papers — Various*

Title *"It's Oh Boy" Self-Promotion*
Design Firm *Oh Boy, A Design Company,*
San Francisco, CA
Art Director/Designer *David Salanitro*
Illustrator/Photographer *David Salanitro*
Copywriter *David Salanitro*
Client *Oh Boy, A Design Company*
Printer *Expressions Lithography*
Fabricator *Golden State Embossing*
Paper *Cardboard*

2

Title *"I'll Be"*
Design Firm *Concrete, Chicago, IL*
Designers *Jilly Simons and Susan Carlson*
Copywriter *Deborah Barron*
Client *The Bauer Family*
Printer *Active Graphics, Inc.*
Typographer *Concrete*
Paper *Mohawk Vellum and French Speckletone*
Bindery *Zonne*

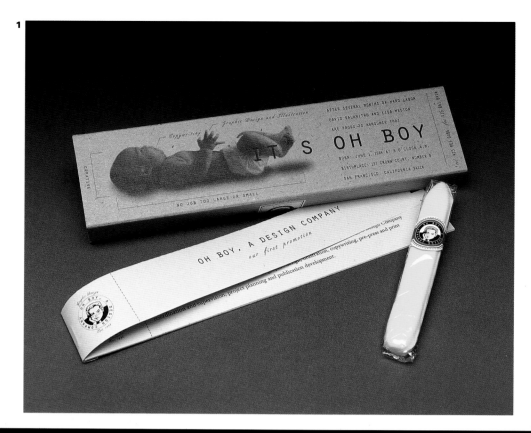

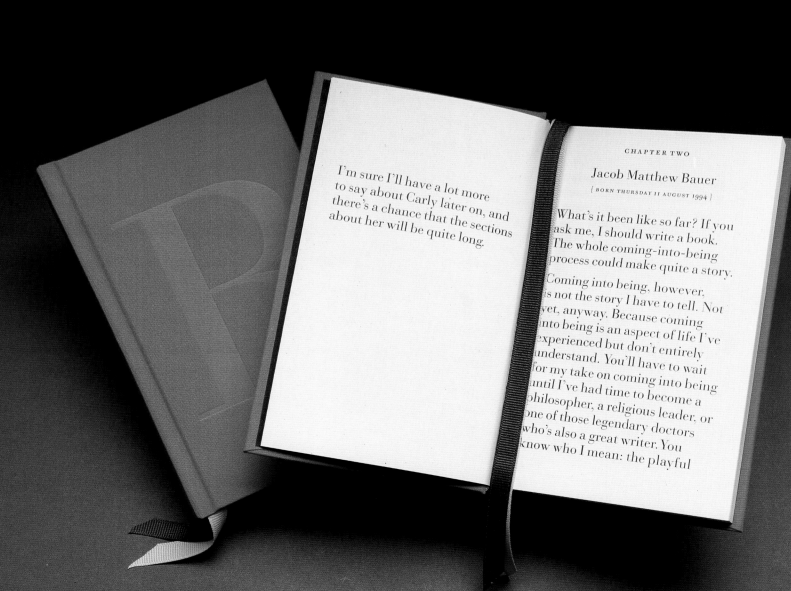

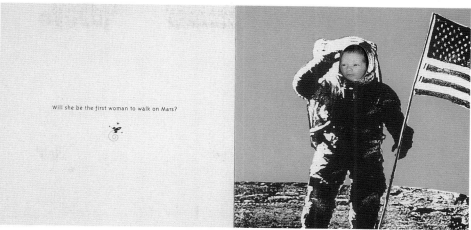

3

3
Title *Rachel Brown Birth Announcement*
Design Firm *SullivanPerkins, Dallas, TX*
Art Director/Designer/Illustrator *Dan Richards*
Copywriters *Dan Richards and Mark Perkins*
Clients *David Brown, Amy Brown, and Bob Davis*
Typographer *Dan Richards*
Printer *Riverside Press*
Paper *Simpson Starwhite Vicksburg*
Natural Smooth 65# Cover

4
Title *Katy Oldach Birth Announcement*
Design Firm *Mark Oldach Design, Chicago, IL*
Art Director/Designer *Mark Oldach*
Photographer *Anthony Arciero*
Copywriter *Mark Oldach*
Client *Katy Oldach*
Printer *First Impression*
Paper *Neenah, Kimdura*

4

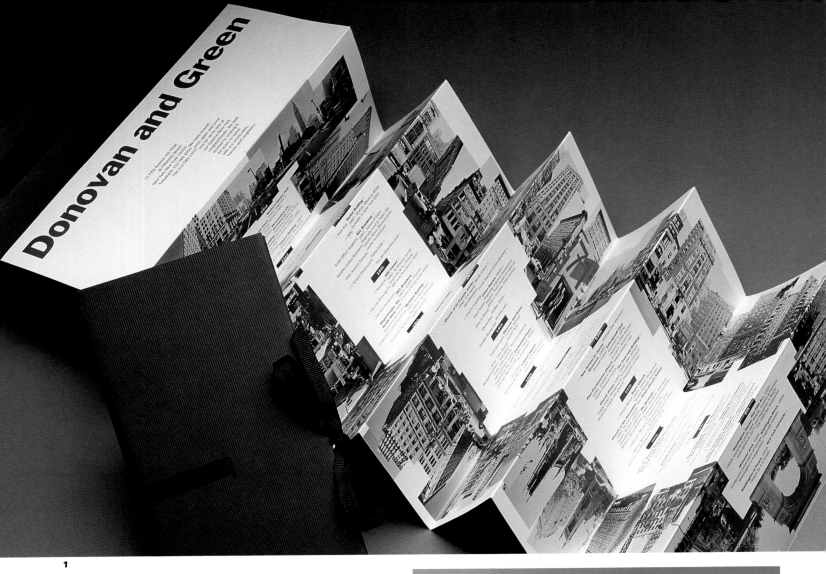

1

1
Title *Donovan and Green Moving Announcement*
Design Firm *Donovan and Green, New York, NY*
Art Directors *Michael Donovan and Nancye Green*
Designer *Vanessa Ryan*
Photographer *Austin Hughes*
Copywriter *Susan Myers*
Client *Donovan and Green*
Printer *CGS*
Paper *Champion Benefit*

2
Title *"Design for the Fun of It"*
Design Firm *Neal Ashby, Annapolis, MD*
Art Director/Designer/Illustrator *Neal Ashby*
Copywriter *Jennifer Kornegay*
Client *AIGA/Washington, D.C.*
Typographer *Neal Ashby*
Printer *Steckel Printing*
Paper *Simpson Starwhite Vicksburg*

2

3
Title *SHR Perceptual Management Christmas Card*
Design Firm *SHR Perceptual Management,*
Scottsdale, AZ
Art Director *Barry Shepard*
Designer/Copywriter *Nathan Joseph*
Client *SHR Perceptual Management*
Printer *Heritage Graphics*
Paper *Fox River Confetti Kaleidoscope*

4
Title *The Container Store Christmas Card*
Design Firm *Sibley/Peteet Design, Dallas, TX*
Art Director/Designer *Rex Peteet*
Illustrators *Rex Peteet and Mike Broshous*
Copywriter *Rex Peteet*
Client *The Container Store*
Typographer *Sibley/Peteet Design*
Printer *Monarch Press*
Paper *Simpson Evergreen*

3

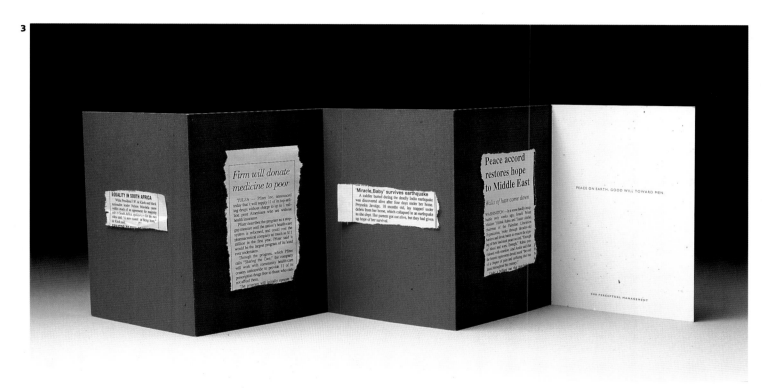

4

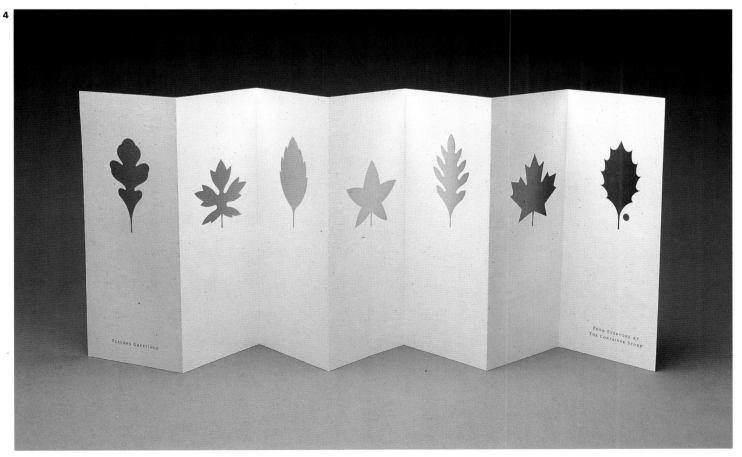

1

Title *"The Nature of Intolerance"*
Design Firm *Rigsby Design, Inc., Houston, TX*
Art Director *Lana Rigsby*
Designers *Lana Rigsby, Troy S. Ford, and Michael Thede*
Photographers *Gary Faye, Bruce Barnbaum, and Keith Carter*
Copywriter *JoAnn Stone*
Client *Fox River Paper Compsny*
Typographer *Troy S. Ford*
Printer *Heritage Press*
Paper *Fox River Confetti 80# Kaleidoscope Cover and 80# White Text*

1

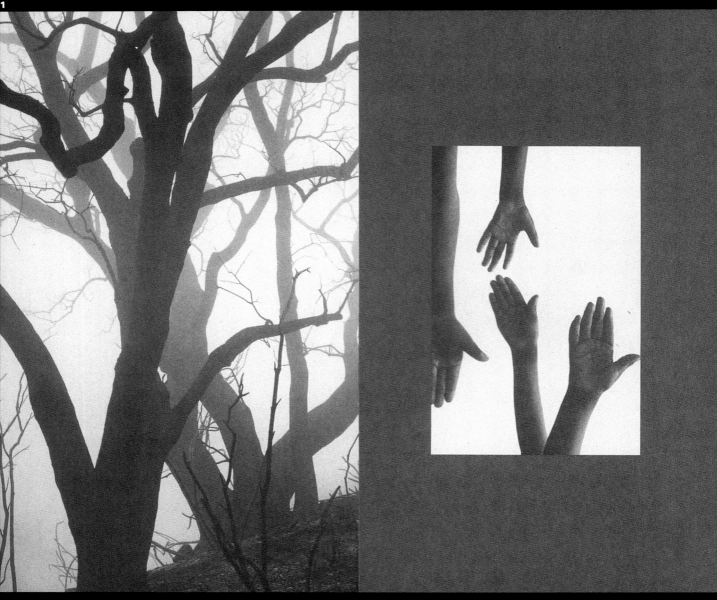

2

2
Title *Confetti Time Capsule*
Design Firm *Tolleson Design, San Francisco, CA*
Art Directors/Designers *Steven Tolleson and Jennifer Sterling*
Illustrators *Jonathan Rosen and Jack Molloy*
Photographers *John Casado and David Magnusson*
Copywriter *Lindsay Beaman*
Client *Fox River Paper Company*
Typographer *Tolleson Design*
Printer *Bradley Printing Company*
Paper *Fox River Confetti*

3
Title *Covenants and Contracts*
Design Firm *Herman Miller, Inc. (In-house)*
Art Director *Michael Barile*
Designers *Michael Barile and Glenn Hoffman*
Photographer *Jim Powell*
Copywriter *Clark Malcolm*
Client *Herman Miller, Inc.*
Printer *Herman Miller Corporate Publishing Services*
Paper *Gilbert Esse Smooth 80# Red Gray Cover,
Beckett Concept 70# Glacier Whitewove Text,
and Cross Pointe Medallion 80# Beige Vellum Text*

3

1

ISBN 0-465-00437-7

2

ART WORK

John Millei, artist, art director, scenic painter

Millei is a self-taught artist. He has worked in the film industry as a scenic painter, set builder, and art director. He has had solo exhibitions at Ace Contemporary Exhibitions, Los Angeles; Marc Richards Gallery, Los Angeles; and Marc Jancou Gallery, Zurich. His work has also been shown at Art Center; the Los Angeles Municipal Art Gallery; Claremont College, Claremont, California; and the California Palace of the Legion of Honor, San Francisco. He is represented by Ace Contemporary Exhibitions. He lives and works in Los Angeles.

1
Title *"Art Lessons" Book Jacket*
Art Director *Roberto de Vicq de Cumptich*
Designer *Angela Skouras*
Photographer *Robert Mapplethorpe*
Publisher *Basic Books*
Printer *Phoenix Color*

2
Title *Art Work*
Design Firm *Art Center College of Design,*
Pasadena, CA
Creative Director *Stuart I. Frolick*
Art Director/Designer *Rebeca Méndez*
Photographers *Various*
Copywriters *Laurence Dreiband and Wendy Adest*
Client/Publisher *Art Center College of Design*
Printer *Typecraft, Inc.*
Paper *Matrix Matte, Lexatone Karnak Beige*

3
Title *Dieter Appelt Exhibition Catalog*
Design Firm *Silvio Design, Chicago, IL*
Designer *Sam Silvio*
Photographer *Dieter Appelt*
Client *The Art Institute of Chicago and Ars Nicolai*
Typographer *Paul Baker Typography, Inc.*

3

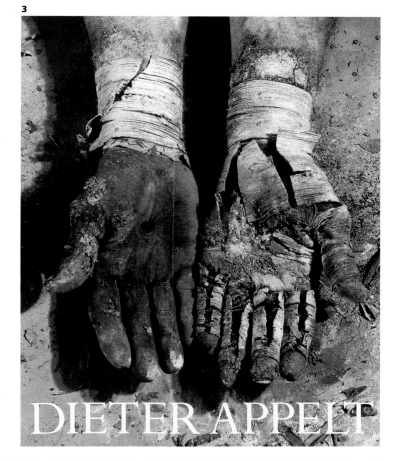

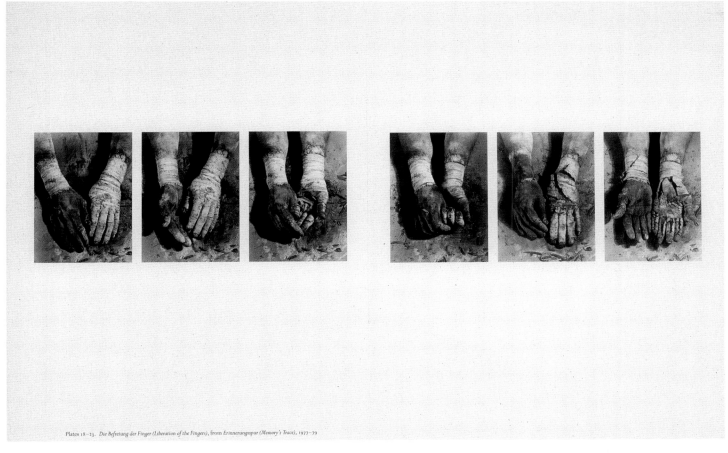

Plates 18–23. *Die Befreiung der Finger (Liberation of the Fingers), from Erinnerungsspur (Memory's Trace), 1977–79*

1
Title *The Music Box Project*
Design Firm *Matsumoto Inc., New York, NY*
Art Director/Designer *Takaaki Matsumoto*
Photographers *Various*
Publisher *On the Table, Inc.*
Typographer *Matsumoto Inc.*
Printer *Hull Printing Co.*
Paper *Mohawk Superfine*

2
Title *Asyst Lab Book*
Design Firm *Tolleson Design, San Francisco, CA*
Art Director *Steven Tolleson*
Designers *Steven Tolleson and Jean Orlebeke*
Client *Asyst Technologies*
Typographer *Tolleson Design*
Printer *Digital Engraving*
Paper *Various*

3

Title *Capp Street Project Catalog 1991–93*
Design Firm *Morla Design, San Francisco, CA*
Art Director *Jennifer Morla*
Designers *Jennifer Morla and Craig Bailey*
Photographers *Various*
Copywriter *Constance Lewallen*
Client *Capp Street Project*
Typographer *Morla Design*
Printer *Cal Central Press*
Paper *Incentive 100 Offset 70# Text and 30# Chipboard Cover*

4

Title *VH-1 Honors*
Design Firm *Werner Design Werks, Minneapolis, MN*
Art Directors *Cheri Dorr and Sharon Werner*
Designer *Sharon Werner*
Client *VH-1 Networks*
Typographer *Great Faces, Inc.*
Printer/Fabricator *Diversified Graphics, Inc.*
Paper *Mohawk Vellum and Various*

5

Title *Building Bridges Across Time*
Design Firm *Koc Design, San Francisco, CA*
Art Director/Designer *Nancy E. Koc*
Cover Photographer *Thea Schrack*
Copywriter *Gail Grimes*
Client *California Pacific Medical Center*
Typographer *Nancy E. Koc*
Printer *Coast Litho*
Paper *Simpson Coronado Recycled SST*

5

1

Title *Darrell Eager Stationery*
Design Firm *Charles S. Anderson Design Company,*
Minneapolis, MN
Art Directors *Charles S. Anderson*
and Todd Piper-Hauswirth
Designer *Todd Piper-Hauswirth*
Client *Darrell Eager Photography*
Paper *French Construction Recycled White*

1

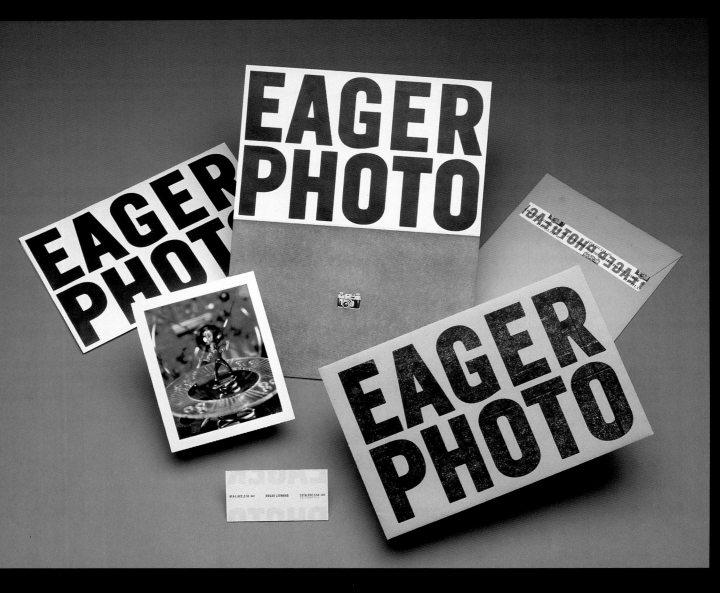

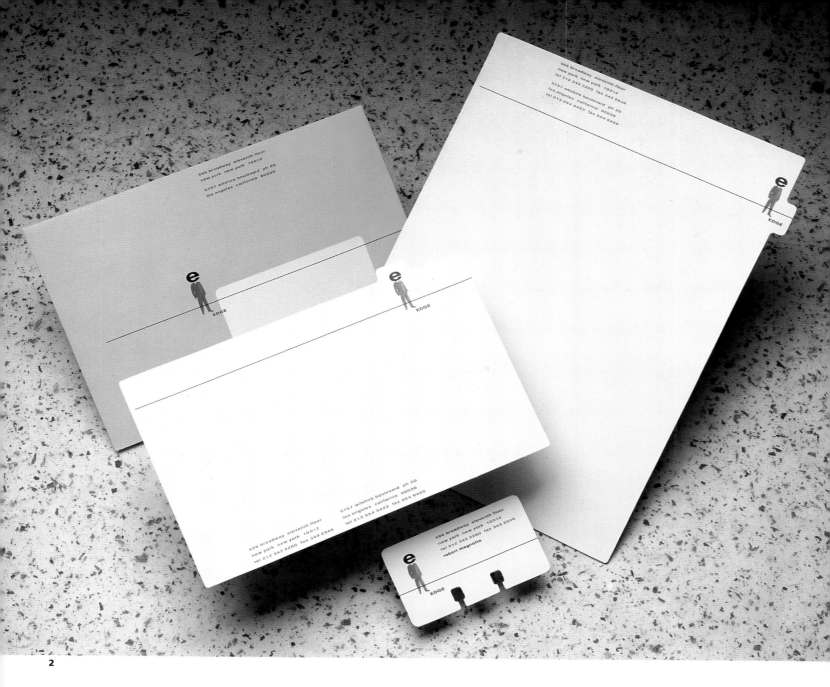

2

2

Title *Edge Stationery*

Design Firm *Todd Waterbury, Portland, OR*

Art Director/Designer/Illustrator

Todd Waterbury

Client *Edge Reps Ltd.*

Typographer *Todd Waterbury*

Printer *American Menu Printing*

Paper *French Dur-o-Tone Butcher Paper*

3

Title *Extreme Technologies Corporate Identity*

Design Firm *The Mednick Group,*

Culver City, CA

Art Director *Scott A. Mednick*

Designer *Ken Loh*

Client *Extreme Technologies*

Typographer *Ken Loh*

3 TM

EXTREME
technologies

1
Title *Man Bites Dog Logo*
Design Firm *BlackDog, San Rafael, CA*
Art Director *Michael Mabry/*
Michael Mabry Design
Designer/Illustrator *Mark Fox*
Client *Man Bites Dog*

2
Title *Rip Saw Photography Identity*
Design Firm *Werner Design Werks, Minneapolis, MN*
Art Director/Designer/Illustrator *Sharon Werner*
Client *Rip Saw Photography*
Calligrapher *Sharon Werner*
Printer *Heartland Graphics*
Paper *Scott Manila Tag, Simpson*
Starwhite Vicksburg, and Various

3
Title *Results Marketing Logo*
Design Firm *Richardson or Richardson, Phoenix, AZ*
Art Director *Forrest Richardson*
Designer *Debi Young Mees*
Client *Results Marketing*

4
Title *Fed Ex Logo*
Design Firm *Landor Associates, San Francisco, CA*
Art Director *Lindon Gray Leader*
Designers *Wallace Krantz, Bruce McGovert,*
and Lindon Gray Leader

5
Title *United States Association for Blind Athletes Logo*
Design Firm *After Hours Creative, Phoenix, AZ*
Art Director/Designer/Illustrator
After Hours Creative
Client *United States Association for Blind Athletes*
Typographer *After Hours Creative*
Printer *Fittje Brothers*
Paper *Beckett Expressions Iceburg*

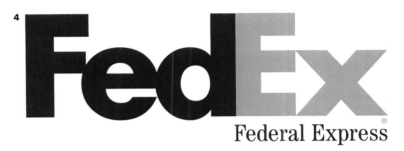

1
Title *DHA (USA) Stationery*
Design Firm *Sagmeister Inc., New York, NY*
Art Director/Designer *Stefan Sagmeister*
Photographer *Tom Schierlitz*
Client *DHA (USA)*
Typographer *Stefan Sagmeister*
Printer *Robert Kushner*
Paper *Strathmore Writing Paper, Bright White Wove*

2
Title *Profile Logo*
Design Firm *SullivanPerkins, Dallas, TX*
Art Director *Ron Sullivan*
Designer *Lorraine Charman*
Client *The Rouse Company*
Typographer *Lorraine Charman*

3
Title *Magico Logo*
Design Firm *Frazier Design, San Francisco, CA*
Designer/Illustrator *Craig Frazier*
Client *Magico*

1

2

PROFILE

A WEEKLY PUBLICATION OF THE ROUSE COMPANY

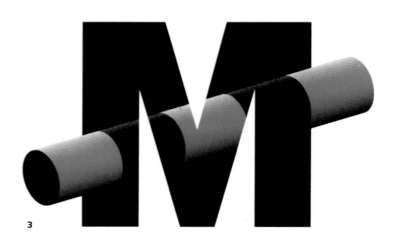

3

MINDSCAPE®

4
Title *Mindscape Corporate Identity*
Design Firm *The Mednick Group, Culver City, CA*
Art Director *Scott A. Mednick*
Designer *Tom Thorton*
Client *Mindscape*
Typographer *Tom Thorton*

5
Title *Asyst Rolo Card*
Design Firm *Tolleson Design, San Francisco, CA*
Art Director *Steven Tolleson*
Designer *Steven Tolleson and Jean Orlebeke*
Client *Asyst Technologies*
Typographer *Tolleson Design*
Printer *Digital Engraving*
Fabricator (Metal Etching) *Insite*
Paper *Various*

1

2

3

THE STONE KITCHEN

1

Title *Kuhlmann Design Group Corporate Identity*
Design Firm *Douglas Oliver Design Office,*
St. Louis, MO
Art Director/Designer *Deanna Kuhlmann*
Client *Kuhlmann Design Group, Inc.*
Typographer *Douglas Oliver Design Office*
Printer *Reprox*
Paper *Simpson Starwhite Vicksburg*

2

Title *Verlaine Gourmet Coffee House Logo*
Design Firm *Eisenberg and Associates, Dallas, TX*
Art Director/Designer/Illustrator
Bruce Wynne-Jones
Client *Verlaine*

3

Title *The Stone Kitchen Logo*
Design Firm *Geer Design, Inc., Houston, TX*
Art Director/Designer *Mark Geer*
Photographer *Key Sanders*
Client *The Stone Kitchen*
Typographer *Geer Design, Inc.*
Printer *Specialty Press*

4

Title *New York Public Library Logo (Initials)*
Design Firm *Chermayeff & Geismar Inc.,*
New York, NY
Art Director/Designer *Steff Geissbuhler*
Client *New York Public Library*

5

Title *New York Public Library Logo*
Design Firm *Chermayeff & Geismar Inc.,*
New York, NY
Art Director/Designer *Steff Geissbuhler*
Client *New York Public Library*

6

Title *Naked Music Stationery*
Design Firm *Sagmeister Inc., New York, NY*
Art Director *Stefan Sagmeister*
Designers *Stefan Sagmeister and Veronica Oh*
Photographer *Tom Schierlitz*
Client *Naked Music*
Typographer *Veronica Oh*
Printer *Robert Kushner*
Paper *Strathmore Writing Paper, Bright White Wove*

4

The New York Public Library Celebrating Its Second Century

5

6

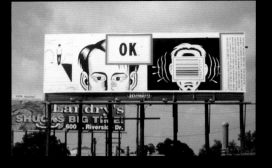

Right
Title *OK Billboards*
Design Firm *Wieden & Kennedy, Portland, OR*
Design Director/Designer *Todd Waterbury*
Creative Directors *Peter Wegner,*
Todd Waterbury, and Charlotte Moore
Illustrators *Daniel Clowes, Calef Brown,*
Charles Burns, and David Cowles
Copywriter *Peter Wegner*
Client *The Coca-Cola Company*
Typographer *Todd Waterbury*
Printer/Fabricator *Kubin Nicholson*
Paper *Advantage Coated*

Below
Title *OK Wildposting*
Design Firm *Wieden & Kennedy, Portland, OR*
Design Director/Designer *Todd Waterbury*
Creative Directors *Peter Wegner,*
Todd Waterbury, and Charlotte Moore
Illustrators *Daniel Clowes, Calef Brown,*
Charles Burns, and David Cowles
Copywriter *Peter Wegner*
Client *The Coca-Cola Company*
Typographer *Todd Waterbury*
Printer *Color Magic*
Paper *Mylar*

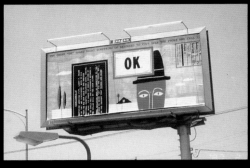

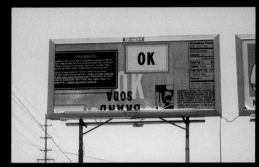

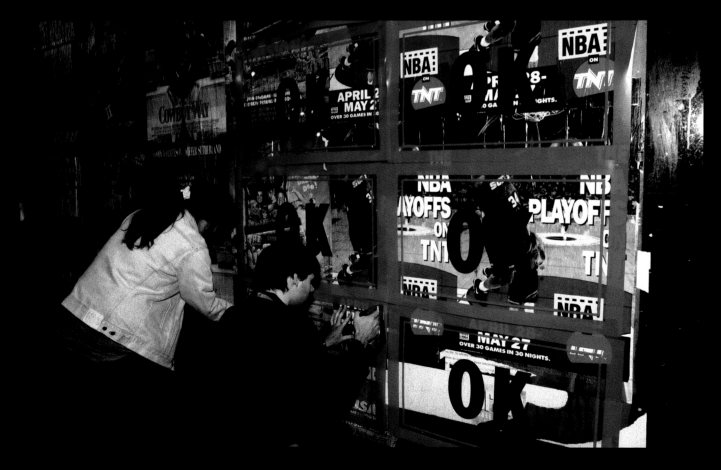

Title *AIGA "Issues & Causes" Traveling Exhibition*
Design Firm *Johnson and Wolverton, Portland, OR*
Art Directors *Alicia Johnson and Hal Wolverton*
Designers *Hal Wolverton, Geoffrey Lorenzen, and Gena Gloar*
Photographer *Mark Hooper*
Client *AIGA/Portland*

Title *JBL On-Board Trade Show Installation*
Design Firm *Fitch, Inc., Boston, MA*
Art Directors *Ann Gildea and Jane Brady*
Designers *Jane Brady, Christian Uhl,*
Ben Segal, and Jack Herr
Photographer *Mark Steele*
Copywriter *Mike Mooney*
Client *Harman Consumer Group*
Panels *Aperture*
Fabricator *Farmington Displays*

Title *"Tees & Cues"*
Design Firm *The Hively Agency, Houston, TX*
Art Director *Charles Hively*
Copywriter *Don Rush*
Client *Metropolitan Transit Authority*

So you want to drive to work?

So you want to drive to work?

So you want to drive to work?

Why not take the bus?

Title "Call Me"
Design Firm *Two Headed Monster, Hollywood, CA*
Art Director *David J. Hwang*
Designers *David J. Hwang and Joan Raspo*
Client *Seventeen Magazine*
Typographer *Joan Raspo*

Title *"Sound Bytes"*
Design Firm *Two Headed Monster, Hollywood, CA*
Art Director/Designer *David J. Hwang*
Client *TCI*
Typographers *David J. Hwang and Joan Raspo*

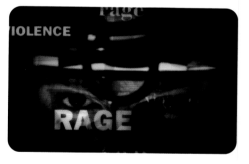

Title *"Under the Helmet"*
Design Firm *Two Headed Monster, Hollywood, CA*
Art Director/Designer *David J. Hwang*
Client *Fox Sports*
Typographer *David J. Hwang*

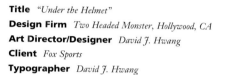

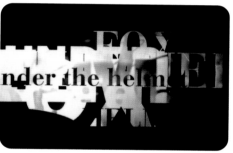

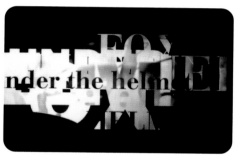

Title *"Front Page"*
Design Firm *Two Headed Monster, Hollywood, CA*
Art Director/Designer *David J. Hwang*
Copywriter *Krysia Plonka*
Client *Fox Network*
Typographer *David J. Hwang*

Title *OK Broadcast Ads:*
"Mirror," "Meter," "Documents"
Design Firm *Wieden & Kennedy, Portland, OR*
Design Director *Todd Waterbury*
Creative Directors *Todd Waterbury*
and Peter Wegner
Directors *Donna Pittman, Mark Hensley,*
and Pittman Hensley
Producer *Amy Davenport*
Illustrators *Daniel Clowes, Charles Burns,*
and David Cowles
Copywriter *Peter Wegner*
Client *The Coca-Cola Company*
Typographer *Todd Waterbury*

1

AN OPEN LETTER:

THEREFORE, THE REST OF THIS COMMERCIAL MAY BE VIEWED BY *ANYONE* HOLDING A SMALL POCKET MIRROR TO THE SCREEN.

2

"OK-NESS" & YOU

"OK-NESS"

NOW! 33% MORE "OK-NESS"!

3

CERTAIN DOCUMENTS REGARDING "OK" SODA HAVE BEEN DECLASSIFIED.

"OK" SODA · "BEVERAGE" · BUBBLES · CITRUS · SPICES

THINGS ARE GOING TO BE OK.

1
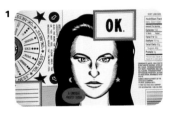

ATLANTA, GEORG... ©1995 THE COCA... FOR INFORMATION...

THINK OK/DRINK OK

2

12 FL OZ (355 mL) · 58630177

THINK OK/DRINK OK

3

OK.

OK.

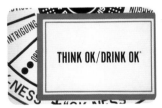
0 K-NESS

Title *OK Broadcast Ads:*
"Mystic Woman," "Burns Boy," "Abstract Woman"
Design Firm *Wieden & Kennedy, Portland, OR*
Design Director *Todd Waterbury*
Creative Directors *Peter Wegner*
and Todd Waterbury
Directors *Donna Pittman,*
Mark Hensley and Pittman Hensley
Producer *Amy Davenport*
Illustrators *Daniel Clowes, Charles Burns,*
and David Cowles
Copywriter *Peter Wegner*
Client *The Coca-Cola Company*
Typographer *Todd Waterbury*

Title *OK Broadcast Ads:*
"Legal," "Elevator," "Secret Code"
Design Firm *Wieden & Kennedy, Portland, OR*
Design Director *Todd Waterbury*
Creative Directors *Peter Wegner, Todd*
Waterbury, and Charlotte Moore
Directors *Donna Pittman, Mark Hensley*
and Pittman Hensley
Producer *Kevin Diller*
Illustrators *Daniel Clowes, Calef Brown,*
and Charles Burns
Copywriter *Peter Wegner*
Client *The Coca-Cola Company*
Typographer *Todd Waterbury*

1

QUESTIONS HAVE ARISEN ABOUT OUR BRAND NAME AND THEME LINE WHEN USED IN CASUAL CONVERSATION.

OUR ATTORNEYS RECOMMEND THE FOLLOWING:

"THINGS ARE GOING TO BE 'OK'®."™

2

DEAR _____,

THIS IS A TELEVISION CHAIN LETTER PROMOTING "OK" SODA.

TOM B. OF LITTLE ROCK, ARK. DECLINED A CAN OF "OK" THEN

THAT GOT STUCK BETWEEN FLOORS FOR SIX HOURS.

HAPPILY, THE OTHER PEOPLE IN IT (MOSTLY THIRD GRADERS) KNEW AN IMPRESSIVE RANGE OF "KNOCK-KNOCK" JOKES.

3

TO RESPOND TO ALLEGATIONS THAT THE TELEVISION CHAIN LETTER IS SOME SORT OF SECRET CODE.

A "SECRET" OR "CODE" OF ANY KIND WOULD BE KPN6UG55.

2NG4S 3R GOING TO BE OK.
OK.

Title *"Your Breasts" Breast Cancer*
Public Service Announcement
Design Firm *Lifetime Television, New York, NY*
Art Director *Kendrick Reid*
Creative Director *Lynn Lazaroff*
Cinematographer *Janice Molinari*
Producers *Jill Gershman and Marcelle Karp*

Title *"Kajoobies" Breast Cancer*
Public Service Announcement
Design Firm *Lifetime Television, New York, NY*
Art Director *Kendrick Reid*
Creative Director *Lynn Lazaroff*
Cinematographer *Janice Molinari*
Producers *Jill Gershman and Marcelle Karp*

Lorraine Wild
chair
James Abrams
Nicholas Callaway
J. Abbott Miller
jurors

A I G A

D L E I A N D E

5 APRIL 95

F I F T Y B O O K S

50 books

While pinning down their subjects, the lost books open up space and time: they connect our minds and our bodies to their authors and designers and editors and printers in

a most visceral way, and they connect our selves to our thoughts in a most intimate way. After too many hours with television or movies or cyber-space, the non-virtual

reality of the book is almost shockingly human, simultaneous-ly tough and frail, takes for granted, missed over. They are scary in large piles, and for good reason.

 Graphic designers

eli gib ili ty

Please read all instructions careful-ly. All books that have originated and been designed in the U.S. or Canada between Jan. 1994 and Dec. 1994 are eligible. All books

should be entered in the categories listed. If you are uncertain of the category, we will place your book in the category which will show it to its best advantage for

judging. Work will be judged by a panel of jurors with the chair serving as a juror.

the energy that they contain challenges us, and have really feelit. Books are not meta-phors for connection, they are connection. Perhaps the current attempt to create

interactivity in new media has responded our eyes to the subtlety and intensity of one-oldest and most ordinary form of interactivity that won't jury, or always,

is looking forward to celebrating the most extraordinary specimens of communication in print.
Lorraine Wild

are idea embalmers.

cat ego rie s

Please do not enter any book if you will not be able to submit four additional copies upon acceptance you/cents in the Limited Edition category will be

responded to submit only two additional copies) The four additional copies of each selected title are requested for exhibition in New York, for the traveling show.

for the Frankfurt Book Fair, and for the Rare Book and Manuscript Collection at Columbia University.

LORRAINE WILD

Lorraine Wild is a partner at ReVerb, a graphic design firm in Los Angeles, and teaches graphic design and graphic design history at the California Institute of the

Arts, where she was director of the Program in Graphic Design from 1985 to 1991. Wild is also a tutor in the graphic design pro-gram at the Jan Van Eyck Akademie in

the Netherlands. She designs books, catalogues, and posters for cultural and educational institutions. Her writing has been widely published.

 loving undertakers

GENERAL TRADE BOOKS

Books for store dis-tribution (including how-to books, cookbooks, craft and hobby books).

SPECIAL TRADE BOOKS

Books for store distribution which are primarily picture or photography books.

JANET ABRAMS

Janet Abrams is a New York-based cultural critic who writes about the design arts, media technologies, and social change. Currently Writer-at-Large for I.D., the

international design magazine, and a contributor to many other publications, including Archis, Sight & Sound, Lotus International, and Blueprint, she is also

the curator of DIVague, a Con-versation series on design and technology at Cooper Union.

preserving bits of data

LIMITED EDITION, PRIVATE AND FINE PRESS BOOKS, AND SPECIAL FORMATS

Collector's books, fine editions, deluxe art books, and books in which the quality or produc-tion, innovation or experimentation is deemed of para-mount importance. Only books in this

category will not be required to submit four additional copies if accepted. If you cannot submit at least two additional copies, please do not enter this book in the competition.

NICHOLAS CALLAWAY

Nicholas Callaway founded Callaway Editions, Inc. in 1980. The publish-ing firm specializes in the design, pro-duction, and publi-cation of illustrated books and multi-

media products. His titles are released internationally in simultaneous co-editions. Callaway books have received numerous awards, including the American Book

Award, the Carey-Thomas Award, the Association of American Museum Publications Award, France's Prix Nadar, from among numerous others.

like so many butterflies

PROMOTIONAL AND MAIL ORDER BOOKS

Books produced for a specific audience distributed as no charge by compa-nies or institutions and books for sale by mail order only.

TEXT AND REFERENCE BOOKS

All books used for instruction in schools, from ele-mentary and high school texts to college, technical, and vocational texts including encyclo-pedias, atlases, dictionaries, and yearbooks.

J. ABBOTT MILLER

J. Abbott Miller is director of Design/Writing Research, a design and writing studio that creates books and exhibitions on cultural aspects of design and art.

The studio has established an imprint called Kiosk, with Princeton Architectural Press. Miller is designer of the award-winning magazine Dance Ink. In 1993 Miller and

his partner Ellen Lupton were recipi-ents of the Chrysler Award. Miller is a contributing editor of Eye, and editor of the American Center for Design's journal Statements.

pinned to felt

JUVENILES

Books published primarily for children. Does not include textbooks.

PAPERBACKS

All paperback books including those designed for the mass market Paperback books will be judged in their entirety.

The American Institute of Graphic Arts is a national non-profit organization founded in 1914, the AIGA has its chapters nationwide. Its publications include programs of competitions,

exhibitions, publica-tions, and educational activities to promote excellence in graphic design. AIGA members are involved in all aspects of the graphic arts: packaging, illustrate, advertis-

in a jewel box.

MUSEUM PUBLICATIONS AND UNIVERSITY PRESS BOOKS

For-sale catalogues and books (hard-cover or paperback), published by museums or university presses.

ing, and interactive and exhibition design, or work in printmaking and graphics. The website is written for the charitable sharing information within

the field, but also reaches a broader audience by increas-ing interest in public design.
William Drenttel,
President

Paul Saffo
ID Magazine
January/
February 1995

grap hicd esig nusa

The 16th annual hardbound volume honoring AIGA exhibitions throughout the years, will serve as a permanent record of the vitality of graphic design in America, as well as

a yearly national reference for the design and business communities. The book will include captioned illustra-tions of all pieces selected for the exhibi-tion, as well as essays on leading

individuals, busi-nesses, and organi-zations in graphic design. It will have approximately 360 pages with over 750 illustrations. It will sell for $59.95, but it is distributed free to AIGA members.

While pinning down their subjects, the best books open up space and time: they connect our minds and our bodies to their authors and designers and editors and printers in a most visceral way, and they connect ourselves to our thoughts in a most intimate way. After too many hours with television or movies or cyberspace, the non-virtual reality of the book is almost shockingly human, simultaneously tough and frail, taken for granted, obsessed over. They are scary in large piles, and for good reason: the energy that they contain challenges us, and never really fades. Books are not metaphors for connection: they are connection. Perhaps the current attempt to create interactivity in new media has re-opened our eyes to the subtlety and intensity of our oldest and most ordinary form of interactivity. This year's jury, as always, celebrates the most extraordinary specimens of communication in print.

Lorraine Wild
Chair

J U R Y

Janet Abrams
Cultural Critic
New York, NY

Eric Baker
Principal/Designer
Eric Baker Design Associates
New York, NY

J. Abbott Miller
Director
Design/Writing/Research
New York, NY

Lorraine Wild
Partner
Reverb
Los Angeles, CA

Three graphic designers joined a cultural critic to select the fifty books of 1994. Their charge was not whimsical but decades old. The four-person jury — some book makers, some authors, but book lovers all — would perpetuate a process repeated annually since 1923. They would choose carefully, with an aim to cull not the best but what custom defined as the fifty representative best — as widely representative as possible of solutions to the various problems of printing and bookmaking in books produced in the United States and Canada during the preceding year.

"Is that a book...a catalogue... a pamphlet?...Ooh, they've used Meta...Oh, they've squished it...I like the cover...the inside is boring...It's perfect for its subject...appropriate...responsible...not a cliché." The jury selected by category with an eye toward balance in the design (low budget and high) of cover and body, and (in the case of one juror) intent. A book's meaning as a project rarely is considered a valid criteria, but "it absolutely enters my reading," he explained.

They skimmed over Helvetica and traced the topology of the page, noting color, stock, margins, leading, line length, and scale. Shunning excessive die cuts, varnishes, and fancy papers, they savored the unexpected juxtaposition of image and text and lauded compelling solutions to thorny typographic and organizational challenges. They lamented the stratification of book design that pegs designers by genre and suggested that architectural designers try their hand designing cookbooks for a change. All the while affirming that with little or no increase in design fees over the past fifteen years (a subject so depressing that the chair declined to discuss it), book design is without question a labor of love.

The jurors selected fifty singular books from 450 entries in eight categories: cookbooks to juvenile, textbooks to trade (surprisingly, several high-profile examples were missing from the pool). The jury hoped that next year's entries would show greater participation in the categories of fiction, visual books, paperbacks, university and institutional presses, experimental works, and closer collaborations between the creators of text and design. Pondering the future of the book, they saw renewed opportunities to capture transitions in publishing today.

The *Book Show* claims a legacy nearly as diverse as the book itself. The competition's early rosters of participants and jurors included such designers, printers, and publishers as Goudy, Bayer, Lubalin, Lionni, Harry Abrams, R.R. Donnelly, and Condé Nast. For years the show opened at the Grolier Club, the New York Public Library, the Plaza Hotel, and the Metropolitan Museum of Art. The Rare Book and Manuscript Library at Columbia University has archived every year's show since 1924. The *Book Show* has survived wartime shortages, traveled to Europe, Latin America, and the Far East during the Kennedy years, and even inspired Britain's own *Books of the Year*. "The show virtually charts the route of the AIGA and the role of graphic design," said the chair.

Why honor and preserve these fragile yet potent specimens? "There is something untranslatable about a book," wrote John Steinbeck in one of many bound catalogues that for fifty years marked each AIGA *Book Show*. "It is itself — one of the few authentic magics our species has created."

Moira Cullen

Title *Life on the Edge: A Guide to California's Endangered Natural Resources*

Art Director *Michael Cronan*

Text/Jacket Designers *Michael Cronan and Anthony Yell*

Illustrators *Randy Schmieder and Carol Barner*

Photographers *Various*

Jacket Photographer *Earthsat*

Publishers *BioSystems Books/Heyday Books*

Printer/Binder *Singapore National Printers, Ltd.*

Paper *Storä Papyrus Nymölla Multiart Silk*

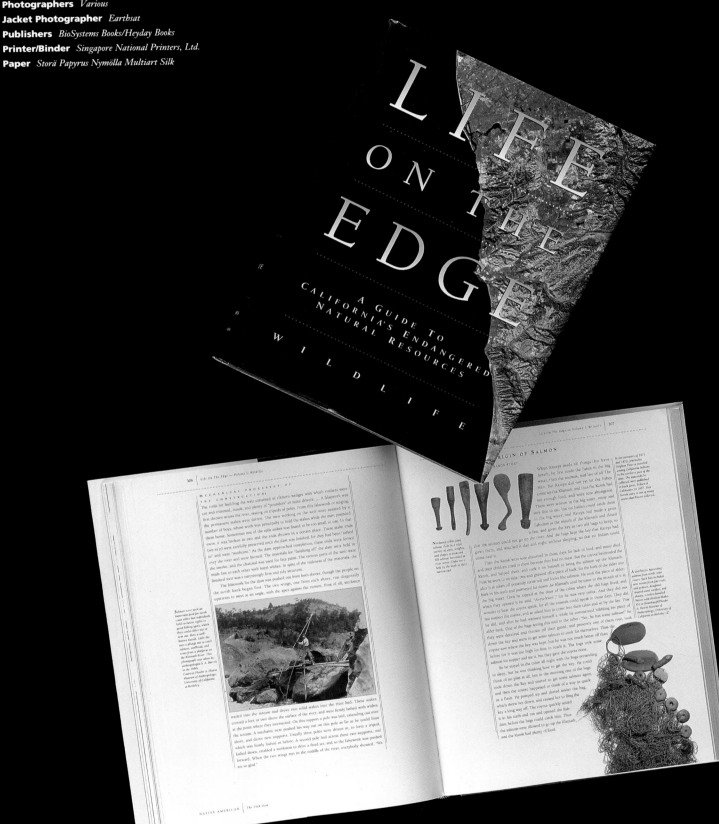

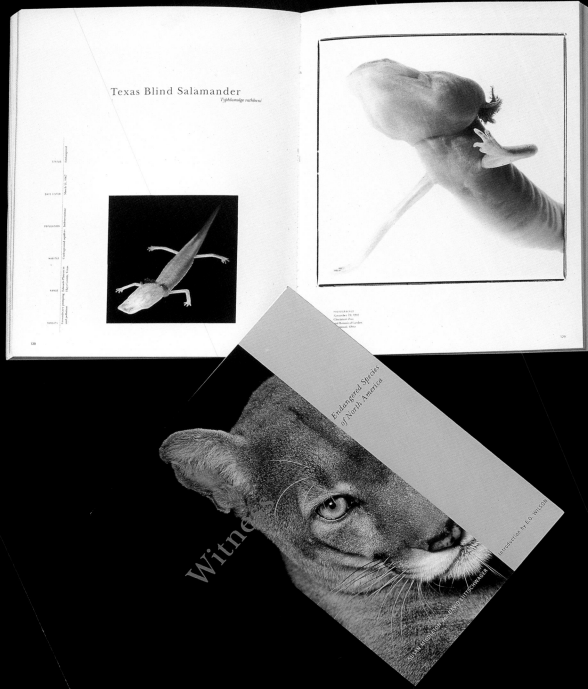

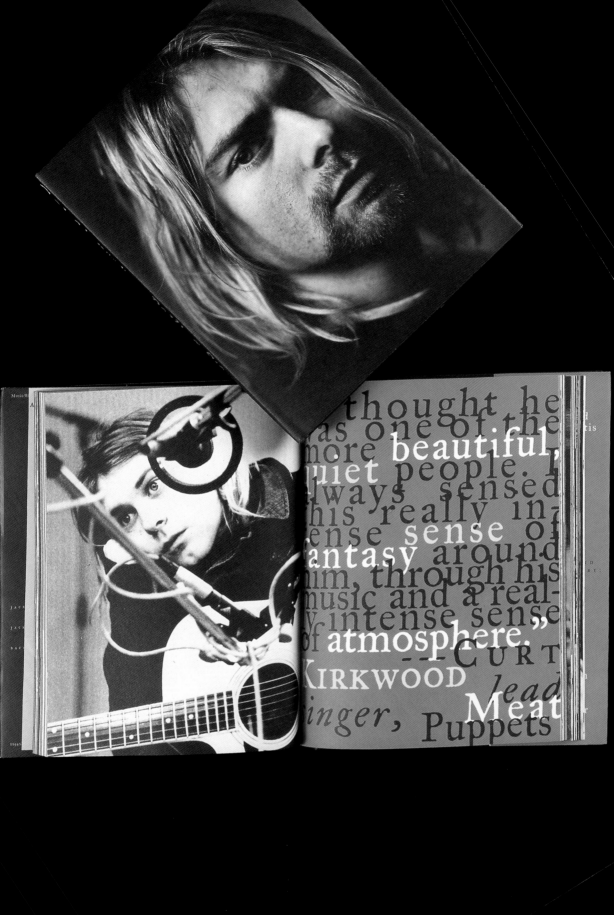

"...thought he was one of the more beautiful, quiet people. I always sensed this really intense sense of fantasy around him, through his music and a really intense sense of atmosphere." —CURT KIRKWOOD *lead singer,* Puppets

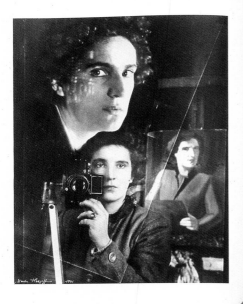

[PLATE 78]

Marta Hoepffner

1941

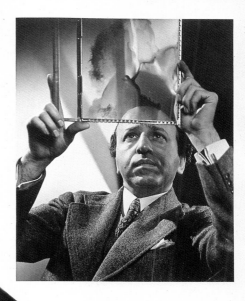

[PLATE 79]

Yousuf Karsh

1947

the camera i

Photographic Self-Portraits

Title *Rodeo*

Art Director *Roger Gorman*

Designer *Rick Patrick*

Photographer *Louise L. Serpa*

Jacket Designers *Roger Gorman and Rick Patrick*

Publisher *Aperture Foundation, Inc.*

Typographer *Betty Type, Inc.*

Printer/Binder *Arti Grafiche Motta Spa*

Paper *150 gsm Garda Gloss*

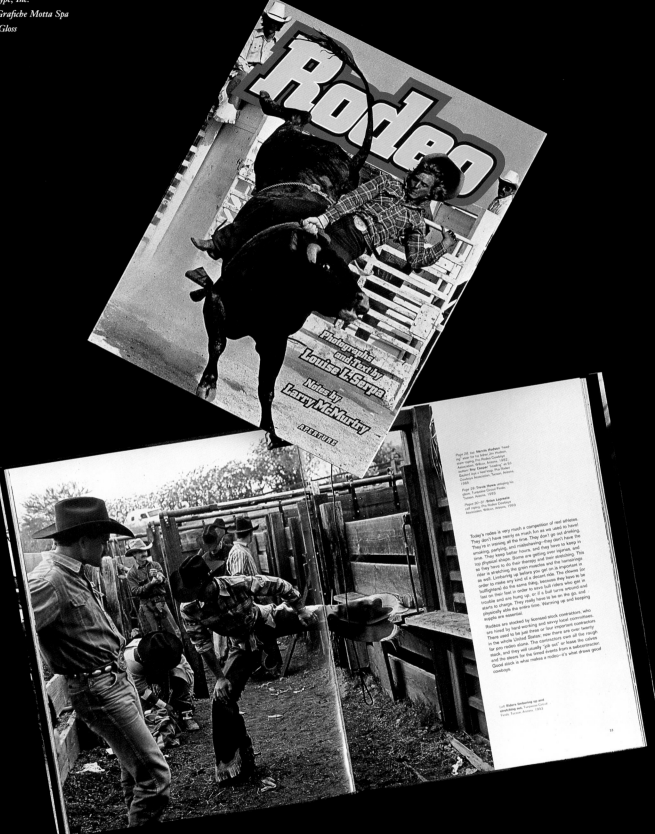

Grilled Sea Scallops with Avocado-Corn Relish on Crisp Tortillas

The great thing here is not only the flavor but the mix of textures—the crispness of the tortilla, the crunchiness of the corn, and the creaminess of the avocado, all accenting the sweet, juicy scallops.

2 cups peanut oil
4 flour tortillas, cut into quarters
16 large sea scallops, grilled (page 107)
6 tablespoons Avocado-Corn Relish

1. In a large saucepan or deep fryer over medium-high heat, heat the oil to 375° F., or until a piece of tortilla sizzles when immersed. Fry the tortillas until crisp and drain on paper towels. Set aside.

2. Grill the scallops as described on page 107.

3. To serve, arrange 4 tortilla quarters on each plate. Top each with a layer of relish and 1 scallop.
Makes 4 first-course servings

Avocado-Corn Relish

2 Haas avocados, peeled, seeded, and coarsely chopped
1 cup roasted corn kernels (page 8)
3 tablespoons finely diced red onion
¼ cup coarsely chopped cilantro
¼ cup fresh lime juice
2 tablespoons regular or light sour cream
Salt and freshly ground pepper

Combine the avocados, corn, onion, cilantro, lime juice, and sour cream in a bowl and mix well. Season to taste with salt and pepper. May be prepared up to 1 day ahead, covered, and refrigerated. Bring to room temperature before serving.
Makes 2¼ cups

Bobby Flay's Bold American Food

More than **200** Revolutionary Recipes

Bobby Flay with Joan Schwartz + Photographs by Tom Eckerle

Rodin
IN HIS TIME

Auguste Rodin

FRANCE, 1840–1917

Invocation

CATALOGUE NO. 41

c. 1900
Musée Rodin cast 4/8, 1986
Bronze
31 × 12¼ × 9½ in.
(78.8 × 26.0 × 24.1 cm)
Inscribed on base, right:
A. Rodin (4/8); back, at lower edge:
© BY MUSÉE RODIN 1986
Foundry mark on base, left, at
lower edge: Susse Fondeur Paris
Gift of Iris and B. Gerald Cantor
Foundation
AC1992.111.1

Although Georges Grappe suggested a date of about 1886 for the present
figure,[1] the earliest documented date for it is 1900, when it was shown in
Rodin's exhibition at the Pavillon de l'Alma in Paris. There it was called
Dawn Awakening (L'Aurore s'éveillant).[2] Nicole Barbier suggests that
Invocation is an adaptation of a sculpture made for the 1900 exhibition.[3]

Grappe also related the figure to another sculpture called *Old Man in Supplication*
(*Vieillard suppliant*, c. 1886?),[4] most likely because of the similarity of the
gestures of their upraised arms. Although it cannot yet be determined with
complete certainty whether these compositions really were related, there is a
slight visual correspondence between them. Perhaps they also share a
correspondence with Rodin's sculptures of dancers, whose limbs in extension
produce movement in the silhouettes. Their gracefulness is achieved through
unnaturalistic distortion in different parts of the body. The rising line of the
form of *Invocation* emerges from the tenuous position of the figure on its
base and opens and returns into the lyrical double arc of the arms. Although
it is recognizably representational, *Invocation* shows how far Rodin moved
away from modeling realistic anatomies. Even in bronze this sculpture retains
all the characteristics of an incidental sketch, in which the human body is
nothing more than a pretext for developing a nearly abstract composition.

"Pawden me," says Fay to Batty. "Your

is on me. Pawden me."

Title *Mole's Hill*
Art Director *Michael Farmer*
Text/Jacket Designers *Lois Ehlert and*
Lydia D'Moch
Text/Jacket Illustrator *Lois Ehlert*
Publisher *Harcourt Brace & Company*
Typographer *Harcourt Brace*
Photocomposition Center
Printer/Binder *Tien Wah Press*
Paper *130 gsm Matte Art*

Los elefantes · The Elephant Song

This counting song can also be played as a game. While the group stands in a circle and sings, one child makes the slow-motion sway walk of an elephant inside the circle. At the end of the first verse, the child picks a second child, and both do the slow-motion elephant sway walk. Then the second child picks a third, and so on. This version of the song comes from Argentina.

Un e-le-fan-te se ba-lan-cea-ba so-bre la te-la de u-na a-ra-ña.

Co-mo ve-í-a que re-sis-tí-a fue a lla-mar a o-tro e-le-fan-te.

Un elefante se balanceaba
sobre la tela de una araña.
Como veía que resistía
fue a llamar a otro elefante.

Dos elefantes se balanceaban
sobre la tela de una araña.
Como veían que resistía
fueron a llamar a otro elefante.

Tres elefantes…

One elephant went out to play
out on a spider's web one day.
He had such enormous fun
he called another elephant to play.

Two elephants went out to play
out on a spider's web one day.
They had such enormous fun
they called another elephant to play.

Three elephants…

De Colores and Other Latin-American Folk Songs for Children

Selected, Arranged, and Translated by JOSÉ-LUIS OROZCO
Illustrated by ELISA KLEVEN

Title *Herman Miller, Inc.: Buildings and Beliefs*
Art Director *Judy Kohn*
Designers *Judy Kohn and Jessica Ludwig*
Jacket Designer *Judy Kohn*
Jacket Photographer *Paul Rezendez/*
Positive Images
Publisher *AIA Press*
Printer/Binder *Palace Press International*
Paper *157 gsm Mitsubishi Matte Art*

Jeffrey L. Cruikshank
and
Clark Malcolm

Herman Miller, Inc.: Buildings and Beliefs

Office area at Zeeland site

Meeting area at Zeeland site

Title *Mining the Museum: An Installation by Fred Wilson*
Designer *Charles Nix*
Photographers *Ken Schles and Jeff Goldman*
Publishers *The New Press/The Contemporary, Baltimore*
Typographer *Charles Nix*
Printer *Oddi Printing Corp.*

Title Dinosaur Bob and His Adventures
with the Family Lazardo
Art Director Christine Kettner
Text/Jacket Designer William Joyce
Text/Jacket Illustrator William Joyce
Publisher HarperCollins
Printer/Binder Worzalla
Paper Lindenmeyr 80# Patina Matte

Once upon a time,
long ago and far away
in a land called Save-the-Day,
There were

7 silly salamanders and
6 fly-by-night bats and
5 butter-colored flutter-byes and
4 nevermore dinosaurs and
3 bees busy buzzing and
2 shoe-flies in bow ties and
1 worm... squirmy but firm.

55FRIENDS

ABBIE ZABAR

Title *The Sawfin Stickleback*
Art Director *Ellen Friedman*
Text/Jacket Designer *Mara Van Fleet*
Text/Jacket Illustrator *Dan Yaccarino*
Publisher *Hyperion Books for Children*
Printer/Binder *Tien Wah Press*
Paper *135 gsm Storä Nymölla Matte*

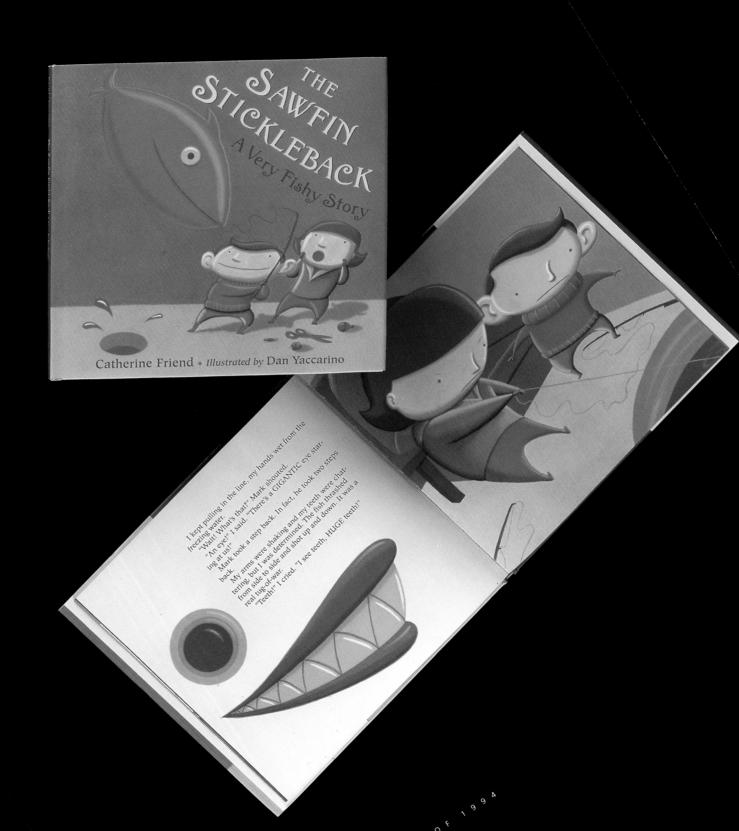

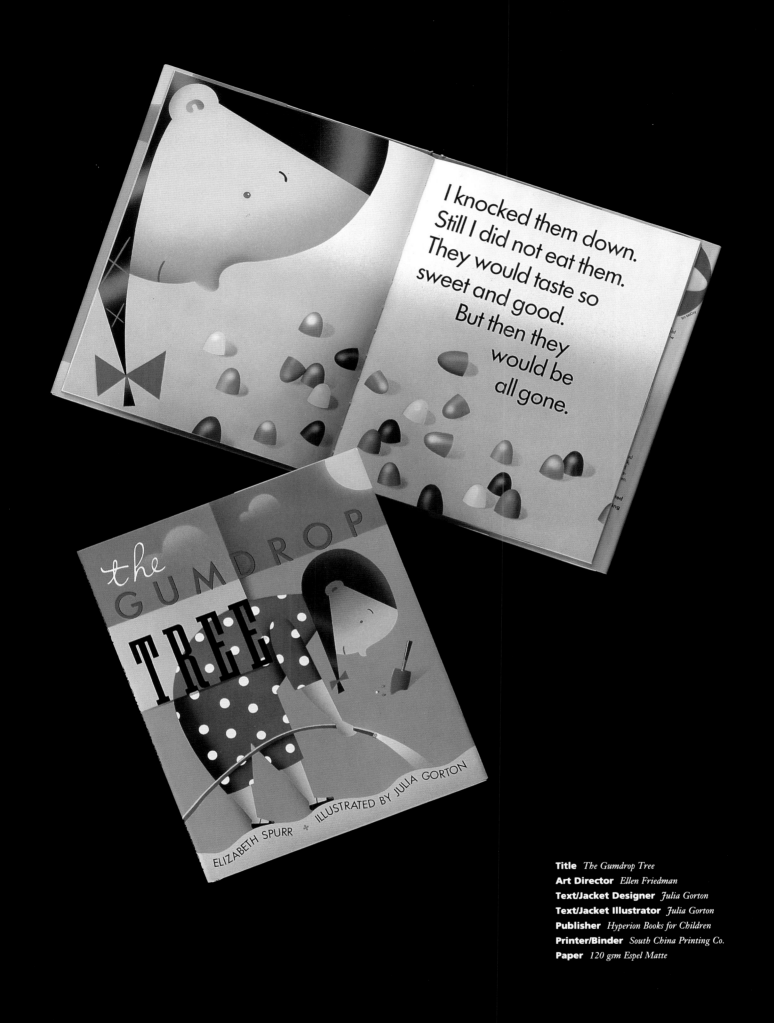

I knocked them down.
Still I did not eat them.
They would taste so
sweet and good.
But then they
would be
all gone.

the GUMDROP TREE

ELIZABETH SPURR + ILLUSTRATED BY JULIA GORTON

Title *The Gumdrop Tree*
Art Director *Ellen Friedman*
Text/Jacket Designer *Julia Gorton*
Text/Jacket Illustrator *Julia Gorton*
Publisher *Hyperion Books for Children*
Printer/Binder *South China Printing Co.*
Paper *120 gsm Espel Matte*

Title *The Mahler Album*

Art Director *Fabien Baron*

Text/Jacket Designer *Johan Svensson*

Jacket Photographer *Frederik Lieberath*

Publisher *Gilbert Kaplan, The Kaplan Foundation*

Printer *The Stinehour Press*

Paper *Condat Supreme Dull and Ikonofix*

Binder *Acme Bookbindery*

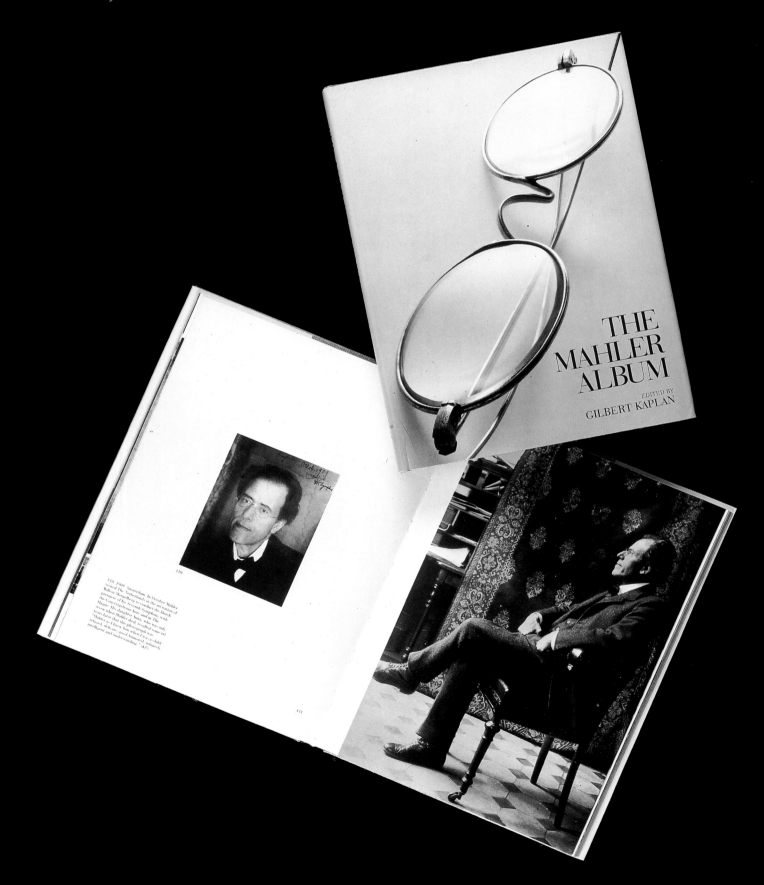

PLATE 2

Bill Duckett nude, reclining on side, hand on knee, ca. 1889,

PLATE 3

Thomas Eakins and students, swimming nude, by circle of Eakins, ca. 1883, platinum print (cat. no. 393 [.480])

EAKINS AND THE PHOTOGRAPH

WORKS BY THOMAS EAKINS
AND HIS CIRCLE
IN THE COLLECTION
OF THE PENNSYLVANIA ACADEMY
OF THE FINE ARTS

Title *Masked Culture*
Art Director *Teresa Bonner*
Text/Jacket Designers *Reiner Design Consultants*
Photographers *Mariette Pathy Allen, Elijah Cobb,*
Harold Davis, Lauren Piperno, and Marilyn Stern
Jacket Photographers *Lauren Piperno*
and Elijah Cobb
Publisher *Columbia University Press*
Typographers *Reiner Design Consultants*
Printer/Binder *Oceanic Graphic Printing, Inc.*
Paper *128 gsm Japanese Glossy Art*

Title *Picture LA: Landmarks of a New Generation*

Text/Jacket Designer *Vickie Sawyer Karten*

Illustrator *Dusty Deyo*

Photographers *Various*

Jacket Photographer *Abby Fuchs*

Publisher *The Getty Conservation Institute*

Typographer *Vickie Sawyer Karten*

Printer *Gardner Lithograph*

Paper *Celesta Dull Text, Brilliant Art Gloss Cover*

Binder *Roswell Bookbinding*

Title *Manhole Covers*
Art Director *Yasuyo Iguchi*
Text/Jacket Designer *Yasuyo Iguchi*
Photoshop Illustrator *Yasuyo Iguchi*
Photographer *Robert A. Melnick*
Publisher *The MIT Press*
Typographer *Yasuyo Iguchi*
Printer/Binder *Quebecor Kingsport*
Jacket Printer *New England Book Components*
Paper *70# Glatfelter Premier Matte*

Title *The Art of Makeup*

Art Director *Fabien Baron*

Designer *Siung Fat Tjia*

Photographers *Various*

Jacket Designers *Siung Fat Tjia and Fabien Baron*

Publisher *HarperCollins/Callaway Editions*

Printer/Binder *Palace Press*

Title *The Boy Who Ate Around*
Art Directors *Henrik Drescher and Ellen Friedman*
Text/Jacket Designer *Stephanie Power/*
Reactor Art & Design Ltd.
Jacket Illustrator *Henrik Drescher*
Publisher *Hyperion Books for Children*
Printer/Binder *Tien Wah Press*
Paper *135 gsm Storä Nymölla Matte*

GROWN-UPS LIKE TO WATCH OTHER PEOPLE PLAY

GROWN-UPS LIKE TO TELL JOKES

GROWN-UPS GET TO DO ALL THE DRIVING

BY William Steig

Title *Grown-Ups Get to Do All the Driving*
Art Director *Holly McGhee*
Text/Jacket Designer *Susan Mitchell*
Text/Jacket Illustrator *William Steig*
Publisher *Michael di Capua Books/HarperCollins*
Typographer *Kennedy & Young*
Printer/Binder *Berryville Graphics*
Paper *Lindenmeyr Patina Matte*

Title *The Violin Masterpieces of Guarneri del Gesu*
Text/Cover Designer *Jerry Kelly*
Cover Photographer *Stewart Pollens*
Publisher *Peter Biddluph Publishing*
Printer *The Stinehour Press*
Paper *Potlatch Vintage Velvet Cream 100# Text*
Binder *Mueller Trade Bindery*

All that remain to be made are the sound holes and a bass bar. The sound holes, shaped like the letter ƒ, must be cut into the top. The flowing tones of the cello will come through the ƒ holes. The violin maker must position the holes exactly. He measures carefully before he traces on the ƒ pattern. He drills a little hole at the edge of the ƒ tracing. The blade of a coping saw is removable. It goes through the hole. Slowly, carefully, the violin maker saws along the line he drew until he has cut all the way around. Out falls the ƒ. With knives he smooths the edges of the holes.

20

MUSIC in the WOOD

CORNELIA CORNELISSEN
Photographed by JOHN MacLACHLAN

Title *Music in the Wood*
Art Director/Designer *Patrice Sheridan*
Jacket Designer/Typographer *Patrice Sheridan*
Text/Jacket Photographer *John MacLachlan*
Publisher *Delacorte Press/Bantam Doubleday Dell Books for Young People*
Printer/Binder *Berryville Graphics*
Paper *80# Westvaco Sterling Litho Satin*

Title *Time Flies*
Art Director *Isabel Warren-Lynch*
Designers *Isabel Warren-Lynch and Eric Rohmann*
Text/Jacket Illustrator *Eric Rohmann*
Jacket Designer *Isabel Warren-Lynch*
Publisher *Crown Books for Young Readers*
Printer/Binder *Horowitz/Rae Book*
Manufacturers, Inc.
Paper Manufacturer *Northwest Paper*
Paper *80# Mountie Matte*

CARACOLA

Me han traído una caracola.

Dentro le canta
un mar de mapa.
Mi corazón
se llena de agua
con pececillos
de sombra y plata.

Me han traído una caracola.

SNAIL

They have brought me a snail.

Inside it sings
a map-green ocean.
My heart
swells with water,
with small fish
of brown and silver.

They have brought me a snail.

17

Title *Songs of Childhood*
Art Director *Morris A. Gelfand*
Designer/Typographer *Morris A. Gelfand*
Illustrator *John DePol*
Letterer *Lili Wronker*
Publisher *The Stone House Press*
Printer *Jim Ricciardi*
Paper *Rives L/W*
Binder *Frank Casto, Alpha-Pavia*

A Century of Artists Books

PABLO PICASSO
Spanish, 1881–1973
Prints and Manuscripts for a Book Project
AUTHOR: Pablo Picasso

Jotting down phrases and sets of words that he planned to organize into a book, Picasso evidently was encouraged by Ambroise Vollard to pursue its design. The artist had devised a style of reproducing a manuscript with marginal decorations in 1936, when he decorated Paul Éluard's poem "Grand Air." As he worked on prints for his own writings, he made several nude figures that, because of their narrow format, seem to have been intended for a book. The more important compositions were his first color prints: portraits of Dora Maar. He created seven color aquatints before several events—including Vollard's sudden death and the general disarray that accompanied the onset of World War II—derailed the project.

Tête de femme no. 1: Portrait de Dora Maar.
[January–June, 1939]. Aquatint and drypoint, in color, on ivory laid Montval paper, 11⁹⁄₁₆ x 9⁵⁄₈" (29.8 x 23.7 cm). Baer 648Ce (*Bloc à tirer*). Collection E. W. Kornfeld, Bern

Tête de femme no. 2: Portrait de Dora Maar.
[April–May, 1939]. Aquatint, in color, on ivory laid Montval paper, 11⅞ x 9⅝" (30.1 x 24 cm). Baer 651D. The Museum of Modern Art, New York, Gift of Mrs. Melville Wakeman Hall

Autograph manuscript, dated April 28–May 1, 1938, in India ink on Arches paper, 10¾ x 6⅞" (26.4 x 17.6 cm). Musée Picasso, Paris

Nu debout I, state IV. [April 27, 1939]. Engraving and aquatint, in black on ivory laid Montval paper, 11¾ x 3⅝" (29.8 x 9.6 cm). Baer 696 IVa. Marina Picasso Collection, Jan Krugier Gallery, New York

Petit Nu debout and *Nu debout I*, state III. April 27, 1939. Engraving, and engraving and aquatint, in black, both on the same sheet of ivory laid Montval paper, 11¾ x 1" (29.5 x 2.5 cm) and 11⅝ x 3½" (29.5 x 9.5 cm). Baer 697b and 696IIIb. Marina Picasso Collection, Jan Krugier Gallery, New York

128

129

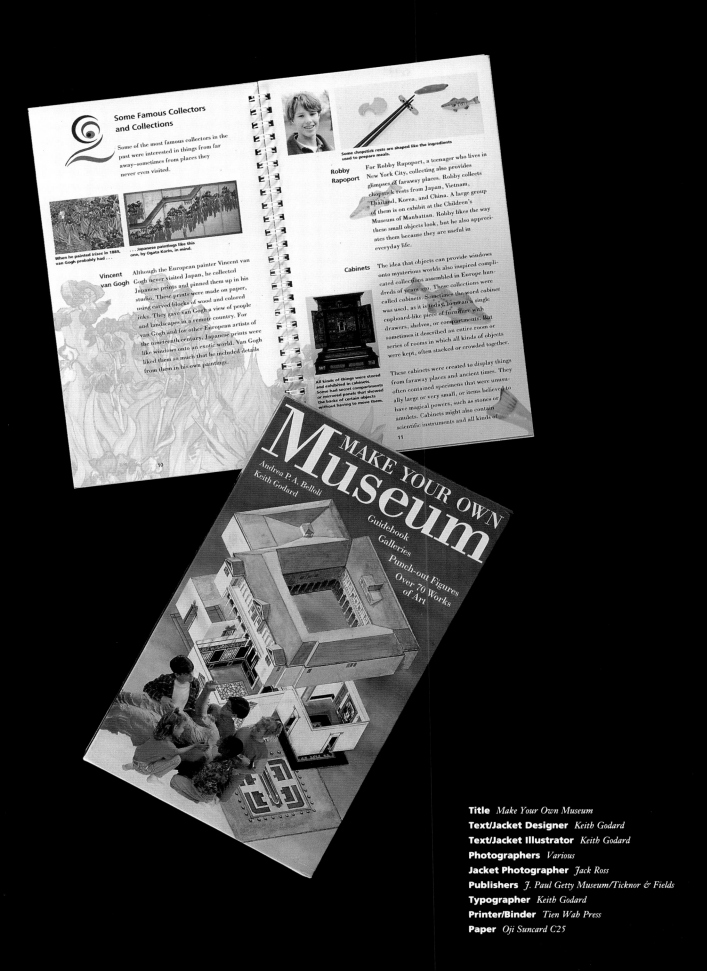

Some Famous Collectors and Collections

Some of the most famous collectors in the past were interested in things from far away—sometimes from places they never even visited.

When he painted *Irises* in 1889, van Gogh probably had . . .

. . . Japanese paintings like this one, by Ogata Korin, in mind.

Vincent van Gogh Although the European painter Vincent van Gogh never visited Japan, he collected Japanese prints and pinned them up in his studio. These prints were made on paper, using carved blocks of wood and colored inks. They gave van Gogh a view of people and landscapes in a remote country. For van Gogh and for other European artists of the nineteenth century, Japanese prints were like windows onto an exotic world. Van Gogh liked them so much that he included details from them in his own paintings.

10

Some chopstick rests are shaped like the ingredients used to prepare meals.

Robby Rapoport For Robby Rapoport, a teenager who lives in New York City, collecting also provides glimpses of faraway places. Robby collects chopstick rests from Japan, Vietnam, Thailand, Korea, and China. A large group of them is on exhibit at the Children's Museum of Manhattan. Robby likes the way these small objects look, but he also appreciates them because they are useful in everyday life.

Cabinets The idea that objects can provide windows onto mysterious worlds also inspired complicated collections assembled in Europe hundreds of years ago. These collections were called *cabinets*. Sometimes the word *cabinet* was used, as it is today, to mean a single cupboard-like piece of furniture with drawers, shelves, or compartments. But sometimes it described an entire room or series of rooms in which all kinds of objects were kept, often stacked or crowded together.

All kinds of things were stored and exhibited in cabinets. Some had secret compartments or mirrored panels that showed the backs of certain objects without having to move them.

These cabinets were created to display things from faraway places and ancient times. They often contained specimens that were unusually large or very small, or items believed to have magical powers, such as stones or amulets. Cabinets might also contain scientific instruments and all kinds of

11

MAKE YOUR OWN Museum

Andrea P. A. Belloli
Keith Godard

Guidebook
Galleries
Punch-out Figures
Over 70 Works of Art

Title *Make Your Own Museum*
Text/Jacket Designer *Keith Godard*
Text/Jacket Illustrator *Keith Godard*
Photographers *Various*
Jacket Photographer *Jack Ross*
Publishers *J. Paul Getty Museum/Ticknor & Fields*
Typographer *Keith Godard*
Printer/Binder *Tien Wah Press*
Paper *Oji Suncard C25*

Title *Building Bridges Across Time*
Art Director *Nancy E. Koc*
Text/Jacket Designer *Nancy E. Koc*
Jacket Photographer *Thea Schrack*
Publisher *California Pacific Medical Center*
Typographer *Nancy E. Koc*
Printer *Coast Litho*
Paper *Simpson Coronado Recycled SST*
Binder *Economy Bindery*

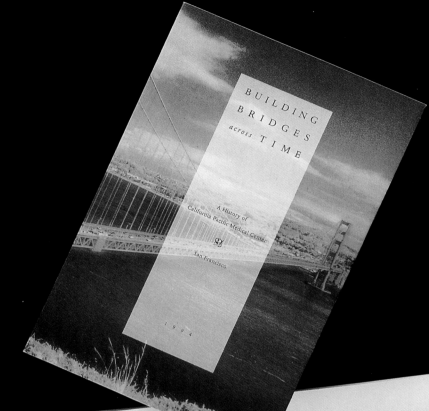

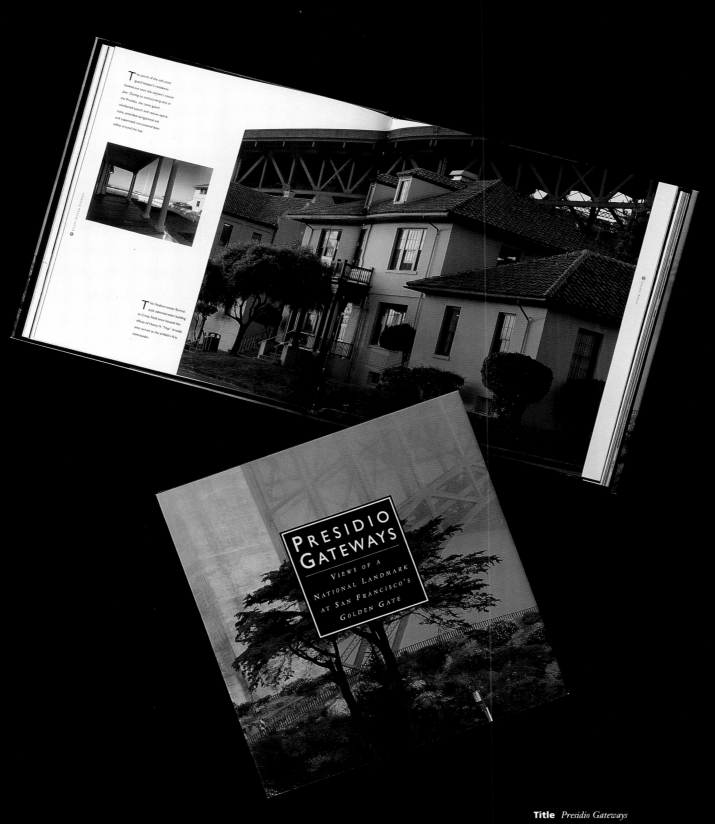

Title *Presidio Gateways*
Art Director *Kit Hinrichs*
Designer *Lisa Miller*
Illustrator *Dugald Stermer*
Photographers *Linda Butler,*
Robert Glenn Ketchum, Mary Swisher,
Lyle Gomes, and Brenda Tharp
Jacket Designer *Pentagram Design*
Jacket Photographer *Robert Glenn Ketchum*
Publisher *Chronicle Books*
Printer *Graphic Arts Center*
Paper *Potlatch Quintessence Remarque 100#,*
Vintage Velvet Creme 100# Text

The Columbia Book of
CIVIL WAR POETRY

FROM WHITMAN TO WALCOTT

Edited by Richard Marius

Confederate General Albert Sidney Johnston

They are a royal race of men, these brothers face to face,
Their fury speaking through their guns, their frenzy in their pace;
The sweeping onset of the Gray bears down the sturdy Blue,
Though Sherman and his legions are heroes through and through.

Though Prentiss and his gallant men are forcing scaur and crag,
They fall like sheaves before the scythes of Hardee and of Bragg;
Ah, who shall tell the victor's tale when all the strife is past,
When man and man in one great mould the men who strive are cast.

As when the Trojan hero came from that fair city's gates,
With tossing mane and flaming crest to scorn the scowling fates,
His legions gather round him and madly charge and cheer,
And fill the besieging armies with wild disheveled fear.

Then bares his breast unto the dart the daring spearsman sends,
And dying hears his cheering foes, the wailing of his friends,
So Albert Sidney Johnston, the chief of belt and scar,
Lay down to die at Shiloh and turned the scales of war.

Now five and twenty years are gone, and lo, today they come,
The Blue and Gray in proud array with throbbing fife and drum;
But not as rivals, not as foes, as brothers reconciled,
To twine love's fragrant roses where the thorns of hate grew wild.

They tell the hero of three wars, the lion-hearted man,
Who wore his valor like a star—uncrowned American;
Above his heart serene and still the folded Stars and Bars,
Above his head like mother-wings the sheltering Stripes and Stars.

Title *Daniel Halpern: Selected Poems*
Art Director *Virginia Tan*
Designer *Peter A. Andersen*
Jacket Designer *Carol Devine Carson*
Publisher *Alfred A. Knopf, Inc.*
Printer/Typographer *Heritage Printers*
Paper Manufacturer *Glatfelter*
Paper *Perkins & Squier Offset Laid, 70#*
Binder *Kingsport Press*

...MacDowell Colony
...Michael McPherson
...ublishing
...McPherson
...bing

...a Confetti Cover and
...White Vellum Text

MEDAL DAY AT THE MACDOWELL COLONY

RICHARD
WILBUR
1992

What the Colony offers is an insular experience in the country, a chance to be a landlocked castaway; here one is protected from external distractions, and rewarded with good company in the evenings. Edwin Arlington Robinson, who came here for 23 years, is quoted in Colony literature as saying of this place, "The impulsion to work is in the air," and the visitor senses at once that benign impulsion....

Of course, no man in his seventies can be sure of persisting in his art, especially if he is a lyric poet. When people asked Robert Frost why he wrote poems, he sometimes answered, "To see if I can make them all different." That answer is both evasive and very true; when a poet catches himself not making them all different—repeating not only his themes but his words and devices also—he may feel that it's time for him to stop. Perhaps some writers cease to write because of a change in the audience—the loss of like-minded friends, the disappearance of those mentors and admired elders whom one had set out to please. It may be that age takes away from some artists the ability to be continuously obsessed, day and night, with some developing idea. Archibald MacLeish, in his latter years, said something of the kind to Donald Hall. And then there is the matter of physical vigor. I think that mental energy is not altogether dependent on physical energy; yet I should think that infirmity of sedentariness might rob one's work of strong rhythms and kinetic imagination: When Edmund Spenser speaks of "sea shouldering whales," he is writing with the body, and it may be that writing with the body is something that gets harder to do.

I shall find out about all these things, but for the present I feel—as John Hersey recently said of himself—that "If I were not writing a book I wouldn't know myself."

❧ 30 ❧

PRAISING

A WRITER FOR HIS STAMINA may seem like tame stuff—like praising an actor for his enthusiasm or a speaker for the length of his wind. But not to another writer, it doesn't. Writers know what stamina entails: it does not mean treading water. What it does mean is an endless series of rebirths, possibly painful, and always risky. It means forever slashing your way into new parts of the jungle, as opposed to setting up shop in the first clearing one comes to, as the hacks do.

WILFRID SHEED ON
JOHN UPDIKE
1981

Echinocactus horizonthalonius var. *nicholii*

NICHOL'S TURK'S HEAD CACTUS

EAGLE'S CLAW CACTUS

THIS is another on the short list of U.S. plants to have been listed as endangered as early as 1979. And it is threatened by the same factors that put most other desert plants at risk: Off-road vehicles, hikers, the development of limestone quarries or mines, and illegal collectors.

This rare cactus is still occasionally found in the Sonoran Desert of southern Arizona and Mexico. Fortunately, many of the plants are on land administered by the Bureau of Land Management and the Bureau of Indian Affairs—organizations that regulate use to protect some of the remaining cactus populations.

70·

EAGLE'S CLAW CACTUS

Echinocactus horizonthalonius var. *nicholii*

*NICHOL'S TURK'S HEAD CACTUS

VANISHING FLORA

DUGALD STERMER

Title *The Body*
Art Director/Jacket Designer
Lucille Tenazas
Designer *Todd Foreman*
Publisher *Chronicle Books*
Printer/Binder *CS Graphics*

element absent in the show's earlier incarnation. Veiled allusions to homosexual love were everywhere detectable: in *Untitled (Perfect Lovers)* (1987–90), twin commercial clocks huddling on the wall ticked out the time in perfect harmony; the adjacent pair of identical circular wall mirrors, *Untitled (March 5th) #1* (1991), promised to reflect the nearby faces of an observing couple; two matching gold rings (wedding bands?) touched to form a figure eight—the sign of eternity, of eternal love—comprised the image on the stack *Untitled (Double Portrait)* (1991); duplicate light-bulb strings, subtitled *Lovers–Paris*, emerged from adjacent electrical sockets to curl on the floor in two softly glowing heaps; and a discreetly framed color photograph of flowers in bloom proved, from the title, to be of the Parisian grave site of the famous lesbian couple Alice B. Toklas and Gertrude Stein. Like Gonzalez-Torres's billboard of an empty but previously occupied double bed, the Hirshhorn installation alluded to libidinal desire while remaining intentionally elusive. Its leitmotif of paired objects suggested

Untitled (Alice B. Toklas' and Gertrude Stein's Grave, Paris), 1992. Framed C-print.

FELIX GONZALEZ-TORRES

72

erotic coupling; the fact that the objects were identical intimated that the desire was to be construed as homoerotic.

Gonzalez-Torres refuses the nomenclature "gay artist," however." The love that he hints at in his work can be either homo- or hetero-sexual—or both—depending upon the viewer's own orientation. To adamantly stress the homoerotic element in the work would mean "falling into a trap set by the Right," maintains the artist, who resists playing the role of marginalized rebel. As he explains:

Two clocks side by side are much more threatening to the powers that be than an image of two guys sucking each other's dicks, because they cannot use me as a rallying point in their battle to erase meaning. It is going to be very difficult for members of Congress to tell their constituents that money is being expended for the promotion of homosexual art when all they have to show are two plugs side by side, or two mirrors side by side, or two light bulbs side by side.

CHAPTER TWO

73

Untitled (Lovers–Paris), 1993. Light bulbs, extension cords, porcelain light sockets, and dimmer switch.

Title *Felix Gonzalez-Torres*
Art Director/Designer *Takaaki Matsumoto*
Publisher *The Solomon R. Guggenheim Museum*
Typographer *Matsumoto Inc.*
Printer *Cantz*

Two Fish, Bahia, 1992
Mario Cravo Neto

Two Forms, 1963
Ruth Bernhard

AFRICA

HERB RITTS

(Book cover, upper portion of image)

Coherence, Counterpoint, Instrumentation, Instruction in Form
by Arnold Schoenberg

Zusammenhang, Kontrapunkt, Instrumentation, Formenlehre

TRANSLATED BY CHARLOTTE M. CROSS & SEVERINE NEFF

EDITED AND WITH AN INTRODUCTION BY SEVERINE NEFF

ZKIF

(Left-hand page)

‼ {1:7} Ein Motiv ist etwas das zu einer Bewegung Anlass giebt. *Eine Bewegung ist jene Veränderung eines Ruhezustandes, die ihn in sein Gegenteil verkehrt.* Man kann somit das Motiv mit einer treibenden Kraft vergleichen. Eine solche wird eines Gegenstandes bedürfen, auf den sie wirkt.

Sie wird gross genug sein müssen um Diesen aus seinem Ruhezustand zu bringen und die Bewegung, die sie erweckt wird ihrer Grösse{,} Dauer und Art nach abhängen von der Art der treibenden Kraft und des getriebene Gegenstandes.

— x —

Das Vorhergehende ist wohl nicht ganz richtig: Was eine Bewegung hervorruft ist ein *Motor.* Man muss zwischen *Motor* und *Motiv* unterscheiden.

Das *Motiv* wird folgendermassen zu definieren sein{:}

Als Motiv ist ein Ding dann zu bezeichnen, wenn es bereits unter der Wirkung einer treibenden Kraft steht, ihren Impuls bereits empfangen hat und im Begriff ist, ihm Folge zu leisten. Es ist vergleichbar mit einer Kugel auf einer schiefen Ebene im Augenblick bevor sie fortrollt; mit einem befruchteten Samen; mit einem zum Schlag erhobenen Arm etc.

Welches sind daher *musikalisch die Eigenschaften eines Motives*{?}

Vorher: jedes kleinste musikalische Ereignis kann zum Motiv werden, wenn man es wirken lässt, der einzelne Ton bereits kann Folgen haben.

13/4.1917 Jeder *einzelne Ton* kann unter Umständen Motiv sein; 2.Bsp. Beethoven op.59 – 1, Seite 5

(music notation) etc. die halbe Note ist Motiv dieser Stelle.

(margin note) Es wird gut sein, … der Unterschied zwischen Motor u. Motiv in die Augen springt.

(Right-hand page)

‼ {1:7} A motive is something that gives rise to a motion. *A motion is that change in a state of rest which turns it into its opposite.* Thus, one can compare the motive with a driving force. Such a driving force will require an object on which it acts.

This driving force will have to be great enough to bring the object out of its condition of rest; and the motion it causes will depend for its size, duration, and kind on the type of driving force and on the object driven.

— x —

The preceding is probably not entirely correct: What causes motion is a *motor.* One must distinguish between *motor* and *motive.*

A *motive* may be defined as follows:

A thing is termed a motive if it is already subject to the effect of a driving force, has already received its impulse, and is on the verge of reacting to it. It is comparable to a sphere on an inclined plane at the moment before it rolls away; to a fertilized seed; to an arm raised to strike, etc.

What, therefore, are the *musical characteristics of a motive?*

First of all: even *the smallest musical event* can become a motive; if {it is} permitted to have an effect, even an individual tone can carry consequences.

13/4.1917 Under certain circumstances, each *single tone* can become a motive; for ex., Beethoven, op.59, no.1, page 5[19]

(music notation) etc. The half note is the motive of this passage.

(margin note) It will be good to … to make obvious the difference between motor and motive.[?]

18. Compare Schoenberg, *Theory of Harmony.* 34.

19. See mm.144–45 or 146–47.

White Friends

Jennifer L. Vest

some or one of them would like me, or think that I was pretty, or become
a friend; and I would have real friends in college, good friends, best
friends, who would never drag a swift and sneaky glance over the top
of my paper to see whether my grade was higher than theirs and get
angry if it was, or hold my arm aloft next to theirs when they got back
from spending Christmas vacation in Bermuda so that they could show
everyone how deep a tan they'd gotten.

These hopes were not only all I ever managed of
question and critique; they were also, quite simply, all I ever managed
of deep consideration where Eastley was concerned. If I opted to ana-
lyze the particulars of my situation, I would perish; if I took a moment
to think about the means by which I accomplished my feat, I would lose
the power to achieve it. It was safer—and, of course, necessary—to
study German, or Ancient and Medieval History, or Biology, or English
Literature, or Sculpture, or Drama, or Latin, than it was turn my at-
tention to the setting in which I learned these subjects. To contemplate
would be to lose the ability to breathe water, and such was a loss I could
ill afford. And so I rose and fell each day, putting off reflection for a date
in the indeterminate future, storing reactions in some unseen place, al-
ways rising and falling, rising and falling, in the steadily wakening or
weakening light.

After awhile
You don't want to explain anymore
You stop telling
Stop being patient
Close your eyes, hold your heart
And run like hell.

They call you narrow then
They want to know why you
No longer want to teach
Them to love you,
No longer want to hold
Their one hand
As they punch you
With the other
No longer want to wipe
The spit from your face
Turn the cheek
Be invincible
Be like granite
And smile
In the stinging
Onslaught
Which they call
Their innocent ignorance.

TESTIMONY

*young African-Americans on
Self-Discovery and Black Identity*
Edited by Natasha Tarpley

Title *Testimony: Young African-Americans on
Self-Discovery and Black Identity*
Art Director *Sara Eisenman*
Text/Jacket Designer *John Kane*
Publisher *Beacon Press*
Typographer *Wilsted & Taylor Publishing Services*
Printer/Binder *R. R. Donnelley & Sons*
Paper *50# Glatfelter B-08 Sebago Antique 400ppi*

Title *Chambers for a Memory Palace*
Art Director *Yasuyo Iguchi*
Text/Jacket Designer *Yasuyo Iguchi*
Illustrator *Donlyn Lyndon*
Publisher *The MIT Press*
Typographer *DEKR Corp.*
Printer/Binder *Quebecor Kingsport*
Jacket Printer *New England Book Components*
Paper *70# Simpson Evergreen Matte*

Jean-Paul Marat
Charlotte Corday

I T WAS JULY 1793—four years after the fall of the Bastille and some six months since the king's execution. To Charlotte Corday, in Caen, as to many others in the provinces, the promise of the Revolution had been irretrievably tarnished. The excesses of the Jacobins were to blame. Even in Girondist Caen there was a guillotine now: its first victim was the priest who years before had attended Charlotte's mother when she died in childbirth. And as Corday knew, no Jacobin in France more avidly promoted the guillotine, or unmasked more "traitors," than the virulent polemicist and pamphleteer Jean-Paul Marat.

So when she read exhortations like "Let Marat's head fall and the Republic is saved!" posted along the streets of Caen, Corday—a young and beautiful descendant of the dramatist Corneille—rose to claim her destined role. On July 9 she boarded the Paris coach. On the morning of the thirteenth she walked from her lodgings to the Palais Royal and along the way bought a newspaper, a black hat with green ribbons, and a large kitchen knife. After one abortive attempt she managed to slip into the house she sought, on the rue des Cordeliers, and then, by loudly declaring that she bore valuable information, to confront Marat himself.

Marat lay, as he had for weeks, in his shoe-shaped tub, attempting with solutions of kaolin to relieve the scaly sores that afflicted his body. A board served as his desk. His receiving *en bain* had the advantage that his broad shoulders and brawny arms were fully visible while his almost stunted lower body was not. As she sat at his side, Charlotte described the rebellious atmosphere at Caen. Asked for names, she coolly ticked them off. Marat was pleased. "In a few days I will have them all guillotined," he said, and thereby made easier what followed. Like the tragedienne she saw herself, Charlotte Corday stood erect, pulled the knife from her bodice, and aimed true.

FIRST ENCOUNTERS
A BOOK OF MEMORABLE MEETINGS
NANCY CALDWELL SOREL AND
EDWARD SOREL

Paul Auster
A COMPREHENSIVE BIBLIOGRAPHIC CHECKLIST
OF PUBLISHED WORKS 1968–1994

C9 Marc Chagall: A Celebration — 1977

a. *First Edition.* New York: Pierre Matisse Gallery, May–June 1977. pp.36. 25.4 x 20.4 cm. Wrappers. n.p. BC
Translation. Includes translation of an essay celebrating Chagall's 90th birthday by Jean Leymarie. Complete title is: *Marc Chagall: A Celebration. Part One: From 1911-1939. Part Two: The 60's and 70's.*

C10 Jean-Paul Sartre. Life/Situations — 1977

a. *First Edition.* New York: Pantheon Books, 1977. Translated by Paul Auster and Lydia Davis. pp.vi,218. 21.5 x 14.6 cm. Cloth in dust jacket. $8.95. BC
Translations. Includes translations of three lengthy interviews and four political essays. Complete title is: *Life/Situations: Essays Written and Spoken.*

b. *First Paperback Edition.* New York: Pantheon Books, 1977. pp.vi,218. 18.3 x 10.7 cm. $2.95. BC,WD

c. *First British Edition.* London: André Deutsch, 1978. pp.vi,218. 22.2 x 14.4 cm. Cloth in dust jacket. £4.95. BC
British edition retitled: *Sartre in the Seventies: Interviews and Essays.*

C11 Jean Chesneaux. China from — 1977
The 1911 Revolution to Liberation

a. *First Edition.* New York: Pantheon Books, 1977. Translated by Paul Auster and Lydia Davis. pp.x,374. 24.1 x 16.2 cm. Cloth in dust jacket. $17.95.
Translation. Chapters 1-3 translated by Anne Destenay.

b. *First Paperback Edition.* New York: Pantheon Books, 1978. $6.95. [not seen]

c. *First British Edition.* London: Harvester Press, 1978. Cloth in dust jacket. £12.50. [not seen]

d. *First British Paperback Edition.* London: Harvester Press, 1978. £5.00. [not seen]

... uc. Mao Tse-Tung: — 1977
...ide to His Thought

...*irst Edition.* New York: St. Martin's Press, 1977. Translation by Paul Auster and Lydia Davis. pp.xviii,238. 24.1 x 16.2 cm. Cloth in dust jacket. $10.00.
Translation.

C13 The Penguin Book of Women Poets — 1978

a. *First Edition.* London: Allen Lane, 1978. Edited by Carol Cosman, Joan Keefe, and Kathleen Weaver. pp.400. 20.4 x 13.5 cm. Cloth in dust jacket. £5.95.
Translation. Includes translation from Anne-Marie Albriach's poem "État."

b. *First American Edition.* New York: The Viking Press, 1979. pp.400. 20.4 x 13.5 cm. Cloth in dust jacket. $14.95.

c. *First Paperback Edition.* New York: Penguin Books, 1979. pp.400. 19.4 x 12.8 cm. $4.95. BC

C14 Jean Chesneaux. China: — 1979
The People's Republic, 1949-76

a. *First Edition.* New York: Pantheon Books, 1979. Translated by Paul Auster and Lydia Davis. pp.xii,260. 24.2 x 16.2 cm. Cloth in dust jacket. $15.00.
Translation.

b. *First Paperback Edition.* New York: Random House, 1979. $4.95. [not seen]

c. *First British Edition.* London: Harvester Press, 1979. Cloth in dust jacket. £12.50. [not seen]

d. *First British Paperback Edition.* London: Harvester Press, 1979. £5.50. [not seen]

FIFTY BOOKS OF 1994

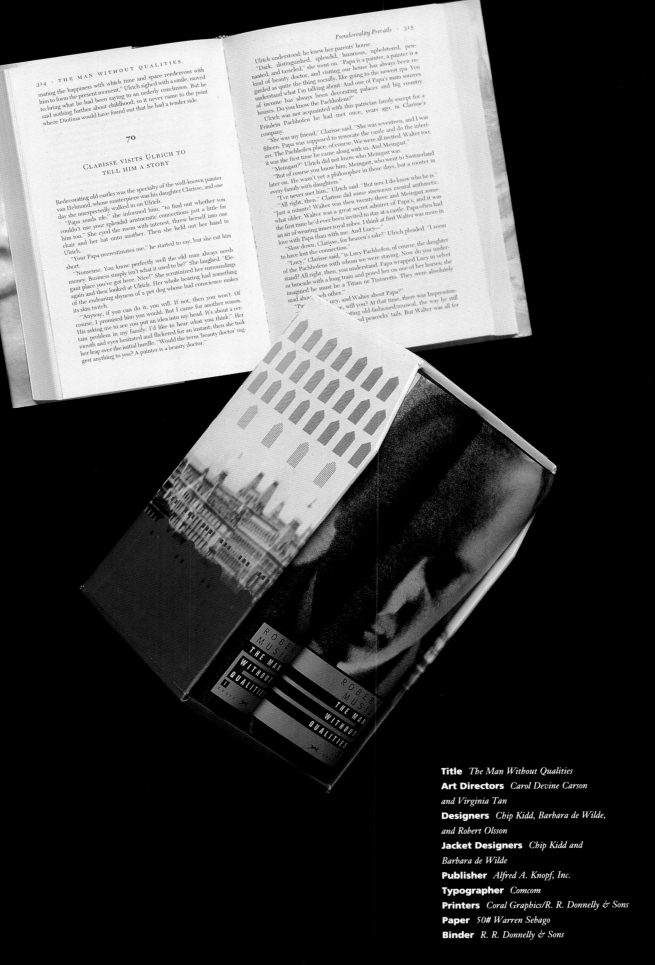

The following text appears on the pages of the open book within the image:

mating the happiness with which time and space rendezvous with him to form the present moment," Ulrich sighed with a smile, moved to bring what he had been saying to an orderly conclusion. But he said nothing further about childhood, so it never came to the point where Diotima would have found out that he had a tender side.

70

CLARISSE VISITS ULRICH TO TELL HIM A STORY

Redecorating old castles was the specialty of the well-known painter van Helmond, whose masterpiece was his daughter Clarisse, and one day she unexpectedly walked in on Ulrich.

"Papa sends me," she informed him, "to find out whether you couldn't use your splendid aristocratic connections just a little for him too." She eyed the room with interest, threw herself into one chair and her hat onto another. Then she held out her hand to Ulrich.

"Your Papa overestimates me," he started to say, but she cut him short.

"Nonsense. You know perfectly well the old man always needs money. Business simply isn't what it used to be!" She laughed. "Elegant place you've got here. Nice!" She scrutinized her surroundings again and then looked at Ulrich. Her whole bearing had something of the endearing shyness of a pet dog whose bad conscience makes its skin twitch.

"Anyway, if you can do it, you will. If not, then you won't. Of course, I promised him you would. But I came for another reason. His asking me to see you put an idea into my head. It's about a certain problem in my family. I'd like to hear what you think." Her mouth and eyes hesitated and flickered for an instant; then she took her leap over the initial hurdle. "Would the term 'beauty doctor' suggest anything to you? A painter is a beauty doctor."

Ulrich understood; he knew her parents' house.

"Dark, distinguished, splendid, luxurious, upholstered, penanted, and tasseled," she went on. "Papa is a painter, a painter is a kind of beauty doctor, and visiting our house has always been regarded as quite the thing socially, like going to the newest spa. You understand what I'm talking about. And one of Papa's main sources of income has always been decorating palaces and big country houses. Do you know the Pachhofens?"

Ulrich was not acquainted with this patrician family except for a Fräulein Pachhofen he had met once, years ago, in Clarisse's company.

"She was my friend," Clarisse said. "She was seventeen, and I was fifteen. Papa was supposed to renovate the castle and do the interiors. The Pachhofen place, of course. We were all invited. Walter too; it was the first time he came along with us. And Meingast."

"Meingast?" Ulrich did not know who Meingast was.

"But of course you know him; Meingast, who went to Switzerland later on. He wasn't yet a philosopher in those days, but a rooster in every family with daughters."

"I've never met him," Ulrich said. "But now I do know who he is."

"All right, then." Clarisse did some strenuous mental arithmetic. "Just a minute! Walter was then twenty-three and Meingast somewhat older. Walter was a great secret admirer of Papa's, and it was the first time he'd ever been invited to stay at a castle. Papa often had an air of wearing inner royal robes. I think at first Walter was more in love with Papa than with me. And Lucy—"

"Slow down, Clarisse, for heaven's sake!" Ulrich pleaded. "I seem to have lost the connection."

"Lucy," Clarisse said, "is Lucy Pachhofen, of course, the daughter of the Pachhofens with whom we were staying. Now do you understand? All right, then, you understand. Papa wrapped Lucy in velvet or brocade with a long train and posed her on one of her horses; she imagined he must be a Titian or Tintoretto. They were absolutely mad about each other.

"Pa[pa was in love with L]ucy, will you? At that time, there was Impression[ism ... pa]inting old-fashioned/musical, the way he still [...]d peacocks' tails. But Walter was all for

Title *The Man Without Qualities*
Art Directors *Carol Devine Carson and Virginia Tan*
Designers *Chip Kidd, Barbara de Wilde, and Robert Olsson*
Jacket Designers *Chip Kidd and Barbara de Wilde*
Publisher *Alfred A. Knopf, Inc.*
Typographer *Comcom*
Printers *Coral Graphics/R. R. Donnelly & Sons*
Paper *50# Warren Sebago*
Binder *R. R. Donnelly & Sons*

ur Backyard

ectors *Randy Swearer and Kate Breakey*

ket Designers *Randy Swearer*

Breakey

et Photographers *Randy Swearer*

reakey

Typographer *Lupine Industries*

nder *Friesens Printers*

Loe Dull

Title *The Fossils of the Burgess Shale*
Art Director *Linda McKnight*
Text/Jacket Designer *Linda McKnight*
Illustrators *Various*
Text/Jacket Photographer *Chip Clark*
Publisher *Smithsonian Institution Press*
Typographer *Graphic Composition, Inc.*
Printer/Binder *Maple-Vail*
Paper *70# Glatfelter Premier Matte*